OXFORD STUDIES IN THE HISTORY OF ART AND ARCHITECTURE

General Editors
FRANCIS HASKELL
CHARLES MITCHELL JOHN SHEARMAN

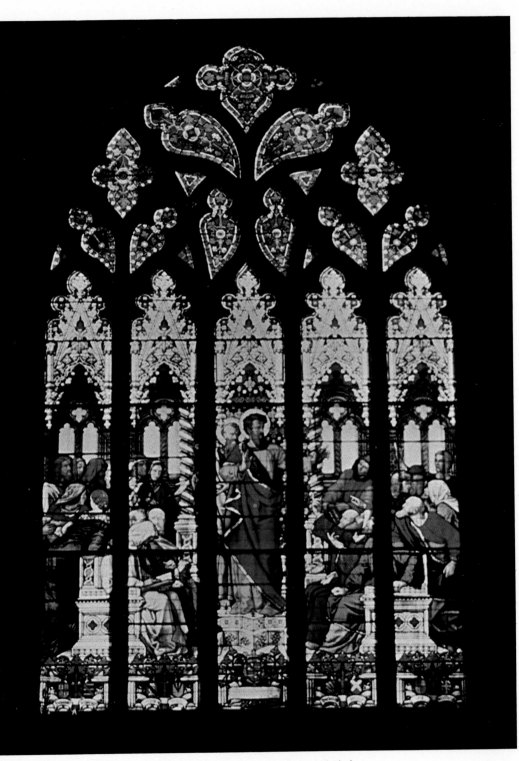

St. Paul and St. Barnabas Preaching at Antioch,
stained glass window, St. Paul's Church, Alnwick, 1853

WILLIAM DYCE
1806-1864

A CRITICAL BIOGRAPHY

MARCIA POINTON

WITH A FOREWORD BY
QUENTIN BELL

CLARENDON PRESS · OXFORD
1979

Oxford University Press, Walton Street, Oxford OX2 6DP

OXFORD LONDON GLASGOW
NEW YORK TORONTO MELBOURNE WELLINGTON
KUALA LUMPUR SINGAPORE JAKARTA HONG KONG TOKYO
DELHI BOMBAY CALCUTTA MADRAS KARACHI
NAIROBI DAR ES SALAAM CAPE TOWN

Published in the United States by
Oxford University Press, New York

British Library Cataloguing in Publication Data

Pointon, Marcia Rachel
 William Dyce 1806–1864. – (Oxford studies in the history of art and architecture).
 1. Dyce, William 2. Painters – Scotland – Biography
 I. Title
 759.9411 ND497.D/ 79-40390

 ISBN 0-19-817358-X

Printed in Great Britain by
Richard Clay (The Chaucer Press) Ltd,
Bungay, Suffolk

To my Mother, Margaret Collin,
and to the memory of
my Father, David Collin

FOREWORD

'This book', says its author, 'is a biography, not simply an art-historical study of William Dyce's achievement in the visual arts.' Those of us who know a little about Dyce will applaud the wisdom of which that statement is an expression; as a painter Dyce is indeed a complex and many faceted character, sufficiently puzzling and sufficiently attractive to make a wonderful subject for study, but when we consider not only the painter but the scientist, the ecclesiologist, the musician, the teacher, the administrator, the intensely active high-churchman, all of whom were combined in that proud, gifted, kindly, peevish, angular personality who, to a puzzled but on the whole admiring generation was known as William Dyce, it must surely be apparent that to devote oneself exclusively to one side of the man's activities, even though it be the most important, would be wrong. It is precisely because he was 'so damned various' and so much of a polymath that Dyce offers so rich and curious a subject for investigation.

Somewhere near the beginning of that rather elongated sentence I referred to those who 'know a little about Dyce'. They do not, it must be allowed, form a very large contingent of the educated public. Perhaps, wandering amongst the nineteenth-century paintings in the Tate Gallery we may have come across a landscape of sea, sky, and deeply serrated chalk cliffs which captures perfectly the stillness and gravity of an autumnal evening. It is a scene pregnant with melancholy, deeply romantic in mood, but entirely and rigorously prosaic in every detail. Everything is stated with such complete authority that we come to a halt; aware, at the very least, that here was a painter who had something to say and knew exactly how to say it. Upon the frame we read: William Dyce 1806–1864, *Pegwell Bay,*

Kent—a recollection of 5th October 1864. Dull would he be of soul who could pass by . . . Nevertheless, although this impressive evidence of his gifts brings us momentarily to a standstill the name of Dyce is not one that comes readily to my mind. Of his own work we see too little and—it must be admitted—he is decidedly unequal; also, although it may theoretically be indefensible, we tend to judge an artist by the company he keeps. In the case of Dyce this means artists such as Eastlake, Maclise, Cope, Regrave, J. R. Herbert (it was not perhaps an age of giants) and by extension, the Pre-Raphaelites who were very much his juniors. He belongs indeed to what very loosely may be called the age of the Prince Consort, a period for which our parents and grandparents had only a disdainful smile; we are beginning to look at it with rather more of curiosity and indeed of respect; also we are beginning to admit that, if not gigantic, some of Dyce's contemporaries were not, after all, mere dwarfs. More importantly we are beginning to appreciate the vast historical importance of an age which undertook a complete revision of art history as it had previously been understood and found itself with quite new and, implicitly, deeply disturbing methods of valuation. The primacy of hellenic art, of the High Renaissance and the 'approved' masters of the Seicento was being under-mined and with it the whole structure of criticism. It was an age also in which Art in Britain becomes available to a far wider public and becomes a concern of government. Finally it may be said that it was at this time that in Britain the purpose and character of art was drastically redirected, we were taken out of Europe and away from the prevailing traditions of our own painting. In these revolutions of feeling Dyce played an important, sometimes a most important, part and for that alone he is well worth study. An examination of his role at this time is the more necessary because I suspect that the little that we do know is misleading. I have spoken of *Pegwell Bay* but there is another celebrated work, by Dyce, best known in Reproduction: *Joash shooting the Arrow of Deliverance*, again clearly the work of an impressive, intelligent and enormously gifted painter. The thing that strikes one most about it is the artist's treatment of the male nude, one which is indeed a most competent piece of draughtsmanship. Nevertheless I suspect that many observers will agree with me in finding this thoughtful and highly professional work much less, or much less immediately sympathetic than *Pegwell Bay*. It is a faithful, religious, and sternly accurate record of an incident in the military history of the Old Testament and reminds us, if only by reason of its manifest piety, of the stock description

of William Dyce: 'the British Nazarene', and because the Nazarenes seem, on the whole, a rather depressing school, the label has done nothing for the reputation of Dyce.

Very deftly, Marcia Pointon has untied and removed the offending ticket; Dyce was at times an intensely spiritual artist and a seriously religious man, but his spirituality is based upon naturalism rather than on the nostalgic idealism of the Brethren of St. Luke; unlike them he celebrates the energy of the body and delights in the visible world. Her explanation is convincing and critically useful inasmuch as it helps us to a better understanding of this artist's work.

As I have already indicated, she does not confine herself to an examination of the artist's paintings and designs, she looks at his work as an educationalist and the part which he played in the formation of the Schools of Design; more importantly, she gives us an arresting picture of Dyce's connection with High Anglicanism, demonstrating the very important artistic and musical aspects of that extraordinary intellectual adventure; above all, she has gone about as far as anyone can go, I should imagine, in finding out what kind of a man Dyce was and what kind of a life he led. It cannot have been an easy task; I myself have attempted to venture into that bare but perplexing wilderness which the student of Dyce must attempt to explore; I have seen her go far beyond the limits of my own tentative excursion and am full of wonder and admiration for what she has achieved. The book is in my estimation a triumph of patient research but the results are given us with no tiresome parade of knowledge and no jargon. It is in fact a straightforward, honest, and unpretentious work and I am proud to have been invited to find a place within its covers.

Quentin Bell

ACKNOWLEDGEMENTS

I would like to thank all the galleries, museums, and libraries to which I have been given access during the period of my research for this study and I would especially like to thank the staff of the National Gallery of Scotland, the Scottish National Portrait Gallery, and Aberdeen Art Gallery for their unfailing patience and kindness in the face of frequent demands on their time. I am much indebted to the many private collectors, too numerous to list, who have shown me paintings and manuscripts and frequently extended to me their hospitality. My thanks go also to those friends and colleagues who have read and offered invaluable advice on sections of this book in manuscript, who have generously given me the benefit of their expertise in subjects unfamiliar to me, who have accompanied me to remote areas of the British Isles in search of material for this book, and who have supplied me during the past six years (through postcards, telephone calls, messages, and other media) with a wonderful quantity of useful information relating to Dyce and his intellectual environment. I would particularly like to thank Mr. Charles Sewter for originally encouraging me to undertake this study and to Professor Quentin Bell for urging me on to complete it for publication. My greatest debt is to my husband and to my children, for their tolerance, patience, and encouragement.

The photographs for many of the plates in this book were made available by courtesy of the librarian, the John Rylands Library of the University of Manchester.

Brighton, 1978

CONTENTS

LIST OF PLATES

Italic numbers in parentheses refer to page numbers of the relevant check-list entries.
Plates (at end) are referred to in the main text by means of bold type numbers in the margin.

Every attempt has been made to establish the ownership and whereabouts of the pictures discussed; any oversights will be corrected in future impressions.

ABBREVIATIONS AND
NOTE ON SOURCES

D.P. Aberdeen Art Gallery, Dyce Papers.

The Dyce Papers which constitute the chief documentary source for this study, comprise a mainly typed transcript of William Dyce's correspondence made by his son, Stirling Dyce, who intended writing the artist's biography. Occasionally there are pages of comment and paraphrase by Stirling Dyce but for the most part the letters, though undoubtedly selected, are transcribed complete as far as we can tell. The original manuscripts from which the transcripts were taken are no longer extant but, where it has been possible to compare the Dyce Papers with manuscripts from other collections, they have been found to be accurate and reliable. The section of the Dyce papers covering the artist's period of study in Rome has, unfortunately, been missing since the last war. As the page numbering of this typescript is erratic, chapter numbers only are given in footnote references.

INTRODUCTION

This book is a biography, not simply an art-historical study of William Dyce's achievement in the visual arts. There are two important reasons for this. In the first place, a chronology for the paintings of an artist whose style fluctuated during the forty years or so of his working life, whose total *oeuvre* is relatively small, and who seldom dated and frequently did not exhibit his pictures, can only be established through a year by year examination of the artist's life. Secondly, we can only begin to understand the nature and the extent of Dyce's achievement by considering his activities and expression in all media.

It has not been my intention to evade the issues raised by a traditional approach to the history of art; individual paintings and drawings in addition to works of applied art are, therefore, discussed in detail in the text. However, since the life of William Dyce, besides his artistic accomplishments, has much to offer any reader concerned with nineteenth-century studies, this book is not directed exclusively to art-historians.

In recent years, and especially since the centenary exhibition of his work at Aberdeen Art Gallery and at Agnew's in London in 1964, there has been a tendency to view William Dyce, the painter, as one of the most talented and serious of nineteenth-century British artists. Nevertheless, grave misconceptions about the artist remain. His name is still linked without qualification to the Pre-Raphaelite Brotherhood. He is assumed to have divided his life up into periods devoted to specialized activity: portraits in the thirties, the School of Design in the forties, fresco painting in the fifties, and so on. He is regarded as the British Nazarene, yet the relationship of his art to the ideas, events, and beliefs of his own country and his

own time are either overlooked or studied superficially. Dyce was at the centre of many of the major issues that confronted the Victorian art world. Whether it be art education and industrial design, the decoration in fresco of the new Houses of Parliament, the correct and authentic way to restore medieval ecclesiastical stonework, or the most suitable way of arranging the pictures in the National Gallery, William Dyce seemed able to provide an answer to almost every dilemma and every difficult decision faced by the administrators. Dyce is recognized as a public figure because of his work at the School of Design and on account of his polemical writing. Yet his work at the School has hitherto been examined in isolation and the importance of his public position in relation to his creativity as a complete individual has never seriously been considered. Dyce is seen as the Aberdeen-born artist who lived and worked a London life but his connections with Scotland were strong and very important to him.

This book seeks to redress these misconceptions, pre-conceptions, and semi-truths. Above all, it seeks to understand the quality and extent of Dyce's achievement by considering all his commitments and responsibilities in different and frequently dissimilar fields: ecclesiology, music, design, easel painting, stained glass design and many other areas. As we follow Dyce through his life, these different areas of achievement emerge as connected aspects of the creative life of an individual who struggled to be true to his own intellectual and religious ideals and at one with the period in which he lived.

I

THE EARLY YEARS
1806–1832

The gaunt granite house in Aberdeen, where on 19 September 1806, William Dyce was born, still stands in a massive and sturdy terrace. The narrow street slopes steeply down towards the docks. The masts of fishing vessels, the scurry and bustle of the harbour are readily visible as the spectator looks down Marischal Street from outside number forty-eight. In the other direction, the skyline is dominated by the dignified pile of the Town Hall and behind it the shining granite of Marischal College, since 1860 part of the University of Aberdeen. It was, perhaps, something of an omen that William should have been born almost exactly half-way between the picturesque harbour with its views of the open sea, its quays buzzing with humanity, and the stronghold of municipal power reinforced by that of academic learning.

William was the third son and fifth in a family which eventually comprised fourteen children. His father, Dr. William Dyce, was a lecturer in Medicine at Marischal College and was described by his grandson as 'a physician of considerable repute and a man of great scientific attainments'. As the son of a Fellow of the Royal Society of Edinburgh, whose spare time was 'constantly employed in matters of Philosophical, Chemical and Mechanical Science',[1] William grew up in surroundings redolent of scientific inquiry and academic distinction. All six Dyce sons were educated at Marischal College and the eldest, Robert (born in 1798 when his father was twenty-eight), became a lecturer in Midwifery at the College in 1841, after a distinguished army career on the staff of Sir Galbraith Lowry Cole and was appointed to a chair in 1860.

[1] D.P. I.

3

4 Dr. William Dyce had married Margaret Chalmers, daughter of a family whose origins, like his own, go far back into the history of the locality. Despite the demands of successful careers and prosperous marriages, the Dyce children maintained the closest connections with Aberdeenshire. Unlike his contemporaries Benjamin Robert Haydon and Sir Charles Eastlake, William Dyce never accepted the role of an urbanized London artist. In later life his commitments in art education, in the designing of stained glass, and in various administrative activities kept him on the move, but we feel no surprise at finding him in London in 1857, some thirty years after leaving Aberdeen to establish himself as one of the best-known artistic figures of his age, writing to the Provost of West Cathedral, Aberdeen, about stained glass and concerning himself with the glazing of Glasgow Cathedral.[2] Although he confessed to being unfamiliar with 'a great deal of Scottish Highland scenery',[3] many of his landscapes were painted in Scotland. Only his experience of North Wales, which he visited in 1860, could rival what he knew of his native country. The austere and rocky terrain of Wester Ross, the wooded valleys around Aberdeen, and the rolling country of Ayrshire are vividly recorded and recalled in Dyce's mature paintings, and when, towards the end of his life, he became a man of some means, Dyce chose to live not in town but in the rural fringes of London, first at Norwood and then at Streatham.

William was a bright boy. Attending Aberdeen Grammar School after attaining his thirteenth birthday, surely he must sometimes have escaped the rigours of Greek and Latin, and gone with his friends to play at the harbour and watch the boats come in or ramble in the hills. With the example of his father and brothers before him, William entered Marischal College and was awarded his Master's degree in 1823 at the unusually early age of seventeen. Following family precedent he studied Medicine but then turned his attentions to Theology, intending to go to Oxford to take orders. The Dyce family had never rejected the old faith and at least one of his sisters married an Episcopalian minister. William's cousin, the celebrated literary editor, Alexander Dyce, had taken orders after graduating from Exeter College, Oxford, in 1819. Grave must have been Dr. and Mrs. Dyce's misgivings, observing their son's growing absorption in painting. They might have saved themselves much anxiety had they enjoyed the oracle's gift and been able to see that their son, though never

[2] D.P. XXXVI, Dyce to John Webster, 25 Mar. 1857.
[3] D.P. XL, Dyce to R. D. Cay, 20 Oct. 1860.

to take orders, was to distinguish himself as a High Anglican artist and ecclesiological designer. There was to be nothing Bohemian about William's aspirations or life style. Writing to his future wife in 1849, William exhorted her to join him in acknowledging the 'Divine Giver' as the source of their happiness. 'My motto is,' announced the forty-three-year-old artist, '"In all thy ways acknowledge Him and He shall direct thy steps."'[4]

In the leisure time left to him after his studies at Marischal College, William was teaching himself to paint. The intellectual attainment which was to be the basis of his mature art is not apparent in those first essays in paint, portraits of his mother, his sister and her child, and his brother-in-law. Predictably William also, at this time, tried his hand at a self-portrait. The result, although unfinished, reveals a nascent ability to catch **2** a likeness—the broad forehead, aquiline nose, and shapely upper lip are readily recognizable from Dyce's photograph and from an engraving in **33** the *Illustrated London News* of 2 May 1857—and to present a dignified appearance. William's gravity of mien is striking, especially if we compare this self-portrait with that of his youthful compatriot David Wilkie who depicted himself in 1805 with tousled hair, sensitive mouth, and alert but startled expression (Scottish National Portrait Gallery). Wilkie presents himself as a young man of capricious moods and intense sensibility. William Dyce in about 1820 looks, on the other hand, like a man whose mind is already made up, who sees problems ahead but is prepared for the struggle.

William received his first commission in 1823, for a portrait of Sir James M'Grigor, subscribed for by the students of Marischal College of **16** which Sir James was to become Rector in 1826–7.[5] The subject, who later became famous under the Duke of Wellington as 'Father of the Army Medical corps',[6] appears splendid in his robes, ruddy of complexion and humorously gazing from a canvas which, compared with William's attempts at portraying members of his own family, surprises by its confidence of handling (unhappily marred by bitumen) and general air of *panache*. Writing to Geddes to acknowledge the safe arrival of the portrait, William was jubilant. 'The portrait ... is now placed in the north end of the Hall which it adorns not a little', he wrote. 'I called a Meeting of the Gentlemen who are subscribers to it, and all approve of it highly.'[7]

[4] D.P. XXVIII, Dyce to Jean Brand, 6 Nov. 1849.

[5] *Fasti Academiae Marischallanae Aberdoniensis 1593–1860*, ed. P. J. Anderson (1889–98), ii. 437.

[6] J. G. Henderson, 'Notes on the Aberdeen Medico-Chirurgical Society', Forrester Hill, Aberdeen (n.d.).

[7] W. Dyce to A. Geddes, 26 Sept. 1823, MS. Edinburgh University Library, La. IV, 17.

In order to pursue a career as an artist, it was necessary for William, sooner or later, to convince his father of his own aptitude and of the suitability of such a career for the son of an Aberdonian academic family. Accordingly he contrived to paint, in secret as his son tells us,[8] the sort of grand historical subject which might be expected to meet with the approval of Royal Academicians in London. *The Infant Hercules Strangling the Serpents Sent by Juno to Destroy Him* is a sombrely coloured and pedantic essay in the grand style, heavily dependent on Reynolds's painting of the same subject (R.A. 1788) for the impish child, though lacking the master's supportive background figures. As a type expressive of moral conflict, a symbol of virtue chosen at the expense of pleasure and for the sake of the deliverance of mankind from tyranny and oppression, it was a peculiarly apt choice of subject for a young artist struggling to assert his right to act according to his conviction. Art for William was ever a serious matter. In common with his age he believed implicitly in art as a vehicle for moral and religious improvement. Reynolds's *The Infant Hercules Strangling Serpents* was intended as a symbol of the strength of the young Russian Empire,[9] but Dyce was probably just as familiar with the Earl of Shaftesbury's exposition of the subject.[10]

Such was William's determination to succeed and so familiar was he with parental prejudice that he decided that only the stamp of highest authority would suffice. So, accompanied by his sizeable canvas, he set sail in a fishing smack from Aberdeen in 1825 and, on arrival in London, took himself and his parcel to Sir Thomas Lawrence, President of the Royal Academy. The great man allegedly recommended William to pursue his art and reminded him that such recommendations were rare.[11] Such words of approval were enough to convince Dr. Dyce of his son's promise and on 7 July that same year, William was admitted as a probationary student at the Royal Academy on the recommendation of J. T. Smith of the British Museum. The drawings which he was obliged to submit before entering had been executed in the exhibition rooms of Alexander Day in the Egyptian Hall. William was, as we shall see, fortunate in the friendships he established during his early weeks as a student in London.

Alexander Day was the son of a miniature painter of the same name

8 D.P. I.

9 F. Saxl and R. Wittkower, *British Art and the Mediterranean Tradition* (1948), ch. 64.

10 Anthony Ashley Cooper, 3rd Earl of Shaftesbury, *Charakteristicks* (1707).

11 D.P. I.

who practised in Rome. As a dealer and as a portrait painter and medallist Alexander lived in Rome and, after 1816, in London. William Dyce's other chief acquaintance in London in 1825 was William Holwell Carr, the wealthy and cultivated clergyman who exhibited his landscapes at the Royal Academy between 1797 and 1820, but whose main claim to distinction lies with his generous benefaction to the National Gallery. Holwell Carr was, like Alexander Day, a much-travelled gentleman whose conversation would have revealed his easy familiarity with the great masters of painting. It comes, then, as no surprise to learn that William had been in London only a few months when he became disillusioned with the education offered by the Royal Academy schools and felt an intense desire to visit Rome.[12] Years later when he found himself at the centre of the controversy over art education, William must have looked back with wry amusement to his own brief period as a student. Brief it was, for, spurred by dissatisfaction and by the fact that Alexander Day was planning to return to Rome himself in the autumn of 1825, William withdrew from the Academy and set off in the company of his friend.

In Rome, William was able to join the lively colony of young English and Scottish artists at the recently established British Academy.[13] John Partridge portrayed the nineteen-year-old William Dyce in Rome in a crayon drawing which shows a fine-boned and somewhat delicate face with broad forehead, long nose, and self-conscious set to the mouth. It was, perhaps, at the British Academy, where students drew from the life and studied design, modelling, and composition, that Dyce sat to one of its founders, his compatriot, Lawrence Macdonald, then aged twenty-six, for the bust which remains in the possession of William's descendants. We can only wonder whether William's friends talked with him of the German community of artists, the Nazarenes, living an ascetic and artistic life in the Monastery of S. Isidoro, but we may be sure that in such a place and in such company William enjoyed his first sojourn abroad. In 1832, with two more visits to Rome behind him, William recorded an accumulation of sensations relating to the city. 'And what do you think of Rome, or rather what does Rome make you feel?', he asked David Scott. 'Does not its greatness and sublimity of character overwhelm you? ... All my recollections of it are associated with the most delightful, I may say exquisite

5

18

[12] D.P. I.

[13] Dr. L. Jannattoni, *Roma e gli Inglesi* (Rome, 1945), p. 147, lists Dyce as a student at the British Academy but gives no source.

feelings. In truth, to me Rome was a kind of living poem, which the soul read unceasingly, with the soothed sense which poetry inspires.'[14]

The loss of biographical material relating to this period of William's life makes it difficult to be certain what primarily engaged his attention in Rome in 1825. However, his son tells us that William concentrated during this visit on improving his knowledge of Titian and Poussin. His admiration for classical art had been encouraged by perusal of sets of engravings after works by Raphael, Domenichino, and Poussin, the closest he could come, as a student in Aberdeen, to a genuine experience of the old masters.

6, 9 However, judging by *The Infant Hercules* and *Bacchus nursed by the Nymphs of Nysa*, which William exhibited at the Royal Academy in 1827 after his return from Italy, he was more concerned at this stage with the painterly qualities of Titian and Rubens than with the compositional linearism of Poussin. It was much later in his career that Dyce adopted the thin, flat, tempera-like use of paint, and the linear manner which characterizes his best-known paintings of the fifties.

One of the most cultivated and sociable figures in Rome society in 1825 was Baron Bunsen. Married to an English wife who shared his tastes for Bible study, music, and art, Bunsen was Secretary to the Prussian Legation in Rome from 1816 until 1841 when he came to London as Ambassador. He and William Dyce were to become close friends and, after his arrival in London, Bunsen invited William to stay with him in order to meet Neukomm, the German composer, to 'hear a good deal of sacred music' and to see 'the "Edition of 'Select German Psalms'," printed now according to the musical signs of the Hebrew text'.[15] Bunsen's interests were very much those which Dyce was to develop on his own account, namely liturgical practice, early church music, and theology. As Bunsen was away from Rome during Dyce's second visit to the city in 1827, conveying the *Madonna della Famiglia di Lanti* by Raphael to the Prussian Museum and undertaking diplomatic business, and as Dyce did not visit Rome when he was again in Italy in 1832, it seems likely that the two men met in 1825. John Stuart Blackie, William's Aberdeen friend, visited Rome in 1830 and enjoyed 'the society of Gibson, Wyatt, Severn and not a few Germans as well as English'.[16] Bunsen, whom Blackie regarded as 'a

[14] W. B. Scott, *Memoir of David Scott, containing his Journal in Italy, Notes on Art and other Papers* (1850), iii. 195.

[15] D.P. XVIII, Le Chevalier Bunsen to W. Dyce, 13 Nov. 1844.

[16] J. S. Blackie, *Notes on a Life* (Edinburgh, 1910), p. 53.

fine fellow',[17] is frequently mentioned in correspondence between the two Aberdonians and it may be that William introduced his friend to the German Baron.

Until the rediscovery of early paintings by Dyce provides stylistic evidence of contact with the Nazarenes or until missing papers relating to Dyce's visits to Rome are found, it is impossible to prove when William Dyce made contact with Overbeck and his friends. However, Bunsen was, in 1825, in an excellent position to introduce Dyce to the Nazarenes. He and Overbeck had been intimate friends since 1817 and Bunsen's wife writes of 'a very lovely Madonna with the Infant Jesus ... of which [Overbeck] permitted a copy to be taken' and which she valued as a record of the time and of the 'gentle and heavenly-minded artist, who soon after this withdrew from all companions of a different religious persuasion from that which he had adopted'.[18] Overbeck may have retired from the scene, but other Nazarene artists were still very much a part of the Bunsen household, attending performances of the 'old Latin Church music', examining compositions for four voices by Palestrina which Bunsen had had specially copied and regarded as 'a great treasure',[19] and, in the case of Schnorr, taking up residence in the Bunsen home for several years. The milieu was exactly that in which a young man of William Dyce's temperament would have thrived. It can be no accident that his achievement as a Victorian intellectual was to be in early Church music, in art, and in theology.

By early 1827 William was back in Aberdeen, painting, reading, and renewing old acquaintances. He was also working on *Bacchus Nursed by the Nymphs of Nysa* and must, one surmises, have discussed the subject with John Stuart Blackie, that brilliant young man who was William's lifelong friend and intellectual confidant and who was to enjoy a distinguished career as Professor of Humanities at Aberdeen and, subsequently, as Professor of Greek at Edinburgh.

Bacchus, when exhibited, was accompanied by a Greek quotation from Homer's *Hymno in Bacchum* and the subject is, like *Hercules*, typical of the learned classical milieu of Aberdeen in which William grew up. It concerns the son of Zeus and Semele who, in order to be preserved from the wrath

[17] D.P. XII, J. S. Blackie to W. Dyce, 11 Jan. 1845.
[18] Frances, Baroness Bunsen, *A Memoir of Baron Bunsen* (1868), i. 145.
[19] Bunsen, i. 145.

of Hera, was conveyed by Zeus to Mount Nysa where he was reared by the nymphs.

9 The finished canvas of *Bacchus* has not survived, but a preparatory oil
7, 10 sketch, a watercolour, and a pen and ink drawing give us a fair idea of what the painting was like. The main influence on Dyce was clearly the great Bacchanals of Titian. Whilst accepting that *Bacchus* must have been a highly derivative painting we should give the artist his due for struggling
7 manfully with problems of light and space. The watercolour at Yale would seem to be the earliest of the three surviving studies. In this, Dyce worked out broadly and boldly a composition with a strong vertical emphasis and an admirable feeling for distance. The spatial elements are sensitively articulated through the use of shadowed and highlighted figures in the foreground, the arching of trees in the middle distance, a pool of light on the meadow beyond, and—in the far distance—the brightness of the open
10 sky. By the time he came to draw the preparatory pen and ink sketch in Aberdeen, Dyce had decided to change the format in order to spread the figures over a horizontal field. As originally planned, the figures would have been crowded but the change is detrimental to the total effect. In place of the promise of a Poussinesque idyll in which the characters exist as part of a gentle evocation of nature on a vast scale, a group of figures act out their parts against a backcloth, the flatness of which is emphasized by the
9 now vertical trunks of the trees. In the relatively finished oil panel at Aberdeen, this effect is even more exaggerated. Dyce has omitted the three distant figures on the right in the drawing, introduced another centaur into the composition, turned the shepherd (who gazes into the distance in the drawing) towards the centre of jollity, and pushed all the figures closer towards the centre. It is interesting to see Dyce, at this early stage, rejecting a spatial interpretation of his subject. A predilection for the arrangement of figures on the surface plane is a feature of Dyce's mature style. This early example shows clearly that it was not a sort of primitive *naïveté* which motivated Dyce to adopt this device in the fifties, but the deliberate decision of a design-conscious painter.

Before leaving Aberdeen for the Royal Academy show in London in the summer of 1827, William tried his hand at landscape. Westburn was the home of William's mother's family and it was this attractive house that
43 William introduced into a composite view of Aberdeen featuring the twin towers of St. Machar's Cathedral and the lantern of King's College in impossible relative positions, as well as a generous stretch of coastline.

Staley identifies *Westburn* with the *Coast Scene: Composition* which Dyce exhibited at the Royal Scottish Academy in 1832 and finds it surprisingly old-fashioned for this stage in Dyce's career.[20] It is much more likely to be *Park Scene*, an oil painting in Dyce's studio sale,[21] bought by Agnew's and subsequently acquired by the artist's widow who presumably wished to retain the painting because of its family connections. Staley likens William's developing landscape style in *Westburn* to that of Patrick Nasmyth in his Scottish views and compares it with the landscape backgrounds of Dyce's portraits of the thirties. There is, however, a delicacy in the treatment of the parkland in *Westburn*, and a lush tranquillity rendered with a notice-able degree of exactitude, which is quite unlike the more robust landscape backgrounds of the later portraits, and which approximates most closely to the style of the soft, sweeping views of Andrew Wilson. The latter enjoyed a prominent position in Edinburgh artistic society between 1818 and 1826. His son was well known to Dyce by 1837 and he numbered among his pupils William's friend, the future photographer, David Octavius Hill. Further evidence for an earlier dating lies in the Italianate arrangement of trees in balanced diagonals in *Westburn* corresponding closely to the Yale sketch for *Bacchus* which William was working on in late 1826 or early 1827.

Despite his early rejection of the Royal Academy schools, William enjoyed the friendship of many Academicians and Associate Members during these early years before he had begun to make his own reputation as an artist. One such friend was Augustus Wall Callcott who was twenty-seven years William's senior and had been elected A.R.A. in the year of William's birth. It would be rewarding to know more of the nature of these early friendships. The discrepancy in age between Callcott and Dyce per-haps suggests an unusual degree of maturity in the younger man. The two were still corresponding in 1832 when William had settled for a period in Edinburgh and, as members of the Etching Club in the forties, they had many friends in common. We may see this friendship as a paradigm of the relationships of William's mature years, relationships with men who did not exclusively concern themselves with the visual arts but were, like W. E. Gladstone, Sir Charles Eastlake, and Beresford Hope, cultivated men of letters, musicians, and theologians. Callcott was the brother of a distinguished musician and had himself been a chorister in Westminster

[20] A. Staley, *The Pre-Raphaelite Landscape* (Oxford, 1973), p. 162.
[21] Christie's, 5 May 1865.

Abbey. He had resolved the conflict between his musical and his artistic inclinations by the time William met him and was established in his profession as a painter of landscape, but it may well be that William's musical work in the movement to revive early Church music in the forties originated in friendships like that with Callcott.

When William arrived in London in the summer of 1827, Callcott and his wife were on honeymoon in Italy. Infected with a yearning for Rome, William wrote off to his friend and once again, set off for the Continent in the autumn of 1827. He now began to build upon the tentative landscape of *Westburn* and, as the titles of subsequently exhibited paintings show, took up the habit of open-air sketching. *The Church of La Trinità di Monte, Rome*, exhibited 1829,[22] might have been painted without the aid of on-the-spot studies. *A View on the Isle de France: Paul et Virginie*, exhibited in 1830,[23] must have been imaginary but *A View on the River Garigliano, Lower Italy* was probably based on first-hand experience of the locality. If William was, indeed, reunited with Augustus Wall Callcott in Italy it may have been due to the older artist's influence that William cultivated the practice of open-air landscape study.

The year 1827 was, according to William Dyce's son, when Dyce 'without the smallest intercourse with the Germans then in Rome and ignorant even of the existence of the new school of Purists ... began as they did to regard Art exclusively in its moral and religious aspect and, as a consequence, to perceive the great charms of the works of the devout masters of the fifteenth century'.[24] For us, with the benefit of hindsight, this seems almost impossible to believe. William's son proceeds to recount the well-known anecdote of a *Madonna* painted by Dyce in 1828 'which attracted the Germans then living [in Rome] in crowds to his studio, on the report of Overbeck, whom Mr. Severn had invited to see it'. This picture was supposedly the origin of the reputation William enjoyed in Germany for, it is said, when it was time for the young Scot to return home, the Germans in Rome, assuming poverty to be the reason for his departure, subscribed in order to buy the *Madonna*.[25] The celebrated Dr. Waagen, writing in 1854, recalled a *Madonna* by Dyce in the Berlin Gallery[26] which may have

[22] Royal Institute for the Encouragement of Art in Scotland.

[23] Royal Scottish Academy.

[24] D.P. I.

[25] M. Howitt, *Frederick Overbeck* (1886), i. 451.

[26] G. F. Waagen, *Treasures of Art in Great Britain* (1854), i. 427. The whereabouts of the painting is no longer known.

been that purchased by Overbeck and his friends. However, James Dafforne, writing in the *Art Journal* during Dyce's lifetime, denies that the Nazarenes ever purchased the painting.[27]

William's friendship with members of the Nazarene community is incontrovertible. When J. R. Hope-Scott, the eminent parliamentary barrister, was about to leave for Rome in September 1840, William sent him letters of introduction and messages for Schnorr in Munich and Kestner and Overbeck in Rome. For the last William enclosed a *Benedictus* of his own composition in the belief that Overbeck 'would find in it (for he is a musician) letters of introduction and messages for Schnorr in Munich and Kestner and January 1834, William Davies wrote to William from Rome saying that Overbeck often spoke of his Scottish friend,[29] and later that same year, Edward Steinle in Rome recalled the 'excellent young Scot, Dices [*sic*], who promised so much, but was then suddenly recalled by his father'.[30] Dyce was eventually to be seen as the arch-exponent of what Thackeray called the 'new German dandy-pietistical school'[31] and as the British Overbeck.[32] Stirling Dyce is by no means infallible as a source of information and—as the contradictory nature of accounts of William's relations with the Nazarenes indicates— it is difficult to be absolutely certain when and how the meeting between our subject and the German artists took place.

The *Madonna* admired by Overbeck is lost and the earliest paintings by William Dyce to reveal any radical change in style from the pattern of *Hercules* and *Bacchus* are *The Dead Christ* of 1835 and the *Madonna and Child* now in the Tate Gallery, London, which seems likely to be that exhibited at the Royal Academy in 1838. Nevertheless, designs for pictures of 'The Annunciation', 'The Visitation', and 'The Entombment', favourite

62, 93

[27] J. C. Dafforne, 'William Dyce, R.A.' *The Art Journal*, vi (1860), 294 n.

[28] National Library of Scotland, MS. 3669 fos. 58–61, W. Dyce to J. R. Hope-Scott, 17 Sept. and 21 Sept. 1840.

[29] D.P. I, W. Davies to W. Dyce, 9 Jan. 1834. The identity of the correspondent is problematic. The spellings Davis and Davies are frequently given as variants for the artist of this name in reference works. The best-known English artist of this name in Rome at this time was J. P. Davis (so called Pope Davis) who exhibited Roman subjects at the Royal Academy from 1824 (*Portrait of the late Pope*) to 1844. But it seems more likely that Dyce's correspondent, who is also mentioned as *William* Davies in a letter to Dyce from Wiseman, was William H. Davies who is not recorded as having any connections with the Roman church but who exhibited Roman subjects at the Academy in 1832 and in 1838 (Four cameos in the Roman style).

[30] National Library of Vienna, MS. 132/98–4, fo. 4.

[31] 'May Gambols: or Titmarsh in the Picture Gallery', *Fraser's Magazine* (June 1844).

[32] D.P. XXIX, Bishop Brechin to Dyce, ?1851.

subjects with early Renaissance artists, were exhibited by Dyce in 1829.[33]

64 A drawing of 'The Entombment' may possibly be related to the 1829 design. Whilst not in any way 'Nazarene', it presents a biblical subject with an immediacy, and in what would appear to be a landscape setting, anticipating Dyce's mature work. The youthful St. John, whom

62 Dyce was to portray in sorrowful resignation in *The Dead Christ* of 1835

88 and also in *St. John Leading the Blessed Virgin Mary from the Tomb*, plays a part in this scene.

The art of the Nazarenes was probably known in England before 1830 but only in very limited circles. The fact that one of the earliest Nazarene paintings to be commissioned by a British tourist, Schnorr's *Marriage at Cana* of 1819, hung in a Scottish collection until very recently, might lend credence to a theory that William Dyce was familiar with the Nazarene style. at an early date, if not with the artists themselves. It would, however, have been an astonishing coincidence if he had fundamentally changed the direction of his art on the basis of seeing the one painting by Schnorr in Scotland, especially as there was, at that date, no body of published material to support a taste for early Italian masters or German revivalists. It was not until the forties that the publications of Eastlake, Pugin, Ruskin, and Lord Lindsay were disseminating knowledge about these schools.

We may, therefore, fairly assume that William's knowledge of Nazarene art and the early schools was acquired during one of his visits to Italy. We have already mentioned the probability of such a meeting taking place in 1825 through the agency of Baron Bunsen. Lacking any material evidence for a change of style, we may view Stirling Dyce's assertion that his father began to regard art 'exclusively in its moral and religious aspects', without any knowledge of the Nazarenes, with some scepticism. Dyce's son set out, after his father's death, to vindicate the artist's reputation which had suffered much as a result of the delays and the premature deterioration of the frescoes in the Queen's Robing Room. He cannot be regarded as a reliable commentator on his father's life. The fact remains that Stirling Dyce gives 1827 as the year in which Overbeck was introduced to Dyce by Severn. He could very easily be in error as to the year and, indeed, if Severn were responsible for the introduction, he could have effected it in 1825 as he had resided in Rome since accompanying Keats there in 1820. On his own confession, William spoke only a few words of

[33] Royal Institution for the Encouragement of Art in Scotland.

German[34] but Overbeck's English was good and communication cannot have been a problem. It is strange that Severn, who was an inveterate gossip and letter writer, never mentions William Dyce in his letters or journals from the Rome period although he does mention visits to Overbeck and his friends.[35] Dyce and Severn were involved with each other much later through the Houses of Parliament fresco scheme, the Schools of Design, the Etching club, and probably through their mutual patron, W. E. Gladstone. However, it seems less likely that Dyce discovered Nazarene art in 1827 thán in 1825 and, although Severn was described by William as 'everybody's man and a very obliging creature'[36] the social milieu of Rome was clearly more complex than Stirling Dyce indicates.

By 1829, William Dyce was back in Aberdeen. His activities during the next four years suggest a lack of direction and an uncertainty about his professional identity. His son tells us that he painted a number of pictures of the Madonna which did not sell and, disillusioned, he abandoned art. Material evidence shows, however, that he was painting regularly. Commissions for portraits began to flow; Duncan Davidson—distinguished **20** Aberdeen advocate and Dean of Faculty at Marischal College—was depicted in a stern and rigidly posed half-length. His wife, in a pendant **19** portrait, presents an unaffected openness of gaze which is belied by the frivolity of her feathered hat and decorative chain. Helen Boyle, daughter **15** of Lord Justice Clerk, portrayed by Dyce on the occasion of her marriage to Sir Charles Dalrymple Fergusson on 1 June 1829, was a subject of more elevated birth than any yet attempted by Dyce and, in his effort to achieve sophistication, our artist falls short of the conviction of characterization which makes Duncan Davidson and his wife memorable in their solemnity.

William Dyce was soon to acquire a reputation as a particularly sensitive portraitist of women and children. It is to the delightful chalk drawing **21** of William's sister Isabelle, aged nineteen in 1830, that we must turn to appreciate the origins of Dyce's success with female subjects. William was very close to his sister and when, after her marriage to his friend Robert Dundas Cay in 1835, she lived in Blackford Road, Edinburgh, William must have been a frequent visitor. In a head-and-shoulders study William

[34] D.P. XXX, Dyce to Henry Cole.

[35] W. Sharp, *The Life and Letters of Joseph Severn* (1892); unpublished letters in the Keats Museum and Library, Hampstead; 'Plan for the Various Incidents of my Life' by Joseph Severn, Houghton Library, Harvard University.

[36] National Library of Scotland, MS. 3669, W. Dyce to J. R. Hope-Scott, 17 Sept. 1840.

presents his sister with erect head, chin firm, eyes alert and intelligent. Unlike the contemporary giant of portraiture, Sir Thomas Lawrence, William rejects the possibility of creating an abstracted, sexual atmosphere through elongated neck, heavy lidded eyes, and full mouth, reinforced by a background which stresses the impermanent. Instead he concentrates on conveying unique qualities of reserve and dignity.

By 1831, Dyce felt ready to exhibit as a portrait painter at the Royal Academy[37] and the following year he was compelled to tell Callcott apologetically that he would not be able to see the Academy exhibition as he was so busy painting portraits in Edinburgh. 'People say', declared William, 'that I succeed with ladies best and this as you know is the best way of pleasing the gentlemen.'[38]

William also pleased himself in these years and that did not mean devoting his energies exclusively to establishing a portrait practice. Having indulged in a little elementary pillaging in Rome, he was able to present the Society of Antiquaries in Edinburgh with some ancient fragments of fresco from the Baths of Titus. In a paper delivered to the Society on 25 January 1830, William expressed the hope that they might 'serve with the help of Vitruvius to give ... a pretty correct notion of the manner in which the ancient Roman fresco painting was executed.'[39] The Baths of Titus must have made quite an impression, for William did not content himself with mere archaeological hypothesis but took up his paints and decorated a room at forty-eight Marischal Street with arabesques. This early demonstration of interest in the techniques of fresco is significant coming from one who was, more than any other nineteenth-century figure, to find his fate inextricably interwoven with the rise and decline of the fashion for fresco, and who was to collapse on the fresco painter's scaffold in 1863.

William Dyce is remembered today primarily as a painter of vision and conviction and secondarily because of his role in the development of state-controlled art education. However, once we acknowledge that we are studying a Victorian artist, we raise problems that cannot be adequately answered by the procedures which define the discipline of Art History. In 1830, not only was William painting portraits, he was also writing about

[37] Three portraits were exhibited by Dyce: *Miss Levien*, *A Gentleman*, and *Rev. Edward Irving*, all three are now lost.

[38] D.P. I, Dyce to Callcott, 26 May 1832.

[39] *Archaeologia Scotica* iii (1831), 316.

the Baths of Titus, composing an essay, 'On the Garments of Jewish Priests', a work commendable for its concern with archaeological accuracy,[40] and preparing to carry off the Blackwell prize at Marischal College for his treatise 'On the Relations between the Phenomena of Electricity and Magnetism and the Consequences Deducible from those Relations'.[41] Dyce's activities outside the field of the visual arts are relevant to our endeavour to understand the mind of the Victorian polymath; they also complement or set in relief his work as an artist. Our respect for the creative artist may lead us to regret that William Dyce's early exhibited *penchant* for the theoretical threatened his progress as a painter and caused him to be elected to the company of the Prince Consort, Henry Cole, and Sir Charles Eastlake. With them Dyce was to become a spokesman for an age which believed in the duty of an educated élite to establish art 'not merely for the purposes of amusement but in its relations to the history of the nations ... and to the handicrafts which had been and might be employed to elevate and improve'.[42] What we cannot afford to do is to ignore some areas in which William Dyce operated because they do not happen to correspond with current presuppositions about the role of the artist.

Participating simultaneously in the processes of scientific investigation and in creative art, William Dyce was acting within a well-established tradition. Shelley, as a young poet in Oxford, had gazed with delight at the phenomena revealed by experiments with an air pump he kept in his room, along with an electrical machine, a solar microscope, a galvanic trough, and other apparatus.[43] Erasmus Darwin was inspired to describe his botanical investigations in poetic form, and Humphry Davy had written poetry about his native Cornwall as well as speculating about the nature of matter. William's intimate friend John Stuart Blackie was similarly inclined and published collections of Gaelic songs, translations of Aeschylus and Goethe, and verses: 'The Origin of the Species', 'Dust and Disease', and 'The In-osculation of Science and Art'.

William Dyce's essay on electro-magnetism is more interesting to us for what it fails to establish than for what its author actually achieves. It comprises an up-to-date survey of the investigations conducted by

[40] D.P. I.

[41] Marischal College minutes, 16 Nov. 1830.

[42] Sir Theodore Martin, *The Life of H.R.H. the Prince Consort* (1875), iv. 13.

[43] T. J. Hogg, *The Life of Percy Bysshe Shelley*, ed. E. Dowden (1906), p. 54.

scientists Oerstedt, Ampère, and Faraday into the phenomena of electro-magnetism, but William made no experiments himself and was concerned chiefly in detecting flaws in the explanations proposed by others. He con-cluded that, although electricity sometimes produces magnetic effects, they have separate sources and are not dependent upon one another. In fact, magnetism always arises from a flow of electric charge but the 'current' is inside atoms in the case of permanently magnetized bodies. William Dyce had no means of knowing about atomic currents and, therefore, in a strictly logical way, he rejected Ampère's view that permanent magnets are really due to electrical currents. Ampère was in fact correct in the hypothesis he was unable to prove and he must have been aware of the flaws in his evidence that the young Aberdonian was at pains to point out in his prize-winning essay. Ampère, a creative scientist, was prepared to tolerate uncertainty, to entertain a flawed idea if it were useful and helped towards progress with his investigations. Faraday discovered the generation of electric current by a magnetic effect shortly after Dyce wrote his essay, at a period when there was a widespread search for this missing clue. Faraday's success arose essentially because he performed experiments in the laboratory, encouraging surprises, an approach widely divergent from William Dyce's static process of categorization. Dyce adopted the old-fashioned garb of the philosopher and disregarded the practical white coat of the active new practitioner in science.

Throughout his treatise, William's deference to what he called 'the established economy of nature' is paramount:

Nature is so admirably constructed that it tends continually to reproduce and maintain itself; and consequently to resist and defeat every attempt at a sub-version of its present constitution. So that a knowledge of its primacy and elementary operations in the present state of things can only by hypothetical.[44]

It is clearly a mistake to regard the fact that Dyce wrote on electro-magnetism as an indication that he was progressive in the same sense as, later, his proposals for art education or his collaboration with an architect like Butterfield seem progressive. The nineteenth century struggled to retain the conviction of a divinely ordered system in the face of the gradual destruction of traditional boundaries of belief. Man had never, it seemed, been in a position of such strength to improve his lot and yet so much was happening that could not be contained within the old framework.

[44] Aberdeen University Library, MS. M.263.

'The beautiful revelations of modern science . . . are, all of them, due to the pervading spirit which rose with Christianity and diffused itself over the length and breadth of Europe, which sought to discover in external nature a system of order and beauty indicative of a creative intelligence of the highest order,' declared the *Art-Union* in 1848.[45] A total view of history, especially Christian history, might provide a means of grafting the new on to the old. William was not alone in adopting the metaphor of a journey in his attempt to comprehend progress. The investigations of physical science are, William suggested, like 'a continual journeying, the object of which, *has been,* and *still is* to contemplate by every light and on every side, the perfecting of the system of nature.'[46]

Concerned with contemplating rather than exploring, Dyce lacked the spirit of inquiry and experiment and his essay must have been, in 1830, a far from progressive piece of work. Yet the sense of religious awe which underlies his presentation of the facts is invaluable for the insight which it provides into the developing character of this complex and very private individual. Perhaps the clarity and discipline which we admire in *Pegwell Bay* and in *St. John Leading the Blessed Virgin from the Tomb* owe something **52** **88** to William's respect for the 'established economy of nature'. In his insistence on a universe in which all things have their rightful place and in paintings which convey a deep-rooted religious reverence and calm, untainted by sentimentality and melodrama, Dyce reveals himself as a man who has more in common with attitudes of the eighteenth century than with the age of J. M. W. Turner and John Martin.

The prize money of thirty pounds for his essay on electro-magnetism must have given William and his family some satisfaction though his success cannot have made his way ahead any clearer. He could, it seemed in 1830, become a scientist, a portrait painter, or a classical archaeologist. Unperturbed by the diffusion of his concerns, William refused to commit himself to any single course of development and began to spread his net wider by gaining experience in landscape painting and learning the art of etching. Sir Thomas Dick Lauder's *An Account of the great Floods of August 1829 in* **120** *the Province of Moray and Adjoining Districts* appeared in 1830, embellished with little vignette landscapes in the manner of Andrew Geddes whom William knew. Whilst receiving instructions from the author, Dyce must have visited Morayshire; his plates show a new feeling for the picturesque

[45] *The Art-Union* x (1848), 341.
[46] Aberdeen University Library, MS. M.263.

and a basic skill in topography. Most of the scenes are organized with a dark, strongly textured foreground area of stones, pebbles, and tufted grass, giving way to a light, sparsely treated area which is then backed by a darker area again. Small figures or topographical details are picked out in the foreground or middle distance, thus creating a sense of proportion. Dyce had clearly learned the lessons which the Revd. William Gilpin had to teach but it was a useful training for an artist whose earlier attempt at
43 landscape, in *Westburn*, was marred by a feeling for rococo decorative qualities. Some of the best plates in Sir Thomas Lauder's book are remarkable for the decisiveness with which the sweeping lines of the river bed are conveyed and the artist's concern with the texture of the landscape anticipates the interest in geology which he developed later in life.

44 In *Fisher Folk*, exhibited at the Scottish Academy in 1832, William rejected the topographical and the Italianate traditions and turned to the type of sea-shore scenes favoured by Bonington, Collins, and Isabey. We notice particularly the silhouetted central group of figures, the genre interest of the littered lobster crates, the sandy track in the foreground, and the wrecked ship on the skyline. The treatment of light reflected in patches on the water from broken clouds suggests the influence of early works by Turner.

 Dyce never again produced a landscape with quite this combination of local genre, dramatic lighting, and robust handling. *Fisher Folk* remains an
45 isolated and atypical work. However, *Shirrapburn Loch*, which must date from 1831 or 1832, anticipates many of William Dyce's later concerns in landscape painting. Once known as *Landscape in Wales*, this picture differs in concept, colour, and treatment from the Welsh landscapes of 1860 and from the Scottish landscapes of the fifties. The colours in the latter are
54 generally bleached as in *The Highland Ferryman*, and the former reveal clearly the influence of Pre-Raphaelite colour on Dyce. Shirrapburn Loch, a local name for Glen Shirra, is not far from the area of Morayshire where William was sketching in preparation for Sir Thomas Lauder's publication in 1829 or early 1830. Dyce depicts it with a mellow depth of colour in a painting which emphasizes the isolation of the place and the silence in which the heron fishes, unafraid of humanity. The foreground boulders and the bridge are shown in detail but the treatment of these, the hillside, and the trees is much coarser than anything we find in Dyce's landscapes of the fifties. The painting of boulders, the arrangement of dark and light areas in the picture, and the sense of quietude, consciously created, at least in part, through the

light cast from behind on to the tops of rocks and the parapet of the bridge, leaving the solemnly shadowed side of the hill facing us, is reminiscent of some of the Morayshire etchings.

The creation of an atmosphere of pregnant silence through the representation of landscape is something of which Dyce became absolute master in later years with paintings like *Gethsemane* and *The Man of Sorrows*. More **92, 71** significant from the point of view of William's technical development in these teacherless years in Scotland is a water-colour executed in 1832 before his departure for the Continent. Robert Dundas Cay's sister, Frances, had married into the Clerk Maxwell family whose country house at Corsock now stands derelict in the beautiful Dumfriesshire valley of Glenlair. William, on holiday in the summer of 1832 at Corsock, painted his earliest known water-colour, surely one of many since lost, and shows himself able **46** to achieve a degree of subtlety of colour, and a free yet delicate handling, which is lacking in *Shirrapburn Loch*. In so far as a central focal point is **45** retained with the fence blocked with brushwood and the foreground pool, Dyce is still responding in *Glenlair* to the demands of the picturesque. But here are no herons, no sails on the horizon. The feature selected as central to the composition is entirely original, a part of the place, and it is presented with the sort of sympathetic objectivity which typifies Dyce's best portraits of the mid-thirties. The feeling for different natural textures: the dry hardness of heather roots like grasping fingers over the pool, the coarse grasses, the damp spongy turf, the weathered wood of the fence, and the sun-warmed stones of the wall, is created through the use of marvellous rusty, peaty colours on yellow paper. The harshness of the brushwood is suggested by scratching out the paint and the distant hills are rendered in mysterious depth by the application of chalk.

This holiday in Glenlair provided, it seems reasonable to suggest, a foundation in experiment and practice with landscape painting, upon which Dyce was to build for many years. It was an experience, the recollection of which must have remained with him through many dreary London years and propelled him again towards the landscape of Scotland when a release from tedious administrative duties permitted.

There is evidence of much walking across the hills that summer of 1832. Near Glenlair the romantic castle of Threave stands accessible only by boat. An unfinished oil sketch of the castle in dramatic lighting rendered with broad brush strokes (perhaps influenced by his evolving water-colour technique) testifies to William's pilgrimage to this local beauty spot.

Further north, but still within walking distance for an energetic young man, stands the remains of the Cistercian monastery of Dundrennan which William painted the following summer. He retained this picture and the water-colour of Glenlair. Both works were sold in his studio sale in 1865.

In Edinburgh in 1832 William had been 'perfectly *over-run* with employment'. He announced to Callcott that 'by one of those changes in fortune which one cannot account for', he had got 'all the employment in Edinburgh in portrait painting'.[47] Relations with the family of Lord Meadowbank commenced with two portrait commissions at this time. Alexander Maconochie Welwood, Lord Meadowbank, to whom Dyce was to address the *Letter* he wrote in 1837 in collaboration with Charles Heath Wilson, **23** was posed against a classical column, shadowed by a tumble of drapery, in a grand portrait exhibited at the Royal Academy in 1832. Despite the illogicalities of lighting in the picture (the sky suggests a source of light to the left of the subject, while the shading of the face suggests one to the right) and the rather uninteresting treatment of the lower quarter of the canvas, Dyce succeeds here in combining the atmosphere of sophistication **15** to which he aspired in his portrait of Helen Boyle, Lady Fergusson, with **20** the directness of approach which characterized Duncan Davidson.

Harriet Maconochie Welwood was Lord Meadowbank's youngest daughter who died at the age of sixteen. Dyce's portrait was painted as a **38** pendant to Lord Meadowbank's and exhibited at the same time as *Contentment*, a title suggesting that the artist had Reynolds's *Age of Innocence* or similar child portraits in mind. He may have learned from Reynolds the device of viewing an infant subject from a position lower than her own eye level, thus avoiding a 'top of the head' view such as the adult usually gets of a child. By portraying Harriet seated on the ground with her legs tucked under her, Dyce has avoided all the problems attendant on full-length portraits of children: problems of proportion, naturalism of pose, of children who look like miniature adults. It is natural for a child to kneel and the position enables Dyce to simplify the formal and representational elements involved and so concentrate on the personality of the child. Harriet's portrait impresses with a pleasing sense of symmetry, the figure placed in a relentlessly central position, thrust forward towards the surface of the picture, all sense of depth negated by the dominant stripes of the child's dress. Devoid of sentimental coyness, Harriet gazes from the canvas

[47] D.P. I, Dyce to Callcott, 26 May 1832.

with dark-eyed gravity. Some two years later Dyce painted another Maconochie, Mary Anne, but, judging by a copy of the painting,[48] which is all that survives, Dyce failed to achieve the high standard of his portrait of Harriet. In 1837 a portrait of William Maximilian, eldest son of Lord Meadowbank, was exhibited by Dyce at the Royal Scottish Academy.

The question of William Dyce's debt to Reynolds is an interesting one. Probably his first experience of highly accomplished painting was before Reynolds's *Dr. Beattie* (1773) which was in the possession of the family until 1881 when it was presented to Marischal College. Dyce never used this portrait as an immediate source but he undoubtedly learned from it something of the master's handling of paint and treatment of an individualistic sitter, qualities which emerge in Dyce's portrait of Lord Meadowbank. It is significant that, in making his first attempt at historical painting, William should have turned to Reynolds's *Infant Hercules* rather than to a Scottish academic classicist like Gavin Hamilton. One is constantly reminded of Reynolds in looking at William's portraits of children, though what one sees is only a reminiscence and not a quotation. In a number of cases, we find William confidently setting out to surpass his eighteenth-century master by losing nothing of the charm with which Reynolds endowed his child sitters but gaining immensely in spontaneity. Hanging in the home of his mother's relatives, and certainly known to William, was a small and charming portrait of one of his aunts, Charlotte Alexandrina **30** Chalmers, as a child. The artist was another eighteenth-century portrait painter, Lady Bell who, born Maria Hamilton, was the sister of William Hamilton R.A.[49] The portrait shows a small girl with a muff, three-quarter length, and gazing directly out of the canvas with mischievous eyes. The format of the portrait, and especially the symmetricality of composition and the refusal to dilute the individuality of the subject by elaboration of background remind us of the directness of approach in Dyce's portrait of Harriet Maconochie Welwood. William paraphrased Lady Bell's painting with its recollections of Reynolds's *Lady Caroline Scott as 'Winter'* and at the same time contributed his own note of irony. The anonymous subject in William's energetically handled oil painting carries an enormous muff but is depicted in a summer landscape and wears a mop cap and light clothing. *Child with a Muff* remains in the collection of **31** one of the artist's descendants and would appear to have been executed

[48] Collection of Major Hog.
[49] *Gentleman's Magazine*, part i (1825), p. 570.

purely as an exercise in the manner of late eighteenth-century portrait painting.

We may suppose that William was not so completely 'over-run' with employment in Edinburgh as to prevent his occasional escape from town into the Pentland Hills or on excursions to the coast. Roslin Chapel, celebrated by Scott and Wordsworth,[50] is redolent of Scottish baronial and ecclesiastical history. Tradition has reinforced architectural excellence with an air of mystery through the story of the apprentice who, proving a better craftsmen than his master in carving the base and capital of a column, was murdered for his pains. Dyce painted a small oil panel (roughly the same size as *The Castle of Threave*) showing the chapel in a state of mellow decrepitude prior to the restoration work carried out at the suggestion of Queen Victoria after her visit in 1842. The fine carving is visible, but Dyce's painting is in no sense an architectural study and the chief interest lies in the play of sunlight which floods through the loosely swinging door, illuminating the sandy interior but failing to touch the mossy dampness of the corners or illuminate the Bible and rosary which lie abandoned in the foreground. An air of questioning, of a narrative incomplete, pervades the painting. It is curious, turning from this, to look at the unrefined rendering of the same place by William's younger brother Charles who in 1847 painted Roslin Chapel and, recalling the glory which restoration again brought to mind, dramatized the scene by the inclusion of two monks and a Cromwellian soldier. Very little is known of Charles Dyce but the existence of a landscape executed by Charles in 1848[51] suggests that he went to South Africa, perhaps through the agency of his eldest brother, Robert, who served on the staff of Sir Galbraith Lowry Cole when he was Governor of the Cape of Good Hope. A full-length portrait of Sir Galbraith by William Dyce hung in Government House there.

<div style="margin-left:2em">47</div>

[50] Scott, 'Rosabelle', and Wordsworth, 'Composed in Roslin Chapel'.
[51] *South Africa: View of Cape Town from Table Bay*, 1848, Water-colour, Sotheby's, 6 Dec. 1967 (9). Charles Dyce's *Roslin Chapel* is in the collection of P. A. Campbell Fraser, Esq.

2

'THE FIRST STEP IN
A NEW AND BEAUTIFUL TRACK'
1832–1837

In Venice in the autumn of 1832, David Scott drew Dyce sketching in a **17**
gondola. The two young Scots artists had met in Paris and, after travelling
independently to Venice, joined up again, and shared the journey from
Venice to Mantua. There they went their separate ways, David Scott to
Rome, with a commission to draw the Delphic sybil for his friend, and
William back to Scotland, bearing letters for David Scott's father.[1] A series
of water-colour subjects in the Dyce sale of 1865, indicates that William's
route to Italy lay via Calais, through the Rhône Valley to Northern Italy.
It comprises roughly three groups: river views and mountain landscapes,
studies of architecture, and coastal scenes. On his return from Italy, William
plunged again into a frenzied whirl of portrait commissions but at least one
subject from his tour was worked up into a finished painting and exhibited.
Part of the Arsenal, Venice was shown at the Royal Scottish Academy in 1833.

 The Rhône at Avignon, now in the British Museum, is exemplary of the **50**
first group of continental water-colours. It is much weaker in colour and
more washy in treatment than *Glenlair*. Staley has drawn attention to the **46**
similarity between this work and the washed skies and picturesque, sketchy
details of Bonington. The colour, as Staley points out, is almost mono-
chromatic. The luminous distance and the boldly cast shadows give a sense
of light so strong that it destroys colour, a reaction characteristic of other
Northern artists (Corot and Eastlake, for example) to the South.[2] A water-
colour of a coast scene, in Aberdeen Art Gallery, provides some indication
of how Dyce dealt with the third group of subjects. Women in picturesque

[1] W. B. Scott, *Memoir of David Scott* (1850), ii. 72, 73, 78.
[2] A. Staley, 'William Dyce and Outdoor Naturalism', *Burlington Magazine*, cv (1963), 470.

costumes and a donkey with panniers occupy the foreground, whilst across the bay distant mountains are visible. A breadth of treatment for the foreground and the distance is combined with a scratchy technique for the detail.

It may be that William did not feel sufficiently confident on his return to Scotland to modify the oil techniques and the studied approach of **45** *Shirrapburn Loch* according to the open-air naturalism he had discovered through water-colour. That Dyce was painting in the open air can scarcely be doubted. Scott drew him in action and the complete absence of landscape drawings as opposed to water-colours suggests that on that particular occasion, as on others, he was painting outside. Progression and experimentation in water-colour accompanied by a considerably delayed response in other media is a commonplace in British art. Turner is a case in point. Not until the fifties was Dyce ready to introduce some form of landscape naturalism and open-air observation into his oil paintings. It is, however, very misleading to suggest that Dyce abandoned landscape for a substantial period between the late thirties and the late forties. Quite the contrary; his residence in London after 1837 sharpened his appetite for nature, particularly for the limpid light of the English coast. The water-colours of the forties are of crucial importance in a chronology of Dyce's **52, 56** landscape painting for, without them, *Pegwell Bay* and *A Scene in Arran* appear as a sudden and unpremeditated blossoming of outdoor naturalism.

Scottish artists like Wilkie and Geddes had established something of a tradition for etching in the second decade of the century and, back home **125** in 1833, William Dyce gave serious attention to this genre. *The Young Angler*, dated 1834 and *The Border Tower* were probably the two etchings which were exhibited at the Royal Scottish Academy in 1835, described in the catalogue as 'studies from nature', an indication that William was attempting to consolidate the experience of his continental water-colour painting. Both are executed in an open, graphic style which gains its effect from sensitive handling in dry point on a largely white background. Ever sympathetic to the manners and preoccupations of children, Dyce shows the young angler lying on his stomach, chin in hands, and gazing over the water, his home-made rod abandoned beside him. *The Border Tower* is more robust and looser in treatment than the etchings of Geddes, who tended to use the Rembrandtesque low horizon, but Dyce's windblown tower might have come straight from the Dutch master.

124 Three interior scenes with elderly women: *Cottage Interior, An Old Woman,*

and *A Visit to the Alchemist* are remarkable for their depth and softness of tone, and for the way in which light is exploited to create a simple but dramatic effect. William worked on the etching of the old woman over a period of some years. Imprints of this design, signed and dated 1833 and 1834, survive, and in 1837 William, writing to his friend John Denham of his intention to send 'an etching or two' as well as a 'Caledonian Missy' to the Royal Academy, announces that 'The Old Woman with tub has turned up again after a disappearance of a year but', he fears, 'it is not quite a delicate enough morsel for public view.'[3]

The simple directness which is the keynote of Dyce's best work characterizes *Cottage Interior*, everything in the composition being subordinate to the inrush of light through the small latticed window. The ladder-backed chair and the deep hearth, contrast with and stabilize this flood of light. Dyce's ability to suppress extraneous detail and to eschew a narrative, literary flavour in order to attain this satisfying presentation of simple, related shapes, unified by light, is remarkable in an age in which the narrative content of a painting was so highly esteemed. The use of carefully controlled light is a favourite device of Wilkie and, of all Dyce's etchings, this comes closest to the work of his compatriot. Wilkie's career must have seemed to the young Dyce in Edinburgh, the archetypal success story and, although he cannot have had much sympathy for Wilkie's choice of subject in oil painting, he could have learned from Wilkie's *Lady seated at a Window*,[4] how to use a window as a focal point in an etching. On more than one occasion at this period, William signed his work with a monogram like Wilkie's 'D.W.' in reverse.

The next few years saw William Dyce as Edinburgh's most sought-after portrait painter. Stirling Dyce, who had access to his father's studio account book, states that his father was paid ten to fifteen guineas for portraits, but this must refer to drawings or pastel studies. In 1835 William was asking one hundred and thirty guineas for a portrait of Captain Gordon[5] and he clearly distinguished between 'regular portraits with background all painted' and 'merely heads with little else'.[6] A number of child portraits were executed by Dyce between 1833 and 1837. Dora Louisa Grant, aged six, is depicted in a delightful portrait in oil, exhibited in 1833. Less solemn

36

[3] National Library of Scotland, Acc. 3044, W. Dyce to J. Denham 16 Mar. 1837.
[4] C. Dodgson, *The Etchings of Sir David Wilkie and Andrew Geddes* (1936), No. 7.
[5] D.P. II, W. Dyce to P. Davidson, 5 Nov. 1835.
[6] National Library of Scotland, Acc. 3044, W. Dyce to J. Denham, 16 Mar. 1837.

than Harriet Maconochie Welwood, Dora clutches a white rabbit and gazes, bright-eyed, while a blustering breeze sends the clouds scudding and her pink sash, green hair ribbons, and stray ringlets fluttering. There is a touch of Hoppner or Lawrence in the great expanse of sky and, in the

37 child and her pet, an echo of Reynolds's *Miss Jane Bowles*[7] or Raeburn's *Boy and Rabbit* (R.A. 1816). However, Dyce has painted Dora in a composition which is essentially enclosed, the arms folded in front, the feet neatly tucked away, and lacking the sense of movement and abandon in, for example, Lawrence's *Julia Peel*.[8]

40 *John, tenth Earl Lindsay*. 'No, guess again', also exhibited in 1833, marks a new departure. The child is dressed in the archaic style of clothing fashionable in child portraiture and seated on a terrace, concealing something furry on his knee. With its novel narrative element and its general air of levity, this portrait anticipates what is perhaps Dyce's most adventurously

39 romantic portrait, *Alexander Jardine, eight Bart.*, exhibited the following year. Dyce seems to have abandoned the idea of 'biographical' adult portraits with *James Hamilton, M.D.* of 1832 who was presented, without total success, against a background of George Herriot's hospital. Master Jardine of Applegirth, as the eighth Bart. was known when Dyce's painting was exhibited, is shown full-length on the battlements of a castle against a stormy sky, in a portrait which combines a romantic setting with a cool appraisal of the subject.

 Between 1832 and 1837, the attention which William Dyce was paying to the branches of art most closely associated with design, etching, and

121 book illustration (in 1836 another commission from Sir Thomas Dick Lauder came his way[9]), suggests that he was already preoccupied with the problems that were to result in the *Letter to Lord Meadowbank* of 1837 and Dyce's subsequent removal to take charge of the School of Design in London. We have already seen William achieve a formal harmony of

38 symmetrical design in *Harriet Maconochie Welwood* of 1832. In a chalk draw-
42 ing of his nephew, Adam Wilson, executed around the year 1834, Dyce, by concentrating on the head and shoulders and using an oval frame, emphasizes the formal, aesthetic qualities inherent in the human face. A strong, central, vertical axis is created from parting to nose, chin, and buttoned jacket. The line of the chin and that of the eyes and hair above

[7] 1775, Wallace Collection.
[8] 1828, Sir George Cooper, Bt.
[9] Sir Thomas Dick Lauder, *The Highland Rambles* (Edinburgh, 1837).

the ear, divide the oval into a narrow, central, horizontal section with larger sections above and below. Similarly the line of the child's fringe and the inner edge of his collar create a central lozenge shape. The round shape of the child's head itself is placed carefully, slightly above centre within the oval.

The practical advantages of the crayon medium had not escaped William. 'What do you think of my having begun to draw in crayons?' he asked Robert Dundas Cay. 'Won't that be something new for the *modern* Athenians?' He continues, 'I think as far as I have practised the crayons that I have been extremely successful and that they are likely to meet with approbation and patronage in Edinburgh especially as they can be done more speedily and what is of more consequence—more cheaply than oil pictures.'[10]

Increasingly Dyce was finding himself in demand as a portrait painter. 1835 was a prolific year. A refined full-length of Sir Galbraith Lowry Cole with whom William had personal connections through his elder brother, Robert, was exhibited in Edinburgh in 1835 and in London two years later. Sir Galbraith's head is treated with great sensitivity. The character and elegance of the sitter are conveyed through a mode of handling which is looser than Dyce had hitherto been accustomed to use. There is, however, an intimation of this in the portrait of Nicolson Bain, the Edinburgh University Librarian, which Dyce painted in 1832 using, what was for him, an abnormal degree of impasto in the face. The painting of Sir Galbraith's clothing is much less successful and the gentleman tends to present, as a result, a rather baggy effect. A more painterly approach is used by Dyce also in his portrait of Mr. James Ivory, painted some time before he was made Solicitor General of Scotland in 1839, the first stage in a series of distinguished promotions which were to culminate in his appointment as a Lord of Justiciary in 1849. He appears firmly upright in the centre of the uncluttered canvas his right hand clenched, in a portrait strongly expressive of bourgeois determination and civic responsibility. Dyce was particularly successful at conveying the stalwart, down-to-earth directness of character of middle-class, professional subjects.

The summer of 1835 saw William again at Glenlair, painting Mrs. John Clerk Maxwell (*née* Frances Cay) and her son James, then aged four. The portrait was commissioned by Mrs. Clerk Maxwell's brother, Robert, who had just become engaged to Isabelle Dyce. Romance was very much in

[10] D.P. II, W. Dyce to Robert Dundas Cay, 14 Oct. 1834.

the air at Corsock and William, writing to send the happy couple the family's 'united and warm congratulations' found space to mention that Tibby, Robert's younger sister, thought William 'in matters pertaining to the fair sex much improved' and gave him 'some hope of becoming a *ladies' man*!!!!' In the same letter William declares that 'the picture has gone on remarkably well and promises to be the *thing*.'[11] Robert Dundas Cay,

22 however, recalled in later years that the portrait of the elfin-faced child (who was to become one of the most brilliant physicists of the nineteenth century) at his mother's knee, did not proceed smoothly. 'There was the extreme difficulty ... [of] inducing Fanny to sit', Cay remembered, 'then Dyce took ill before it was finished' and all the time Cay's main concern was in pushing his fortune with William's sister.[12]

Dyce painted Mrs. Clerk Maxwell three-quarter-length, turning slightly to the right, and clasping to her the child who looks round laughing at the spectator. The two are not communicating with each other, as the physically intimate pose might imply, but a directness of contact is established between the viewer, the elaborately dressed mother, and her mischievous child. Some years earlier, William had sketched James as Puck in a caricature of his own painting of 1829, (now known only from a photo-

14 graph, Check-list p. 198, p. 210). In the Clerk Maxwell portrait William, perhaps recalling Reynolds's child portraits, emphasizes the elfish features of the child, who looks as though he is about to bound away to play. This is the strongest part of a work which is uneven in quality and which betrays very definite weakness in the painting of the mother's hands.

The Dyce family and its ramifications kept William busy at his easel throughout 1835. A three-quarter-length portrait of Isabelle dressed in black lace was painted probably to celebrate her wedding.[13] Lowry William Frederick, son of William's elder brother Dr. Robert Dyce, was

34 portrayed in one of William Dyce's most successful and charming child portraits. Like Harriet Welwood and Dora Grant, Lowry Dyce was to die at a tragically early age when he drowned in the River Don, a fact that adds poignancy to the portrait, exhibited in 1835 in Edinburgh. There is a deficiency in the foreshortening of Lowry's right arm but Dyce has

[11] D.P. II, W. Dyce to R. D. Cay, 18 Sept. 1835.

[12] Birmingham City Art Gallery archives, R. D. Cay to Professor Clerk Maxwell, 12 Apr. 1877, Transcript.

[13] The portrait is now missing but a description is contained in a letter sent to the Director of Aberdeen Art Gallery in 1964.

admirably captured the responsive intelligence and grave curiosity of the small child. The background is even flatter than in the portrait of Harriet Welwood and effectively sets off the child's fair features and the un-complicated immediacy of the pose. Lowry Dyce was also the subject of a whimsical portrait exhibited by Dyce at the Royal Academy in 1837. With recollections of his own portrait of the young Earl of Lindsay and more than a savour of Reynolds's *Master Crewe* of 1776, Dyce painted his nephew as a highwayman (*Who goes there?*), his childish frame weighted **35** by absurdly large weapons, a paper boat at his feet. We are bound to regret this attempt to apply to portraiture the veneer of subject-painting when we contrast the natural openness of statement of the earlier portrait of Lowry with the archly humorous mode of *Who goes there?* Similarly William's attempt in 1836 to present Mrs. John Dundas and her daughter in an idyllic pastoral scene is, though not unpleasing, less successful than the more conventionally posed Clerk Maxwell portrait.

When painting his immediate relatives, Dyce tended to dispense with background paraphernalia, stormy skies, classical columns, and balus-trades. The more conviction he felt about his subject, the more severely he rendered it. William painted his father in 1835, the year before he died in a portrait which is stark and simple. The painting of the expressively bony hands is more than competent but Dr. Dyce is embittered in expression **3** and we are left wondering whether William intended to present his father's figure so small in comparison to the size of the canvas, that the Doctor's wizened form has a strange air of pathos. An equally expressive, but more cheerful, portrait of a relative is that of William's cousin on his mother's side of the family, Catherine Sarah Brown whom he portrayed around **24** the year 1837. There is an elegance and at the same time a simplicity in this three-quarter-length portrait of a young girl in a white dress with a yellow sash and a single pink rose in her bodice. The handling of paint and the characterization of the subject suggest that Dyce was by this date fully confident of his powers as a portrait painter.

The assurance that characterizes *Catherine Sarah Brown* did not always come easily to William. A curious record of indecision and ineptitude in his practice as a portrait painter comes to us from the diary of his grand-uncle, Alexander Chalmers. William had called on his uncle in London as early as February 1825 but it is not until March 1834 that Chalmers first mentions that William 'wants me very much to sit to him for my portrait'. On 29 May William took his first sketch and 'made considerable

progress'. He came again on 30 May and made three more visits, on 2, 4, and 9 June. The following day William took the picture away with him, saying that he would complete it at his lodgings and then deliver it in a finished state. Alexander Chalmers never received his portrait although 'high admiration' was expressed and there was talk of an engraving. The sitter became increasingly perplexed as the artist prevaricated and, in some irritation, wrote in his diary in July: 'as to William Dyce, I know not what to make of him'. In excessive heat on 29 July, William called again on his uncle and 'spoke much about the picture' but Chalmers could not understand what he was saying and was glad when he left. By the end of August hope had been abandoned and Chalmers was provoked to his final word on the subject: 'Dyce's behaviour is most shameful, but I shall have nothing to do with him.'[14] The only portrait which can be identified with this subject is of such an inferior quality that it can only be supposed that William felt dissatisfied with his work but unable to announce failure to his subject and, therefore, never delivered the painting.

It has been suggested that Dyce's engagement in portraiture in the thirties constitutes a deliberate turning away from what he may be assumed to have learned in Italy. However, it is evident from a study of the portraits of this period that Dyce was increasingly prepared to use paint with a certain **22** *bravura*. The Clerk Maxwell portrait of 1835, for example, is very much more **19, 20** painterly in treatment than the Davidson portraits of 1829. Familiarity with Titian at first hand in Venice might have been responsible for this development. If, on the other hand, we turn to the question of Nazarene influence, we are bound to acknowledge that the Germans, looking back to Dürer, were deeply concerned with portraiture both in specific representations of friends and family, and in the general sense of a devotion to individualized physiognomy as opposed to idealized humanity. Dyce's portraits are always more painterly than anything of a similar nature by Schnorr or Overbeck. Yet, compared to the fashionable portrait style of the thirties as exemplified by Lawrence, Dyce's colour is used thinly to fill in drawn areas rather than as a direct descriptive medium.

There was, in Scotland, a strong native current of robust, rustic portraiture, opposed to the refinements of Lawrence and sustained in the work of nineteenth-century portrait painters like the Lauder brothers. Dyce had grown up in an environment which valued a seriousness, a static solidity of approach in portraiture. It would be rash to suggest that what might

[14] *In Memoriam Alexander Chalmers 1759–1834* (privately printed, n.d., *c.* 1889), pp. 50, 81–7.

be termed the 'puritanical' portraits of Dyce derived their essential strength exclusively from either his native tradition or from Nazarene art. It is worth pointing out, nevertheless, that an early acquaintance with the one followed by exposure to the other may have contributed to the simple directness of approach in Dyce's most striking portraits. This approach endows his work at this time with a quality of dignity which cannot be divorced from the similar quality of calm gravity which we find in later paintings like *St. John Leading the Blessed Virgin from the Tomb.*

88

'You, at least will not give in to the popular English absurdity of refusing to give a man the credit of doing more than one thing', wrote William Dyce to John Ruskin in 1851.[15] From the time of his graduation from Marischal College, William had exercised his mind and talents in many areas. It was not always easy. Correspondence with Nicholas Wiseman, Rector of the English College in Rome, reveals to us, behind the façade of the successful Edinburgh portrait painter of the thirties, an intensely zealous Anglo-Catholic artist struggling to convey to an unappreciative public the purity of Christian art. Wiseman, who was up to date on all developments in the Oxford movement and to whom William sent his essay 'The Jesuits' in 1833, played an important role in helping William to clarify the religious conviction which was eventually to make him one of the most articulate spokesmen of High Anglicanism outside Oxford.

William's success in Edinburgh in 1834 did little to mitigate his sense of living in an alien and pagan society. Wiseman wrote to him in September, full of sympathy for the predicament of a Christian artist in a materialistic society:

Your feelings upon [religious art?] ... I am delighted to see you have cherished within you bright and pure in spite of the smothering atmosphere all around you. When portrait painting and scene painting or what is very akin to it form the surest careers to success for a young artist, to see one who dares to admire and longs to imitate the old, symbolic, Christian manner of the ancients is refreshing indeed to the mind; it is like listening to a strain of Palestrina after a boisterous modern finale. I do not know whether the wish to paint your symbolical designs for the B.V. [Blessed Virgin] excludes every other place but Rome for its fulfillment. Here it would be difficult not to say impossible to procure such a commission; but if you have courage enough to make the first step in a new and beautiful track, before the eyes of our own countrymen, and raise a new style and new school in England, where I am sure you would have many

[15] Letter prefacing W. Dyce, *Notes on Shepherds and Sheep* (1851).

admirers, I can from this moment promise you place and opportunity and room enough to put all your designs in execution.[16]

By 1840, Rome and his German and English friends residing there, were still very much at the forefront of William's mind. J. R. Hope-Scott was visiting Rome to collect books for the library that was being acquired for Trinity College, Glenalmond, manuscripts for Pusey's Library of the Fathers, and engravings after religious paintings.[17] Dyce took the opportunity of commissioning his friend to purchase some music of Palestrina. By this time he was endeavouring to achieve in music what Overbeck had achieved in art. Like Wiseman, who likened the old symbolic art to a strain of Palestrina, William believed that painting in the manner of Fra Angelico and composing in the manner of Palestrina were parallel activities. William sent an introduction to Schnorr in Munich[18] and arranged for Overbeck to show Hope-Scott the works of art he liked best in Rome. William also gave him a list of his own 'first loves' which included—all remaining fresh in his memory—Perugino, Botticelli and Ghirlandaio in the Vatican (significantly no mention of Michelangelo), Raphael's *Disputà*, Pinturicchio, Masaccio, Fra Angelico, and Giotto. 'I have named most of the works which people never look at and I shall beg you to find out for yourself the pictures which everybody seems to see', William told Hope-Scott. In a postscript he advised his friend that if he should go to Florence he must not miss Andrea del Sarto's *Entombment* and *Madonna del Sacco*, though this artist was not, William believed, 'a very Christian painter'.[19]

William was preoccupied with ways and means of becoming a Christian painter, and he must have felt deeply frustrated to be in Edinburgh in 1834, remembering the enchantment of his 'first loves', Perugino and Fra Angelico and recalling Overbeck who, William Davies wrote, 'talked much of Dyce'[20] and was delighted with a miniature of the Madonna on a throne with two saints 'in the old manner' which Davies had painted for the Pope.[21]

Wiseman wrote of William's 'wish to paint' symbolical designs of the Blessed Virgin. This leaves some doubt as to whether he was already engaged in the painting of religious subjects or merely planning his future

[16] D.P. I, N. Wiseman to W. Dyce, 1 Sept. 1834.
[17] R. Ornsby, *Memoirs of James Robert Hope-Scott* (1884), i, 214–15.
[18] Ornsby, i. 231.
[19] National Library of Scotland, MS. 3669, W. Dyce to J. R. Hope-Scott, 17 Sept. 1840.
[20] D.P. I, W. Davies to W. Dyce, 9 Jan. 1834.
[21] D.P. I, N. Wiseman to W. Dyce, 1 Sept. 1834.

practice. Apart from the documentary references to the Madonna bought by Overbeck in 1828, the earliest evidence of what we shall come to recognize as a characteristic combination of religious subject and naturalistically treated landscape appears in *The Dead Christ* of 1835. However, **62** Dyce exhibited *Christ Crowned with Thorns* in Edinburgh in 1830 and he may well have been working on similar compositions at the time of corresponding with Wiseman in 1834. Exhibited at the Royal Scottish Academy, the altar piece *The Dead Christ*, was still known in the early years of this century[22] but can now be judged only from an old photograph. It was sold at Christie's in 1947 as *Pietà, Landscape with the Dead Saviour, the Virgin St. Joseph and St. John.*

The four figures in *The Dead Christ* are grouped along the surface plane, a device which Dyce was to use in 1837 in his award winning cartoon *The Judgement of Solomon* and subsequently develop into something of a **11** stylistic feature in works like *Jacob and Rachel* of 1850. Although the posing **76** of the figures and the voluminous treatment of their draperies is Raphaelesque, the sweetness of expression, particularly in the figures of St. John and the Virgin, is reminiscent of an artist like Filippo Lippi. St. John, his head drooping in sorrow, anticipates the figure of the young apostle in *St. John Leading the Blessed Virgin from the Tomb*, begun in 1844. **88** Undoubtedly St. John as the youthful witness, the scholar, the disseminator of Christian truths, had a special meaning for Dyce, an artist convinced of the ultimately religious function of all art.

The landscape shows a distinct attempt to impart a Middle eastern **62** flavour to the scene. In the distance the Temple of Jerusalem is visible, in front of this, Calvary with its three crosses. Palm trees and distant mountains complete the biblical background. The sturdy trunks of the two large trees in the foreground seem oddly at variance with this. Their girth and the proliferation of foliage remind the spectator of European trees and their introduction into the composition might owe something to the influence of Poussin on Dyce in the thirties. It is interesting to notice in the foreground the detailed clarification of stones, twigs and plants which we usually associate with a much later period in Dyce's career when, as in *George Herbert at Bemerton* of 1861, for example, he appears to have been **112** working under the influence of Pre-Raphaelite practice. The landscape of *The Dead Christ* bears little relation to known landscapes by Dyce of this period although an attention to detail is a feature of *Shirrapburn Loch* **45**

[22] A. Chester, 'The Art of William Dyce, R. A.', *Windsor Magazine* (1909), 576–90.

of *c.*1831. It would seem that it was a certain class of subject which brought out a latent feeling for detail in Dyce at this early date. The Dead Christ is set in a landscape which is neither obsessively archaistic in the manner which Holman Hunt was to adopt nor organized and manipulated in order to reinforce the spiritual message in a Renaissance manner. There is a Poussinesque naturalness about the event taking place in the landscape which becomes the predominant feature of Dyce's religious landscapes of the fifties.

93 *The Madonna and Child* which Dyce exhibited at the Royal Academy in 1838 also makes important use of landscape. It must have been just such a painting of the 'B.V.' which Wiseman had in mind though Dyce's 1838 version, now in the Tate Gallery, has little of the 'old, symbolic Christian manner of the ancients' and is greatly indebted to early Raphael. A painting like the *Tempi Madonna* of Raphael could scarcely have been regarded by Wiseman or Dyce as representative of ancient, pure, Christian art. One must, however, bear in mind that any painting of the Madonna in 1838 was inevitably a conscious gesture against Protestant prejudice. As late as 1850, the editor of *The Art Journal* found Protestants still vigilant in their prohibition of religious pictures in churches.[23] It would have been impossible at this time for people to dissociate their reactions to such a painting from their attitudes to Roman Catholicism. Dyce's *Madonna and Child* of 1838, posed without supporting figures on the surface plane of the canvas against a landscape reminiscent of the Arno valley, would have seemed to Dyce's contemporaries an unapologetically devotional figure. The painting is cautiously handled, warm in colour and, when compared

96 with the *Madonna and Child* which Dyce painted in 1845 for the Prince Consort, sentimental in mood.

The Madonna peeps coyly from beneath half-closed lids. Three-quarters of the porcelain, dimpled cheeks and chin are seen framed in a filigree arrangement of wispy hair, delicately half covering the ears. The plaited and beribboned *coiffure* and the arabesques of the diaphanous veil are echoed in the painstakingly decorative treatment of the tree in the background. In later versions of the *Madonna and Child*, Dyce replaced the seductive curve of back and neck and the self-consciously lowered lids with

96, 98 a severe and straight-backed profile figure whose firm gaze concentrates on the Holy Bible and who is clad in heavy folds of green, blue, and red drapery. Even the vulnerable-looking, plump fingers which hold and caress

[23] *The Art Journal*, xii (1850), 1 May.

the child's right foot are replaced in the Prince Consort's picture by firm fingers with realistically depicted nails and confident grasp.

In a small oil of the *Madonna and Child* which has survived in the collection **101**
of one of the artist's descendants, Dyce placed his figures in a bare and rocky landscape which anticipates the characteristic backgrounds of pictures like *The Man of Sorrows* of 1859. The paint is thin and the handling lacks **71**
the certainty of the Prince Consort's picture. Like the Tate Gallery *Madonna*, the Kincairney *Madonna* is presented as a three-quarter-length figure with down-cast eyes, but the source in this case is not Raphael but Lucca della **103**
Robbia. Dyce had drawn a pencil sketch of the *Virgin of the Apple* in the **102**
Bargello on one of his visits to Italy and he adapted it to suit his needs in the Kincairney *Madonna and Child*. Probably in order to avoid the difficulty **101**
of foreshortening the child's legs Dyce covered them with drapery, but otherwise the compositions are almost identical. The droop of the Virgin's mouth is expressive in the same way as that of the young St. John in *The Dead Christ*. It is an expression that anticipates the introspection of Pre-Raphaelite womanhood.

There are on record in the region of twelve finished canvases of the Madonna and Child by Dyce as well as numerous drawings. The survival of one canvas with a descendant of the artist is significant as it lends credence to Stirling Dyce's assertion that his father painted many versions of this subject on his return from Italy but was unable to sell them. Relatives of artists have not infrequently found themselves in receipt of unsaleable canvases. We may infer that *The Dead Christ*, the Kincairney *Madonna*, and even the more highly finished and larger Tate Gallery *Madonna* are the sole survivors of a much larger corpus of work of a similar nature executed by Dyce during the thirties.

Conscious of the formative influence of the Grand Tour on British artists, it is all too easy for us to overlook the importance of local collections of old masters, dubious or authentic, when examining the development of an artist's style and skills. William Dyce's enthusiastic concern with the purchase of old masters appears early and grows apace with that of Eastlake with whom he was, in later years, to confer about the formation of a national picture collection. In 1863, William, as the guest of 'the good and amiable Lady Bellhaven', wrote heatedly to Denham of the government's failure to secure Sir Thomas Lawrence's collection of old master drawings, a collection which Eastlake had examined two years earlier whilst informally lecturing the Lords Brougham and Moncrieff, and the Prince Talleyrand

in French on the virtues of individual items.[24] The fact that the Duke of Hamilton, a fellow guest of Lady Bellhaven's, had offered to take the collection off Lord Melbourne's hands for £20,000, should the purchase, once made, be denounced as a piece of extravagance on the part of the government, particularly impressed William. 'Can you believe it possible', he wrote, 'with such a guarantee, that the government should be so foolish as to let a collection slip through their hands they admitted could never again be made.'[25]

In the same letter, William describes, with immense delight, the Duke of Hamilton's picture gallery. 'The palace', declared William, 'is perfectly crammed full of pictures many, most indeed, of high class. In the portrait gallery which is 125 feet in length', William continued fervently, 'there are 5 or 6 Van Dycks and a Reynolds, all whole lengths.' He picks out for special mention Rubens's *Daniel in the Lion's Den* but denies himself the pleasure of communicating further on the subject of the Hamilton gallery as 'a description of a collection of pictures ... of all descriptions, is most stupid.'

The influence of a variety of old masters is evident in William Dyce's work at this period and his taste is as fickle as it is wide. In an attempt to establish himself as a painter of scenes from Scottish history at a time when his commissioned work was exclusively in the field of portraiture, **114** Dyce painted *John Knox dispensing the Sacrament at Calder House* in about 1836, an improbable choice of subject for an artist with Dyce's religious leanings. It was, however, a popular subject painted by Chalon, Frith, Wilkie, Cope, and others. Dyce's version of *John Knox* is atypical of the artist's work in its attempt to suggest the depth of the room and in the grouping of a large number of figures. The painting, which Dyce proposed to etch as an illustration to a book by T. F. Dibdin,[26] possibly reflects the artist's interest at this period in the engravings, or even in the paintings, of Rembrandt.[27]

[24] Lady Eastlake, 'Memoir of Sir Charles Eastlake', prefixed to Sir Charles Eastlake, *Contributions to the Literature of the Fine Arts* (1870), 153–4.

[25] National Library of Scotland, Acc. 3044, W. Dyce to J. Denham, undated letter, datable to 1836 by reference to commission for tapestry cartoon received by Dyce in that year.

[26] Jupp Catalogue, xiv, Royal Academy Library. W. Dyce to T. F. Dibdin, 7 May 1837. The etching does not appear ever to have been executed.

[27] A number of Dutch and Flemish paintings, including a Rembrandt portrait, are among works from the Duke of Hamilton's collection sold at Christie's 6 Nov. 1919. Dyce, as we have seen, enjoyed access to the Duke's picture gallery.

The Italian Beggar Boy, which may be the painting exhibited in Edinburgh **13**
in 1836, reveals Dyce paying homage to Spain if, indeed, we may refer
to a composition which is a blatant amalgam of Murillo's *Poor Nigger Boy*,
and *The Dice Player* in Dulwich College Gallery, as homage. Like the land-
scape studies of the thirties this water-colour is executed in broad washy
strokes overlaid by dry highlights. The colours are fresh, with sandy buff
colours and ultramarine dominant. *The Descent of Venus*, (see check-list,
subject paintings, iii) which attracted much notice in 1863,[28] is unashamedly
Rubensian. *The Choristers*, (see check-list, subject paintings, iv) a painting
which, had it not survived in the collection of a descendant of the artist,
would be hard to recognize as authentic, is an essay in the manner Frith.
The figures are crude but some areas of the background are treated with
a delicate brushwork reminiscent of Gainsborough, a feature which rescues
the picture from total mediocrity.

Edinburgh in the first half of the nineteenth century took the lead over
London in art education. The Trustees' Academy, administered by the
Board of Trade for the Encouragement of Manufacture in Scotland, had
been in existence since 1760. When, after 1829, it amalgamated with the
Scottish Institution as the Royal Scottish Academy, Edinburgh boasted
facilities for education and exhibition equal or superior to those of London.
William Dyce continued to exhibit at the Royal Scottish Academy until
the end of his life and, although he does not seem to have played a significant
part in its foundation, he was undoubtedly impressed by its more audacious
members' efforts at democratization.[29] Later he was to express criticism
of the Royal Academy, London, in the strongest terms.

It was due to his participation in a competition organized by the Board
of Manufactures that Dyce first became involved in the whole question
of design in relation to art and industry, a question which was to occupy
his attention for many years and radically change the course of his life.
In 1836, Dyce and David Scott shared the prize offered for a tapestry
cartoon with *The Judgement of Solomon* and *Lady Macbeth Leaving the Daggers
by the Sleeping grooms* respectively.[30] Dyce's cartoon in tempera is a carefully **11**
planned composition with a strongly horizontal emphasis which, judging
by a preparatory drawing, was not part of his initial idea for the subject. **12**

[28] S. Redgrave, *A Dictionary of Artists of the English School*, 2nd edn. (1878).

[29] Dyce was an Associate Member of the R.S.A. from 1835 until 1853. Not being resident in
Scotland, he did not qualify for full membership, but in 1859 he was elected an Honorary Member.

[30] W. B. Scott, *Memoir of David Scott containing his Journal in Italy, Notes on it and other Papers*
(Edinburgh, 1850), 203.

The action takes place on a raised parapet, a device borrowed from the Venetian school which Dyce favoured because it enabled him to reduce his composition to a simple pattern of vertical and horizontal planes against which the subject could be seen in terms of vital movement. The figures are very dependent on Raphael and Signorelli, Dyce's central female figure deriving from Raphael's *Massacre of the Innocents* and his male figure on the right, seen from behind, strongly echoing the male nudes of Signorelli even to the detail of the striped loincloth. The cartoon succeeds· as an academic exercise. Whether it was ever executed is not known.

113 Dyce used a similar parapet and flattened background in *Francesca da*
63 *Rimini* exhibited in 1837, and in *St. Catherine*, an essay in Raphaelesque, female spirituality, of uncertain date but probably painted about 1845
67 shortly before his diploma painting *Omnia Vanitas*. *Francesca da Rimini* was formerly a larger picture including Lanciotto, the avenging brother, stealing upon the lovers from the left. Only his fingers can now be seen on the left hand side of the picture. The generalized landscape background, similar to those of portraits of this period, contrasts with the very detailed treatment of the two figures whose hair, hands, book, and creased sleeves are minutely depicted. The sharp-featured profile of Paolo with his wavy hair and bulbous eyes is very similar to a portrait in a private Scottish collection, said to be of Catherine Dorcas Maule Jardin. The position of Paolo and Francesca on a terrace recalls *The Judgement of Solomon*. The flattening of the background and the arrangement of figures on the surface-
96 plane anticipates the 1845 *Madonna*. It is significant to see Dyce working out, in 1837, a composition which depends for its effect on these features and, especially, on the use of profiles, a view of the human face which Dyce
79 was to exploit not only in the 1845 *Madonna* but in *Jacob and Rachel* of 1850, and in the Queen's Robing Room frescoes.

113 *Francesca da Rimini* is a key work and one which enables us to see William Dyce's position in relation to the culture of his age. We are bound to notice the choice of a subject which had recently gained enormous popularity and was to become even more celebrated by artists as the century progressed. Flaxman's illustrations to Dante were published in 1807 and influenced Koch and Ingres, and probably also Keats who wrote his sonnet on the lovers in 1819 after a vivid dream.[31] Delacroix painted a water-colour

[31] J. A. Koch painted *Paolo and Francesca* in the Cassino Massimo in Rome, 1825–9. Ingres painted a number of versions of the subject from 1819. Keats's conception of the subject is dealt with by I. Jack in *Keats and the Mirror of Art* (Oxford, 1967), 99–100.

of the subject in 1826 and William's friend, C. W. Cope exhibited his *Paolo and Francesca* in London the same year as *Francesca da Rimini* was on show in Edinburgh. Later both Rossetti and Alexander Munro, the Scottish sculptor interpreted the subject.[32] In their work the sensuousness and erotic passion implicit in the subject is stressed but in Dyce's it is subdued and contained within a rigidly controlled composition. Dyce's attenuated, adolescent figure of Paolo, leaning sharply forward, represented in flat, linear silhouette probably owes something to the influence of Flaxman. Another source might have been Retzsch's *Romeo and Juliet* of 1836 or even Overbeck's *Italia and Germania* of 1811–28 which Dyce would certainly have known. The thrust of Paolo's body anticipates the treatment of the male figures in *Jacob and Rachel* and *Religion: the Vision of Sir Galahad*. **76, 152**

A three-quarter-length portrait of Sir George Clerk, uncle of James Clerk Maxwell and a powerful politician in Peel's administration of the 1840s, was exhibited by Dyce at the Royal Scottish Academy in 1837. It is now sadly scarred by bitumen. A scheme for a series of engraved portraits of the children of Scottish aristocrats which Dyce was planning at this time with his friend, John Denham, seems never to have materialized. Dyce offered to go out of town in order to sketch the offspring of 'absolute nobles' though he could provide drawings of 'a grade or two lower' without leaving Edinburgh where they 'abound most'. The portraits were to have been mounted in an album called 'Buds' and Dyce was confident that it would be a profitable concern if 'well got up'. Confident of gaining easy access to the homes of the nobility Dyce remarked to Denham: 'I have now the reputation of painting children best and . . . could easily obtain permission to paint as many buds as may be required'.[33] One reason why this plan was never put into effect must have been Dyce's appointment as Master at the Trustees' Academy in Edinburgh.

William was unlikely to have been fully aware what the implications of this appointment were to be. Charles Heath Wilson, son of Andrew Wilson the landscape painter, accepted a similar post and the two new appointees' first task was the preparation of a report requested by the Board on the proposed reorganization of the Academy. This was addressed to Sir Alexander Maconochie Welwood, whom Dyce had painted in 1832 **23**

[32] M. Pointon, 'W. E. Gladstone as an art patron and collector', *Victorian Studies*, xix.1 (Sept. 1975), 88–92.

[33] National Library of Scotland, Acc. 3044, W. Dyce to J. Denham, 16 Mar. 1837.

and was published as the *Letter to Lord Meadowbank* in 1837.[34] In London, the recently established Select Committee on the Arts and their Connections with Manufactures had set up a Council to organize a London School ot Design. The members of this body, having no very clear idea of what might be achieved and how to go about it, were delighted to receive the *Letter to Lord Meadowbank*, with its rational approach and practical propositions. London officialdom, puzzled and irritated by the complexities of the situation and the friction of personalities as dissident as B. R. Haydon and Poulett Thomson, thought it recognized in William Dyce, a man who could offer real assistance. Accordingly Dyce, as the *Letter*'s chief author, was summoned to London to commence his long, tenuous, and agonized relationship with the Board of Trade and the Council of the School of Design.

[34] W. Dyce and C. H. Wilson, *Letter to Lord Meadowbank and the Committee of the Honourable Board of Trustees for the Encouragement of Arts and Manufactures, on the best means of ameliorating the arts and manufactures in point of Taste* (Edinburgh, 1837).

3

SUPERINTENDENT OF THE SCHOOL OF DESIGN
1837–1843

From the very beginning, William Dyce's association with the School of Design was threatened by schisms, his integrity questioned, and blame laid at his door for mishaps which were in no way his responsibility. Acrimony, the fruit of contention over principle and practice, and the unpleasant odour of bureaucratic wrangles and personal vendettas have marred Dyce's reputation as an artist. Even the authorship of the *Letter to Lord Meadowbank*[1] was brought into question. William wrote in 1844 to Bellenden Ker, stating that he had in his possession documents which proved that he was the 'prime agent and mover in the business'. The scheme was planned, Dyce claimed, between himself and Lord Meadowbank some months before Charles Heath Wilson knew anything of it. 'Nothing is or ever was further from my mind than to deprive Mr. Wilson of any credit which he deserves in the matter', wrote William, 'but as a whole it was my composition. . . .'[2] Yet throughout the *Letter* 'we' is used by the authors and it is difficult not to feel that Dyce in this matter, as in others, is punctilious to the point of small-mindedness.

There is a danger of inferring too much from Dyce's problematic relationship with the council of the School, of seeking to find in the discord and enmity, a clarification of general obscurities in our knowledge of Dyce through his work and as a man. It has been said, for example:

[Dyce] was capable of giving his thought clear and expressive form. . . . he was, almost, a great man. Almost but not quite. There was something lacking in Dyce which frustrated him at every turn. He was, like so many other British painters,

[1] W. Dyce and C. H. Wilson, *Letter to Lord Meadowbank*.
[2] D. P. III, W. Dyce to Bellenden Ker, 14 Dec. 1844.

a person of extraordinary gifts who somehow wasted himself; perhaps he followed a wrong direction, or perhaps at bottom, there was in him some profound tendency to frustration and defeat, something that made him seem almost to rejoice in his own tribulations, something which led him more than once, to abandon his art.[3]

Dyce interpreted 'art' in a wider sense than this twentieth-century writer and, although undoubtedly frustrated by the obstacles which barred his road to success as an administrator in the early forties, he was genuinely concerned with design in his own art and with the relations between fine art and industrial design. He himself tells us that he and Lord Meadowbank were communicating on the latter subject late in 1836 or early in the following year. Dyce's move to London was the result of this concern and of his desire to progress beyond portraiture and the limitations of Edinburgh society.

In order to explain why certain things happened and other things failed to happen in William's professional life in this period, it is necessary to understand what sort of man he was. William Dyce was disliked by many a person who found himself at the receiving end of some infuriatingly dogmatic reminder. He quarrelled with both George Richmond and Ruskin in this way though reconciliations smoothed the way to subsequent communication. At Osborne in 1847 Sarah Spencer, Lady Lyttelton, described Dyce as 'one of the least agreeable, and most dry and half-sneering mannered men I have ever met'[4] and Lady Eastlake, four years later, meeting him at her dinner table called him curtly 'clever enough and handsome too'.[5] Dyce's intellectual arrogance probably irritated many but his learning, his cultivated taste, and his good sense also drew to him friends like W. E. Gladstone and John Stuart Blackie. Dyce also enjoyed the friendship of C. W. Cope who was not in any way an intellectual artist nor a man with elevated social connections. Cope's devotion to his friend was such that he finished one of the frescoes in the Queen's Robing Room.

William was himself aware that he presented a formidable exterior. Writing to his future wife in 1849, William was touchingly open:

I know your diffidence and natural humility (the greatest of all virtues) and I fear you think me critical: but when you know me better you will find that under an aspect of pride almost approaching insolence towards the proud and pre-

[3] Q. Bell, *The Schools of Design* (1963), 77–8.
[4] *The Correspondence of Sarah Spencer, Lady Lyttelton*, ed. Hon. Mrs. Hugh Wyndham (1912), 368.
[5] *Journals and Correspondence of Lady Eastlake*, ed. Charles Eastlake Smith (1895), i. 266.

tending, my real nature is humble and simple,—at least it is my aim and desire to be so, and in you I look for love and truth and simple affection, which I prize more than talents and empty accomplishments.[6]

This is not, perhaps, the place to attempt a further assessment of what the 'real nature' of William Dyce was. It is abundantly clear to us, however, that the arts of conciliation and expediency were not among Dyce's strongest points.

'When will England learn', demanded the editor of the *Art Journal* in 1851, 'that even for the purposes of commerce Art is useful—and that where the higher and nobler Arts are assiduously cultivated, the inferior and industrial ones are also sure to flourish?'[7] The idea that the cultivation of fine art would also take care of industrial design was exactly the attitude that Dyce and Wilson were seeking to combat in the *Letter to Lord Meadowbank*. Believing firmly in the need for a practical connection between the arts of design and manufacturing industries, the two Scotsmen advocated a studio-workshop system in which students would apply themselves to courses in design appropriate to the tasks they intended eventually to undertake. They would thus be discouraged from aspiring to plaster casts of antique sculpture or the life-class, the prerogatives of the fine artist, and would find fulfilment and useful employment in designing wallpaper or fire-irons. Dyce and Wilson are insistent, however, that 'education for the liberal arts of design is only a higher degree of that which is required for the industrial and not anything different.'[8] Patterns produced in the school would be supplied to industry, a suggestion which was both bold and novel. The plans proposed by Dyce and Wilson have been described as 'at once liberal and authoritarian',[9] assisting the mechanic to rise but determining the direction in which he would rise by placing a master in control who had, himself, received a different sort of training.

The progress and development of art education in this country has already been charted by writers well-versed in the complexities of nineteenth-century social history.[10] Our task is to try to disentangle from the muddle of prejudice, vilification, and incorrect information, a clear picture

[6] D.P. XXVIII, W. Dyce to Jean Brand, 6 Nov. 1849.

[7] *The Art Journal*, iii (1851), 116.

[8] *Letter to Lord Meadowbank*, 81.

[9] Bell, *Schools of Design*, 81.

[10] The literature on this subject is rapidly growing. See particularly Bell, *Schools of Design* and S. Macdonald, *The History and Philosophy of Art Education* (1970).

of the contribution made by William Dyce to art education and to assess how his philosophy and practice affected his own life and work.

When William arrived in London in the early summer of 1837, at the behest of the Board of Trade, it was decided that he should leave almost immediately for the Continent where he would observe the practice of art education in relation to the requirements of industry and, it was hoped, return with an authoritative plan for the London Normal School of Design which had been established earlier that year under the directorship of Papworth. In a frenzy of activity William endeavoured to comprehend the mysteries of the various branches of industry. 'On Saturday ... I was occupied all day in Spitalfields among the silklooms, of this subject I am obliged to make myself master,' he wrote to Wilson, 'the day before I was occupied in a glass manufactory, the day before at a porcelain warehouse.'[11] The peaceful life of the Aberdonian academic and even the busy social calendar of the popular Edinburgh portrait painter must have seemed far away on those days spent in noisy London factories.

In Lyons, Dyce visited the *Academie des Beaux Arts* where students worked in the life-class and at a range of liberal studies, but he preferred the German (especially the Bavarian) system under which students were trained in a workshop to design for specific areas of industry. On his return, Dyce submitted a report in which he recommended the German practice.[12] Thereupon ensued one of the upheavals which were to characterize the evolution of government-sponsored art education in this country for many years. The directorship and the secretaryship of the School were abolished and their incumbents skilfully removed. Dyce was then appointed Superintendent. He remained in this post through major controversies and conspiracies until 1843, when he resigned. At this point he was offered and accepted the less arduous appointment of Inspector of the Provincial Schools. These had been established largely as a result of Haydon's unorthodox but typically energetic campaign-tour undertaken in 1837, while Dyce was out of the way on the Continent. Haydon was in radical disagreement with Dyce so it is not surprising that the latter's Inspectorship was as fraught with crises as his period of office as Superintendent. After

[11] D.P. III, W. Dyce to C. H. Wilson, 7 Aug. 1837.

[12] The final version, *Report or Reports made by Mr. Dyce, consequent to his journey on an Inquiry into the State of Schools of Design in Prussia, Bavaria and France*, is dated 7 April 1838 but it was not published as a parliamentary paper until 3 Mar. 1840. An abstract was presented to the Council immediately after its author's return.

becoming an Associate of the Royal Academy and accepting the Professorship in Fine Art at King's College in 1844, Dyce finally severed his connections with the Schools in the following year.

Several urgent tasks awaited the attention of the newly appointed Superintendent of the Normal School of Design in 1838. It was imperative to augment the ludicrously small group of about twelve pupils then enrolled at the country's only government sponsored institution for art education. Looms and other equipment appropriate to functional training were introduced and study from the figure prohibited. The artisans, who had to decide in advance the trade they were going to follow, disliked the system which involved them in work not greatly different from what they had been doing in the factory. They wanted a life-class, the very thing which the Dyce–Wilson scheme did not allow. Haydon, convinced that designers and industrial artists needed the same training as aspiring history painters, had opened a rival institution, the Society for the Promotion of the Arts of Design, where a life-model was provided. Dyce was eventually compelled to introduce the same facilities at his School premises in Somerset House in order to retain the few students he had.

Disturbances punctuated Dyce's period in office. The causes ranged from the inefficiency and pedantry of the Council to the carping and backbiting that went on between students and staff, and among the staff themselves. The Superintendent was determined to adhere to his doctrines but was harassed by the critical attitude of the Council and of members of the public and by overwork. Because he was only required to attend the School for teaching purposes two mornings and one evening a week, Dyce, suggests Macdonald, was unjustified in complaining that he had no time for his own painting and that he was being reduced to an administrative automaton.[13] However, when he was appointed Superintendent, Dyce took over the jobs of the director and the secretary and undoubtedly the latter position necessitated much clerical work. It is clear from the frenetic correspondence of Dyce during these years that he was far from idle. For example, in 1840 he sent three guineas to David Laing whom he had agreed to provide with an illustration to Scott's 'Thomas the Rhymer' in lieu of payment for a portrait of Shakespeare. 'I find my engagements so numerous', wrote Dyce, 'that I am obliged to limit myself to necessary occupations.'[14] He certainly was painting little and it seems fair, since we

[13] S. Macdonald, *The History and Philosophy of Art Education*, 120.
[14] W. Dyce to D. Laing, 28 Feb. 1840, MS. Edinburgh University Library, La. IV. 17.

know that his contract obliged him to devote all his time to the School, to assume that this was the main reason for his failure to produce more pictures.

At the same time, we must admit that William's early life is stamped, not perhaps with indecision, but with a reluctance to sacrifice one line of interest in order to single-mindedly pursue another. This multiplicity of engagement is ultimately the strength of Dyce as an artist. His mature painting is as concentrated in intention as his early life is lacking in decisiveness. He brings to that painting much of the intellectual range and spiritual experience through which he had adventured as a young man. We are in a position to criticize William for lack of foresight in accepting so restrictive a post as that of Superintendent at a salary of four hundred pounds per annum. We must, nevertheless, try to understand how a man of Dyce's intensely cerebral and philosophical turn of mind must have seen, in the School of Design, a chance to put into practice a system, planned in detail, and designed according to firm principles. His essay on electromagnetism, as it had turned out, was useless theory, disproved and cast aside by the relentless progress of science. His hopes of establishing a school of Christian art would, it seemed, never be fulfilled. Here, at last, was a chance to put a scheme into practice and to enjoy—as Dyce initially did enjoy before things turned sour—a degree of respect and accolade.

The ambivalence about his role as an artist that was noticeable in the young Dyce in Aberdeen in 1830, is still apparent in a letter he wrote to Poulett Thompson at the time of his appointment in May 1838. Dyce said that he had 'at more than one period the intention of abandoning the practice of art except as a matter of private gratification chiefly because he doubted whether his talent for painting were original enough to obtain for him the reputation which he had the vanity to suppose his general ability or rather varied studies warranted him to aspire to.'[15] To accept the post at the School of Design seemed a way of resolving this dilemma but, naturally, administration and teaching made the practice of his art seem suddenly more precious to him than it had ever been.

Bell and Macdonald present opposing views of Dyce's work at the school[16] and other writers have offered widely divergent explanations for the problems Dyce faced. For T. S. R. Boase, Dyce was 'an able organizer

[15] D.P. V, W. Dyce to Poulett Thomson paraphrased by J. Stirling Dyce.
[16] Bell, *The Schools of Design*. S. Macdonald, *The History and Philosophy of Art Education*.

and a strong character who held his own views and intentions'.[17] W. D. McKay believed that Dyce's period with the School constituted 'ten years . . . practically lost to his art',[18] while D. Farr attributes the School's failure to establish itself speedily not to 'lack of enthusiasm' on Dyce's part but to a system 'which ignored the need for combining practical instruction in industrial skills with more formal artistic training.'[19] Bell is sympathetic to Dyce though he is, at times, inaccurate and tends to overstate his case ('Disappointed in the Schools, harrowed by his work on the House of Lords frescoes, Dyce worried himself into a decline').[20] Macdonald, however, attributes the troubles at the School in its infancy almost exclusively to the personal deficiencies of Dyce, whom he describes as a 'narrow, High Church Nazarene', preoccupied with methods not with art. Dyce, asserts Macdonald, detested classical and Renaissance art and longed for the re-establishment of a class of medieval craftsmen working religiously for the glory of God. Macdonald states that Dyce believed fine art to be a distraction from this religious task if influenced by Renaissance humanism or the study of the nude.[21]

The respect with which Dyce regarded classical and Renaissance art is more than evident in his own painting. As for his affiliation to the High Church faith, it was in no sense 'narrow'. In fact, the demand of Tractarians for all kinds of ecclesiastical objects in wood, metal, and glass provided work for designers during the forties. His faith did not lead Dyce to envisage 'a strictly ordered Christian Society in which every person should be trained only for that class of Society in which he was predestined to serve.'[22] A sense of responsibility about society was encouraged by the Oxford movement. Accordingly Dyce, in time presented pupils at the school attached to All Saints, Margaret St. with copies of the *Drawing Book of the Schools of Design*.[23] Macdonald reveals the sort of ignorance in his use of the term 'Nazarene' that we are accustomed to excuse in mid-nineteenth-century commentators.

Haydon believed that Dyce was a threat to everything he himself stood for and wrote to Gladstone at the Board of Trade in 1843, when Dyce

[17] T. S. R. Boase, *English Art 1800–1870* (Oxford, 1959), 208.
[18] W. D. McKay, *The Scottish School of Painting* (Edinburgh, 1906), edn. 1911, 245.
[19] D. Farr, *William Etty* (1958), 90.
[20] Bell, *The Schools of Design*, 257.
[21] S. Macdonald, *The History and Philosophy of Art Education*, 78, 119.
[22] Macdonald, 77.
[23] D.P. XXVIII, W. Dyce to Henry Cole, 1852.

was appointed Inspector, to express regret and 'predict nothing but mischief'.[24] Actually, Dyce was as much opposed to academic hierarchies as Haydon. To suggest, as does Macdonald, that Dyce was a narrow-minded theorist who was diametrically opposed to Haydon and who sought to deny all the benefits of High Art to design students, is to confuse the issue as much as the paranoid Haydon confused it.

In a letter to George Richmond in 1846, Dyce clearly states his own view of what his job entailed:

I would with all possible despatch get rid of the notion of a director who sits in an office all day writing unnecessary letters, taking the business out of the Secretary's hands—or if he goes into the School interfering with the arrangements of the masters for no apparent present or ultimate object—and set up in its stead the idea of a director who personally conducts the higher class, who as a teacher is on an equal footing with the masters and who, while he is responsible to the Council for the general conduct of the whole school, is only among the masters *primus inter pares*.[25]

Dyce attributed sufficient importance to the life-class to go along to St. Martin's Lane with William Etty in 1843, although he had, in 1825, rejected the chance of obtaining admission to the Royal Academy life-class. Whether he regarded study from the nude as a cause to be passionately fought for, is doubtful. In later years, perhaps as a result of ill health, he not infrequently handed over his responsibilities as Visitor in the Academy life-class to Mulready.[26] The fact was that the Academy, in which the life-class was pre-eminent, had not produced a single designer to lift the country's industry from its dependence on foreign designs. The eminent Dr. Waagen, in evidence before the Select Committee on Arts and their connections with manufactures in 1835, had declared the system of academies to be a poor substitute for the medieval workshop or guild. Dyce, in the *Letter to Lord Meadowbank*, was not suggesting something completely new but was making a positive attempt to break the dichotomy between the artist and the manufacturer. He was not a wicked 'experimentalist'[27] but a thoughtful man concerned with practical possibilities, with improving design for industry and creating the sort of environment in which the kind of

[24] *The Diary of B. R. Haydon*, ed. W. B. Pope (Cambridge, Mass., 1963), v. 277–8.
[25] D.P. XXIV, W. Dyce to George Richmond, 3 Dec. 1846.
[26] See William Mulready's account book, Victoria and Albert Museum.
[27] D.P. X, B. R. Haydon to W. Dyce, ?1843.

communication so lacking in the Royal Academy schools, where visitors left students more or less to their own devices, could be established.

In the *Letter to Lord Meadowbank*, Dyce and Wilson do not commit themselves to one side or the other in the dispute between fine art and practical training. They offer the evidence available and are at pains not to undervalue the importance of the life-school:

... It is quite certain that a degree of ability sufficient ... to lead the possessor to eminence and wealth as a house decorator, would enable him, with the utmost application, and the best opportunities, to become only a very inferior artist.

It is, of course, towards the student in such branches of industry as these, that the judgement of the master would chiefly be required to render its directing assistance. He would be called upon to decide how far his instruction in the principles and practice of the fine arts ought to be carried in any particular case. We are decidedly of the opinion, that *there ought to be a limit to the operations of your proposed schools in this respect; yet we should be sorry, in present circumstances to fix it—we should be sorry that, in the absence of every other means of fostering the artistic talent of the country, the advantages which your academy will afford should be denied to any; —especially as we are aware of the important services which the drawing school, established now for a considerable period, under your auspices, has rendered to the cause of fine arts.*[28]

To say that Dyce was preoccupied with methods not with art should not constitute a criticism of the man. In an age in which informed and uninformed opinion verbalized on every conceivable subject, in an age in which the inculcation of taste was regarded as a government responsibility and formed the criterion by which everything was judged, Dyce is to be congratulated. An 'experimentalist' was just what was needed.

It may have been less the inclination to experiment that alienated those with whom Dyce was concerned in this venture than his evidently pragmatic approach. Unlike many of his contemporaries, William understood clearly that while it might be morally desirable to educate operatives, the structure of the manufacturing industries was such that this education would in no way influence the character of manufactures. He had studied factories in operation and, whilst he may or may not have accepted the ills attendant upon the division of labour, he saw this system as a reality within which he had to introduce reform. The system itself was, it seemed, there to stay. Dyce directed his greatest wrath against the ill-informed and idealistic meddlers who failed to comprehend the reality of the situation in

[28] W. Dyce and C. H. Wilson, *Letter to Lord Meadowbank*, 32; my italics. The drawing school referred to is the Edinburgh Trustees' Academy where the figure was the prime subject of study.

the manufacturing industries. Writing to Edward Edwards, the librarian, in 1838, with characteristic forcefulness Dyce inveighed against William Ewart and his associates

who think that in providing schools and exhibitions for artisans they have done all that is required for the amelioration of taste in manufacture.

They lately most inadvisedly called a meeting in Spitalfields of the hand loom weavers for the purpose of obtaining their co-operation in the establishment of a school there, which they supposed would have the effect of raising the character of the figures each manufactures. Now what is the fact? Why this: that the weaver is & always must remain a mere mechanic, who executes by an amount of labor [sic] without the slightest ... skill, what is prepared for him by the designer and card piecer. It is not in this case the weaver who requires education but the designer; & those two professions can never be united in the same individuals.[29]

One of the tasks that Dyce undertook as Superintendent at the school **126** was the production of *The Drawing Book of the Schools of Design*, published in 1843. In rejecting entrenched academic notions that the ability to draw the human figure indicates the ability to draw anything, Dyce understandably did not foresee that he was sentencing generations of school-children to mechanical copying. In his introduction, Dyce stresses the importance of inventiveness and suggests that the patterns he provides be used as a guide. It was unfortunate that the *Drawing Book* should have been seized upon by unimaginative elementary school teachers, obsessed with technical excellence.

It is clear from the *Letter to Lord Meadowbank* that Dyce had in mind the Greek 'school' rather than the medieval workship. 'The masters', wrote Dyce, 'should occupy the same position in their Academy that the ancient painters did formerly in schools.'[30] Endeavouring to practise his own principles, Dyce engaged actively in design work. His efforts now may seem meagre but they were made with serious intent. An undated design **131** for the façade of a church with polychromatic, inlaid representations of **127** saints, drawings for geometrical pavements of the type manufactured by Minton, and a drawing for a candlestick closely based on Nicolo dell' Arca's candle-bearing angel in San Domenico, Bologna, and intended to be one of four candlesticks which would 'hit the happy medium between Popery,

[29] W. Dyce to E. Edwards, 18 Nov. 1838, MS. Manchester Public Libraries, Letters to Edward Edwards, 1838–39, V, no. 664. I am indebted to Mr. Roger Smith for drawing my attention to this letter.

[30] W. Dyce and C. H. Wilson, *Letter to Lord Meadowbank*, 30.

Puseyism and that Churchism which in any wise will bear candlesticks for the Altar'[31] are among designs drawn by Dyce in the forties. It is significant that all were associated with the requirements of the Cambridge Camden Society in refurbishing its churches.

Like the new coin, and the drinking fountains which Dyce designed later in life, these drawings are characterized by a degree of simplicity and an awareness of the importance of function, which is rarely seen before William Morris and his generation reacted against the ornate products which were the pride of manufacturers at the 1851 Great Exhibition. **130** **133, 134**

In 1842 William received from James Burns a commission to illustrate *Nursery Rhymes, Tales and Jingles.* Like William, Burns was the son of a Chalmers, and the two men were therefore cousins. But the publisher inclined increasingly towards the Roman faith and was shortly to shock many with the announcement of his conversion. At least two engravers were involved in the edition which set out to reproduce a wood-engraving effect. The press immediately noticed that the framing, rusticated borders of overlapping and intertwined wood adorned with exotic fruits and flowers, was German in origin, whilst acknowledging that the engravings appeared to be 'original fancies by various English artists'.[32] The plates are unsigned but Dyce's son claims that his father was responsible and the reviwer quoted above thought he could detect 'Messrs. Dyce and Herbert among the contributors'. Dürer had used similar borders in, for example, *St. Sebaldus on the Column* and an obvious source for the exotic fruits and foliage would have been the 1833 Douce edition of Holbein's *Dance of Death*, in which the plates are faithful replicas of the 1547 Lyons edition. **122**

William Dyce's hand can be identified in the illustrations to 'God Almighty Three in One', in which he used a sectional arrangement, a device he was to use again in one of his signed illustrations for *Poems and Pictures* to be published by Burns in 1846. The illustrations to 'Little Miss Muffet', 'Pretty Maid', and 'How Many Days' all contain single figures treated with a degree of fresh naturalism which is recognizably a feature of 'The Spinning Maiden's Cross' in *Poems and Pictures*. All Dyce's figures have a healthy and robust naturalism which is clearly distinguishable from **123**

[31] D.P. XXVIII, W. Dyce to H. Cole, 28 Aug. 1848. The drawing is reproduced in Bell, *The Schools of Design.*

[32] Contemporary review bound in with a second edition, British Museum, Dept. of Prints and Drawings.

the languid, ephemeral quality found in the figures of other illustrators like Cope and Selous.

122 The style of illustration in *Nursery Rhymes, Tales and Jingles* is associated with work that was being done at this time at the School of Design. Dyce and Herbert were both engaged there and in a postscript to a letter of 1840, Dyce told David Laing: 'If you want any borders or tail pieces in the old style drawn on wood, there are students of the school here who will be too happy to draw them for you at your own terms.'[33] David Laing was an antiquarian who edited a large number of old Scottish ballads and was secretary of the Bannatyne Club, founded by Sir Walter Scott for printing rare Scottish tracts. In the same letter, Dyce asked Laing to show Francis Turner Palgrave, who was about to visit Edinburgh, any antiquities that would interest him. There were evidently close links at this time between antiquarians in London and Edinburgh and the influence of men like David Laing on Burns's publishing ventures was probably as important as the more commonly recognized impact of German illustrated books.

Nursery Rhymes, Tales and Jingles was typical of a new type of children's literature which was being promoted in the early forties by Henry Cole. Under the pseudonym of Felix Summerly, Henry Cole—a great pioneer in modern design—brought out in 1841 the first edition of his *Home Treasury* intended to cultivate the 'Affections, Fancy, Imagination, and Taste of Children'.[34] There was concern among a small group of people at this time that the many tales and songs of children passed down from time immemorial had all but been lost from memory, swept into obscurity by the conquering forces of Peter Parley who was intent on improving children's knowledge and understanding. The Percy Society acknowledged the urgency of the rescue work by devoting volume IV of *Early English Poetry*, published in 1846, to *Nursery Rhymes of England*. William was able to advance the cause by presenting copies of *Nursery Rhymes, Tales and Jingles* to friends with young families.[35]

The 'Affections, Fancy, Imagination and Taste' of children were, unfortunately, far from Dyce's mind when he embarked on designing the
126 cover for the School of Design's *Drawing Book*. The personified image of

[33] W. Dyce to D. Laing, 28 Feb. 1840, MS. Edinburgh University Library, La. IV. 17.

[34] Quoted by F. J. Harvey Darton, *Children's Books in England: Five Centuries of Social Life* (Cambridge, 1932; new edn. 1959), p. 241.

[35] D.P. XII, W. Dyce to J. Fairlie, 27 Nov. 1844.

'Design' set in the mould of Raphael's 'Daniel' in Sta. Maria della Pace
was arrived at after lengthy discussion with Etty. The latter recommended
'a lofty majestic figure of Nature; her brows bound with stars, her snowy
bosom veiled with clouds; attended by the Three Graces, or the Three
Plastic Arts ...' (The idea of a happy co-operation of Art and Nature was
the basis for much of Dyce's polemic.) 'Ornament should be essentially
graceful, and as the School derives more from Art than Nature, I think',
wrote Etty, 'they (the Arts) should dominate.'[36] William Dyce may have
felt Nature should dominate. At all events he ignored his friend's advice,
for which we should, perhaps, be grateful. Had Etty, however, attended
Dyce's lecture on ornament in May 1848, he would have heard him
reiterating the principle of ornamental form derived from Nature. 'We
may', declared Dyce, 'be satisfied that in the employment of geometrical
forms, we are but following the great example of Nature herself.
That same nature which, in the animal and vegetable world, has afforded
us every variety of curvilinear form has, in the crystalline, given us the
whole range of rectilinear form.'[37]

Progress at the School, albeit slow and tortuous, was discernible. The
number of pupils gradually increased and Dyce, by 1842, had rid the
establishment of its original teachers and obtained the services of W. H.
Deverell and, more importantly, the promising young Roman Catholic
artist, J. R. Herbert with whom he collaborated in illustrating *Nursery
Rhymes, Tales and Jingles*. But increasingly Dyce felt, however loudly he
might proclaim the 'intrinsic and independent excellence' of design as a
branch of art 'capable of enlisting on its behalf all the heartiness, zeal and
enthusiasm which the prosecution of other kinds of art calls forth',[38] that his
position was threatened by his inability to practice as a fine artist. W. E.
Gladstone (whom Dyce had first met at a soirée in Edinburgh in 1828)[39]
had scarcely crossed the threshold of the Board of Trade as its Vice-
President in 1841, before Dyce wrote to complain of his position in the
strongest terms. 'The Council of the School for the last three years', declared
William,' 'have continued to encroach on my liberty in respect of my
profession.' The governing body was, Dyce claimed, by preventing him

[36] D.P. VII, W. Etty to W. Dyce, 13 May 1841.

[37] D.P. XXV, transcript. Objections to Dyce's views were voiced in a letter to the *Journal of
Design and Manufacture*, i (Mar.–Aug. 1849).

[38] D.P. XXV, transcript, 'Lecture on Ornament', May 1848.

[39] D.P. I, information from Dyce's son.

(through the restrictive terms of his contract) from pursuing his art, reducing him to 'the condition of a mere amateur'.[40]

Dyce's criticism of the Council is couched in the most bitter language. 'They engage', wrote Dyce to Gladstone, 'in taking microscopic views of my proceedings; and in discussing minute matters of arrangement which, if the situation of manager is of any use ... except perhaps in the shape of periodic reports ought never to come before them.' The fundamental problem was that the members of the Council were, of necessity, chosen because of their association with industry. They were exceedingly suspicious of a man of William Dyce's education and breeding and attempted to obtain a degree of autonomy over the School which was, naturally enough, unacceptable to Dyce. The arrogance and intractability of William Dyce's character cannot have been the entire cause of the trouble. Even the very establishment-orientated *Art-Union* realized the true cause of the disputes at the School. 'We were simple enough to believe', announced the editor in 1847, 'that a Director means one who directs!'[41]

In addition to the constant friction with the Council, Dyce had other difficulties to contend with. Innovations like the Jacquard machine and the loom failed to attract the expected number of students, not because those who attended the weaving classes were bored, but because they soon discovered that their training did not lead to advancement in an industry, the owners of which were reactionary and preferred to use old designs or stolen patterns. The glare of adverse publicity must have been exceedingly wearing for the thirty-five-year-old Superintendent. Haydon's opposition was vociferous and frequently malicious and allegations ranging from inefficiency to malpractice and plagiarism were not uncommon.[42]

One fundamental reason why the School of Design failed to attract the talent or the numbers anticipated was that it existed in isolation. 'On one point I have long made up my mind', wrote Dyce to Benjamin Hawes (a member of the Council who ceased to attend its meetings because of the absurdity of discussing the mending of a shovel) 'which is that the Government School cannot produce the good which it is intended for, isolated as it now stands, until the *times of posterity* if even then. We have

[40] W. Dyce to W. E. Gladstone, Oct. 1841, B.L. Add. MS. 44358. This correspondence is quoted fully by Bell, *The Schools of Design;* pp. 92–7.

[41] *The Art-Union* (1847), p. 278.

[42] *The Art-Union* (1847), 395–6 carries a letter from an indignant and dissatisfied parent of two students.

begun at the wrong end', Dyce diagnosed, 'we have established a university before we have any grammar schools....'[43]

The Council of the School was unmanageable because it had been created in a philanthropic tidal wave which swept all concerned towards a monument to public beneficence and patriotism before practicalities had been considered. 'If we wish to hold our place among the nations of the earth, every encouragement must be afforded to the arts of design', the Rt. Hon. Henry Labouchère (President of the Board of Trade) is reported to have said as late as 1850 at the annual prize-giving ceremony at Somerset House,[44] more concerned with the appearance and status of the establishment than with anything actually going on in its studios and workshops.

A typical feature of the age was that any artistic project was mobbed by the public which swung unpredictably from approbation to censure and, even when sustaining an enthusiasm, was indifferent to the pecuniary position of the artists involved. Haydon, Hilton, Cope, and Severn were flattered by the immense public attention their work occasionally received, but gained little financial benefit. Cope wrote bitterly of his painting *The Board of Guardians*, exhibited in 1841, 'written about in the papers and admired by crowds' but 'allowed to come home unsold'.[45] The *Art-Union* pontificated about the best influence on the progress of Art, that of 'educated example, acting upon a sensitive, generally educated people ...' and remarked that 'the lower classes', though not what they were, 'are not what we wish ... nor, as our fellow-men, are they what they must be.'[46] But such paternalism concealed a meddling, frequently ill-informed, and ultimately irresponsible desire on the part of an amorphous section of opinion to nationalize art and make it a public affair. This was the most irrepressible force against which Dyce had to pit his strength at the School of Design.

We cannot doubt that William was relieved in 1844 to be able to resign his post as Inspector and to sever his formal connections with the School of Design but it is misleading to suggest that Dyce's period at the Schools divides his career in two[47] or that he subsequently dropped all interest in art-

[43] Bell, *The Schools of Design*, 94, quoting D.P. VI.
[44] *The Art Journal*, xii (1850), 61.
[45] C. W. Cope, *Reminiscences* (1891), 45.
[46] *The Art-Union*, ix (1847), editorial.
[47] As does A. Staley, 'William Dyce and Outdoor Naturalism', *Burlington Magazine*, cv (1963), 470.

education or design. He maintained an interest in former pupils, writing to Henry Cole at the Department of Practical Art (The Board of Trade) in 1852 about his 'best pupil', A. Hudson, and recommending him as 'particularly good at *glass* painting and church decoration'.[48]

We are in danger of falling into McKay's error, of regarding this period of Dyce's life as 'ten years practically lost to his art'.[49] In fact, Dyce continued intermittently to paint and was engaged in many activities which, whilst not fully stretching him as a painter, did exploit some of his talents for draftsmanship. *Jessica*, bought by W. E. Gladstone from the Academy in 1843 for thirty guineas, is Dyce's only secular subject painting of this period. The purchaser thought it exhibited 'the greatest purity of character and the clear subordination of design to expression but without any of the harsh or crude features which are sometimes found in connection with such excellencies'.[50]

Gladstone, who knew only too well of William's tribulations at the School, undoubtedly wished to encourage his fellow countryman in the practice of his art. It is difficult, however, from the evidence of an engraving after *Jessica*, to agree with his judgement of the painting. Renamed *The Signal*, the engraving belongs to what Dickens described as 'The Fancy Ball School of painting'.[51] It is a sweetly cloying depiction of Jessica, from *The Merchant of Venice*, leaning from a window, waving a handkerchief, whilst an irate Shylock is visible in the background. Gladstone, who noted the picture's change of title, stated that Dyce had painted Jessica from a 'living subject' but the composition clearly owes much to a long tradition of representations of women leaning from windows, established by Rembrandt and traceable through a line of Venetian subjects perpetuated in Landseer's *The Mantilla* (engraved by Robinson), Turner's *Jessica* and Etty's *Brides of Venice*.[52]

William also found sufficient time away from his administrative responsibilities to paint a religious subject, *The Christian Yoke* (exhibited at the British Institution in 1841 and the Royal Scottish Academy four years later) which, were it not missing, might have provided an important link

106 (margin)

[48] D.P. XXVIII, W. Dyce to Henry Cole, 14 Aug. 1852.

[49] W. D. McKay, *The Scottish School of Painting*, p. 245.

[50] W. E. Gladstone, 'Notes on My Pictures', Glynne Gladstone MSS., Clwyd County Record Office, Hawarden.

[51] *Bleak House*, xxix.

[52] Engraving by A. Linley. Etty exhibited the original at the R.A. in 1831 as *Window in Venice during a Festa*.

between *The Dead Christ* of 1835 and *The Good Shepherd* of 1859. He also **62, 85**
commenced work on what was to be one of his most successful religious
subject paintings, *St. John Leading the Blessed Virgin Mary from the Tomb*, **88**
some time between 1841 and 1842. He had completed the painting in its
essential details by 1844 but then laid it aside, presumably as he became
caught up in fresco work at the Houses of Parliament.

Already, in 1841, William was exploring the idea of fresco and pondering
the differences in technique between the work of the various Italian masters.
In August 1841, two years before resigning his post as Superintendent,
William called on Haydon 'with the air of a Master of the School of
Design' and examined the fresco specimen that Haydon was preparing for
the Westminster competition for which Dyce had been too busy to enter
himself. He 'saw & felt nothing of the Poetry' alleged Haydon 'but pointed
out the color [*sic*] of the lips and said it would not stand, and that I had
too much impasto, and the colours ought to be stained drawing, hatched,
glazed & thin.' Dyce expressed the view that Haydon was emulating
'Michelangelo's style of Fresco, & not Raphael's, & he was a bungler with
his tools.' Haydon retorted 'to be like him was at least something in a
first attempt.'[53]

Another popular misconception about William Dyce's career is that his
painting of portraits ceased when he left Edinburgh. One of his most
remarkable portraits in oil, that of Margaret Dyce Brown and her sister **41**
Catherine Hannah was painted whilst William was employed at the
School. Margaret was daughter of Revd. David Brown, Principal of the
Free Church College of Aberdeen and husband of one of William's sisters.
The portrait has long been known as *The Sisters*. Margaret Dyce Brown,
the elder child was born in 1836 and since she looks at least five years
old, the portrait could not have been executed before 1841. The extra-
ordinary effect of *The Sisters* derives from a combination of carefully
controlled and co-ordinated factors; the soft lamplight creating an arc of
light over the children (suggestive of the intimacy of some of Joseph Wright
of Derby's paintings) the evocation of personality through the contrasting
direction of the children's gaze (one intent on the book, the other looking
out of the picture), the subdued colour with greys, oranges, browns, and
greens dominant and—rendering the whole scene in poignant and moving
clarity—the sharpness of contour and simplified emphasis on the planes of
the table, the book, and the area behind the children.

[53] B. R. Haydon, *Diary*, vi. 85–6.

William must have returned to Aberdeen at intervals to recover from the rigours of London life and the quarrels with the Council. It must have been on one such visit that he painted *The Sisters* and in 1840, the portrait of Mrs. Crombie, a world-weary member of a distinguished Aberdeen family who sits bolt upright in her chair holding a Bible. The painting is now an almost total wreck but must always have been an extraordinary sepulchral object.[54] There is a great deal more energy and verve about

29 the portrait of Sir Galbraith Lowry Cole which Dyce painted before the subject's death in 1842. This is a much less formal rendering of Sir Gal-

28 braith than that which William painted in 1835 though he is still very recognizably the same man. In a portrait which is half-length and oval, Sir Galbraith is presented still as a man of intelligence and sensitivity. His refined and aquiline features are, however, softened with advancing years and greater experience. The characteristic determination of gaze and firmness of mouth remain but the military swagger, the arrogance and haughtiness of mien have gone. Moreover, the landscape of the earlier full-length has been replaced by a plain and unpretentious background.

[54] *Mrs Crombie* was dated 1840 by Miss Isabelle Dyce, the artist's daughter, in a checklist compiled by R. Ironside and still in the Tate Gallery. The list has proved reliable on other subjects.

4

ECCLESIOLOGY
1839–1844

William blamed the restrictive conditions of his employment as Super-
intendent at the School of Design for his failure to establish himself as a
painter in London. It is, however, clear that he was no more prepared to
limit his activities in London strictly to the fields of fine and applied art
than he had been in Scotland. He was, at the very time of his fiercest
arguments with the Council, immersed in the preparation of *The Order of* 118
Daily Service which was to be published in 1843, in writing articles on
Church music for publication in the *Christian Remembrancer* in 1841, and in
many other schemes. Some, like the planning of chapels and the designing
of series of book illustrations were linked, albeit tenuously, with his function
at the School of Design. In much of this work he was associating, if not
collaborating, with W. E. Gladstone. It is easy to bemoan such distractions
in William's career. In so doing, we escape from the dilemma of Dyce's
professional identity but we also miss the rich complexity of his life.

W. E. Gladstone was more to Dyce than merely the purchaser of *Jessica* 106
and later, of *Beatrice*. Gladstone had contacts in many walks of life. It may 66
have been he who was responsible for introducing Dyce to Beresford Hope
who was to commission from Dyce the reredos for All Saints Church,
Margaret St. Gladstone was also acquainted with Thomas Woolner and
artists associated with the Pre-Raphaelite brotherhood. He was in an
excellent position to open up to Dyce in the forties a large section of London
intellectual and artistic society. Gladstone and Dyce were united by their
High Anglican practice. We shall, in due course, appreciate the significance
of William's High Church faith in relation to his paintings of the fifties.
It is sufficient at this point for us to notice that between 1839 and 1843

William was becoming increasingly a spokesman on ecclesiological matters.

A deep sense of indebtedness to the past permeates all ecclesiastical arts of the mid-nineteenth century but, unlike those revivalists who became convinced of the value of ancient church ritual and practice through their preoccupation with the artistic styles of the Middle Ages, William Dyce approached ecclesiology in the forties as one who had already discovered for himself the virtue of theological study and the importance of authenticity in conveying to an initially unsympathetic public the intellectually tenable position of the Tractarian. His involvement with the ecclesiologists, the wing of the Oxford movement which concerned itself with the visual arts and with architecture, was, for Dyce, the next step in that 'new and beautiful track' of which Nicholas Wiseman had written to him in 1834. William, in the forties, was caught up in a movement to clean up the interiors of churches, to re-establish trained choirs and authentic Christian music, and to ally the forces of the fine and decorative arts in support of religious doctrine. The momentum of this movement astonished even the members of the Cambridge Camden Society who had initiated it. Surveying the scene in 1849, the editor of *The Ecclesiologist* declared: 'Architects excogitate, and committees patronize, and dignitaries at their private cost, build churches of a richness and a truthfulness in design, which we had not at first, when our society was struggling into existence in Hutt's back-room, ourselves any clear conception of.'[1]

William Dyce's dilemma in this period arose from the fact that he was, as Gladstone so aptly expressed it, 'an artist working for his daily bread'[2] but, at the same time, he was mingling with gentlemen of a more privileged class than himself with whom he shared an ambition to educate a wide public in High Anglican faith through the arts and music. W. E. Gladstone, Sir Thomas Dyke Acland, and Pusey were sustained by inherited wealth. Perhaps only Gladstone (who was to come to William's rescue in 1845 with the loan of a hundred pounds)[3] of all William's Tractarian acquaintance realized that to undertake the task of designing a frontispiece such as that to Tertullian in Pusey's *Library of the Fathers* (1842), **119** for which Dyce provided a *St. John in the Wilderness* on the model of Guido

[1] *The Ecclesiologist*, lxxv (Nov. 1849), 204.

[2] W. E. Gladstone to Mrs. Gladstone, 4 Dec. 1841, Gladstone – Glynne MSS., Clwyd County Record Office.

[3] D.P. xii, W. Dyce to W. E. Gladstone, 20 Mar. 1845.

Reni's celebrated painting,[4] or planning a chancel, meant falling behind in his paid employment.

Gladstone and Dyce were both members of the Society for Promoting Christian Knowledge and it was under these auspices some time during the Autumn of 1839 that the first discussions took place about a 'Life of Our Lord' to be illustrated with a series of prints after old masters. J. R. Hope-Scott, Acland, Pusey, and Revd Browne, Classical Professor of King's College, as well as Gladstone, were involved in the scheme which was intended with a view to popular instruction. As a bait, Acland suggested to Dyce that the Revd. Browne would be 'a good recipient of your view of Christian art'.[5]

Ideological differences caused disagreement and the publication was delayed and, finally, abandoned despite J. R. Hope-Scott's efforts at collecting suitable engravings in Germany in 1840.[6] It would be of little interest to us were it not that, whilst discussing the illustrations with Gladstone, Dyce explained very clearly his attitude to late Medieval and early Renaissance art, and his belief as regards the educational function of ecclesiology. Probably with Overbeck or Schnorr in mind, Dyce had suggested that, in place of prints after old masters, he should provide original designs 'keeping on the old key like the Germans'. Acland rejected this proposal, preferring to begin with some acknowledged authorities like the 'loggie of Raffaelle or the prophets of the Sistine Chapel'.[7] Dyce, indignant at the realization that Oxford was upholding a system of hackneyed copying, wrote to Gladstone to state his position:

I do not know how far you still contemplate an adherence to the rule laid down in the first instance, that all the designs should be ancient ones; but if you are able to dispense with this I shall be most happy to give my assistance ... I can assure you that my unwillingness to assist in the mere reproduction of ancient designs is not the result of any foolish vanity but (at least I think) of a true estimate of the vocation of an artist and of the use of Art. Both the one and the other belong to their age: and I confess that it seems to me just as unwise to reproduce (supposing it possible) the models of Art of the 15th and 16th centuries, with a view to *popular* instruction as it would to preach the sermons of those

[4] D.P. XIII, J. Newman to W. Dyce, 31 Oct. 1841.
[5] D.P. V, T. D. Acland to W. Dyce, 19 Nov. 1839.
[6] R. Ornsby, *Memoirs of James Robert Hope-Scott* (1884), i. 231.
[7] D.P. V, T. D. Acland to W. Dyce, 19 Nov. 1839.

ages in modern pulpits. I say this with the fullest conviction of the inferiority of modern preaching and modern painting to the ancient.[8]

William is here enunciating not merely a defence of the creative artist's status in an age which was witnessing annually the invention of a multifarious range of techniques of reproduction, but also his views on the essential contemporaneity of religious art. With Dyce the act of communicating, of educating, of inspiring his audience takes precedence over archaeological accuracy or historical authenticity. The latter qualities he held in the highest regard and, provided they could be combined with an appeal to the contemporary understanding, he embraced them wholeheartedly. But in the case of his paintings, he placed Christ in a Scottish glen as in *Gethsemane* and, asked to advise about the colouring of the capitals of Lichfield Cathedral in 1860, he rejected authenticity in favour of a general effect comprehensible to a modern congregation.

The illustrated Bible project dragged on until, in December 1843, William finally withdrew, telling Gladstone that he feared he had done 'more than was prudent' in offering to help:

For the next year I have so many necessary engagements that it is really out of my power to become bound by any new ones but such as directly lead to profit ... my circumstances oblige me to look solely for the present to the means of at once providing for my subsistence and of regaining my lost footing as an artist.[9]

By 1840, Dyce was regarded as an authority on all aspects of the visual arts without ever having established himself, to his own satisfaction, as an artist. The anomaly of his position troubled William although Eastlake, with whom Dyce was invited to submit a report on the lighting of art galleries in 1840 and whose position was similar, does not appear to have suffered any disquiet in accepting the yoke of arch-connoisseur and public spokesman on matters artistic.

C. R. Cockerell was a member of the Council of the School of Design and, therefore, well acquainted with Dyce. Having attempted to combine two institutions with different functions in one very splendid building for the University of Oxford, Cockerell encountered problems in lighting the two galleries intended for paintings in the south wing of the Taylorian Institute.[10] Dyce and Eastlake were invited to consider lighting in general

[8] D.P. XII, W. Dyce to W. E. Gladstone, 6 Dec. 1843.
[9] D.P. XII, W. Dyce to W. E. Gladstone.
[10] D. Watkin, *The Life and Work of C. R. Cockerell* (1974), 205–6.

and Cockerell's proposals in particular. Eastlake canvassed the authoritative views of Dr. Waagen of the Berlin Gallery and Dyce elicited from Professor Schnorr some valuable information about the lighting of the Pinakothek in Munich in a letter which he was compelled to have translated for him and which he carefully retained to consult again in 1853 when preparing a report on the National Gallery.[11] Dyce and Eastlake were hampered by lack of information about the pictures which were to be displayed. Their report contains searching criticism but no uniformity of opinion.

The architect of the Taylorian must have thought highly of William Dyce and he did his best to put other work of a more or less artistic nature in his way. The Oxford authorities allotted two hundred pounds for a painting on the ceiling of the Library of Modern Languages and C. R. Cockerell wrote inviting Dyce to avail himself of an opportunity which was 'glorious' and 'importing the future in every way' even though the remuneration offered for painting a circle twenty-five feet in diameter was 'vile'.[12] As there is no sign of the ceiling ever having been painted we may assume that Dyce was unable to afford to devote his time to the glorious cause.

The role of pictorial art in the High Church movement was never specified by Keble, Pusey and other leaders. The vital function of the written word was plain. Architecture and the applied arts were, no one doubted, essential if correct ritual and liturgical practice were to be re-established in the Church of England. But in what area and to what ends the painter was to be employed were questions which remained obscure. It is, perhaps, for this reason that we find William in the early forties still searching for a niche he might occupy in the edifice of Tractarianism. The ecclesiologists, preoccupied with building programmes, were not yet ready to consider major decorative schemes or altar-pieces within the church. Yet William was regarded as an asset in the movement and was constantly called upon to offer advice on projects for which he had not ultimately any personal responsibility and to undertake small commissions which never came to fruition.

It was in this way, in 1840, that William's name is associated with a branch of art that was to cause him much heartache. C. R. Cockerell had recently designed the Chapel of the Holy Evangelists at Killerton in

[11] D.P. XXX, W. Dyce to Henry Cole, 28 Feb. 1853.
[12] D.P. XXII, C. R. Cockerell to W. Dyce, 12 Nov. 1846.

imitation of St. Mary's Chapel, Glastonbury. Wondering to whom should be given the commission for the stained-glass windows at Killerton, Cockerell expressed dissatisfaction with Thomas Willement who had worked with Pugin. 'I believe Willement is incapable of doing them as a gentleman should desire to have them...,' remarked Cockerell, 'with all submission they should be drawn by learned hands, such as Dyce's or Eastlake's.' Cockerell goes on to complain of the 'horrors' tolerated in Protestant churches and suggests that 'if the *drawing* were made & super-intended by a learned hand, the colour and paint' might be done by Willement.[13]

Whether Dyce was in fact persuaded to contribute his learned skill to Willement's stained glass is not known. However, it is in the difficult role of superintendent that we find him in 1848 helping Wailes with the east window of All Saints, Hursley, built by J. P. Harrison for Keble who was vicar there from 1836 to 1866. The church was consecrated in a ceremony which William attended in October 1848.[14]

At the same time William was supervising the cartoons that the O'Connors were preparing for the glass in the chapel at Trinity College, Glenalmond, the school for the sons of Episcopalian clergy, founded by W. E. Gladstone and J. R. Hope-Scott in a beautiful valley near Perth. The glass produced by the O'Connors for Trinity College is without distinction and it is clear that William found the task of supervising, that had been thrust upon him, no easy one to accomplish. Dyce already knew the O'Connors, for Butterfield had persuaded him in 1848 to draw the cartoons for the east window of Christ Church, Hoxton (now demolished), which was manufactured by the O'Connors.[15] Dyce regarded the father-and-son team of glass painters as inferior artisans, obstinately refusing to be guided by the superior hand of the fine artist. If he spoke to Wailes and the O'Connors in anything like the tones of scorn and exasperation which ring from the letter he wrote to Hope-Scott about the glass for Hursley and for Trinity College in 1849, it is hardly surprising that he failed to obtain their co-operation. Dyce speaks in this letter with the voice of one who has recently despaired of inspiring the artisans at the School of Design to educate themselves into becoming responsible craftsmen:

[13] Watkin, p. 181.

[14] D.P. XXVIII, W. Dyce to J. Keble, 9 Oct. 1848.

[15] P. Thompson, *William Butterfield* (1971), 462.

Mr. O'Connor senior and junior have both shewn that they despise both me and my assistance. The one rejects the ornamental design as unworthy of his criticism, and the other my offer to finish (in reality to execute, for I only asked him to put in the outline slightly) the cartoons—so that I wash my hands of the whole affair. The result will be that your window will exhibit the usual beauties of the O'Connor glaziery. I expect a similar result in the case of the Hursley window which Wailes is to do. He has agreed with Judge Coleridge that I shall correct the cartoons but I fear he is only *shamming* as O'Connor has. The truth is our glass painters are mere money making glaziers who dread the introduction of a kind of art which would require better workmen and so diminish their profits.[16]

No lesson was learned, it would seem, for William was still prepared to correct Francis Oliphant's cartoon for the choristers' window at Ely Cathedral at the cost of considerable 'time and labour' some time before 1856[17] and to offer to 'superintend the designs and correct the cartoons' for the glass to be installed in West Church, Aberdeen at about the same time.[18] William's renewed activity in the field of glass painting at this later period was probably due to a degree of fame he was enjoying as a result of the completion of the one window for which he himself was largely responsible, at St. Paul's Church, Alnwick. This, however, is another and **frontispiece** much longer story to which we will return in due course.

W. E. Gladstone consulted William about his plans for Trinity College from the earliest and most tentative stages. We must now retrace our steps a little to consider Dyce's association with a scheme so dear to the heart of the Gladstone family. During the early forties, William made an effective bid to establish himself as an authority in ecclesiological matters remote from the province of the fine arts as traditionally defined. In 1843 he published a pamphlet, *The Form and Manner of Laying the Foundation Stone of a Church or Chapel* composed for the building of Christchurch, Westminster, in which he described in detail the correct manner of conducting the service on such occasions. The following year *Notes on the Altar*, an historical survey of the position and function of the altar in relation to the Anglican service, was published. Dyce's contribution to Trinity College seems to have developed from his concern with church ritual and function.

[16] D.P. XXVIII, W. Dyce to J. Hope-Scott, 25 Jan. 1849.

[17] *The Art Journal*, n.s. iii (Feb. 1857). The earliest mention of the window, of which the corner containing the date and inscription is broken, is in *The Builder*, xiv (1856). The undated right-hand section of the cartoon survives in Aberdeen Art Gallery.

[18] D.P. XXXVI, W. Dyce to J. Webster, Lord Provost of Aberdeen, 8 Dec. 1856.

On 22 January 1843, Gladstone and Hope-Scott went to call on Dyce and saw his 'beautiful designs' for Trinity College.[19] Exactly what these designs were is hard to say. John Henderson of Edinburgh was the architect but the fact that the first proofs of an aerial view of the college were sent to Gladstone from Dyce at the request of Henderson may suggest that here again Dyce was engaged in some advisory capacity in the over-all scheme as well as being responsible for actually designing some of the detail. Henderson was a well-known architect responsible for many Scottish churches including St. Andrew's, Fasque, the church the Gladstone family attended when in Scotland. None of the public acclaim which the architect enjoyed for his achievement at Trinity College was shared with Dyce.[20] But the latter remarked to Gladstone that the lithograph view of the College was 'a very nice print which even the Camden Society ought to be pleased with',[21] which suggests that he was, perhaps, a sort of ecclesiological watchdog.

Trinity College is built in a hybrid style of ecclesiastical and domestic High Gothic. Passing through a Tudor gate-house, the visitor find himself in a large courtyard, the south side of which is closed by a cloister. On the east side is the main hall built above an undercroft, and the chapel with its tower and spire, all completed with Puginesque attention to detail. The main body of the chapel is outside the courtyard area. This was completed in 1851, the west wing having been finished three years earlier. The hall was not completed until 1863. Dyce, as we have observed, was sufficiently concerned with the correct liturgical placing of the altar to write a pamphlet on the subject. The one aspect of Trinity College, for which we can be absolutely certain Dyce was responsible, is the arrangement of the chapel. Gladstone wrote in terms of deference to his friend who was 'busied upon the Scottish College Designs', venturing to send 'a suggestion relating to the arrangement of the Chapel'. It is clear from his letter that the matter was left entirely to Dyce's discretion but that the two men shared similar views on the pre-eminence of the altar and the chancel over the pulpit:

I presume it to be most probable that the building will be of an oblong form without aisles—but with a recess on the north side and near the east end for

[19] *The Gladstone Diaries*, ed. M. R. D. Foot and H. C. G. Matthew (Oxford, 1974), iii. 1840–7.
[20] Dyce is not mentioned in the account of the college in *The Builder*, ix (1851), 25, nor in G. St. Quin, *A History of Glenalmond* (1956).
[21] D.P. XII, W. Dyce to W. E. Gladstone, 18 Apr. 1844.

the organ. If this be so might you not place the clergy within the limit of the chancel, the choir face to face along each side immediately next westward, and the pupils and congregation all facing eastward in transverse benches from each side of the middle aisle? A space would naturally intervene between the chancel and the general mass of seats and that, it seems to me, might advantageously receive the choir. I am much inclined to value highly concentration of the action of the service at the east end of the chapel as most conducive to unity, solemnity and devotion: and I should hope no objection would be taken to the manifestly primitive and natural, and not very Roman practice of placing the clergy in the chancel. But if my arrangement offends against any canon of beauty or propriety I do not for a moment stand against your authority.[22]

Today the proportions of the chapel are sadly distorted by the introduction of a large gallery at the west end but it is still possible to observe that the size of the chancel is considerable for such a small church. The question of the choir was one which occupied the thoughts of both men. Passionately interested in music, Gladstone worshipped at Margaret Street Chapel, the one London church where more or less authentic singing of psalms was part of the service. William allegedly had taught himself to play the organ at the age of twelve[23] and, when C. W. Cope came to paint his posthumous portrait it was not with palette and brushes that he **32** represented his friend and fellow artist but with a sheet of music and a pile of books.

Encouraged by Wiseman, who hoped to see him 'engaged on a grander work and editing the graduale and antiphonary for the whole church, at least in England',[24] William published *The Order of Daily Service* in 1843.[25] **118** One of William's cousins on his mother's side, the publisher, James Burns, made a splendid job of producing the book in quarto volumes, bordered on every page with wood-engraved head, side, and tail strips, the text printed in black-letter with the rubrics and staves in red. William's work marked the first step towards a general re-adoption of Marbeck's communion service, thus founding a tradition in Anglican liturgical music which has lasted to the present time. William's scholarly investigations of the conventions of Latin plain chant, summarized in the appendix, opened

[22] D.P. XV, W. E. Gladstone to W. Dyce, 19 Apr. 1843.
[23] D.P. XIII, information given by Dyce's son.
[24] D.P. XVI, N. Wiseman to W. Dyce, n.d. datable by reference to *The Order of Daily Service*.
[25] *The Order of Daily Service, the Litany and Order of the Administration of the Holy Communion, with Plain-tune according to the use of the United Church of England and Ireland* (1843).

the way to a potentially satisfactory method of chanting the psalms in English.[26]

In 1844, William set the Scottish communion service to music and, in the hope that it would be used by the choir for which he and Gladstone had made such ample provision at Trinity College, William sent his friend a copy.[27] As the decade of the forties slipped by, the two Scotsmen cemented their friendship during Monday evenings spent endeavouring to recapture within the sober confines of All Souls and Trinity National Schools, Langham Place, the immortal beauty of Palestrina and Monteverdi.

[26] See B. Rainbow, *The Choral Revival in the Anglican Church* 1839–72, (1970), 81.

[27] D.P. XVIII, W. Dyce to W. E. Gladstone, 28 July 1844. By 1850 the Scottish office and the English were used alternately at Glenalmond. See R. Ornsby, *Memoirs of James Robert Hope-Scott* (1884), i. 280.

5

'A PRE-EMINENTLY EDUCATED ARTIST'
1844–1847

The choral revival in the Anglican church had commenced in a very limited way about 1839. It was closely related to the Oxford movement and the ecclesiologists were quick to realize that a reconsideration of the arrangement of the interior of the church implied inevitably a reassessment of the role of music. Appropriately, ecclesiologists sought first to remedy a situation in which 'a few miserable and effete singers [were] running about from choir to choir, and performing to a crashing and bellowing of organs, the most meagre and washy musick' in the universities of Oxford and Cambridge. 'How could churchmen', demanded the ecclesiologists, 'learn anything, under such a system, of the depth and majesty and sternness and devotion of true church musick?'[1]

William Dyce was not only an accomplished musician and a 'pre-eminently educated artist'[2] he was also a skilful polemicist. Knowing his own powers of verbal persuasion, William early launched his own offensive in the press. He and his associates in the Motett Society were often accused of 'the prejudices of Latinity and anti-artistic formularities',[3] of esotericism and antiquarianism, and yet the articles which William wrote for *The Christian Remembrancer* in 1841 are illuminated not merely by his concern with authenticity and theological correctness but by a genuine desire to fulfil a profound need among church-going people, a need for vital, formal,

[1] *The Ecclesiologist*, xxv, xxvi (Sept. 1843), 2.

[2] F. T. Palgrave, *Essays on Art* (1866), 135.

[3] G. A. MacFarren, *The Musical Times* (Aug. 1867), quoted by P. Scholes, *The Mirror of Music* (1947), ii. 554.

choral activity which, if neglected, would eventually disrupt the established church. William's plea is urgent, emotional, and very forceful:

Can any of our readers point out to us a modern parish church with a chancel, that is with a choir and a sanctuary? ... We have plenty of churches in which there is singing after a sort, but we have none with ecclesiastical choirs. Does it seem to anyone that this is a great defect ... a corruption ... a despoiling of its beauty and decorum? Do we lament this defect? Do we make any efforts to correct the evil?—Alas!—Sunday after Sunday, year after year passes away and the service of our parish churches remains the same lifeless, cold, spiritless routine. Instead of the busy, energetic and animated antiphonal chanting of the Psalms by a choir at the altar, we have them read verse about by a solitary priest and his clerk. Instead of the figured music of the hymns we have ... a chant drawled out by a few charity boys and girls: or more frequently we have no chant at all, the only music being that sung to a metrical Psalm or two which forms no part of the service.[4]

The dyadic character of William Dyce's art is, perhaps, most clearly to be understood by observing Dyce as musician and ecclesiologist. The Aberdonian intellectual who exchanged information with Pusey and Newman concerning the authenticity of manuscripts and the acquisition of treatises by Fathers of the Church,[5] whose history of church music was derived from Greek and Hebrew sources,[6] also believed passionately in the poetical and emotional involvement of the faithful in a Christian past remote from the humdrum world of the historian. Remarking on the ability of his contemporaries to appreciate the 'character and works of ages byegone', Dyce points out that this happens not in a 'general way or by the cold and dispassionate estimate of antiquaries, but heartily and as a matter of religious and poetic sentiment'. Dyce believes that 'we become denizens of the past, make its thoughts our own, are inspired by its feelings with an ease, readiness and pleasure.'[7]

Today we are easily able to comprehend the way in which a painting **86, 112** like *Joash Shooting the Arrow of Deliverance* (1844) or *George Herbert at Bemerton* (1861) acts through the union of the literary or the archaeological and an intensity of personal feeling and religious conviction which is unequalled in the age. His contemporaries found the qualities of William's art difficult

[4] *The Christian Remembrancer*, iv (1841), 192–201.
[5] D.P. XIII, Letters to Dyce, July 1841.
[6] *The Christian Remembrancer*, i (1841).
[7] See n. 6.

to describe. This must not surprise us; they were too close to their subject. But they did not fail to appreciate that coeval with the 'literary aim' and the 'persevering industry' is a 'peculiar tenderness about his style, severe as it is; a kind of reserved grace—a modesty which wins its place in the beholders mind, and retains it'.[8]

Comparisons between music and the visual arts abound in William's writings. He saw no hope for any of the arts until a truly Christian society could be re-established and he was prepared to stake modern knowledge against this:

Greater research and a sounder philosophy of art have shown that religious feeling, so far from being accidental to the art of the middle ages, was of its very essence; ... that so far from being a hindrance to the progress of the arts, since they have lost this, they have wandered and cast about like a ship without a rudder, at one time ministering to sensuality, at another seeking to re-animate the poetry of paganism as a substitute for that of Christianity.[9]

The artist of the supremely spiritual Joash and Galahad, not surprisingly, blamed the sensual for all that was at fault in art and music. What the demon of theatrical music is to true Gregorian chant, Rubens is to the purity of the *quattrocentisti*. Purcell is dismissed because his works, with few exceptions, 'smack more of the theatre than the church ... works done with a feeling akin to that which made the contemporary painters dress up their apostles, saints, or angels, in the flowing wigs and satins of the court, or give to their portraits of women of virtue the airs of courtesans.'[10] No wonder Dyce's aggressive influence was missed at Salisbury Cathedral where someone was needed to 'eject Mozart and some *hujus generis* who infest the choir'.[11]

86, 152

The ceremonies of the Roman Church, at the chapel of the Sardinian embassy in London where visiting Italian opera singers used to perform during the service, or in Rome itself, were no more to William's taste than the paucity of the Anglican service. 'There is no recognizable difference', he contemptuously remarked, 'between the music of the church in the morning and that of the theatre in the evening.'[12] Madrigal groups and

[8] F. T. Palgrave, *Essays on Art* (1866) 135–6.
[9] *The Christian Remembrancer*, ii (1841), 284–92.
[10] *The Christian Remembrancer*, i (1841), 104–12.
[11] D.P. XIII, J. R. Hope to Dyce, 26 Nov. 1841.
[12] *The Christian Remembrancer*, i (1841).

societies dedicated to the singing of anthems were fast becoming very popular in London and, later, in the provinces. Although prepared to admit in private to Gladstone that he regarded madrigal singing as 'eminently social and opposed to the theatrical style', and a source of amusement which 'turns to good account a very moderate degree of musical talent',[13] William publicly denounced its bad influence. He was out of sympathy with his environment both artistically and musically and strove energetically, not to adapt his own work to accord with current standards, but to revolutionize his environment. Casting behind him Poussin and the great Venetian colourists, and much music which clearly entranced him (Mozart, he found, 'such a great musician that he makes us forget the outrage he has perpetrated on the moral sense'),[14] Dyce applied himself to reform. He could still, in 1847, create the voluptuous mermaids who wait on Neptune at

146 Osborne if called upon to do so by royalty, but the offensive of 1841 in *The Christian Remembrancer* carried Dyce to victory in 1844 when he established the Motett Society, ensuring his reputation as 'an arranger of Latin music to our English language, and a composer both of simple and of elaborate music of the purest school of ecclesiastical art'.[15] In the same

86 year he painted *Joash* in which we see, for the first time, the absolute and uncompromising insistence on that purity of line, simple effectiveness of composition, and concentration which, in opposition to the current taste for theatricality in John Martin, contrived use of space in Maclise, baroque violence in Landseer, or sensuousness in Etty, form the most memorable and distinctive features of William Dyce's art.

The Motett Society evolved out of the Musical Antiquarian Society, founded in 1840 in order to 'print scarce and valuable musical works, which at present exist only in manuscript in separate and detatched parts, or which, having been long out of print are unattainable by those who may wish to possess them'.[16] With E. F. Rimbault, that industrious antiquarian and musicologist in charge, and William Dyce at his right hand, the Musical Antiquarian Society was launched with works by Byrd, Purcell's 'King Arthur', 'Dido and Aeneas', and music by Orlando Gibbons. The Motett Society was founded four years later in an attempt

[13] D.P. XV, Dyce to W. E. Gladstone, 12 July 1843.

[14] *The Christian Remembrancer*, i (1841).

[15] D.P. XLII, obituary read at the meeting of the Motett Choir in May 1864 after the death of William Dyce.

[16] Prospectus, British Library.

to create the 'conditions ... felt by many to be indispensable to the right performance and appreciation of Sacred Music',[17] conditions of reverence which the founders thought lacking in the "Various Musical Associations" which had something in common with the Motett Society. With the encouragement and patronage of Prince Albert, music societies were becoming very popular among the educated classes. William chose for the Motett Society a name which would most clearly indicate the exclusively religious nature of the music with which it would be concerned; the motet being the form of composition most commonly used by polyphonic composers from the middle of the thirteenth century. Unlike its parent body, the Motett Society laid great emphasis on the performance as well as the publication of music.[18] E. F. Rimbault edited a considerable quantity of music though he acknowledged that Dyce was responsible for adapting the greater part of the motets of Palestrina.[19] In all, 122 large folio pages were published with full score and piano or organ accompaniment, appearing in three parts: Anthems, Services for Festivals, and Miscellaneous Anthems.

Characteristically William's participation in the Motett Society was both on a theoretical and on a practical level. When a collection of music was offered to the British Museum from the estate of L'Abbate Fortunato Santini in 1848, William was officially consulted about the value. L'Abbate Santini was known to William from his visits to Rome, and in 1840 William had urgently requested Hope-Scott, who was about to visit the Holy City, to go to Santini's and collect for him the manuscript of an *Alleluia* sung in St. Peter's on Easter day.[20]

Discovering manuscripts and early sheets of church music engaged much of William's attention and he wrote in excitement to his friend the Revd. Thomas Helmore, fellow Motett member and Master of the Chapel Royal about 'an old treatise on Canto Fermo' containing the 'psalm-tones arranged in the way Fétis has done them' and a 'set of masses by a singer

[17] Ibid.
[18] G. Grove in *A Dictionary of Music and Musicians* (1954), v. 915 and B. Rainbow in *The Choral Revival in the Anglican Church 1839–72* (1970), 65, are in error in suggesting that the Motett Society was simply a publishing venture. The prospectus of the Society and letters from Dyce make it clear that music was performed by members of the society. Q. Bell in *The Schools of Design* (1963), 92, confuses the Motett Society and the plan for an illustrated *Life of Our Lord* which Dyce and Gladstone discussed in 1839.
[19] G. Grove, *Dictionary*, v. 915.
[20] National Library of Scotland, MS. 3669, W. Dyce to J. R. Hope-Scott, 17 Sept. 1840.

of the Papal chapel founded on Palestrina's most celebrated motets'.[20a] As
the years went by and William's time became increasingly taken up with
the practice of painting, it was Helmore who wrote and kept him informed
of progress in the choral revival in the church. He became Godfather to
one of William's children[21] and, when Dyce was buried one snowy day
in February 1864 at St. Leonard's Chruch, Streatham, where he had been
Church Warden for many years, the choir of the Chapel Royal under
the direction of Helmore sang the whole service in plain tune. By 1851,
when the Motett Society amalgamated with the Ecclesiological Society,
Dyce had acquired for the Society a collection of music of sufficient value
for him to wish to safeguard it.[22] William was also a composer of no mean
ability. His 'Non Nobis Domine', composed in 1856 was sung at the Royal
Academy dinner of that year, an innovation which was not repeated, more
probably because of the Academicians' lack of musical sense, than because
of any deficiency in William's skill. The members of John Hullah's choral
classes were guinea pigs for William's compositions[23] and, appropriately,
the Motett choir commemorated its founder soon after his death, in May
1864, with the performance of four of his own compositions.

The year 1844 was a triumphant one for William Dyce. The Motett
Society was attracting the patronage of men of learning and taste like
Gladstone and Acland and, free from the worst trammels of the School
of Design, William emerged into public view as a painter. When the Royal
86 Academy exhibition opened in May, *Joash Shooting the Arrow of Deliverance*
immediately attracted attention. Thackeray wrote in praise of 'Mr. Dyce's
two fierce figures'[24] and *The Art-Union* rejoiced that Dyce had presented
Joash clad 'in the manner of the figures in the Egyptian relics, a
circumstance showing research after authorities for costume; without which
an artist can never accomplish truth'.[25]

William's choice of subject reflects urgency, his sense of aim, and the
artistic energy that had been pent up during his years at the School.
Rejecting the sensuous for the cerebral, though softening what some
reviewers regarded as an intolerable hardness and dryness[26] with warmth

[20a] D.P. XXXIII, W. Dyce to Revd. T. Helmore, 7 Apr. 1853.
[21] D.P. XXIX, Revd. T. Helmore to W. Dyce, 14 Feb. 1852.
[22] D.P. XXIX, W. Dyce to Revd. T. Helmore, Nov. 1851.
[23] D.P. XXIX, J. Hullah to W. Dyce, 7 Nov. 1851.
[24] 'May Gambols', *Fraser's Magazine* (June 1844).
[25] *The Art-Union*, VI (June 1844), 158.
[26] 'The English School', *Manchester Art Treasures Exhibition* catalogue (1857), 93.

of colour, Dyce created a painting of indomitable physical energy and spiritual intensity. The subject, taken from the Book of Kings, concerns the youthful King Joash who visited the aged Prophet Elisha on his death-bed to seek advice as to how Israel might be freed from Syrian domination. The prophet told him to open the eastern window and shoot an arrow in the direction of the enemy as a symbol of the victory he would gain. The figures relate to the canvas in such a way that their full-standing height could not be contained within the area. The result of this arrangement is a powerful sense of suppressed energy.

In *Joash* Dyce rejects the narrative potential of the subject in a way **86** which was to become, paradoxically, typical of his treatment of literary subjects. Despite the narrative implications of the *Joash*—the assumption of knowledge of prior and subsequent events—the picture encloses us in the confined space of that austere and ascetic interior and forces us to sense the vibration of fanatical zeal, to witness the transference of will from the withered Elisha to the athletic Joash. The stress on the mental and spiritual rather than on the sensual and happening elements in Dyce's art accounts, to some extent, for what has been seen as a rigid and static style. But the seeming disregard for the way in which people move in space (which we shall see to be a flaw in some of the Queen's Robing Room frescoes of the fifties) is a source of strength in a small easel painting like *Joash*. The rigid disposition of figures, the empty spaces, and the almost exclusive use of the surface-plane of the painting for the main figures, imply an active dismissal of the narrative implications and concentrate our attention on the mental condition of the protagonists. Building on the experience of *Joash*, Dyce rejected the type of literary scenes selected by Maclise, for example, scenes rich in the variety of human character and personality, colourful, historical subjects with sensuous or romantic overtones. Dyce painted George Herbert, Beatrice, King Lear, Henry VI, people set apart by reason of their special mental or spiritual condition.

Joash is, in one sense, a very physical painting. But the flesh, the tensile limbs, the taut muscles, the bodily energy is used, not with the sensuousness of Rubens or the drama of Michelangelo, but in a Blakeian way. It is strictly controlled and directed towards the expression of spiritual energy and patriotic intrepidity. It is significant that the mouths of the two figures in *Joash* (who are themselves the painting in its entirety) are absolutely concealed behind the strongly muscular arms. In thus depicting Joash, Dyce departed from the fine study on which he based this figure. Mouths are **116**

most expressive of passion, sensuality, and the mystery of personality. Dyce deliberately avoids the possibility that the senses might intervene and modify a cerebral statement about will, made through super-physical energy.

Joash won for William Dyce his Associate Membership of the Royal Academy. Whilst remarking that William was little known as an artist outside London and even there his reputation was 'confined within a limited circle', *The Art-Union* was generous in acknowledging his 'high abilities'. Though he had produced few works, those which the public had been fortunate enough to see were, *The Art-Union* claimed, 'lions'. Dyce was, it recognized, 'one of the few British painters who may be described as learned—one of the few who consider it as much their duty to read and think as to draw and paint'.[27] This was praise indeed from the recently established vehicle of popular British artistic opinion but it was a German collector who bought the painting and it was hung for many years in the Kunsthalle in Hamburg.

86 The muscularity of Dyce's figures and the violence of gesture in *Joash* were, as much as any single feature in the artist's work, the result of his style being labelled 'German'. But William's approach was fundamentally different from that of the Nazarenes. He was concerned with archaeological accuracy as much in his Old Testament paintings as in his essay 'On the Garments of Jewish Priests'. The bracelet, the bow, the dagger, the sandal, and the woven loincloth of Joash are fastidiously observed in William's painting. At the same time, however, we notice that they are not there purely to create authentic atmosphere though this was, inevitably, what the popular press admired. The interplay between areas of marble-smooth walls or human flesh and delicately patterned ornamentation creates a fascinating and repeated visual contrast between austerity and richness. The Nazarenes were little concerned with archaeological accuracy as such, preferring to imitate the illustrated conventions of medieval art. Thackeray, noting that the critics called *Joash* 'French', thought Dyce should be proud of being a Frenchman.[28] Certainly in this, his first painting to receive public approval, William was more indebted to the French than to the Germans. He had not forgotten his friends at the Monastery of St. Isidoro but David, Vernet, and Delaroche could better help him to achieve the ends he desired than the artists of the saintly German community. Almost every French

[27] *The Art-Union* III (1 Dec. 1844), 360.
[28] 'May Gambols', *Fraser's Magazine* (June 1844).

neo-classical painting of note incorporates at least one figure with arms raised dramatically like those of Elisha. William need only have looked inside his trusty and companionable edition of Landon[29] to find, for example, an engraving of David's *Blind Belisarius*. The evocation of a feeling of supreme strength and willed restraint by the careful rendering of smooth walls stone by stone and the simple geometrical arrangement of buttress, ledge, or step is a device which, similarly, William might have learned from David or any of his academic French followers.

Whilst *Joash* was being admired by Thackeray and others at the Royal Academy, William took up his duties as Professor of Fine Art at King's College, London. The newly created chair had been offered to Eastlake in 1833 and in 1836, and refused on both occasions. Reverting to the scientific interests of his early years, William attempted, in his inaugural lecture on 24 May 1844, to find a common approach to art and science. It was not a new experience for him. Like many of his contemporaries, Dyce had engaged in a Casaubon-like search for definitive keys and universally applicable common principles which would open up to Western man a new understanding of the disparate parts of intellectual history. In 1838 William's brother-in-law, the Revd. David Brown, had spoken to him of 'old studies, in which you were perpetually engaged in seeking to discover the connections that subsisted amongst the arts and sciences according to the ancients and the principles, if any there were, common to all of them'.[30]

Commencing with a system of classification which would cover music, art and science, Dyce proceeds to discuss 'the Science of Fine Art' which, he admits, might seem at first to be excluded from the domain of science altogether because it depends on Beauty, Character, Action, Passion, Sentiment, and so on.[31] Dyce says little that had not already been said by Hogarth, Richardson, Reynolds, and other modern English writers, not to mention the classics, and French and German literature on the Fine arts. The essay abounds in sweeping statements unsupported by illustrations and is heavily dependent on theories of the Ideal. 'The artist', says Dyce,

[29] C. P. Landon, *A Collection of Etchings of the Most Celebrated Ancient and Modern Productions in painting, sculpture and architecture of the Italian and French Schools: from originals preserved in the Louvre, Paris. With descriptions from the French of C. P. Landon, etc.* (1821).

[30] D.P.V, Revd. Dr. D. Brown to W. Dyce, 27 July 1838.

[31] W. Dyce, *Theory of the Fine Arts. An Introductory Lecture delivered in the Classical Theatre of King's College London, May 24, 1844* (1844).

'looks at nature only in her completeness, and has for his drift to render her more perfect ...' Scientific man, claims Dyce, pulls nature to pieces and examines elements in her structure not in order to show how beautiful they are, though this he does nevertheless. The artist, 'although he makes no attempt to resolve [Nature] into her elements, yet since his effort to bring nature as a whole into harmonious and exact operation presupposes the existence of her constituent parts, so practically he anticipates discoveries of the science which deals with them in the abstract.'

Dyce seems unable to conceive of an art form which is not immediately related to the physical facts of nature and in our search for common principles we are reduced, finally, to the feeble assertion that 'every imitative art, since it addresses itself to us through the senses, necessarily employs sensible means and materials of imitation which, belonging to some part of the natural world, are included according to their kind in some branch or other of physics.' Should we dismiss this disappointing venture as an over-ambitious endeavour in an insufficiently understood discipline? Dyce was attempting, at King's College, not merely a discussion of aesthetic theory up to date (which would in itself, in 1844, have been a difficult enough task) but a summary and definition of the whole of human cultural history. *The Theory of the Fine Arts* fails to fulfil our legitimate expectations of learning something more of the relationship between William Dyce the theoretician, the speculative philosopher, the polemicist, and William Dyce the artist.

William's academic friends did not hesitate to applaud his pedantic and abstruse verbal excursion of May 1844. John Stuart Blackie, claiming to have planned a book himself on the Theory of the Fine Arts, 'an old hobby' of his, urged William on to alert the dull British ear.

... When about to preach on any such text, the first thing is position. This you have; and you live too in an age as likely to listen to sense on that subject as it was to what I am forced to call ingenious and elegant nonsense in the days of Alison[32] ... I shall be eager to hear that you create works to produce a regular *opus*—to raise a staple architecture of aesthetical sciences before the loose and vague optics of our British auspices.[33]

How far the students of King's College shared Blackie's enthusiasm is

[32] Archibald Alison (1757–1839), *Essays on the Nature and Principles of Taste* (1790), and other works.

[33] D.P. XII, J. S. Blackie to W. Dyce, 20 Mar. 1845.

doubtful. Dyce never lectured again nor, so far as we may ascertain, engaged in any other teaching activities at the College. Perhaps William had, after all, learnt a lesson from his experiences at the School of Design. Apart from an occasional lecture or sally into print, from this time William's main concern was with practising his art. Perhaps he realized that he was not a gifted teacher, that, despite the social gulf between artisan and university student, the same skills in persuasion and tuition were needed with both. Dyce was never fully effective as an aesthetician, a theorist, or a teacher. Nevertheless his intellect, his breadth of learning, his fastidious study of history permeated his artistic and musical work. Born only six years after the close of the eighteenth century, the respect for order, clarity, and discipline which he inherited from that age was strengthened through his scientific, historical, and philosophical studies and became a framework within which his best and most personal expression was achieved. William was not a second John Ruskin. His main gifts did not lie in the verbal expression of things perceived, identified, and described but he is wholly convincing when creating something in which he believes personally and completely, whether it be the *Order of Daily Service* or a painting of the Madonna and Child.

London in the summer of 1844, at least the informed and fashionable section of its population, was agog with excitement over the exhibition of fresco at Westminster Hall. The dramatic conflagration in which the Houses of Parliament had been destroyed in 1834 seemed likely to present an unprecedented opportunity of state patronage for British artists. Sir Charles Barry's magnificent new building was nearing completion. The Royal Commission on the Fine Arts with the Prince Consort as its Chairman and Sir Charles Eastlake as its Secretary, having duly consulted Peter von Cornelius, the renowned German exponent of the recently revived Renaissance technique of fresco, was cautiously, very cautiously, moving towards a decision concerning the decoration of this grand new monument to the British Empire. In May 1843 a cartoon competition had been held and the Commission had sent Charles Heath Wilson, new Director of the School of Design, abroad to write a report on fresco. It was felt that sufficient evidence of ability was to be seen among the competitors of the cartoon competition to justify proceeding, the following year, to an exhibition of fresco specimens. The widespread interest in the enterprise is reflected in the portentous title of *The Book of Art*,[34] published in 1846, which is not,

[34] F. K. Hunt, *The Book of Art* (1846).

as might be expected, a study of the pictorial traditions of Western Europe or an all-embracing study of man's creativity, but an account of the Houses

145 of Parliament fresco competition.

The spirit of sixteenth-century Florence was being re-created in Victorian London. Mrs. Merrifield in her celebrated book on fresco painting, comparing the spirit of optimism and confidence in England in the middle years of the century with the prosperity, splendour, and spirit of inquiry which characterized Renaissance Italy, believed England to possess advantages unknown to the Italians.[35] Artists like C. W. Cope found the invitation to submit cartoons in May 1843 an 'electrical appeal' likely to 'open a new field of employment ... in the direction of a nobler kind of art'.[36] Here, it seemed, was an opportunity for the British to excel at last in the field of historical painting, to establish themselves in the highest category of art. The spirit of excitement was to be sustained for a surprisingly long time and in 1850 we find Mrs. Merrifield writing in *The Art Journal*, awaiting the removal of the scaffolding from the newly painted frescoes 'with as much eagerness as ... when the "Last Judgement" of Michael Angelo was about to be exhibited for the first time to the expectant and admiring crowd'.[37]

William Dyce, at the time of the cartoon competition in May 1843, was fully engaged at the School of Design, planning Trinity College, Glenalmond, and quarrelling with recalcitrant glass manufacturers. Feeling that he had lost his position as a fine artist and 'hopeless of his work attracting the English approbation of the day',[38] William did not take part in the cartoon competition. In July 1842, Haydon, after visiting William's studio, left a poignant, if perhaps not utterly impartial, record of artistic dereliction:

His painting Room, the old Life Academy of the old Academy ... with brushes, colors, plaister, lime, a large Picture unfinished, Letters, Papers, pens, Ink, Drapery, a lay figure with her head the wrong way as if in Despair!—announced lassitude, bad habits & the art given up. He acknowledged it.[39]

By May 1844 William's outlook on life had changed. *Joash* was complete and on exhibition, the Motett Society was flourishing and the problems

[35] Mrs. M. P. Merrifield, *The Art of Fresco* (Brighton, 1846), introduction.
[36] C. W. Cope, *Reminiscences* (1891), 146.
[37] *The Art Journal*, xii (1850), 4.
[38] F. M. Hueffer, *Ford Madox Brown, a Record of His Life and Work* (1896), i. 36.
[39] *The Diary of B. R. Haydon*, ed. W. B. Pope, xxiv, 16 July 1842.

of the School of Design were behind him. Accordingly he sent along to Westminster Hall a fragment of the fresco which he was currently engaged in painting in Lambeth Palace. 'I quite feel', he wrote to Eastlake as Secretary of the Commission, 'that I have not sent enough to establish my claim to employment ... but I hope that my circumstances will be taken into account ... my time for three years at least (virtually for six) has been exclusively given to the public service: and recently I have been at liberty for too short a period to enable me to regain my footing as an artist.'[40]

Despite his diffidence about entering for the fresco competition, it would seem that William had managed, yet again, to place himself at the forefront of a new movement. His discussions with Lord Meadowbank about education at the Trustees' Academy in 1836 had been timely. Now we find William, just as the artists of London are transferring cartoons to fresco, already painting a full-scale fresco. Just as he found himself rapidly thrust into control at the School of Design, he was shortly to find himself with a larger share of responsibility for the new fresco decorations than he would have bargained for had he had any idea of the pain and hardship it was to cause him from now until the time of his death in 1864.

Of William's fresco at Lambeth Palace no trace remains. The subject was the Consecration of Archbishop Parker in 1589, an event of ecclesiological significance since, after a dispute by Romanists about the validity of the ceremony, Matthew Parker set down in writing the order of the service which has been adhered to ever since. The fact that William was able to submit a section of the fresco to the competition suggests that he did not paint directly on to the wall but used some kind of casing for the plaster which was subsequently inserted into the wall. A contemporary woodcut and two drawings give us a fair idea of the composition which is, in a general way, reminiscent of Raphael's *Mass at Bolsena* and *Oath of Leo* in the Vatican. A preparatory sketch presents the chief figures raised above the eye-level of the spectator and set against a vertical pattern of columns and pilasters. This design was rejected in favour of a composition in which all the figures are presented on a single plane against a series of Gothic arches. Another source of influence might have been Eustache Le Sueur's *The Mass of St. Martin, Bishop of Tours*, painted for the Convent of Marmoutiers in 1651 and engraved in Landon.[41]

[margin: 140]
[margin: 141, 142]
[margin: 141]
[margin: 142]
[margin: 143]

[40] D.P. XVIII, W. Dyce to Sir C. Eastlake, 1 July 1844.
[41] C. P. Landon, *A Collection of Etchings* ... (1821). Dyce owned a copy of this work.

140 There is a stark simplicity about the composition as we see it in the woodcut but it is evident from a letter to Eastlake that the completed painting contained many other figures. With characteristic insistence on historical authenticity, William wrote:

The composition is not complete ... it only includes the personages at the altar viz: the Archbishop (kneeling and receiving the gospels), Bishops Barlow, Scovy, Hodskin and Coverdale, and the Archbishop's two chaplains, all of whom I have *habited* according to the minute description of the ceremony given in the registers of Lambeth. If the whole composition were given it would be extended in front and on either side and take in on a lower level four torch bearers, several bishops elect and doctors ... and part of the choir.[42]

William probably already had considerable experience of domestic decorative schemes. His first experiments with fresco in his father's house in Aberdeen in 1829 pre-date those of other British artists and it is alleged that 'at least one of the rooms at Basildon Park, Goring, where James Morrison lived, has a ceiling which almost without question was designed by Dyce'. Morrison, who died in 1857, was an enthusiastic and discerning collector and it is not difficult to believe that 'a number of [his] finest pictures were secured on the advice of the Scottish Pre-Raphaelite'.[43] It is, however, extremely difficult to ascertain what, if any, painting on walls or ceilings Dyce executed at Basildon Park. The drawing-room ceiling has an arabesque design painted on canvas and inserted into the ceiling but this is unlike any other large-scale work by Dyce. The ceiling of the dining-room at Basildon was originally decorated with nine roundels, of which the central three are now in the Basildon Room of the Waldorf Astoria Hotel in New York. These contain subjects painted in a manner not dissimilar from Dyce's treatment of classical subjects (as in *Bacchus and the*

9, 146 *Nymphs of Nysa* or his fresco at Osborne) but until more evidence comes to light it is not possible to be certain whether these panels are the work of Dyce.

The interest that William showed in the medium of fresco painting was well-founded and genuine. Nor was he averse to restoration work. The excitement over fresco painting, as proposed for the decoration of the new Houses of Parliament, drew the attention of connoisseurs to neglected

[42] D.P. XVIII, W. Dyce to Sir C. Eastlake, 1 July 1844.
[43] Anon. review of paintings at the Grosvenor Gallery, *Glasgow Herald*; undated news cutting inscribed 1915, kept in the family of descendants of William Dyce.

examples of painting in this medium, dating from the Middle Ages and later, and still extant on walls of buildings around the country. William accepted the commission to restore Rigaud's painted ceiling at Trinity House representing the junction of Father Thames and Father Severn, though he was happy to hand the task over to the young Holman Hunt when other more interesting and lucrative opportunities arose.[44] Holman Hunt was careful to leave intact the 'trenchant touchings of Dyce'.[45] The respect and awe with which Holman Hunt regarded William are some of the earliest manifestations of a relationship of such importance that we must defer discussion of the subject.

The Prince Consort, Chairman of the Royal Commission on the Fine Arts, wishing personally to encourage fresco painting, in 1844 commissioned four artists to decorate a room in the Buckingham Palace garden pavilion with scenes from Milton's *Comus*. Having recently arrived from Germany, **144** the Prince was an admirer of the Nazarenes and, reputedly, invited Cornelius to come to England and decorate the Houses of Parliament. Cornelius's celebrated reply was, so Ford Madox Brown tells us, 'What need have you of Cornelius to come over and paint your walls when you have got Mr. Dyce?'[46] Undoubtedly Prince Albert saw the Buckingham Palace Pavilion[47] as an English equivalent of the Cassino Massimo in Rome, decorated by the Nazarenes in 1818 with scenes from Tasso. It also, he may have reasoned, provided relevant experience for the greater task of decorating the Houses of Parliament.

William was not originally invited to paint at the Buckingham Palace pavilion but William Etty found the discipline of completing one section of the wall at a time on wet plaster which he could not then re-touch without starting from the beginning again too much for him. 'Fresco! oh that word!' he declared, 'for the future it will be a "word of fear" ... I think neither fear nor favour will induce me to undertake another.'[48] Prince Albert rejected Etty's *Hesperus* and asked William Dyce to paint a substitute without informing him of the true nature of the situation. Speaking in praise of *Hesperus* at the Royal Academy dinner of 4 May

[44] W. M. Rossetti, *Pre-Raphaelite Diaries and Letters* (1900), 278.

[45] W. Holman Hunt, *Pre-Raphaelitism and the Pre-Raphaelite Brotherhood* (1905), i. 229.

[46] F. M. Heuffer, i. 36.

[47] No longer extant. Engravings of the rooms by L. Gruner appear in Mrs. A. Jameson, *The Decorations of the Garden Pavilion at Buckingham Palace* (1846).

[48] W. Etty to Mr. Colls, quoted in A. Gilchrist, *Life of William Etty R.A.* (1855), ii. 168.

1844, the Prince Consort endeavoured to redress the offence but it was William's letter of 8 July to his old friend that extricated him from this invidious position.[49] William's fresco of the final scene of Milton's masque is a very German-looking painting, to judge by Grüner's engraving. The simple grouping, the use of austere architectural detail to emphasize the figures in the foreground plane (in a way reminiscent of *Joash*), the tabloid arrangement of figures in carefully devised medieval costumes (an excusable anachronism), all contribute to make this the most successful of a disparate group of frescoes.

For William, the decoration of the pavilion was in a real sense a trial run for the Houses of Parliament. A fragment of cartoon for the figure of the attendant spirit who kneels at the right has survived and shows William exercising his considerable powers of draftsmanship, powers he was to exploit fully in the frescoes at Westminster. The grouping of the figures 160, 162 anticipates in general *Courtesy* and *Mercy* in the Queen's Robing Room. William also suffered, in the grounds of Buckingham Palace, a foretaste of the sort of interference and the kind of financial problems which were to assail him at the Houses of Parliament. Prince Albert was a man of considerable taste and education and he saw his role in relation to the patronage of the arts as a very active one. The artists at work on the pavilion frescoes received visits from the entire royal family twice a day.[50] What they did not receive was adequate financial compensation. William Bell Scott found Dyce at this time in an almost 'ruinous' position. 'He had been several times out to Windsor, lost many days in town with Sir Charles and other people, had made sundry sketches, had completed a cartoon full size before beginning the picture, and after the painting was finished and placed, the sum he was to receive was only a hundred pounds.'[51]

Joash was sold for only seventy pounds and William was obliged in 1845 to accept Gladstone's loan of £100 to help him out of financial straits. He felt understandably bitter about the Buckingham Palace pavilion decorations and wrote to his brother-in-law:

I daresay you will think Her Majesty very *shabby*: and so she is—the painters are paid by her like the Doctors with thanks and sometimes with honours, but

[49] Ibid.
[50] Sir Theodore Martin, *The Life of H.R.H. The Prince Consort* (1875), i. 167–9.
[51] W. Bell Scott, *Autobiographical Notes of the Life of William Bell Scott*, ed. W. Minto (1892), 208–9.

with very little money ... The commission has been to me a serious pecuniary loss; though I have succeeded in pleasing both the Prince and the Queen.[52]

The Prince was, indeed, pleased with William, so much so that he immediately commissioned from him a painting of the Madonna and hung it in a prominent position in his dressing room at Osborne.[53] A *Madonna* in Nottingham must be a preparatory study for the Prince Consort's picture. Twelve items connected with paintings of the Virgin and Child appeared in the Dyce sale of 1865. Lot 141 was 'Mother and Child. A study in fresco for the picture in the Queen's collection'.[54] It seems unlikely that Dyce would have painted a study in fresco for a picture which he intended to be in oil on canvas. But the roughly executed Nottingham version, painted on board, might have been mistaken by an ignorant person for fresco.

In painting the final version, William raised the skyline, creating an effect which, like the white cloth now covering the Virgin's head, differentiates the picture more clearly from the Tate Gallery *Madonna* and brings it closer to the flatter effect of Nazarene paintings like Overbeck's *Joseph and His Brothers* at the Casa Bartholdy. By 1845 William had considerable experience in composing paintings of the Madonna. Lot 44 in the Dyce sale was a pen drawing of the Madonna, dated 1842 and lot 52 was *The Virgin Praying*, dated 1844. Further oil paintings of the subject existed as well as drawings. In particular, a *Madonna* with an arched top, with similar dimensions to the Osborne *Madonna*, was in the Heugh Collection until 1878.[55] John Brett owned another such painting by Dyce, in which the Virgin was represented beneath a portico, her face seen three-quarter view, holding the child who stands astride her knee.[56] The Madonna in the Osborne painting reminds us of quattrocento profile-portraits and, like Raphael's *Madonna of the Goldfinch*, she holds a Bible in which scraps of writing, looking like the prophecy regarding the Son from Isaiah, are discernible. But the Osborne Madonna is dressed in a heavy, loose-sleeved tunic very different from the clothing of Raphael's Virgin. William made a special study of the qualities of heavy cloth when loosely draped on the female form in a study now in Birmingham City

96

98

93

94, 95
99, 102

96, 100

117

[52] D.P. XII, W. Dyce to R. D. Cay, 6 Feb. 1845.
[53] F. Davis, *Victorian Patrons of the Arts* (1963), 21.
[54] Christie's, 5 May 1865.
[55] Christie's, 11 May 1878 (205).
[56] Christie's, 5 Apr. 1864 (717) with photograph.

Art Gallery. The cloth in this drawing is bunched up in heavy folds below the waist at the back and adds weight and dignity to the subject.

97 William painted *St. Joseph* as a pendant to the Osborne *Madonna* between 1846 and 1847. Also a three-quarter-length figure in semi-profile, St. Joseph wears heavy robes to match those of the Virgin. But the landscape against which he stands is more specific than in the *Madonna* and, with the dilapidated buildings on the right and heavily pruned trees, it anticipates the lowland Scottish scenery which Dyce used in *The Good*

85 *Shepherd* of 1856. The head of Joseph, with the frowning brow and the deep-set eyes with their suggestion of foreboding, is much closer to the type of Christ, burdened with responsibilities as Dyce presented him in *The Good Shepherd*, than to the traditional figure of St. Joseph. The Prince Consort was not at first satisfied with *St. Joseph* but, after unspecified alterations, decided that the head was of great beauty and the whole picture superior to the *Madonna*,[57] a view which we would find it hard to share.

The unusual qualities of the Osborne *Madonna* were grudgingly acknowledged by the press and, in Germany, where William might have expected to find approval for an art which was based on a flat and simple, linear composition and sincere Christian feeling, it was stated:

W. Dyce is of the small number of those who, approaching the Perugino—Raffaelo time, follow the principles of the School of Overbeck. His *Madonna and Infant Christ* ... is of unique appearance; it is graceful but somewhat cold in expression and colour ...[58]

William Dyce was in this, as in other instances, a little ahead of his time. The Osborne *Madonna* was too German and too 'avant garde' to appeal to a wide public and yet, only a few years later, a taste for German art and a revival of interest in late medieval and early Renaissance painting became widespread. People were far more inclined to view the work of *quattrocentisti* or the 'primitive' productions of Nazarene artists with approbation and a serious regard in 1850, than they were in 1845. The influence of the Prince Consort and the realization that Germany led Europe in the fresco revival were instrumental in this change of attitude. Mrs. Merrifield wrote about German art in *The Art Journal*[59] which also published illustrated articles on contemporary German art.[60] In 1848 early

[57] D.P. XXVI, Mr Anson (the Prince Consort's secretary) to W. Dyce, 13 Mar. 1847.
[58] From *Kunstblatt*, quoted in *The Art-Union*, ix (1847), 21.
[59] e.g. xii (1850), 2.
[60] *The Art-Union*, x (1848), 239. *The Art Journal*, xiii (1851), 90–1.

German paintings from the collection of Dr. Campe of Nuremberg were auctioned[61] and the same year a whole room of the Royal Academy was devoted to an exhibition of reputedly early Flemish and Italian paintings, including the Wilton diptych.

When William Dyce exhibited his fragment of *The Consecration of Archbishop Parker* at Westminster Hall in the summer of 1844, it was condemned by the majority. 'Those who knew what Art was held their peace. Babblers pronounced it quaint—it was a copy of some old work—it was papistical—it was German—it was that most abhorrent thing, Christian art. How could a bishop have it in his palace?'[62] In 1851, Lord Ward's collection of largely early paintings was exhibited free at the Egyptian Hall and attracted fifty thousand visitors!

At last, on 1 July 1844, the great day arrived when the results of the fresco competition were announced. B. R. Haydon was in despair at his lack of success as were forty-nine other artists who had devoted precious time and expensive materials to the competition. William Dyce, among the six selected to present full-scale cartoons for the House of Lords, wrote to Sir Charles Eastlake on the 16 July about his subject, *The Baptism of* **147** *King Ethelbert*: 'I easily trace your considerate hand in assigning to me the subject which, had choice been left to myself, I should have selected.'[63]

The sweet taste of success seems fairly quickly to have cloyed. In spring 1845 William was in debt and sick. Struggling to complete the cartoon, fresco specimen, and coloured sketch of *The Baptism of King Ethelbert*, required by the Commission for exhibition in May, he wrote to Eastlake asking for the favour of a week longer than the time stipulated. 'I have been thrown out of my calculations as to time by a most inopportune attack of influenza which made me so feeble I could hardly stand on my ladder,' complained William.[64] In July he was, finally, awarded the commission to paint King Ethelbert in fresco in the central panel above the throne in the House of Lords. Eager to replenish his store of first-hand knowledge of Italian Renaissance and modern German fresco, William left for a tour of Italy in September.

The Commission was prepared to pay William's expenses on this journey but, writing to Eastlake in July, he announced that he would prefer to

[61] *The Art-Union*, x (1848), 342.
[62] F. M. Hueffer, i. 36, quoting Ford Madox Brown.
[63] D.P. XX, W. Dyce to Sir C. Eastlake, 16 July 1844.
[64] D.P. XX, W. Dyce to Sir Charles Eastlake, 23 May 1845.

pay his own way as the Commission would expect a report if he accepted expenses and he preferred to remain 'unfettered by any such condition'.[65] Yet it is hard to imagine where Dyce would have found resources sufficient to finance a journey through Germany and Italy and, as he did in fact write a detailed technical report,[66] we may reasonably assume that he thought better of his assertion of independence and accepted the Commission's money.

Two drawings survive as testimony to the breadth of William's interest in fresco in Italy, as well as the report. In Florence he studied and painted in water-colour Taddeo Gaddi's *Entombment* in the Bardi Chapel of Sta. Croce (Birmingham Museums and Art Gallery). William probably shared the popular nineteenth-century view that this was the work of Giotto with whom the history of Renaissance fresco painting was thought to begin. At Grotta Ferrata, William executed a minutely detailed and beautifully washed drawing of the demoniac (epileptic) boy, a detail of the fresco by Domenichino in the chapel of St. Nilus. William was particularly interested in the use of colour by Pïnturicchio, Ghirlandaio, Domenichino, and other fresco painters. He made diagrams and extensive notes on colour, not all of which were included in his report[67] and must, by the very nature of things, have executed many washed drawings in addition to the two which have survived. William undertook no task that was not executed with the highest degree of thoroughness.

William's fresco in the Lords' Chamber amounted to a test case for the Commission and its completion was eagerly awaited by everyone. The subject is the baptism of the first Christian king, Ethelbert, by St. Augustine in the presence of Queen Bertha and a crowd of spectators in St. Martin's Church, Canterbury. In addition to the fresco, which has survived in a much restored state, we have a cartoon for the spectators on the balcony, a drawing for the same part of the fresco, studies of groups of women and children and drawings for two of the male figures; the monk who stands at the far left-hand side of the balcony and Ethelbert himself. It seems not improbable that one of these two was modelled on the Abbé Santini with whom Dyce was certainly acquainted and whom he may have sketched in Italy in the autumn of 1845. William Gardiner, visiting the country

Margin numbers: 110, 147, 148, 149

[65] D.P. XX, W. Dyce to Sir C. Eastlake, 28 July 1845.

[66] 'Observations on Fresco-painting', printed as Appendix IV to the *Sixth Report of the Commissioners on the Fine Arts*, (1846).

[67] D.P. XXI contains the original notes.

shortly afterwards, wrote in *Sights of Italy* (1847): 'The Abbate, who is a handsome man with a very venerable appearance, has just sat for his picture to an English artist, as a figure to be introduced into one of the frescoes which are to adorn the British House of Parliament.'[68] The Abbé Santini was a distinguished ecclesiastic, composer, and owner of the finest library of old music in Rome. In 1840, William had commissioned Hope-Scott to visit Santini in the Via Vittoria and purchase some manuscript music.[69] C. W. Cope, the only other English artist who might fit Gardiner's description, was interested neither in music nor in the Roman Church.

The tall narrow fresco of *King Ethelbert* is split in two horizontally by a wall across the centre, the two halves being linked by the monk on the steps at the left who gestures upwards towards the spectators with one hand and down towards the baptism with the other. This division was sustained in the frescoes painted on either side by Cope and Horsley and helps, overall, to mitigate the impression of excessive height. The device of a row of spectators looking down upon a scene taking place below owes much to Venetian artists like Giovanni di Mansueti who employed it in his frescoes in the Scuola di San Marco, and Carpaccio who used a similar arrangement in *The English Ambassadors*. The clarity of line and immediacy of vision of these two artists would have appealed strongly to William's taste in historical painting. The relationship of the three foremost figures is almost a direct transcription of Mantegna's fresco, *St. James Baptizing Hermogenes* in the Church of the Eremitani, Padua.[70] William studied Mantegna's technique during his tour of 1845 and Mantegna's *Triumph of Caesar* series at Hampton Court were, naturally, recalled to memory, examined, and discussed during the debate about fresco.

147

William completed *King Ethelbert* with great rapidity in spite of some criticism of his treatment of the subject from Prince Albert and the necessity of painting in the dust and dirt thrown up by carpenters and masons in the half-finished Lords' Chamber.[71] In conversation with the Prince, William 'gathered ... that he had taken up a notion that the king ought to be *in the font*'. William doubted this and having researched the subject, sent Sir Charles Eastlake 'an official note containing such explanations

[68] I am indebted to Dr. Kathleen Wells for drawing my attention to this passage.

[69] See p. 34.

[70] Now destroyed but reproduced in F. Knapp, *Andrea Mantegna: der Meisters Gemälde und Kupferstiche* (Stuttgart, 1910) pl.2.

[71] See C. W. Cope, pp. 172–3.

and authorities' as might be necessary to justify his treatment. 'Not', remarked William, 'that I consider extreme accuracy of any moment, so that [i.e. as long as] the representation is intelligible, but that it is good to prevent cavilling.'[72]

In retrospect, Richard Redgrave thought *Ethelbert*, unveiled in solitary glory in 1846, a poor recompense for four years of inquiry and exhibition, and the expenditure of quantities of time, energy, and optimism by numbers of artists.[73] At the time, however, it was hailed as a considerable national and personal achievement. 'Let us speak seriously on a triumph so glorious', wrote David Octavius Hill to his friend, 'most fervently I wish you all joy and honour ... with long life, health, strength, a brilliant fancy and sound mind to execute all and ten times more than your sovereign and your country expect from you.'[74] Hill was a humorous man and there is, undoubtedly, a touch of conscious irony mingled with his genuine pleasure in his friend's success. There is also, sadly, to us reading his letter after the passage of years, the unintended irony that comes from our knowledge that William's 'long life' was to be cut short, his strength drained and his 'brilliant fancy' dulled by his efforts to fulfil the expectations of his sovereign and country.

The journals were delighted with *King Ethelbert. The Art-Union* gave its blessing in September 1846 and *The Athenaeum*, which was subsequently to take up a very critical attitude to the whole fresco scheme, contrasted William's work very favourably with the insipidity of the Nazarenes.[75] It continued to be admired as the empty spaces on either side were filled. Ford Madox Brown thought it the 'most refined and beautiful of all the frescoes there'[76] and Dr. Waagen, having formed 'the highest expectations of this painter from a picture of the Virgin and Child ... seen some years since in Berlin' was 'the more delighted to find them thus fulfilled'.[77]

[72] D.P. XX, W. Dyce to Sir C. Eastlake, 23 May 1845.

[73] R. and S. Redgrave, *A Century of Painters of the English School* (1866), 462.

[74] D.P. XXIII, D. O. Hill to W. Dyce, 19 Oct. 1846.

[75] *The Athenaeum*, (5 July 1845), 664.

[76] F. M. Hueffer, i. 36.

[77] Dr. G. Waagen, *Treasures of Art in Great Britain* (1854), 427. The author confuses the subject of Ethelbert with *Religion*, the first of the Queen's Robing Room frescoes.

6

THE PATRONAGE OF A PRINCE
1847–1849

Prince Albert, unscathed by the discontent and ill-feeling which his patron-
age of English artists at the Buckingham Palace pavilion had engendered,
or perhaps ignorant of it, approached William Dyce in 1846 with a view to
commissioning a fresco for the staircase at Osborne House. Once again,
Sir Charles Eastlake acted as mediator. The way in which the Prince
tapped, in personal enterprises, the nascent skills of fresco painters at a time
when, it was felt by many, all their energies were needed for the mammoth
task of decorating the Palace of Westminster, seems to accord ill with his
responsibilities as Chairman of the Royal Commission. However, Prince
Albert was firmly convinced of the duty of the royal family to set an
example to other people of means and education, and lead the nation to a
revival of fresco painting in private and public buildings which would sur-
pass that of Germany and other European nations.

Eastlake agreed with William's choice of a subject from Boccaccio but,
as William had 'some misgivings with respect to the associations of a *moral*
kind which the subject might suggest', Prince Albert's secretary was given a
list of possible subjects. The royal couple chose 'Neptune Resigning his
Empire of the Seas to Britannia' as most appropriate for 'a kind of dedica-
tion picture of the building'.[1] The subject was, however, much less suited to
William's particular talent for clarity of line and for relating varied, but
somehow self-contained and static forms in space, than a tale from
Boccaccio would have been. The Neptune fresco was painted at Osborne
between 3 August and 7 October 1847.[2] William turned, almost inevitably,

[1] D.P. XXII, W. Dyce to Sir C. Eastlake, 31 Aug. 1846.
[2] Inscribed in the corner of the fresco.

to Raphael's *Galatea* in the Farnesina in Rome and to the fleshly, allegorical
9 paintings of Poussin that had inspired *Bacchus and the Nymphs of Nysa* of 1826.
Regressing to his earliest exercises in historical painting, William modelled
the dark-haired, reaching naiad in the foreground of *Neptune* on the nymph
in *Bacchus* who stretches her arm to have her cup filled by the leaping satyr.
8 A heavily corrected drawing for this figure testifies to the difficulties experi-
enced by the artist in treating again a genre of subject which he had
abandoned.

The chief problem of *Neptune* is that the crisp, decisive line which is a
source of strength when allied to simplified forms and used to convey the
determined and unambiguous actions of figures like Joash, Jacob, or
Galahad, when applied to the anatomical contortions of tritons and mer-
maids or to unbelievably voluminous folds of drapery, whipped by a strong
north wind, creates a harsh, uncompromising series of forms which fail to
cohere as a whole. At least two of the figures (for one of which a cartoon
fragment survives) are superimposed by female faces so blatantly Victorian
in style with their wide foreheads, straight noses, 'prunes and prisms'
mouths, and hair neatly looped in door-knockers over the ears, that they
might have walked out of any Victorian drawing-room to find themselves
astonished but undismayed, amid the scantily-clad company on the beach
at Osborne.

Dress, or rather the absence of it, was a controversial question. The sketch
for *Neptune*, presented by William to the Queen and the Prince Consort at
Osborne during negotiations over the commission, was 'most graciously
received'. William related to his friend Cope that the 'Prince thought it
rather nude; the Queen, however, said not at all'. William stayed for lunch
and was requested to begin work as soon as possible.[3] The nudities were to
scandalize the nursery-maids and French governesses at Osborne[4] but
Sarah Spencer, Lady Lyttelton, called to the staircase on 29 July by Prince
Albert to observe William at work on what was 'interesting the Prince most
deeply and everybody a little', remarked merely that fresco painting was 'a
curious process, and so intricate' that she wondered 'it was invented so long
ago'.[5] Lady Lyttelton was even less impressed by the artist himself, with
whom the Prince Consort left her to pass the time of day. William sur-
prised the lady by saying, 'Pray, do you know the result of the Oxford

[3] C. W. Cope, *Reminiscences* (1891), 167–8.
[4] Ibid., 172–3.
[5] *The Correspondence of Sarah Spencer, Lady Littelton*, ed. Hon. Mrs. Hugh Wyndham (1912), 368.

election yet?' She answered in the negative and then asked if William was interested for either candidate. 'Yes—for Mr. Gladstone', replied William, 'he is my personal friend.' 'I should as soon have expected to find a friend in a file', confided Lady Lyttelton to her correspondent, 'but I felt a sort of fellowship with the file directly.'

Prince Albert watched, hawk-like, over William as he laboriously covered the area of plaster, section by section, with waves and elegant human forms, during the long summer weeks of 1847. In November, after William had returned to London, the scaffolding was removed. The Prince was moderately pleased and desired the royal secretary to tell Mr. Dyce that the colours were 'much softened and blended' since His Royal Highness had last seen the painting. Flattering William with the opinion that *Neptune* was unequalled in the country as a 'beautiful work of Art', the letter winds up with a criticism of the child floating in the lower left-hand corner and a request that William 'be disposed to look at that again'.[6] It would seem to our eyes that the painting of the child, who lies on the surface of the water as on a candlewick counterpane, is the least of the faults in *Neptune*.

Life at Osborne was not all work. William was initially lodged in a cottage on the royal estate and, later, at East Cowes. Diversions were not lacking for one enjoying 'rural felicity in thatched cottages' and William's letters to his friend Cope, who—busy on his scaffolding in the Lords' Chamber—was to be pitied, are punctuated with innuendoes about local belles and references to amusements. He found time to execute pastel drawings of the four royal children; only the study of the Prince of Wales, to whom *Nursery Rhymes, Tales and Jingles* had been dedicated in 1842, has survived. In late July or early August, before the court migrated northwards (an event which William recorded in a letter to Cope of 13 August),[7] William painted a water-colour of Osborne House itself. The flag tower, **51** completed in 1846, bears the royal standard which shows the Queen to be in residence. The lower tower, which was not completed until 1848, does not appear.

William was further developing the water-colour technique with which he had experimented in the early thirties. *Osborne House* displays the same broadly washed skies and fluid treatment of foliage as *The Rhône at Avignon* **50** but William is now bolder in his use of colour and contrasting tones. A *Study*

[6] D.P. XXVI, C. B. Phipps to W. Dyce, 18 Nov. 1847.
[7] C. W. Cope, 172–3.

of Rocks and Fearns, Isle of Wight was lot 119 in the Dyce sale[8] and John Pender, the well-known Victorian collector owned a small water-colour of Puckaster Cove, the Isle of Wight which, when sold in 1873, fetched £105,[9] a price which suggests that William might have made a living out of landscape painting had he been inclined to do so. These works are now missing, but two water-colours of Culver Cliff survive. There is no evidence in the extensive biographical material relating to William's life that he ever again spent a summer in the Isle of Wight, or even that he returned to correct the fresco as requested by Prince Albert. The supposition that all the Isle of Wight landscapes were painted in the summer of 1847 is reinforced by stylistic evidence.

Both views of Culver Cliff are taken from practically the same position, from which the cliff can be seen across the sands on the other side of the wide bay. Here the resemblance ceases. One water-colour is relatively large and shows the beach and the promenade alive with activity: children, fishermen, bathing machines, and a group of well-dressed people, one of whom looks out to sea through a telescope. Lobster pots, dinghies, and drift wood are scattered at random over the beach and the artist observes all this from the vantage point of a raised walk. The ant-like figures, dispersed casually and appearing a little vulnerable in the great expanse of the bay, anticipate the mood of *Pegwell Bay*. But the figures, though engaged in those desultory, sea-side activities which Constable and Delacroix recorded at Brighton,[10] which charmed Queen Victoria in Frith's painting,[11] and which never fail to delight the English eye, are so far distant in Dyce's painting of Culver Cliff as to be tantalizing. William was, it would seem, grappling with a new problem, that of incorporating figures into a landscape without destroying the naturalness of the scene.

Culver Cliff, in William's other version of the subject, is observed from a low viewpoint in a water-colour which emphasizes, not the flat expanse of sand, but the stony slope of the beach, and the transition from fine sand to seaweed and mussel beds, and then to deep, clear water. The paint is applied in quick, dry strokes, reminiscent of the handling of *Glenlair*. Humanity also features in this composition but, in this case, the figures are

48, 49

49

52

48

46

[8] Christie's, 5 May 1865.

[9] Christie's, 27–30 Jan. 1873. The water-colour was 24.7 × 34.2.

[10] J. Constable, *The Marine Parade and Chain Pier, Brighton* (1827). Tate Gallery. E. Delacroix, *Brighton, Worthing in the Distance* (1825). Louvre.

[11] W. P. Frith. *Life at the Seaside.* R.A. 1854. Purchased by Queen Victoria.

not just dotted haphazardly around the beach as they may have appeared to William one summer day in 1847 but are grouped in order to enhance the general arrangement. The two men repairing a boat in the foreground create the sort of cruciform, focal mass that William achieved with the pile of brushwood in *Glenlair*. The white-clad figure in the middle distance, and the two figures by the boat, accentuate the recession and contrast with the startling whiteness of Culver Cliff.

A study of water-lilies and other plants, painted in water-colour (perhaps in the garden Prince Albert was creating at Osborne) probably dates from the mid-forties. It lacks the attention to geological detail and the harsher colour which characterize William's Arran water-colours of 1859. The same **57, 58** accurate but not obsessive recording of detail and strong washes of colour suggest a date in the forties for a pleasing landscape-study depicting a country lane, bordered by a fence and huge elm trees painted in subtle shades of grey and green. The location of this study, and of an unfinished oil study of a gate flanked by elms (in a private Scottish collection), is clearly the landscape of England rather than William's native land of stone walls and blasted thorns.

Had William found life monotonous on the Isle of Wight, two events on the mainland in the summer of 1847 would have provided a diversion. In July the 'Gothic' crown was minted. It bore a profile bust of the Queen, **130** in what was probably thought of as medieval costume, and archaic lettering. The coin was the outcome of a happy relationship between Dyce and William Wyon, the medallist. Dyce had already assisted Wyon in 1842 with the depiction of St. George for the new gold sovereign which was not minted until 1851.[12] On obtaining four of the newly-minted crowns in July 1847, William's old friend, Sir Charles Cockerell, declared that they had absolutely turned his head with admiration. 'I can only say', he wrote, 'that if William Dyce did not design it I will eat one.'[13] William's reply makes clear the extent of his responsibilities for the coin. 'It is a joint concern', William declared, 'but the *idea* of the coin is mine and some important parts e.g. the Queen's *head gear* and dress and the arrangement of the shields on the reverse are almost copied from my drawings ... So far as I am concerned it is an old story, for I lighted yesterday on one of the drawings with the date 1842.' The coin was evidently a hangover from William's period at the School of Design, and yet it is interesting to note that the

[12] D.P. IX, W. Wyon to W. Dyce, 11 Nov. 1842.
[13] D.P. XXVI, Sir Charles Cockerell to W. Dyce, undated.

162 head-gear and dress of the Queen, referred to in this letter, anticipate the
habiliments of Guinevere and her ladies which William was to paint in the
Queen's Robing Room at Westminster Palace in the fifties. An interesting
parallel might also be drawn between the profile head of the Queen and the
96 profile presentation of the Madonna in the Osborne and Nottingham
98 paintings of 1845. William was modest, almost diffident, about his
achievement and his letter concludes: 'I have only been the bellows-blower
... you must give him [Wyon] the credit of the performance.'[14]

The second event which disrupted the rustic tranquillity and regal calm
of life for William in the summer of 1847 was an event of a very different
order and must have caused a number of red faces. James Burns, founder
of the publishing house of Burns and Oates, son of a Professor of Theology
at Glasgow University, was one of William's close friends and a relative
through his mother's family. He was a member of the committee of the
118 Motett Society and was responsible for publishing *The Order of Daily Service*
122 as well as *Nursery Rhymes, Tales and Jingles* in 1842 and *Poems and Pictures* in
123 1846, to which William contributed illustrations. Burns had been among the
most enthusiastic advocates of early choral music and, in November 1842,
had discussed with William his plans to visit Rome and study 'the right
mode of performance' of Palestrina and acquire information with a view to
establishing a Choral Institution in London.[15] On 13 September 1847,
C. W. Cope wrote to William Dyce on the Isle of Wight:

I have heard two or three times that 'a publisher and an Academician' had gone
over to Rome. I have been asked by one or two 'were you gone?' I said I knew
you were gone as far as Osborne but I did not think further.[16]

James Burns was the publisher who had seceded to the Roman Catholic
Church; the artist was, of course, not William—who, despite his flirtation
with Rome and his friendship with Wiseman, remained a staunch member
of the Anglican body—but John Prescott Knight. Nevertheless, the reputa-
tion, which William had carefully defended against accusations of Popery
through all his activities in painting religious subjects and re-establishing
church music, was now threatened. William returned to London in order to
set matters straight. Burns was an influential member of the Motett Society
which had always insisted on its exclusively Anglo-Catholic affiliation. To

[14] D.P. XXVI, W. Dyce to Sir Charles Cockerell, 16 July 1847.
[15] D.P. XVI, J. Burns to W. Dyce, 27 Nov. 1842. Mistranscribed by Stirling Dyce as 1848.
[16] D.P. XXVI, C. W. Cope to W. Dyce, 13 Sept. 1847.

William's credit, his chief anxiety seems to have been, not his own reputation but that of the Society he had brought into being three years earlier. Closely associated with the Society was St. Mark's College, Chelsea, founded in 1841, where the accomplished and trained choir performed the works which the Society published. The choral revival was blamed by many for the continuing rise of Popery and St. Mark's College became the scene of demonstration and protest as the number of secessions to Rome increased in the forties.

Therefore, arriving back in London, William's first task was to write to Thomas Helmore, fellow committee member of the Motett Society and Musical Director at St. Marks, about the reputation of the Motett Society. Helmore replied on 16 September:

> . . . As it seems desirable that any misconceptions which may possibly arise, respecting the objects and tendencies of the society, from the late withdrawal of one of its most active members, should be removed as early as possible—and as the filling up of vacancies in the committee by persons of well accredited fidelity to the Church of England will be the surest mode of effecting this object, I am unwilling to lose time in again communicating with you on the subject.[17]

Helmore said he could not bring himself to believe, as some of William's friends in Scotland had done, that after all the two men had said to each other in private, William could have given any ground for the 'very general and I believe . . . malicious reports which have been circulated.' Helmore expressed himself very glad to have 'the opportunity . . . of contradicting them on the highest authority'. A committee meeting was duly called and a circular, headed by the names of the committee but bearing no allusion to James Burns, was sent out to all members. In time the storm blew over and William was able to return to his painting.

One of the pleasures of life at Osborne must have been the conversation of Prince Albert on intellectual and artistic matters. When he was not advising artists how to paint their frescoes, the Prince was, undoubtedly, charming company for a man of William's taste and temperament. It was in conversation with the Prince Consort at Osborne that the idea of a cycle of frescoes based on Malory's *Morte d'Arthur* as an English equivalent to the German *Niebelungenlied* was first mooted.[18] The ancient and recurrent English myth, emerging in the far distant past from a most glorious period

[17] D.P. XXVI, T. Helmore to W. Dyce, 16 Sept. 1847.
[18] J. Dafforne, *The Art Journal*, n.s. vi (1860), 296.

of English history, was more than a mere literary equivalent, it epitomized English cultural creativity and the potency of English rule.

Prince Albert was deeply immersed in his own national traditions and arts when he arrived in this country in 1840 and he believed that it was his appointed duty to foster here a similar nationalistic movement. Watching the crowds which thronged the cartoon exhibition in Westminster Hall in July 1843, Prince Albert saw at work an influence which would 'elevate the character and habits of the people'.[19] Fresco painting was a nationalistic movement, designed to unify a people in an age of radically changing social and industrial conditions, through the re-creation of a past which was part mythical and part technical. Cave Thomas, who worked in fresco in the Houses of Parliament, admired the German artists because 'they identified their art-revival with a newly awakened yearning aspiration towards a more important extended united national existence.'[20] If Germany could achieve this, why not Great Britain?

The visionary kingdom of King Arthur had, throughout history, existed in the national imagination as a majestic golden age and the belief that Arthur could, and possibly would, reappear to herald a new era of English greatness, was more than mere fancy.[21] Malory was an appropriate source for the fresco painter; the *Morte d'Arthur* might be interpreted by a sensitive and scholarly artist and lead to a high point of literary painting. In this matter William was, for once, in tune with his age. 'The more I studied the subject the more I became convinced that Arthur was a real person,' he declared to Eastlake in 1848.[22] The new Houses of Parliament, as they neared completion, were viewed with intense emotion. The carriage entrances were compared to 'those lofty aisles at Cologne, upon which the eye gazes with loving wonder, awe struck by their graceful majesty and strength'.[23] It was in this great cathedral to historicism, the palace that was to house the governmental machine of a thrusting empire, and to the background of this climate of opinion that William Dyce received, in July 1847, the commission to decorate the Queen's Robing Room with frescoes of

[19] Sir Theodore Martin, *The Life of H.R.H. the Prince Consort* (1875), i. 166–7.

[20] Cave W. Thomas, *Mural or Monumental Decoration* (n.d., *c.* 1870 ?), 15–16.

[21] The general background to Arthurianism can be read in G. Ashe, *The Quest for Arthur's Britain* (1968). The literary revival of the Arthurian legend in England in the nineteenth century is efficiently dealt with in K. Tillotson, 'Tennyson's Serial Poem', in G. and K. Tillotson, *Mid-Victorian Studies* (1965).

[22] D.P. XXVII, W. Dyce to Sir C. Eastlake, 20 July 1848.

[23] *The Art-Union*, ix (1 July 1847), editorial, 233.

Malory's *Morte d'Arthur*. Much of the next two years were spent preparing designs for the seven compartments and it was not until 1849 that negotiations were complete and William started work.

Meanwhile, work was continuing in the first stage of the great fresco scheme, the decoration of the Lords' Chamber. All manner of difficulties and problems were coming to light, problems which were to plague William in his long struggle to complete the Queen's Robing Room in the years to come. A lack of foresight meant that the deep recession of the wall spaces, the side-lighting, and the stained glass in the windows rendered the paintings almost invisible. The wall spaces which were later allotted to some artists in other parts of the building were so inaccessible that the artists had to paint on detachable frames which were later fixed to the walls. One happy but unforeseen result was the effect of gaslight which, Cope told William, made the frescoes look 'very brilliant and much improved'[24] though the same gaslight must have been partly to blame for the appallingly dirty state into which the pictures very quickly deteriorated.

It was hard for men of this age of progress in science and industry to accept that a technique mastered by monks in fifteenth-century Italy required all their ingenuity, skill, and inventiveness. The technical problems which William and his fellow artists faced in their attempts to revive this 'lost' technique were manifold. William, with his early experience of fresco, was better equipped than most and showed an admirable readiness to experiment, proposing bizarre variations like the use of large slates fixed to a framework of wood or metal as a basis for fresco,[25] and experimenting with compounds of starch and sugar in his search for an 'insoluble compound for use with all colours'.[26] Meanwhile the Museum of Economic Geology saw the fresco painters' need for chemist's expertise as an opportunity to rid themselves of an unwanted member of their staff. Desiring to dissuade Lyon Playfair from taking up a post in America, yet acknowledging that the Museum could not support two chemists, Sir Henry de la Beche announced to Dr. Buckland on 12 October 1842 that he had a plan for Richard Phillips, the chemist currently employed at the museum, which would provide 'efficiently' for him to do 'real service to the country. I mean', says de la Beche, 'in connection with the Fine Arts Committee,

[24] C. W. Cope, 169–70.
[25] D.P. XX, W. Dyce to Sir C. Eastlake, 22 Aug. 1842.
[26] D.P. XXXIII, Correspondence with John Barlow of the Chemical College, Nov. 1853 and C. W. Cope, 200–1.

their stuccoes, etc.; so that the frescoes (in the Houses of Parliament), if there should be any, may be permanent, and the colours not fly off in half a dozen years.'[27] But Richard Phillips was 'an obstinate little fellow', it seems, and the fresco painters had to manage without the benefit of his knowledge.[28]

Other problems arose from the nature of the fabric itself and from the shortage of skilled labour, problems which no degree of artistic ingenuity could solve. Plasterers, whose job it was to prepare the ground vital to the successful application of paint, were few and far between. William, in a magnanimous mood, told Eastlake in 1846 that the plasterer who worked with him on the frescoe, *King Ethelbert* would acquire such experience 'as to enable him to remove all practical difficulties out of the way of the artists who are to fill the other compartments'.[29] But by the following year, when Maclise needed a plasterer, William had taken his man off to Osborne with him.[30]

The Royal Commission's obtuseness over the question of money was evident from the start when they refused to advance funds to artists to cover their removal to larger studios and the expenses incurred studying the fresco technique. If the price was only payable on completion of the fresco, and the artists were unable to command the necessary funds to proceed, they were scarcely in a position to accept a commission which was going to take up so much time and use up so many resources, as William pointed out to East-lake.[31] Neither the commissioners nor anyone else seems to have anticipated the demoralization and the disastrous psychological effects on the artists of a monotonous existence, working day after day on the scaffolding without the support and assistance of the studio which Italian artists had enjoyed.

An inquiry was the sole object really entrusted to the Commission but its members proceeded to attempt to carry out the plans they recommended. Sir Martin Archer Shee, in evidence to the Select Committee in 1841, had advised against holding competitions on the grounds that the best artists would not compete for fear of being ousted by some nonentity. The competitions did cause problems but the real trouble began after the few

[27] W. Reid, *Memoirs and Correspondence of Lyon Playfair* (1899), 79.

[28] National Museum of Wales, Geology Dept. MS. de la Beche collection (unnumbered), T. W. Philipps to de la Beche, 3 Nov. 1842. I am indebted to John Thackray for drawing my attention to this episode.

[29] D.P. XXII, W. Dyce to Sir C. Eastlake, 18 June 1846.

[30] D.P. XXVI, W. Dyce to Sir C. Eastlake, 15 July 1847.

[31] D.P. XX, W. Dyce to Eastlake, 24 July 1844.

selected artists had started work. The members of the Commission sur-
rounded the artists with bureaucratic regulations and overwhelmed them
with, on the one hand, zealous enthusiasm, and on the other, carping
criticism. In the early months when some encouragement from the Com-
mission might have been welcome, it was necessary for William to write to
Eastlake that, whilst realizing how precious the Secretary's time was, he
would 'esteem it a great favour and feel it like an encouragement' if East-
lake could find time to come and see what he was about at the House of
Lords.[32] Eastlake as a fellow artist and a man of great taste and experi-
ence might have been of practical assistance. The Prince Consort, on the
other hand, could not keep away and became a considerable nuisance.

'So you begin work in the Peer's House on Monday', William wrote to
Cope from Osborne in August 1847. 'Much success to you,' he went on.
'Only, when you are about to paint a sky seventeen feet long by some four
or five broad, I don't advise you to have a Prince looking in upon you every
ten minutes or so ... or when you are going to trace an outline, to obtain
the assistance of the said Prince and an Archduke Constantine to hold up
your tracing to the walls, as I have had.' Such assistance was, as William
remarked somewhat bitterly, 'very polite, condescending, and so forth and
very amusing to Princes and Dukes, but rather embarrassing to the artist.'[33]
Unfortunately it was quite beyond the power of any artist to refuse such
favours and the visit of Lord Morpeth which Cope recorded having
received, whilst on the job in October of the same year, cannot have been an
isolated incident. Like Bedlam and the Foundling Hospital a century
before, the scaffolds of the Lords' Chamber were becoming a major fashion-
able attraction.

The considerable caution employed by William in all his dealings with
the Commission testifies to the stringency of their demands. Financial
controversies apart, there was a lengthy dispute about the ownership of the
cartoons[34] and, at every point, William was prudent enough to cover himself
against accusations of negligence. In April 1846, intending to start work on
King Ethelbert, William warned Eastlake of the dangers of mildew and decay
and was careful to point out that, retaining a copy of the letter, he would
have the power to refer to it 'as a reason against any conclusion which may
be drawn from my work unfavourable to the practice and future encourage-

[32] Victoria and Albert Museum, MS. 86 M. 3, W. Dyce to Sir C. Eastlake, 29 June 1846.
[33] C. W. Cope, 172, quoting W. Dyce to C. W. Cope, 13 Aug. 1847.
[34] D.P. XXII, correspondence between W. Dyce and Sir C. Eastlake.

ment of fresco painting'.[35] Shortly after, he wrote again, this time about cracks in the plaster which, William felt, the Commissioners should know about in case they appeared on the picture.[36] But a single fresco of *King Ethelbert* was relatively straightforward. The painting of an entire room in the Commons was a different matter altogether and the two things William was powerless to insure himself against were his own human fraility and the passage of time.

William's first task was the preparation of a series of detailed water-colour drawings, one for each of the seven compartments of the Queen's Robing Room, which he was expected to submit for the approval of the Commission. His background research and consideration of the most appropriate interpretation of the legend occupied William many months. Possessing high standards of archaeological accuracy himself, and knowing that his work would be scrutinized by the Prince (whose predilection for medieval pageantry was well known), William was painstaking in discovering details of costume and armour and in seeking out a print representing a 'chalice which professed to be the original St. Grail or a rival one ... which is now in Spain'.[37] Pondering questions of great complexity, many of which were answered by Jesse L. Weston some fifty years after his death,[38] William consulted the very limited published material available on the period at that time; works like Edward Davies's *Mythology and Rites of the British Druids* (1809) and *Celtic Researches on the Origin, Traditions and Language of the Ancient Britons* (1804).

The first scheme which William evolved during August 1848, was not confined to 'a bald representation of Arthur and his knights', but treated Arthur as one of the 'Nine Worthies' (from Caxton's *Preface* to Malory) and as 'representative and chief of the highest order of chivalry'. As the pictorial expression of this idea would involve 'the assembled presence of the most renowned Heroes of previous and subsequent times, the whole work would represent the Court of Chivalry presided over by Arthur and exhibit its three orders or aspects, the Christian, the Jewish, and the Pagan'. William was reluctant, writing to Eastlake, to describe how these personages might be arranged but thought that Arthur might be enthroned in the centre with Charlemagne and Godfrey of Bouillon on either side and around

[35] D.P. XXII, W. Dyce to Sir C. Eastlake, 27 Apr. 1846.
[36] D.P. XXII, W. Dyce to Sir C. Eastlake, 4 June 1846.
[37] D.P. XXVI, W. Dyce to unknown recipient, probably Eastlake, n.d.
[38] Jesse L. Weston, *From Ritual to Romance* (1920).

them the knights Paladin, Ecclesiastical poets and heroines of Christian Chivalry, while the two extremes of the picture might be occupied by the representatives of Jewish and Pagan chivalry.[39]

The Prince Consort favoured a central compartment in which Arthur would appear as 'mythological type of the whole'.[40] The central compartment did, in the end, contain a general scene of Arthur with his court around him, *Hospitality: Sir Tristram admitted to the Fellowship of the Round Table*, but this is the only similarity between the final result and William's original intentions which—as described to Eastlake—evoke a cross between an ecclesiastical reredos with a hierarchy of saintly figures, and an assemblage of celebrated personages along the lines of James Barry's paintings in the Royal Society of Arts.

163

William also discussed with Eastlake what he would have to include if he adopted a historical plan. 'The story of Arthur', he wrote to Eastlake, 'though quite full of material for pictorial description and effect, is not only much too large to be adequately rendered ... but the chief part of it turns on incidents which, if they are not undesirable for representation under any circumstances, are at least scarcely appropriate in such an apartment.'[41] Guinevere's infidelity which Tennyson, using the literary medium in the *Idylls of the King* (begun in 1855 and dedicated to Prince Albert, 'scarce other than my King's ideal knight'), was able to transpose subtly to a purely ethical plane, and which the Pre-Raphaelite Brotherhood cherished for its erotic implications, presented William with insuperable problems in decorating the Queen's Robing Room. J. C. Dunlop's view, that many of the Arthurian romances were 'in their moral tendencies ... highly reprehensible',[42] was a view that would have been shared by the majority of William's audience.

Although Malory's *Morte d'Arthur* appealed because of its nationalistic flavour, it was on other aspects of the cycle that William's attention soon focused. It was, finally, as a Christian allegory that William justified his choice. To William, *The Morte d'Arthur* was a sort of '*Pilgrim's Progress* of the Middle Ages', or 'a tolerably intelligible religious allegory, strongly tinctured with the monastic ideas of the 13th. century and seemingly, to some

[39] D.P. XXVII, W. Dyce to Sir C. Eastlake, 15 Aug. 1848.
[40] D.P. XXVII, Sir C. Eastlake to W. Dyce, 22 July 1848.
[41] D.P. XXVII, W. Dyce to Sir C. Eastlake, 15 Aug. 1848.
[42] J. C. Dunlop, *The History of Fiction* (1814), 40. This was an extremely popular work which went into many editions during the nineteenth century.

extent, intended to throw discredit on chivalric greatness.'[43] As a compromise between the historical (or narrative) approach and the Christian allegory, William offered to the Commission a series of moral virtues, each of which would be illustrated by a scene from Malory. These scenes were not always easy to find, as William's choice of virtue was, not surprisingly, dictated by the demands of his own religion and the moral climate of the society in which he lived, rather than by an unprejudiced understanding of his text. Justice, Faith, and Temperance, which he had originally intended painting, had to be abandoned[44] and the room now contains: Religion, Courtesy, Mercy, Generosity, and Hospitality. The latter was unfinished and Courage and Fidelity had not been started when William died in 1864.

It would, however, be unfair to suggest that William was insensitive to Malory whose work had lain, let us not forget, almost totally neglected for centuries. William was breaking new ground yet again and his treatment of Malory is appropriate in historical terms. The personification of moral virtues is fundamental to the literature of the late Middle Ages, to Chaucer, Spenser, and Malory. William himself realized that he was amply justified in an allegorical interpretation of the text. 'This allegorical view of the Romance, if it is worth anything will commend itself', he wrote, 'but I may mention here that it is favoured by hints scattered here and there throughout the work. Merlin, for example, interprets the round table to signify the world, and Arthur and his knights are the great ones of the Earth ...'[45]

William declined the invitation to paint the chancel of St. Paul's Church, Brighton in 1848 (one of several magnificent High Anglican churches to be built in that town in the middle years of the century) and eventually the reredos for the altar was painted by Burne-Jones in 1861 (on loan to Brighton Art Gallery). But his commitment to the Queen's Robing Room frescoes did not necessitate the total abandonment of other activities. Indeed, the exhibition of *Omnia Vanitas* at the Royal Academy that summer **67** won William his full membership of the Academy. As in *St. Catherine*, he **63** seems to have been attempting in this picture to achieve a degree of sophistication which would appeal to a cosmopolitan connoisseur. Inscribed on the frame which is contemporary with the painting are the words 'A Magdalen'. In mid-Victorian England prostitutes were known as mag-

[43] D.P. XXVII, W. Dyce to Sir C. Eastlake, 20 July 1848.
[44] D.P. XXVII, W. Dyce to Sir C. Eastlake, 20 Mar. 1849.
[45] D.P. XXVII, W. Dyce to Sir C. Eastlake, 20 July 1848.

dalens and there is evidence in this figure with long, shining hair, her dishevelled linen revealing a finely rounded shoulder, that Dyce was as much concerned with the image of the contemporary fallen woman (that was to fascinate the Pre-Raphaelites) as with the penitent Mary. If this piece of quasi-erotic biblical allegory, so remote from the precision and directness we have come to expect from Dyce, was created in a bid for recognition from the establishment, then William must have been well satisfied.

In a lecture on ornament delivered to the School of Design in 1848, William voiced the sort of concern that was to occupy Henry Cole, Matthew Digby Wyatt, and Owen Jones in the years ahead, a questioning of the function of ornament and the relationship between natural objects and ornamental forms. For one who had had little to do with the schools since 1844, Dyce was very much abreast of developments. Adhering to his oft-stated view of design as a dignified profession equal to, though different from, that of the fine artist, and reverting to his interest in essential connections between arts and the physical sciences, William unhesitatingly declared:

Ornamental design is in fact a kind of practical science, which like other kinds investigates the phenomena of nature for the purpose of applying natural principles and results to some new end, and indeed if we take an enlarged view of the operations of practical science we shall find that ornamental art is an ingredient necessary to the completeness of the results of mechanical skill.[46]

Exercising his skills within another area of recurrent interest to him, William produced some time in 1848 two fine drawings of the Madonna and Child. One, a three-quarter-length study with profile to the left, shows the Madonna leaning over the child who is seated on a cushion on a raised pedestal before a landscape with buildings. It is signed with a monogram and dated 1848. The other (possibly lot 47 in the Dyce sale,[47] 'The Virgin and Child with Joseph, a beautiful drawing') depicts the Holy Family with the infant St. John and, although undated, is executed in a similar, very linear style with hard pencil lines, white hatching, and crisp folds of drapery. Assuming that the second drawing was executed about the same time as the dated *Madonna*, both these works postdate the surviving oil paintings of the same subject. Taken together they show a marked change in approach to the subject of the Madonna, of which a new 'relief' style of drawing with

94

104

[46] D.P. XXV, transcript, printed in *Journal of Design and Manufacture*, i (Mar.–Aug. 1849).
[47] Christie's, 5 May 1865.

sharp lines and dramatically highlighted areas is a symptom. The change can be summed up in the word 'movement'. There is a lightness, quickness, and elegance introduced into all parts of the drawing. See, for example in the dated drawing, the graceful gesture of the Virgin's right hand, the tumbled curls of the child and the sweep of the Virgin's robe from the waist. In the composition as a whole, Dyce is much bolder now and instead of treating mother and child as a single unit, he separates them, makes the Virgin bend gently over the child and the child reach eagerly up to explore with infantile curiosity the mother's face. This is not the turgid elegance of *Omnia Vanitas* but a new pictorial vitality. The gravity and dignity of the 1845 Osborne *Madonna* have been replaced by a warmth, a stress on the mother–child relationship, rather than on the cult status of the pair.

104
96 *The Holy Family with the Infant St. John* constitutes a further step away from the upright three-quarter-length *Madonna*. Here William has introduced a new format with a horizontal emphasis in which a crowned Virgin literally sprawls on a stone bench while the two children clamber on her and Joseph leans from behind on to the seat. The delicate features of the Virgin, her pose with knees spread, layers of decoratively rumpled drapery, and the rolling, climbing children, suggest some influence from the school of Raphael.

105 The immediate source for the general lines of the composition, the classical details of furniture, the leg of the Madonna and the position of the Christ child, and of St. Joseph, is an engraving after Raphael's *Holy Family* (painted for François I and now in the Louvre) in William's edition of Landon.[48] In the crudely engraved rendering of the subject, the linear qualities are greatly exaggerated. From this mediocre work, William produced his drawing in 'relief' style, so full of life and vigour. In the process of the transition from Raphael to Dyce, a curiously aggressive quality has emerged in the figure of Joseph with his curling hair and beard, fiercely lined face, and angular wrist. He approximates to the popular view of the 'German' type as caricatured in *Punch* at the time. This is not, in any sense, to imply that the figure detracts from the composition.

William seldom signed or dated paintings and this poses problems when trying to fit his works into some sort of chronology. An oil panel, possibly a preparatory study for an altar-piece, depicting Christ's entry into Jerusalem, composed in the manner of a frieze with Christ on the donkey in the centre and figures before and behind, may have been executed at

[48] C. P. Landon, *A Collection of Etchings* . . . (1821).

about the same time as the two drawings we have just discussed. The figures are stumpy and rather crude, with strongly-caricatured facial expressions, but the decorative style of the draperies (reminiscent of the style of an engraving or relief carving of North European origin), like that of the two drawings, differs markedly from the clean-cut, heavy smoothness of the Osborne *Madonna* and *St. Joseph*.

96, 97

7

'THE LEADER OF THE FRESCANTI'
1849–1852

It is difficult to understand why the Royal Commission in the summer of 1849 should have rejected William's preliminary water-colour design for the central compartment of the Queen's Robing Room whilst accepting the other four.[1] We know that Prince Albert wished to have a general representation of Arthur and his knights as the principal subject.[2] What more appropriate than *Piety: The Departure of the Knights of the Round Table on the Quest for the Holy Grail*? Arthur and Guinevere, surrounded by courtiers, bid farewell to Sir Launcelot and his fellow knights. William does not endeavour, in any of the subjects, to provide a substitute for, or an equivalent to, the literary description. Unlike the Victorian literary painter, William never presents a pictorial alternative, something which attempts to explain everything, rendering the literary source superfluous. Rather, the painting and the source of its subject become interdependent as William draws the spectator into the episode he has chosen to paint, involving him in a situation but forcing him to refer back to the literary source for a fuller appreciation of the implications of a situation.

Thus, looking at *Piety*, we ask ourselves all kinds of questions. What is the relationship of Launcelot to the Queen, before whom he kneels? Why is the king so old and grey? How do the King and Queen, the central figures, relate one to another? What is this quest and why is the departure of the knights the central episode? The mystery and complexity of the original story are not sacrificed to satisfy the voracious Victorian appetite for explicit

[1] If William executed the designs for 'Courage' and 'Fidelity', the two compartments which were never painted, they have not survived with the rest.

[2] D.P. XXVII, Sir C. Eastlake to W. Dyce, 29 July 1848.

narrative detail. William's design possesses dignity, historical appeal and, most difficult to achieve in the pictorial medium, allusion to the unknown. *Piety* might be contrasted with, say, William Maw Egley's *Lady of Shallott*[3] in which the artist endeavours by a virtuoso display of detail to explain every aspect of the story on which the painting is based.

From a thematic point of view, *Piety* was a much better choice of subject than *Hospitality* which replaced it. The quest for the Holy Grail was the prime cause of the dissolution of the round table and the consequent disintegration of Arthur's ideal government. Thus the departure of the knights was crucial to the whole cycle. The episode also carries all the emotive pictorial appeal of partings and reunions, scenes dear to Charlotte Yonge, Dickens, and Thackeray and to many a Victorian artist. *Hospitality: The Admission of Sir Tristram to the Fellowship of the Round Table* was a meeting scene but it lacks the combination of bravado and pathos which distinguish William's original choice of subject. Who can read Malory's description of the knights' departure and remain unmoved by the solemnity of diction, the sense of forboding? 'And they put on their helmys and departed and recommaunded them all hole unto the kynge and quene. And there was wepyng and grete sorrow.'[4]

The Morte d'Arthur comprises a complex fabric of partings and reunions, threads being severed and joined again. Therefore to represent a parting as the central scene would have been more true to the spirit of Malory. The admission of Sir Tristram, although it provides an opportunity for the representation of Arthur's court assembled, is simply not central to the idea of Arthur's reign. Significantly, Tennyson, whose own episodic and halting (though ultimately superb) treatment of the story reflects Malory's method, presented the departure as a scene of fundamental importance to the whole concept.

In terms of composition, *Piety* would have been more successful than *Hospitality*. The disposition of figures is mainly along a single, central plane, leaving the immediate foreground vacant and the background to shadowy architecture but there is a great deal of movement among the figures, revolving around a central pool. The to-and-fro sway of the knights, the too deliberate *contraposto*, create some feeling of languidness but the ripple of moving figures creates a certain tension, a feeling of imminent adventure.

It has been pointed out that the composition of *Piety* owes much 'almost

163

150

[3] Painted in the fifties. Mappin Art Gallery, Sheffield.
[4] *The Works of Sir Thomas Malory*, ed. E. Vinaver (1954), xiii.

certainly unconsciously' to Schnorr's work and, in particular to *The Battle of Lipadusa* and the Niebelungen frescoes in Munich.[5] Certainly William must have been familiar with Schnorr's work and, besides the relationship to which Andrews draws attention, there is a pencil drawing by Dyce of knights fighting which testifies to his knowledge of works like Schnorr's *The Army of the Emperor Charlemagne in Paris*, painted in fresco in the Cassino Massimo. But William claimed that he deliberately avoided the Nazarenes when studying fresco. 'I have not been to Munich', he told Eastlake, 'and . . . the only modern frescoes (worth naming) which I have seen are those in the Villa Torlonia, the Casa Bartholdy and those . . . in the Cathedral of Cologne. I kept on purpose', William went on, 'out of the way of the more powerful works at Munich that I might not be diverted from the path which I had chalked out for myself, and which is not that of the Germans.'[6]

Although the composition of *Piety* may owe much to the work of Schnorr, William's style is not as hard and linear as that of the German artist and is, in fact, in many ways very English. The supple-limbed, lounging knights recall the 'medieval' book illustrations of eighteenth-century artists like William Westall or William Hamilton and contrast noticeably with the taut **86, 76** energy of *Joash* of 1844 or *Jacob and Rachel* of 1850.

William must have experienced deep disappointment at the rejection of his design. Shortly afterwards he showed the whole series to Daniel Maclise who was also employed painting fresco at the Houses of Parliament. The young Irishman was full of admiration:

> I can never express to you how much I admire the series you showed me yesterday. You have in these your first thoughts dealt nobly with the theme, and brought to bear upon the subject all stately and elevating associations.
>
> I regret that you should not have the opportunity afforded you of painting the design of what appears to be knights leaving in which there is such splendid business and the fine combination of a hero and his horse.
>
> Although I heard you describing to me the subject of the first design . . . I did not hear for my eye was so interested, that I had no other sense at my command.[7]

The autumn of 1849 and the early part of the following year William

[5] K. Andrews, *The Nazarenes* (Oxford, 1964), pl. 38a with notes.

[6] D.P. XXII, W. Dyce to Sir Charles Eastlake, 23 Mar. 1846. D. and F. Irwin suggest a number of Renaissance sources for Dyce's compositions in the Queen's Robing Room, *Scottish Painters at Home and Abroad* (1975), 254–60.

[7] D.P. XXVII, D. Maclise to W. Dyce, 1 Aug. 1849.

spent preparing his first cartoons for the Queen's Robing Room. In many ways they are more impressive than the completed frescoes not only because the latter have deteriorated and been heavily restored but because something of the grandeur of Dyce's design, the precisely assessed co-ordination of parts is lost in the transference from the monochrome cartoon to the polychrome fresco. The cartoon is essentially a drawn work whilst the fresco, of all media, demands a fluid and painterly handling. It was as a draftsman that Dyce excelled and much of the vitality of his drawing is lost in the fresco.

An aversion to many of the brighter tones used by Renaissance fresco painters was expressed in the 'Observations' which William wrote whilst touring Italy in 1845. Remarks like: 'ultramarine always shows itself by its unpleasant and crude vividness, wherever it has been employed of a tint darker than the blue of the sky', are not uncommon in his report.[8] Such remarks are symptomatic of an artist who operates more through the use of line than through tonal variation. William's cartoons display an admirable certainty of handling, a positive confidence of gesture and movement which is unequalled in the work of his contemporaries. The members of Arthur's court, who remain, despite the artist's rejection of an historical interpretation in favour of an allegorical one, actors in a drama, stand and move in a space which is clearly defined and yet uncluttered by the minor figures and the archaeological paraphernalia upon which Victorian historical painters depended.

William portrays Galahad, Guinevere, Tristram, and Arthur in his cartoons with the crispness and certainty of the German school but without any of the melodramatic muscular distortions, the contrivance of pose, or the lack of sinuous flow that we associate with artists like Strähuber or Retzsch. The details of armour, drapery, and hair are meticulously depicted with sharpness and clarity but they are dispersed over the whole area of the cartoon with great sensitivity, on the one hand, to the monumental strength and solidity of the figures themselves, and on the other, to the sensuous appeal of the decorative surface of the design and the interaction of one richly detailed area with another.

The treatment of drapery provides the widest opportunity for the application of this kind of detail so that it is with no surprise that we look back to William's observations on fresco and find him analysing the techniques of the Italian artists:

[8] Printed as Appendix IV to the *Sixth Report of the Commissioners on the Fine Arts* (1846).

155

In the works of many of the older masters, the draperies are of a uniform tint (the local colour) on which the receding and undercut parts of the folds are made out by darkening, after which the high lights are put on, but in such a way as to give the notion that the whole drapery is seen by a reflected light. The high lights being only on the edges of folds, as is the case with velvet; in this way the light is supposed to be at the side, and rather behind the object illuminated.[9]

Compared to Maclise's cartoon for *The Meeting of Wellington and Blücher*,[10] Dyce's cartoons for the Queen's Robing Room frescoes excel in conciseness of design and in the balance between the vigorous and the static, the monumental and the decorative. It was surely not on the basis of 'truth to nature' alone that the Pre-Raphaelites turned to William Dyce as their mentor in years to come. Young Millais and Holman Hunt must have found in the Robing Room cartoons a model for the dramatic manipulation of carefully planned, emphatic forms.

From 1850 until his death in 1864, aged fifty-eight, William was intermittently at work in the Queen's Robing Room. Already in 1853, he was complaining of nervous exhaustion as a result of fresco painting.[11] About the same time he wrote to Henry Cole excusing himself from advising on a new building to house the National Gallery for reasons of weariness. 'I did begin to scribble a little,' he told Cole, 'but as I can only apply myself to writing at night, I find myself too tired after the day's work in town to make much progress, and I have therefore given up the attempt.' William sadly describes a routine which must have left precious little time for the wife and children for whom he was by this time responsible, let alone for writing reports on the National Gallery. 'I leave home in the morning at 9 and get back at 6 and by the time dinner and tea are over an hour and a half or two hours are all that remain.'[12]

William had been given six years in which to complete seven frescoes and undoubtedly he was himself largely to blame for underestimating the time it would take him and for not realizing the tedium and exhaustion of such a commitment. When the time ran out in 1855 he was granted another year but it was soon clear that this would not be sufficient and the pressure of public opinion which had been building up and William's own sense of

[9] 'Observations on Fresco—painting'.
[10] 1858–9, Royal Academy.
[11] Denham Album, MS. Beinecke Rare Book and Manuscript Library, Yale University. W. Dyce to John Denham, 20 June 1853.
[12] D.P. XXX, W. Dyce to H. Cole, 9 Mar. 1853.

personal failure and depression became intolerable. We may surmise, with the evidence of the low state of his spirits in 1853 before us, that by 1855, William had resorted to the use of the stimulants which, his son tells us, he found necessary to 'support his sinking energies'.[13]

However, all this belongs to the years ahead and we must return to William in 1850, painting the first fresco in the Queen's Robing Room. Only let us bear in mind, as we apply ourselves to an examination which will inevitably take us again into the sad and gloomy future, that William contrived, despite all, to enjoy in the fifties what must have been among the happiest and most creative periods of his life, and that many of his most successful easel paintings belong to these years.

Religion: the Vision of Sir Galahad and his Company was completed in good **152** time by 1851. The fresco, depicting the mystical experience of the Holy Grail is in many ways the most problematic and the most successful of the series. It is problematic because William seems to have conflated two separate episodes from the *Morte d'Arthur* in order to depict a scene which would have the greatest possible Christian significance as well as immediate reference to the story of Arthur's knights. Malory describes in one episode of 'The Quest for the Holy Grail' the miracle of Sir Galahad, the culmination of, and reward for, all his efforts.[14] His chastity ensures this reward is his right: 'For thou art a clene virgyne above all knyghtes, as the floure of the lyly in whom virginitie is signified', says the blind king Mordrayn to Galahad. After performing various miracles by reason of his purity, Galahad, with Sir Bors and Sir Percival, arrives at the Castle of King Pelles and the knights hear a voice which tells them that any man who ought not to sit at the table of Christ must depart. Various people leave and there remain the three knights, King Pelles, and his son Eleazer 'which were Holy men', and King Pelles's niece. This, then, is the setting for *Religion* in which we can identify Galahad in the left foreground with two holy men (King Pelles and his son?) behind and, on the right, Sir Percival, Sir Bors, and King Pelles's niece. However, confusingly, Malory tells us next that armed knights and four women enter bearing the 'maymed king'. Then an old man dressed as a bishop (actually Joseph of Arimathea) and four angels join the company, dismiss King Pelles, and proceed to perform various miracles with the grail cup. The knights sit at the table and see 'a man com oute of the holy vessell that had all the sygnes of the Passion of Jesu Cryste

[13] D.P. XVII. Laudanum and other opium-based drugs were commonly used for this purpose.
[14] Book xvii, ch. 20.

bledynge all opynly'. Christ then promises that the knights will know his secrets and receive 'the hyghe order and mete whych ye have so much desired'. Then he approaches Galahad with the vessel and the knight 'kneled adowne and resseyved hys saveoure'.

152 The finished fresco shows Christ high up on a throne (not mentioned in Malory) and without traces of wounds or blood. Certainly Sir Galahad is about to kneel but Christ shows no indication of descending to administer the sacrament and the grail cup is being held by a bare-headed figure dressed as a monk, not a bishop. It is worth noting, however, that in a preparatory drawing, this same figure is wearing what resembles a bishop's **156** chasuble and the grail cup is placed on the altar. The vision of Christ, distinguished from worldly reality by clouds (nebulous in the cartoon and unconvincing in the fresco), is strangely removed in this drawing from the grail cup. Further non-alignment with the text occurs because there are not as many characters present as Malory describes and the knights are not seated around a table. This latter omission is serious as it was clearly Malory's intention to allude to the Last Supper. Most puzzling is the introduction by Dyce of the four evangelists and their emblems in the visionary section above, supported by clouds.

Before we accuse William of distorting his source in the interests of High Anglican doctrine let us turn to an earlier passage in which Malory describes Sir Galahad, Sir Percival, Sir Bors, and Sir Percivalle's sister in a 'waste foreyst' where they see a white hart leading four lions. They follow the animals to a hermitage 'where a good man dwelled'. They enter a chapel where the hermit is to be seen in 'religious wede' singing mass. Sir Galahad and company listen and:

... at the secrets of the masse they saw the herte becom a man which mervayled them and sette hym upon the awter in ryche sege, and saw the four lyons were chaunged on to the forme of a man, and another to the forme of a lyon and thirde to an egle, and the fourth was changed to an oxe.[15]

The regally dressed lady in the foreground of *Religion* must be Sir Percivalle's sister, and the figure in monastic dress corresponds to Malory's good man in 'religious wede'.

The fact that this second passage describes a visionary experience which is only preparatory to the vision of the grail did not prevent Dyce extracting from it elements (the 'ryche sege' or throne raised on the altar and the four

[15] Book xvii, ch. 9.

evangelists) calculated to render the whole design of the fresco more hier-
archical and more overtly religious. The result certainly retains the spirit of
the original and is, undoubtedly, considerably more lucid than a literal
transposition of the culminating grail vision as described by Malory would
have been. Further evidence of the artist's preoccupation with sacramental
ritual in a medieval setting is to be found in a very symmetrical, undated **157**
drawing of the Trinity which, in theme and composition, has much in
common with *Religion*. The total pictorial concept of *Religion* approximated
to a Florentine altar-piece (the style of the throne accentuating this) in
which Sir Galahad and company occupy the position of donors. The fresco
is charged with dramatic force but, in sacrificing the proximity of Christ
to the knights as described by Malory, Dyce lost an equally important
element. The intimacy of the occasion is what is remarkable in the textual
version, Christ descending, becoming real, approaching humanity. Even a
middle-of-the-road Anglican like Tennyson ignored this quality and
described Galahad's vision vicariously in a terrifying futuristic landscape.
It is scarcely surprising then that Dyce rejected the essential normality in
Malory's description.

The pen and ink drawing, which was executed in addition to the water- **156**
colour drawing submitted to the Royal Commission and the cartoon of
Religion, incorporates the artist's earliest ideas for the subject. Comparing
this with the finished fresco it is evident that Dyce endeavoured to integrate
the separate parts of the design more successfully by introducing into the
fresco a more emphatic diagonal stress; adjusting the forward movement **152**
of Sir Galahad and the stance of the other two knights, reorganizing the
foreground with diagonally placed slabs, and replacing the solitary helmet
in the foreground of the drawing with a diagonally placed shield and
hatchet. The modification of the paving stones, the greater depth of step
up to the altar, and the substitution of a recessed for a flat altar front, all
help to create a greater sense of depth in the finished design. To this end,
the tall acolyte who appears in the drawing is removed and the boy with
the censer is placed behind the monkish figure holding the cup. The sense
of depth is also enhanced (as is the feeling of separation between the
grandeur of Christ and the mortal astonishment of the knights) by the intro-
duction into the fresco of a strong horizontal line of wall and by the greater
variation of light, including the painting of a great, white aureole of light
behind the throne.

The over-all composition of *Religion* derives from Raphael's *Disputà* either

directly, or possibly through the intermediary influence of Overbeck's
154 *Triumph of Religion in the Arts*, the drawing for which was Prince Albert's
Christmas gift to the Queen in 1847. There are also echoes of the Raphael
cartoons as, for example, in the figure of Galahad so strongly reminiscent of
153 the semi-crouching figures in the foreground of *The Sacrifice at Lystra* and
The Death of Ananias. The Raphael cartoons would have been accessible to
William at Hampton Court. When in Italy, in 1845, he visited a recently
discovered fresco attributed to Raphael who, it seems, embodied his idea of
perfection: 'something between Ghirlandaio and Pinturicchio—possessing
the solidity of the former and the transparency of the latter'.[16]

Tennyson avoided placing his *Idylls* at a particular period in time but
William was obliged to consider the question of historical detail. Malory was
writing in the 1450s but the period flavour of all William's frescoes belongs
to the twelfth or thirteenth centuries whilst the general style is Roman or
Florentine from *circa* 1500. If Arthur existed at all it was in the fifth or
sixth century. William seems to have come to a compromise between
archaeological accuracy, fidelity to his literary source, and his own cultural
156 predilections. The pen and ink drawing contains an altar decorated with
Celtic inspired motifs, but this was replaced in the fresco by a series of
Romanesque arches filled with *Cosmati* work. This was certainly more in
accord with the developing taste for polychromatic architecture and
encaustic tiles, for which Butterfield was largely responsible. The star motif
and the peculiar scroll which William introduced into the altar-front in
152 *Religion* he could have seen very close at hand on the tomb of Henry III in
Westminster Abbey.

William's commission for the Robing Room frescoes ensured him an
annual salary of £800 for six years. With the promise of relative financial
security, William lost no time in planning matrimony, and Maclise was
able to write to him in December 1849 to congratulate the 'leader of the
Frescanti' both on his fresco and on his forthcoming marriage.[17] In his
personal life William was not an expansive or demonstrative man but he
was, undoubtedly, a very sensitive one. He delighted in ritual in his personal
life as much as he did in his religious practice and in his public life. It was
through ritual and formal tradition that William achieved an intensity of
personal expression. Discussing with Jane Bickerton Brand, his nineteen-
year-old Scottish fiancée, the proposed date of their marriage, the forty-

16 'Observations on Fresco—painting'.
17 D.P. XXVIII, D. Maclise to W. Dyce, 5 Dec. 1849.

four-year-old artist had very special reasons for pleading a particular date:

But why not the beginning of January? Say the 7th, which is an old country festival of pleasing associations—it used to be called *Plough Monday*, because on that day the country people began the agricultural year, and brought out their ploughs and other instruments of husbandry, repaired them, decked them with evergreens, carried them in procession and ended by a feast and a dance. Pray tell Mrs. Brand this—and say that I would rather the anniversary of your christening were celebrated by your receiving the sacrament for the first time.[18]

William celebrated his liberation from the shackles of his directorship of the School of Design in 1844 by painting *Joash*. The external expression of **86** his joy and optimism at the time of his marriage is *Jacob and Rachel*, the first version of which was painted in 1850. Having deferred marriage for so many years, William chose a subject which constitutes the archetype of the Long Engagement scene so popular in art and literature of the period.[19] The version of *Jacob and Rachel*, exhibited at the Royal Academy in 1850, is now known only from a reproduction.[20] This may have been the painting which was sold at Christie's in 1893 as the measurements given for that work do not correspond with those of any other known version.[21] In painting the version of *Jacob and Rachel* now in the Kunsthalle in Hamburg, exhibited by **79** William at the Royal Academy in 1853, William preferred an unbearded Jacob and, whilst reducing the over-all size of the canvas (from 70.4×91.1 to 58.4×57.0), changed the figures from three-quarter to full-length. Perhaps William was trying to bring *Jacob and Rachel* more in line with his small-scale paintings of the fifties, works like *Gethsemane* and *The Flight into Egypt*. **92, 84** As Staley has pointed out, the overtly biblical landscape of the 1850 picture has been suppressed in the later painting in favour of something more general.[22]

Two more versions of *Jacob and Rachel* are extant, both with three-quarter- **76** length figures and varying only in slight detail from the 1850 painting. A drawing in Aberdeen Art Gallery has full-length figures like the Hamburg painting but in detail it corresponds more closely to the other two extant,

[18] D.P. XXVIII, W. Dyce to Miss J. Brand, Dec. ?1849.

[19] This point is made by Mr. Peter Cunningham in his unpublished thesis, 'William Dyce and the High Church movement' (University of East Anglia, 1973).

[20] *The Art Journal*, vi, (1860), 295, engraved by Butterworth and Heath.

[21] Christie's, 29 Apr. 1893 (112).

[22] *Romantic Art in Britain, Paintings and Drawings 1760–1860* (Detroit Institute of Arts and Philadelphia Museum of Art, 1968), no. 190.

three-quarter-length versions of the subject. Jacob has a wine-flask or water-bottle hanging from his belt and there are palm trees in the background. Staley makes the plausible suggestion that the drawing was made when Dyce was painting the two three-quarter-length versions as an experiment to see how the composition would look in whole-length but that when he came to paint a full-length version, he had made so many changes and had altered the composition so that he thought of it as an independent picture and exhibited it at the Academy as such.

Jacob and Rachel was received with great enthusiasm and William could have sold each version several times over. In 1850 he commissioned Holman Hunt, who had just failed to sell his *Early Britons Sheltering a Christian Mission-ary from the Druids*, to make a copy of *Jacob and Rachel*.[23] The following year Hunt began work on the *Hireling Shepherd* in which, observing the shepherd's eager forward movement and his left arm caressing the girl's neck, and the sheep in the background, we may detect the influence of Dyce.

The Prince Consort, Gladstone, and Colnaghi were all prospective purchasers of the full-length 1853 *Jacob and Rachel*[24] and their competitive application caused William some embarrassment. His sense of obligation to Gladstone as a friend led William to propose that he should paint a replica since it was outside his power to sell him the original. William clearly did not regard the subject as one which he could not further improve. Having developed his theme since 1850 from three-quarter into full-length, he pro-posed to expand the composition still more:

My own idea is that the picture would be rendered more complete by the introduction of other figures; and if you would not restrict me as to time, I think I could produce for you a work, which with all the merit (whatever it may be) of Mr. Lindsay's picture would possess greater interest as a composition and be in fact an original work. In either case the price would be the same, namely two hundred guineas.[25]

If Gladstone succeeded in acquiring a replica, no evidence of his success remains. However, William's letter is of considerable interest as, had he painted the version he describes, it would have been closer to interpretations of the subject by other artists from which Dyce drew inspiration in a general way for his paintings of 1850 and 1853.

[23] W. Holman Hunt, *Pre-Raphaelitism and the Pre-Raphaelite Brotherhood* (1905), 206–7.
[24] D.P. XXXIII, Sir C. Eastlake to W. Dyce, 29 Apr. 1853.
[25] D.P. XXXIII, W. Dyce to W. E. Gladstone, 6 Aug. 1853.

The story of the meeting of Jacob with Rachel, for whose hand he was to labour fourteen years in all, has been perennially popular with artists. Palma Vecchio's dramatic rendering[26] was most influential among the old **74** masters since Raphael's *Meeting of Jacob and Rachel* in the Vatican Logge has much less vitality. Scenes from the life of Jacob were especially favoured by nineteenth-century German painters. Andrews has drawn attention to the similarities between Führich's *Jacob and Rachel* of 1836 and **75** that of Dyce. The figure of Rachel with its 'S' curve is particularly close though the relative positions of the two figures are reversed in William's **76** painting. There is a very important difference, however, between the two interpretations. William has concentrated on the two main figures and discarded the chorus of surrounding persons and thus is able to achieve a degree of dramatic intensity, enhanced by vivid colour, which would have been lost had he introduced other figures. William's rendering of the subject is particularly powerful in the half-length versions where little attention is paid to the pastoral background and the expression of emotional intensity is concentrated through the faces of the couple and through their physical gestures. The lyricism of Führich, who depends heavily on Palma Vecchio, is lost, but in its place is a violent emotional impact, an intensity of personal feeling encapsulated in the lungeing movement of Jacob which reiterates the equally expressive movement of Sir Galahad in *Religion*. The violence of **152** Jacob's movement and the consequent feeling of asymmetry in the painting as a whole, so alien to Führich's *Jacob and Rachel*, is close to Schnorr's pencil and wash drawing of Jacob and Rachel (1820, Frankfurt, Staedel) and to a *Meeting of Jacob and Rachel* by Strähuber. Engravings after this German **80** artist's series on the life of Jacob were published in *The Art Journal* in 1851.[27]

Two water-colour studies which relate, at least in subject matter, to *Jacob and Rachel* are *Ruth and Boas*, a delicate pastoral, executed in a soft and flow- **78** ing manner, and a water-colour of an unidentified young woman in Old **77** Testament costume. The latter has the same firm chin, straight nose, and well-spaced, dark eyes as Rachel and even her hair-style is similar. The colours are strong, like those of *Jacob and Rachel* and the detailed treatment of the dress of the girl and the masonry before which she stands also suggest a date in the early fifties. There is no doubt as to the date of *The Entombment*, a **65** drawing of a subject which William interpreted several times during his life, as the date 1850 is inscribed on the bottom right-hand corner of the

[26] Dresden Gallery, 1525.
[27] *The Art Journal*, xiii (1851), 90–1.

sarcophagus. Unlike the drawing in the British Museum, this version shows Christ raised from the ground and laid out upon the tomb. It is executed with admirable economy of style, in ink with simple sharpness of line and bold hatching. The scene takes place in rocky landscape with no suggestion of oriental vegetation. In this and in style, the drawing resembles the pre-paratory study for *Jacob and Rachel*.

On the death of Sir Martin Archer Shee in 1850, William was asked to stand for the Presidency of the Royal Academy but declined, sensibly enough since, as was well known, Eastlake was the choice of Prince Albert and the Queen. It is surprising that William's name was proposed at all. His critical view of the Royal Academy was well known.[28] Moreover, the Council of the School of Design, with which William had disagreed on important issues on so many occasions, was largely controlled by members of the Academy. Eastlake, it was said, dreaded William's tongue at meetings of the members of the Academy and William's suggestion that an art class for retired Academicians be established must have been regarded as very radical.[29]

William was a popular though, apparently, also a stern teacher in the life-class. He gained the respect of the students for the conscientious way in which he completed the assigned periods of duty which were ignored or neglected by so many artists. 'We all liked Mr. Dyce;' G. D. Leslie recalled, 'he was one of the best visitors I was ever under. He had a remarkably correct eye for drawing and possessed an intimate knowledge of the technique of painting, about which he liked to talk to any of the students who took interest in the matter.'[30]

It was in the life-class of the Academy that Holman Hunt and Millais first came to know Dyce.[31] Perhaps they were involved in an escapade described by Leslie which reflects favourably on a man who—whilst he may have taken himself rather too seriously for modern taste—placed honesty and integrity before prestige and self-importance. Leslie tells how one evening the model arrived completely drunk and, after Dyce had dismissed the model and gone home himself, the students made the most of the occasion, creating a great deal of noise and excitement. William learned of this and next evening 'seemed dreadfully put out, remarking that we [the

[28] See Dyce's obituary, *The Art Journal*, n.s. iii (1864), 113.
[29] *Encyclopaedia Britannica* (Cambridge, 1910), viii.
[30] G. D. Leslie, *The Inner Life of the Royal Academy* (1914), 25–8.
[31] W. Holman Hunt, 206–7.

students] were a wretched set of babies that could not be trusted, that he should report us to the Council, and that probably the medal [silver for which they were preparing drawings] would be withheld'. However, William's sense of personal responsibility was stronger than his desire to save face. 'But Mr. Dyce was a gentleman', concludes Leslie, 'and the next evening he made a little speech to the students, saying he was sorry for what he had said the evening before, for on thinking the matter over he felt that it was his own fault for having left us ... and that either he should have stayed with us or else at once sent us away.'[32]

At the Royal Academy summer exhibition in 1851, next to Maclise's portrait of Bulwer Lytton, hung William's *King Lear and the Fool in the Storm*. The painting is now lost but contemporary reports suggest that it was very much within the tradition popularized by Boydell in his Shakespeare Gallery engravings and raised to the immortal sublime by Barry, Mortimer, and Fuseli in their paintings of Lear.[33] *The Morning Chronicle* described the picture with admiration:

The Old King is raving forth his curses in the fury of the tempest. With every nerve and muscle strung by indignation and agony, he is foaming out his wild wrath to the winds, his regal robes blowing madly about him; while the Fool— that wondrous fool—squatted on the ground, is looking into his face with a half human, half bestial expression of interest and sympathy, and awe and friendliness and wonder ... The face and the attitude of the fool are a triumph of genius. There is conception and creation in every line—the features so coarse, yet far from brutal.[34]

The reviewer concluded that the picture was one which 'once seen, will not soon be forgotten'. Ford Madox Brown told Lowes Dickinson that Dyce's painting presented a misconception of King Lear and the fool but that no one except a fool or a critic would dislike it.[35]

The Academy exhibition of May 1851, in which William exhibited *King Lear* and the young Pre-Raphaelite brotherhood provoked the scorn of the reviewers and also Ruskin's sympathy, was to some extent overshadowed by the Great Exhibition which opened in the Crystal Palace during the same week. William was responsible for designing the headings of the certificates

[32] Leslie, 27.

[33] James Barry, *The Death of Cordelia* (1774), Tate Gallery; J. H. Mortimer, *King Lear*, etching (1775–1776); J. H. Fuseli, *King Lear: Fantasy on the Sistine Ceiling*, drawing (*c.* 1777), British Museum.

[34] *The Morning Chronicle*, Sat. 3 May 1851.

[35] F. M. Hueffer, *Ford Madox Brown* (1896), 78.

which were to be issued to successful exhibitors. The first certificate (given

135 to holders of prizes and Council medals, to those of whom honourable mention was made in the jurors reports and to the jurors themselves) bore a figure representing Peace descending from Heaven in the form of a winged female. She is scattering wreaths over the emblems of Industry and Science, personated in a woman with a distaff and a student with a book who are seated within an arrangement of antique-style arabesques and grotesque dolphin heads. The source of inspiration for this was probably one of the many published collections of engravings after classical decoration.[36] The remainder of the exhibitors, the members of the Royal Commission, the

137 executive committee, and the staff received a certificate bearing a figure of Peace with an olive branch in her hand and the lion and lamb in amity at her feet. She is inscribed in a circle against a view of the Crystal Palace and accompanied by young Science and a child bearing a cornucopia overflowing with the fruits of the earth.[37]

These two designs, which are executed with great delicacy to convey the impression of relief work, show William at his most sophisticated as a designer and recall the interest he had shown as a young man in the decoration of the Baths of Titus. The second design, particularly, has great dignity and statuesque classical restraint. William makes interesting use of the picture-area whilst never abandoning the flat, semi-relief style he believed vital to such a design. The finished drawings for both the certificates have survived and, also, a preparatory sketch for Peace in the first.

136 In the final version, William changed the position of the wings to create an upward lift, complementing the downward curve of the dolphins' tails, and adapted the head-gear and clothing of the figure in order to emphasize the Flaxmanesque, vertical folds of drapery by abandoning the suggestion of a waist-line. There is, of course, a sculptured quality about Dyce's design, which is not a feature of Flaxman's work, but the triangular folds of drapery, creating a descending zig-zag line in the winged figure's clothing, is exactly the sort of effect achieved by Flaxman in, for example, *Achilles Lamenting the Death of Patroclus*, an engraving of 1793.

The classical quality of line in the two designs is to some extent softened by the gentle, volumetric treatment of the supporting figures, the fat *putti* and the figures of Scholarship and Industry. Similarly the softly introspective,

[36] e.g. Lewis Vulliamy, *Examples of Ornamental Sculpture in Architecture* (1823), plate 25 'from a capital in the Ruins of the Temple of Apollo Didymens at Branchidae'.

[37] *The Art Journal*, xiv (1852), 291.

meditative expression on the face of Peace draws the viewer's attention from the formalistically organized setting in which she stands. With centrally parted, heavily flowing hair, broad brow, and neat mouth, this head prefigures the 'meditative' heads painted by Millais in, for example, *Autumn Leaves* of 1856 or drawn by Rossetti in his famous portrait of Elizabeth Siddal of 1855 in the Ashmolean Museum.

William's strong sense of design and his delight in the formal interplay between rectilinear background planes and the curves of human forms, first evidenced in his drawing of his nephew, Adam, *c.* 1832, is most clearly seen **42** in a circular chalk and wash study for a fresco, exhibited at the Royal Academy in 1852. The figure depicted in half-length, is that of a female, **128** seated with a compass in her hand. William used the harsh, horizontal line of a parapet or window-frame, the progress of which is abruptly halted by a vertical at the right, to offset and emphasize the formal qualities of the figure; the perfect oval of the head, the curve of shoulder, breast, forearm, and knee. The draperies and the circular shape in which the whole is enclosed emphasize these qualities. Although there is depth of shadow and a sense of volume, this is reduced to relative insignificance by the insistence on a formal design comprising a circle with two axes, one following the line of the parting of the hair, nose, chin, thumb, left hand, and compasses, the other following the line of the parapet. Within this circle is worked out the relationship between the main lines just mentioned and the various parts of circles formed by the physical features of the subject. A related extant drawing shows the figure (in the traditional pose of Melancholia), in reverse and with more of her face visible. The finished drawing was exhibited as *Study for a fresco* but it appears never to have been executed in that medium.

William never abandoned his passionate interest in theology and in the spring of 1851 he wrote *Notes on Shepherds and Sheep. A Letter to John Ruskin Esq. M.A.*, a reply to Ruskin's *Notes on the Construction of Sheepfolds*. Ruskin did not, William claimed, describe how churches should be constructed and the title of his work was, therefore, misleading. William was, as we have seen, regarded as something of an authority on the theological niceties of church-planning and he attacked Ruskin with earnest and righteous indignation. Ruskin was, of course, a Low-Church Anglican and his views were inevitably inimical to one of William's faith. In May W. E. Gladstone, very much of William's own camp, was dragged into the discussion and agreed, somewhat diffidently, to read William's riposte in proof. 'When I took your sheets from your hand', he told William, 'I was not aware

how deep they cut into theology, or I should not have offered you the valueless aid of my cursory and rather abstracted perusal.' After jotting 'two or three trifling notes' in pencil in the margin he handed the essay back to the author, with the cool reassurance that his position seemed 'sound and the argument very acute'.[38]

It was very rare for William to sign his paintings or to use all his professional titles in publishing. His articles in *The Christian Remembrancer* are signed simply 'William Dyce'. It is, perhaps, some measure of the seriousness with which William regarded the sheep-fold issue that he published his pamphlet with all his colours flying as the work of 'William Dyce M.A. Royal Academician, Professor of the Theory of the Fine Arts, King's College, London'. The matter continued to occupy him for years and in 1857, we find him defending his stand in a letter to Professor Campbell Fraser, the husband of his youngest sister, Jemima.[39] It would not be unfair to suggest that William was, in this instance, very much aware of the position which Ruskin had recently been accorded by informed opinion at the helm of the nineteenth-century school of aesthetic theory and art criticism. Ruskin and Dyce were completely reconciled in 1857 when *Titian*
111 *Preparing to make his First Essay in Colouring*, exhibited by the latter at the Royal Academy provoked a friendly approach from Ruskin.

The demands on William's time were many, but he succeeded, between writing pamphlets and providing ink-sketches in the manner of Overbeck, 'the great Christian artist of the times', to embellish the literary works of querulous Scottish bishops,[40] to finish his second fresco in the Queen's
160 Robing Room by the end of 1852. *Courtesy; Sir Tristram harping to La Belle Isolde*[41] occupies a tall narrow compartment, about which William complained to the Commission. 'I should say it was impossible', he told Eastlake, 'to make a graceful composition of many figures in an upright space, unless the figures are so diminished in size as to render the picture . . . an oblong.'[42] William solved the problem in *Courtesy* by dividing the compartment more or less in half horizontally, putting his chief figures in the lower foreground and filling up the rest with an arch (beautifully decorated in the *Cosmati* style) through which we catch a glimpse of a land-

[38] D.P. XXIX, W. E. Gladstone to W. Dyce, 22 May 1851.
[39] Collection of Mr. P. Campbell Fraser. W. Dyce to Prof. Campbell Fraser, 29 July 1857.
[40] D.P. XXIX, the Bishop of Brechin to W. Dyce, 7 Dec. 1851.
[41] Malory, *Morte d'Arthur*, Book viii, ch. 9.
[42] D.P. XXVII, W. Dyce to Sir C. Eastlake, 25 July 1848.

scape with two youths hawking. William's scheme derives from the
Florentine, fifteenth-century practice of creating three stages of recession
within a picture. In *Courtesy* the three stages are clearly marked out; the
plain tiled foreground containing the main figures, the black and white tiled
middle ground under the archway, and the grassy background. By the time
the fresco was completed William had committed himself deeply to a major
new undertaking in fresco elsewhere. He did not totally neglect the Robing
Room and *Mercy*, the third fresco, was finished two years later. But his **162**
heart was no longer really in the job and there were to be long delays before
Generosity was to be completed and *Hospitality*, the largest of all, begun. **161, 163**

8

'A PIECE OF SUCCESS UNLOOKED FOR AND SURPRISING'
1852–1857

During the early 1840s a small, somewhat drab chapel existed in Margaret Street, in the middle of what is now London's West End. Here the Revd. Frederick Oakley, a man with a strong aesthetic sense and a great love of music, began to introduce chanting and intoning into the services. The choristers wore surplices (a thing almost unheard of outside a cathedral precinct at this date) and as well as daily services, Saints' days and the cyclical, seasonal celebrations of the Anglo-Catholic church calendar were observed. Oakley was impeded by episcopal dictates and harassed by bigots but his chapel became, nevertheless, a centre for Tractarian worship, a mystical, soul-elevating haven from the rigid severity of the Protestant church.

In November 1850, Pusey laid the foundation stone for a new church in Margaret Street which was to be designed by Butterfield at the cost of £60,000, largely to be paid by Alexander J. R. Beresford Hope. That All Saints, Margaret Street, should be the model church of the ecclesiologists was never in doubt in the minds of its sponsors or of the architect. But neither Pusey nor Newman was sympathetic to the innovations of Oakley. The introduction of coloured stoles, rich hangings, and unaccustomed postures were regarded by them as trivial details, attendant on theological issues but not essential to them, innovations which might offend and hinder the reassertion of Catholic truth.

The controversy became increasingly rancorous as the strident polychrome exterior and richly exotic interior of the church, complete with screen and gates dividing nave from chancel, materialized. It culminated in a sermon which the Dean of Westminster preached at the consecration on

28 May 1859 on the text 'To what purpose is this waste?' Part of the waste referred to was a magnificent reredos, painted in fresco in a framework of alabaster niches by Dyce and occupying the whole of the east wall above the altar. The date of Butterfield's earliest designs is generally given as 1849.[1] By 1851, Beresford Hope was already corresponding with William about the iconology of the fresco for All Saints. The former thought it 'strange there should be this little knot of painters who have gone back to the old models, and with whom we have had so little communication. No doubt,' he continued, 'they must have thought us narrow-minded prigs for not having found them out.' Having been 'found out', William agreed to paint the reredos and Beresford Hope was delighted by this 'piece of success unlooked for and surprising'.[2] Surprising it certainly was that William, his huge undertaking in the Queen's Robing Room scarcely touched, should have accepted such a commission.

It is hard to imagine how William could possibly have completed the All Saints reredos by the time of the consecration, originally scheduled for 1852.[3] So much time was lost 'by the Bishop of London objecting to the Chancel screen with gates' that the consecration was postponed until Easter 1853 and, in fact, did not take place until 1859. William was obliged to ask the commissioners for leave from the Queen's Robing Room and on 24 July 1857, dining with a group of Royal Academicians at the Dulwich Picture Gallery, made an unsuccessful attempt to persuade Cope to help him finish the reredos.[4] The explanation of William's apparent imprudence in accepting Beresford Hope's commission is that the decoration of All Saints fulfilled a lifelong ambition. Many years earlier, in 1838, William had inquired of Nicholas Wiseman about the possibility that a Roman Catholic Cathedral might be built in London because he hoped for the opportunity of painting large-scale frescoes in a sanctified building. Wiseman replied that a cathedral was certainly desired but only remotely intended. 'I shall have to write to Mr. Pugin soon,' Wiseman told William, 'and I shall say all in my power to induce him to take you into his councils, should he have any such great work on hand.' Wiseman went on to say that he had already mentioned William's name 'in one or two

[1] H. R. Hitchcock, *Early Victorian Architecture in Britain* (1954), 50; P. Thompson, *William Butterfield* (1971), 507.

[2] H. W. and I. Law, *The Book of the Beresford Hopes* (1925), 164.

[3] D.P. XXIX, Upton Richards to W. Dyce, 23 Jan. 1852.

[4] C. W. Cope, *Reminiscences* (1891), 224.

quarters where I thought something worthy of your abilities likely to be undertaken'.[5] It was not until many years after William's death that a Roman Catholic Cathedral was built. William must have felt, in 1850, elated at the idea of decorating the ecclesiologist's model church. This was more than he had hoped for.

It has been suggested that the idea for the reredos came from Butterfield rather than from Beresford Hope, because the former was interested in Italian painting and the latter was, as we have seen, surprised to discover the existence of artists like Dyce and J. R. Herbert.[6] However, Beresford Hope 'exercised a control over the entire works' and was generally regarded 'as the real proprietor of the church' until it was conveyed to the Ecclesiastical Commission prior to consecration.[7] Beresford Hope may not have known William and his work but Oakley, Hope-Scott, Helmore, and Gladstone—who visited the church in William's company in 1859 and examined the frescoes with the aid of a magnifying lens[8]—were William's close friends and fellow ecclesiologists. Any one of them could have introduced William to Beresford Hope, who became one of the artist's most ardent admirers. In 1852, Beresford Hope wrote to Dyce saying, 'How much I wish it would all [i.e. all the decorative work and the stained glass] be your work with any delay of time.'[9] The fact that Butterfield repeated the idea of the All Saints reredos at St. Alban's, Holborn, 'where the east wall was painted in part colours by the water glass process',[10] is no proof that Butterfield suggested the All Saints fresco. He could have been so impressed by Dyce's painting of the east end and the chancel-ceiling that he decided to repeat the scheme. Butterfield's taste for Nazarene art was, it is clear, superficial. Having bought Overbeck's *Credulity of St. Thomas* as an altar-piece for St. Thomas's, Leeds, he decided that the money could be better spent[11] and Beresford Hope bought the painting to add to the collection of medieval rarities which he kept in a small room with the appearance of a chapel.[12]

To suggest, as does Thompson, that the choice of William Dyce at All

[5] D.P. V, N. Wiseman to W. Dyce, 29 June 1838. William's letter to Wiseman is missing, the contents are to be inferred from the reply.

[6] Thompson, 458.

[7] *The Times*, editorial, 30 May 1859.

[8] D.P. XXXIX, W. Dyce to W. E. Gladstone, 20 June 1859.

[9] D.P. XXXVII, A. J. R. Beresford Hope to W. Dyce, 10 Apr. 1852.

[10] Thompson, 458.

[11] D.P. XXXVII, A. J. R. Beresford Hope to W. Dyce, 22 Nov. 1851.

[12] G. Waagen, *Galleries of Art in Great Britain* (1857), 189–90.

Saints reflects Butterfield's own progressiveness and rationality is mis-
leading. William's own scientific bent was not, as we have seen,
symptomatic of a progressive mind of the cast of Butterfield's. The School
of Design—although progressive within the framework of a highly
reactionary system of education—was not, in its infancy, concerned so much
with experimenting with cast-iron girders, such as Butterfield used at All
Saints[13] and other progressive ideas, as with the designing of paisley silk
scarves and wall-paper. Butterfield's church was designed 'above all ... with
a view to fresco'[14] but the architect, we are told, did not approve the decora-
tions of the chancel vaulting (also Dyce's responsibility).[15] When he was in
Italy in 1854, Butterfield unfavourably compared the colours William was
using at All Saints to those in a fresco by Luini.[16] There may well have been
friction between two such men of strong character and determined views.

William was conversant with the architectural decoration which Butter-
field used so dramatically. Ten years before work commenced on All Saints,
William had experimented on paper with 'the style practised by scholars
of Giotto in Upper Italy ... [in] polychromatic decoration at the end of the
fourteenth century'.[17] But he was very clear in his own mind where
legitimate architectural decoration stopped and falsely-adorned archi-
tecture began. After being consulted in 1860 by Sir Gilbert Scott at Lich-
field Cathedral, he expressed the view that 'neither painting nor sculpture
properly so called are parts of Architecture.' William regarded 'the
spreading of colour over a building' as legitimate but the colouring of
sculpture as 'barbarous and coming down to us from times when the proper
province of the several arts was not understood'.[18] The report which
William made on Lichfield was, it would seem, not understood either.
William was thought to have some 'wild notions' and, although he took a
hand in the restoration of the tricolour on the ribs of the Choir, he did not
proceed far. 'A discussion arose as to the peculiar shade of blue to be used
and by way of showing the exact colour deemed to be suitable, a piece of
blue paper was suspended on the wall. Mr. Dyce took offence at this

131

[13] Thompson, 348–9.
[14] *The Ecclesiologist*, lxxvii (1850), 433.
[15] *The Times*, 30 May 1859.
[16] Thompson, 92.
[17] R.A. 1839 (1187), catalogue entry.
[18] D.P. XL, W. Dyce to A. J. R. Beresford Hope, 17 Feb. 1862.

harmless suggestion, and straight-way packed his paint pots and departed. He was *not* called back.'[19]

We have so far referred to William's painting of the east wall of All Saints both as a reredos and as a fresco. A reredos is normally a wooden structure erected behind and above the altar. William's fresco combined the functions of the traditional English medieval reredos and the east window. The first two tiers of the fresco, with their sculpted niches, correspond to the reredos, whilst the upper level corresponds to the window. The space between the top of the altar and the bottom of the reredos was due to doubt at the time about whether the introduction of a screen would be permitted. William clearly did not wish to risk the lowest tier of the reredos being blocked from the view of the congregation. The allocation of a compartment to each of the apostles, the location of the Virgin Mary and Jesus at the centre of the lowest tier, and the depiction of Christ in Majesty overlooking all, is characteristic of fifteenth- and sixteenth-century reredoses. In the reredos section of William's fresco, the human part of the Christian drama is enacted. The top level, the window-section or tympanum, is distinguished from the lower two tiers by the absence of alabaster niches and is separated from them by a dividing line of castellated carving. In this section we are able to see out past the earthly symbols; the apostles, the nativity, the passion, through the earthly atmosphere to a vision of the after-life and Christ in majesty.

Sadly, William's fresco had begun to decay almost before he had completed it. It was the old story of damp, soot, and, possibly, inadequate preparation of the ground. By 1908 the faces were gone and the drapery had become dust and mildew. It was proposed that Sir George Richmond be brought in to make new designs. Happily, the proposal came to nothing and since the frescoes were beyond restoration, the re-decoration was entrusted to J. N. Comper (who had the greatest respect for Dyce's work) with the proviso that the original effect be retained. Using William's original oil painting in the Victoria and Albert Museum, Comper copied the fresco in oil on to movable panels which were then inserted over the original plaster in the niches,[20] lengthening one or two figures in the tympanum and straightening the bent arms of the crucified Christ, a peculiarity

[19] Revd. J. G. Lonsdale, *Recollections of the Work done in and upon Lichfield Cathedral from 1856 to 1894* (Lichfield, 1895).

[20] J. N. Comper, 'Recollections of All Saints, Margaret St. and St. Alban's, Holborn', MS. Mr. Anthony Symondson. W. A. Whitworth, *Quam Dilecta* (1890), 11 et seq.

which had given rise to speculation but which, *The Times* assured its readers, was due simply to lack of space.[21]

Now that time and the climate have taken their toll of the star-spangled interior of All Saints, Margaret St., it is difficult to imagine how it must have looked when pristine and new. William's painting of the chancel was criticized for being ill in accord with the rest of the church, though providing a fine setting for the fresco.[22] Now that the colours of the vaulting are much subdued and the gilding is partly submerged into its background, the total effect is one of pleasing progression from the dimly-lit and spacious nave to the brilliance and illuminated glory of the chancel. In accordance with the views of Charles Winston, the great authority of the time, on stained glass,[23] grisaille rather than coloured glass was used in combination with the wall-paintings and the daylight floods from the clerestory windows to illuminate the upper tier of the reredos.

Beresford Hope possessed 'an a priori conviction of the architectural need of the arithmetical balance of figures, to make an ecclesiological whole, not merely of the reredos, but of the entire chancel, inclusive of the one altar and its one cross, above which, out of the perpendicular line of which, the central panel will be taken, and form with the altar and altar-cross one whole.'[24] In All Saints, the chancel dominates the nave, and the pulpit dwindles into insignificance. The chancel itself is dominated by the altar and, behind it, reinforcing sacrament with icon, 'a vision of the infinite seen above and beyond the finite', is the reredos.[25] The cross on the altar directs the attention to William's depiction of the crucifixion and above that to Christ in Glory, from the earthly and the transitory to the heavenly and the permanent. Even the formal arrangement William employed reinforces this idea. The earthly sections of the reredos contain uniform, stiff, apostolic figures in the world of the finite. When we ascend to the area of the infinite there is free movement and a harmonious mingling of biblical personages beneath the aegis of the reigning Christ.

Discussing with Beresford Hope the iconography of the reredos, William was on more familiar territory than he had been with the subject of Malory

138

[21] *The Times*, 30 May 1859.

[22] See n. 21.

[23] C. Winston, *An Inquiry into the Differences of Style Observable in Ancient Glass Painting* (Oxford, 1857), 227.

[24] D.P. XXXVII, A. J. R. Beresford Hope to W. Dyce, 10 Apr. 1852.

[25] See n. 24.

in the Queen's Robing Room. But the two men were not in total agreement. William wished to include Paul among the Saints but Beresford Hope objected that he was not one of the original twelve apostles and suggested that St. John could be his representative. 'Can one', he asked William, 'without a private judgement in Catholic iconography (which is very bold) pass over St. Matthias who has been held as substituted, so to speak, among the original twelve who were to sit upon the twelve thrones judging the twelve tribes of Israel—the great idea of the Apostolic College?'[26] William had his own way and St. Paul occupies a key position immediately to the right of the crucifixion. St. John shares the crucifixion compartment with the Virgin Mary, a grouping which William repeated in his easel painting **88** *St. John leading the Blessed Virgin Mary From the Tomb*.

William relinquished his plan of including St. Joseph, however, after Beresford Hope had pointed out that 'the exultation of St. Joseph to an apparent equality with Mary' was a 'neo-roman idea' and one that was peculiarly repugnant to him. 'Pugin, you know, has pronounced against the present attitude to the Iconography of Joseph, and been somewhat bullied by the Romans for speaking out', William was informed.[27] His own response to the Roman Catholic controversy had always been to claim for the Anglican Church many of the features of Romanism under criticism. 'Our present return to the old faith is *really a return*, a rekindling of the old flame of a love never entirely extinguished, and not the new light of a *Roman candle*,' he declared.[28] But he nevertheless acceded in the matter of St. Joseph to the wishes of his patron.

138 The central section of the reredos contains the Virgin Mary on a simple, draped 'throne' and three angels in the background. Beresford Hope's suggestion that William should paint a formal landscape with Jerusalem and Bethlehem on either side in the distance, or symbolical plants in a trellis: vines and passion flowers, was rejected by William. The simple arrangement of a powdering of stars on a dark background which was adopted is very effective.

William succeeded in introducing the figure of St. Mary Magdalen, even though Beresford Hope protested that this would destroy the architectural and the ecclesiological unity of the wall and, as it were, split the

[26] D.P. XXXVII, Beresford Hope to W. Dyce, 22 Nov. 1851.
[27] See n. 26.
[28] D.P. XIII, 'On Ecclesiastical Architecture'.

church up the middle.[29] As the most popular of all the penitent sinners in biblical history, the presence of Mary Magdalen in the top section of the reredos, in a group which includes Elisabeth, the Virgin Mary, Joseph, St. John the Evangelist, St. John the Baptist, Abraham, and David, helps to reinforce the intrinsic idea of the humanity of Christ. All the figures in the group relate to the human lineage of Christ, or to his life as a man. It is balanced by a group of prophets and apostles on the other side, including Moses, Elias, St. Peter, and St. Paul. The evangelists are placed diagonally opposite their symbols, thus forming a compact and effective composition around Christ's *mandorla*.

The Seven Lamps of Architecture, published in 1849 by Ruskin, urged the study of Italian Gothic. In seeking to combine the idea of a great stained-glass east window, containing tiers of saints in richly ornamented architectural niches, the idea of a reredos, and the idea of a fresco, William found inspiration in Italian Gothic altar-pieces. He would certainly have known Ruskin's work and he also owned a copy of F. Zanotti, *Pinacoteca delle Belle Arte* of 1834, a work containing engravings of Italian Gothic altar-pieces.[30] William must also have known Mrs. Jameson's popular *Legends of the Madonna* which was published in 1852. William's presentation of the Madonna at All Saints is one of extreme simplicity and dignity. Looking at the design in the Victoria and Albert Museum, we see her seated on **138** a bench draped with a heavy cloth edged with decorated braid of the type William had already used on the gown of the lady in *Religion*. Family **152** tradition suggests that the model for the Virgin was William's niece, Elizabeth Cay, and certainly the warmth, realism, and degree of finish in this part of the oil study bears out such a claim.[31]

William's simple arrangement of three angels attendant on the Virgin Mary owes nothing to Mrs. Jameson, who lists innumerable saintly personages as permissible attendants for the mother of Christ. Nor does the pose of the Virgin follow her specifications for 'The Virgin and Child Enthroned', although a water-colour drawing attributed to Dyce suggests that he was **99** familiar with this formula. The pose of the Virgin in the All Saints fresco is very close to that of Mrs. Jameson's 'Madre Pia', the Madonna adoring

[29] D.P. XXXVII, A. J. R. Beresford Hope to W. Dyce, 10 Apr. 1852.
[30] F. Zanotti, *Pinacoteca delle Imp. Reg. Academia Veneta delle Belle Arte* (Venice, 1834). Dyce sale, Christie's, 5 May 1865. There is an edition of 1832 in the B.M. Prints & Drawings.
[31] Miss F. K. Dunn of Cheltenham, a surviving daughter of Elizabeth Dunn (*née* Cay) gave this information.

the child. 'He lies extended on her kneee, and she looks down upon him with hands folded in prayer; or she places her hand under his foot, an attitude which originally implied her acknowledgement of his sovereignty and superiority ... Sometimes, but very rarely, he sleeps.'[32]

145 After protesting to Eastlake that he was too exhausted after a day on the scaffold in the Queen's Robing Room to think about the best means of housing the National Gallery, William did, in fact, produce a report.[33] There are similarities between the course of events in 1837 when William Dyce and Charles Heath Wilson had proposed the reorganization of the Trustees' Academy and developments in 1853 as a result of William's report on the National Gallery. Shortly after its publication a select committee was appointed to inquire into the constitution and general management of the gallery. Once again, William was examined at length, and dispatched to the Continent, this time in the company of George Richmond, to visit Kruger's Gallery and ascertain at what price it might be purchased for the nation.[34]

William's proposals went far beyond the suggestions for the building which Eastlake had requested. He believed that a national gallery should present an extensive and representative view of art, affording instruction and pleasure to the people. He attacked Séguier, the first director of the National Gallery, a man who had never been to Italy, for encouraging the notion that 'the page of art had been a blank until Raffaelle and his distinguished contemporaries and successors arose, as if art had sprung up, at one leap, from infancy to manhood.'[35] William did not seek to justify the art of what he called the 'early Christian' (meaning trecento and quattrocento) period on antiquarian or exclusively on comparative grounds. He was prepared to state unequivocally the intrinsic aesthetic validity of an art which many of his contemporaries still regarded as barbaric:

If the maturity of judgement and technical skill of later times were wanting in its *adolescent* state, they were more than compensated for by a freshness of thought and intention, a vivacity, a gaiety, a vividness of impression, an innocence, simplicity and truthfulness which belong to first efforts, and which technical imperfection

[32] Mrs. A. Jameson, *Legends of the Madonna* (1848), 1852 edn., being Part iii of *Sacred and Legendary Art*, 74–5.

[33] W. Dyce, *The National Gallery. Its Formation and Management, addressed by Permission to H.R.H. Prince Albert* (1853).

[34] D.P. XXXIII, W. E. Gladstone to W. Dyce, 21 Nov. 1853.

[35] W. Dyce, *The National Gallery*, Introduction. The forthright quality of Dyce's statements possibly accounts for the fact that his report was published separately and not as an appendix to the *Report from the Select Committee on the National Gallery* (1853).

tended even to develop in greater force than the more universal areas of later art permitted. And, it may be added, there is, in general a *suggestiveness* about the works of earlier masters which gives them a peculiar value and interest, especially to the practical student of art.[36]

Neither William's acquisitions nor his report were greeted with unqualified enthusiasm. Among the 'Early Christian' paintings William acquired for the National Gallery were *Ecce Homo* by Matteo di Giovanni and *The Vision of St. Bernard* by Lippo Lippi. Ford Madox Brown visited the Gallery on 5 December 1854 to see some 'absurd old pictures bought by Dyce'. He approved, however, of 'an Albert Dürer ... very fine, though not painted, rather *mapped*'.[37] *The Art Journal* announced that 'All who are acquainted with our frequently expressed opinions upon Pre-Raffaelism, will scarcely expect us to concur altogether with Mr. Dyce's eulogism of those works, though we are quite prepared to acknowledge they may be studied with much benefit to the young artist.'[38]

Mercy, Sir Gawaine swearing to a court of ladies presided over by **162**
Guinevere, that he would 'never by ayenste lady ne jantillwoman but if he fyght for a lady and hys adversary fyghtith for another',[39] was completed in fresco in the Queen's Robing Room in 1854. The episode in Malory is a serious one as Gawaine, by slaying a lady, has threatened the whole chivalric code but William's rendering of the subject verges on the trivial. The ladies stand relaxed, informally but elegantly grouped, their faces expressing gentle amiability rather than grim determination. This fresco differs from the others in the series as it does not show an action which is representative of the virtue but shows a knight swearing to act in a particular way in the future. *Religion* shows a religious experience, *Courtesy* shows **152, 160**
an act that is courteous, but *Mercy* shows Gawaine being judged guilty of being unmerciful and promising to behave better in the future.

It is doubtful whether this particular example of moral virtue would have been meaningful to an audience unversed in courtly love and the rules of chivalry. A warrior sparing an unhorsed opponent (*Generosity*) is, in any cultural context, acceptable as an example of generosity, but Gawaine's

[36] W. Dyce, *The National Gallery*, 12.

[37] W. M. Rossetti, *Pre-Raphaelite Diaries and Letters* (1900), 148. *The Ecce Homo* is now regarded as the work of an imitator of Matteo di Giovanni (no. 247); the attribution of *St. Bernard's Vision* to Lippi is not always accepted (no. 248); and the portrait which Dyce purchased as the work of Dürer is now attributed to Baldung (no. 245).

[38] *The Art Journal*, xv (1853), 99.

[39] Malory, Book iii. ch. 8.

oath must have sounded a curious note in the temple of Victorian morality. William seems to have been undecided whether he was painting narrative **162** or allegory. What is happening in *Mercy* follows Malory fairly closely but Queen Guinevere's elevation to a Florentine Madonna figure, creates the impression that she is an exclusive personification of Mercy in her treatment of the knight. William may have been influenced by the popularity of personifications like *The Spirit of Chivalry* and *The Spirit of Justice* which Maclise had recently painted next door in the House of Lords.[40]

In May 1855, Ruskin, perhaps still smarting from the shepherds and sheep-folds controversy, made William's Academy exhibit the object of an **108** attack. *Christabel* ('It was a lovely sight to see/the Lady Christabel when she /was praying at the old oak tree'), almost half-length, in an oval, is a virginal young girl, wrapped in a cloak held at the neck with a jewelled clasp, standing beneath the tree described in Coleridge's ballad, 'her slender palms together prest'. Ruskin disapproved of the painting as representative of one of 'the false branches of Pre-Raphaelism' because he felt that William had merely imitated the *forms* of the early Italians not their *spirit*.[41]

Ruskin's view has influenced subsequent writers and *Christabel* has come to be regarded as the first in a series of paintings by Dyce showing the influence of the Pre-Raphaelite Brotherhood. Certainly the ivy-covered oak tree in Christabel is depicted with an attention to detail which would have done credit to the Brotherhood in their 'truth to nature' days and there is an archaistic, medievalizing air about the oval features of the lady. But we must not forget that a degree of truth-to-nature is evident in William's **93** landscapes of the early thirties and that he had, in his 1838 Madonna created an equally archaistic female figure. William had executed a number of literary subjects of the sort which appealed to the Pre-Raphaelites long before he made their acquaintance through Holman Hunt at the Academy Schools in 1849. *St. Dunstan separating Edwy and Elgiva* (a subject which may have been inspired by Fanny Burney's play), exhibited in 1839, and *Titian and Irene di Spilembergo*, exhibited in 1840, both now missing, judging by the descriptive passages which accompanied them, must have combined those qualities of literary narrative and romantic history in which Ford Madox Brown and William Holman Hunt delighted.

109 There is also evidence to suggest that the original idea for *Christabel* dates from before 1855. A very small pencil sketch, signed and dated 'Crossgate

[40] These frescoes were completed in 1847 and 1849 respectively.
[41] *The Works of John Ruskin*, ed. E. T. Cook and A. Wedderburn (1909), xiv, 19.

Manse, July 21 1849' shows a young girl, eyes downcast and hair veiled. Despite some obvious differences (the covered head, the absence of the hands in prayer), there are important similarities between this drawing and *Christabel*. The chiselled eyebrows and shapely nose, the primly pursed lips **108** and smooth lowered eyelids of the girl in the drawing are also character- istics of Christabel. The girl, who seems portrayed from life, has wavy, centrally parted hair like Christabel and a gown with a decorated neck band. The halo, which is inexplicable in a portrait sketch, becomes in *Christabel* the coronet of roses.

Ford Madox Brown's judgement of *Christabel* was that it was 'pretty and mannered'.[42] What his young friends in the fraternity thought of it we can only guess. The complex question of William's relationship to Millais, Holman Hunt, Rossetti, and the other associates, posed by Ruskin's criticism in 1855, remains. It is a question of importance and one we shall again encounter in the ensuing years of William's life.

The time limit within which William was contracted to complete the Queen's Robing Room was extended in 1855 but it seems very doubtful whether he was, in fact, spending much, if any, time at the Houses of Parlia- ment in these years. The fresco in All Saints, Margaret St. was far from complete, and in 1853, William had accepted another commission for a piece of large-scale work, a stained-glass window which was installed in 1857. The east window for St. Paul's Church, Alnwick, was designed by Dyce alone and yet, even without the problems of collaborating with glaziers, the scheme was—like all his other ventures in stained glass— fraught with controversy. William designed five fully coloured cartoons of **139** St. Paul and St. Barnabas preaching at Antioch but, contrary to his wishes, the Duke of Northumberland, for whom Anthony Salvin had built the church, decided that the cartoons should be sent to Germany to be executed at the Royal Manufactory of Munich under the direction of Professor Ainmüller. William became involved in a dispute about the qualities of German glass, widely acclaimed at that time. William believed it to be inferior to English stained glass because excessive enamelling rendered it opaque. The dispute developed into a full-scale row with Charles Heath Wilson in 1857 when the question arose of glazing the new Glasgow Cathedral.[43]

The Alnwick window is a bold concept, transmitted through the use of **frontispiece**

[42] Rossetti, 183.
[43] D.P. XXXVI, W. Dyce to John Webster, 25 Mar. 1857.

brilliant red and orange in harsh collision, offset by large areas of acid green and deep aquamarine. The scene takes place within a sort of recess of gothic architecture. At All Saints, where William was painting when he prepared the cartoons for Alnwick, he made—as it were—a window from a wall. At Alnwick, William created in the window, the semblance of a wall within which is a series of small window-lights, and through these the open sky is seen. He was to use a similar concept in the last fresco to be painted in the

163 Queen's Robing Room, *Hospitality*, where he created an extension to the room, within which the drama is enacted. It was, of course, a convention that had been frequently used by fresco- and mural-painters of the past but, in using this method at Alnwick, William was able to demonstrate the validity of an academic point about which he had argued vehemently with Henry Cole of the Department of Science and Art.

William had found Cole guilty of 'as great a piece of heterodoxy as was ever penned' for his view that 'glass painting should consist of flat tints of colour, without shadow, which must be out of place in that which is intended to transmit light through it . . .' William contended that there was not an atom of difference between the mural-painting and the glass-painting of any period you like to name. 'The conditions of course are reversed', William declared, 'but the same men who thought it proper in mural painting to treat part of a wall as if it were a window, thought it proper in glass painting to treat part of a window as if it were a wall.' William was prepared to see the logic of a principle of glass-painting which rejected the human figure, as being a solid object, and confined the stainer's art to pattern making. To compromise by introducing figures but in flat, un-shadowed colour seemed to William quite untenable.

Normally mild and restrained in writing to his friends, William attacked Henry Cole with rare vigour and asperity:

Do you seriously propound this doctrine as the teaching of your department? I hope not. If you do I give you warning you shall have something more than a private remonstrance on the subject. I happen to be a little interested in the question as I have undertaken to make a large design for painted glass for the Duke of Northumberland to the tune of £800 and it is important to me that the public should be truly *indoctrinated* on the guiding principles of the art.[44]

William, it is clear from this letter, regarded the two architecturally based media of fresco and glass as complementary and comparable. He also

[44] D.P. XXXVI, W. Dyce to H. Cole, 2 Feb. 1853.

defended the use of shadow in painted glass and believed it proper to treat part of a window as if it were a wall. At Alnwick, William created a sense of human drama through the very use of shadow on figures, which Cole rejected and by treating the window surface as though it possessed three-dimensional qualities. He used four planes to suggest recession and a fifth is implied in the daylight seen through the double-light windows. The foreground plane consists of the lower, supporting wall of a raised platform. On this wall are affixed the row of armorial bearings of the Duke. At a small distance from the edge of this wall, rise the end-supports of the two stone benches inlaid with mosaic work and the decorative steps at the top of which St. Paul is standing, in the centre. The bench-supports mark the outside margin of the area in which the action is taking place. At a superior level, this plane is emphasized by the pale, highly decorated pendants and ogee arch of the canopy.

139

frontispiece

The figures are active on a third plane, the inner margin of this area is marked by the simpler and sombrely coloured 'outside' wall. The highly decorated gothic canopies which form a crucial part of the design at Alnwick were also a contentious subject. The great authority of the time, Charles Winston, approved in theory of the use of canopies (as long as the artist did not take liberties with the rules of perspective) because they provided the opportunity of introducing strong contrasts.[45] William's canopies at Alnwick do just this, they lighten, brighten, and establish a spatial dimension. But Winston disliked William's canopy work at Alnwick and lent his voice to the opposing faction in the argument that developed between Dyce and Charles Heath Wilson. But he could not fault William on scholarly grounds and was compelled to admit that he was 'perfectly justified, (having adopted the Italian Gothic) in mixing what you justly call "Gothic" and "Byzantine" ';[46] presumably a reference to William's use of diaper and mosaic decoration within the canopy.

The canopies of William's window are carefully repeated and balanced. The central canopy under which stands St. Paul, is slightly more emphatic because a decorated back wall replaces the window of the other niches. The decorated ends of the two seats and the steps at the top of which St. Paul stands, help to stabilize a scene in which the figures, though crowded closely, display a variety of movement and gesture and evoke generally an atmosphere of agitation. In the lecture he had delivered to the School of

[45] C. Winston, *Memoirs Illustrative of the Art of Glass Painting* (1865), i, 251–2, 291–2.
[46] Winston, i, 24–5.

Design in 1848, William had rationalized the use of repeated decorative forms as a means of preserving a notion of flatness. He had been referring primarily to fabric design but the same principle applies in his own use of repeated, highly decorated canopies at Alnwick. They counteract and offset the use of heavy shadow which some of his contemporaries found so objectionable.[47]

153 Winston regarded the Raphael cartoons as very suitable for adaptation to glass-painting[48] and it is interesting to note that although this opinion was published after William had completed designs for the Alnwick window, *St. Paul and St. Barnabas at Antioch* reflects not only the artist's fidelity to the patron saint of the church for which he was designing, but his regard for Raphael, particularly for the cartoon, *The Sacrifice at Lystra*. William recalled also his own very Raphaelesque work in the House of Lords and the eager-faced women beneath the first left-hand canopy (a 'group of converts to the new religion'[49]) as well as the sages on the right echo the row of women with babes in arms and gesticulating men who look over the balcony to observe the baptism of the first English Christian monarch, King Ethelbert.

William's belief in the essential relationship between stained glass and fresco led him to design for Alnwick a window which closely resembled his work in fresco. He made extensive use of geometrical inlaid work of the *Cosmati* type and decorative mosaics in his window design and at the Houses of Parliament. The flower motif which adorns the archway under which Queen Guinevere stands in *Mercy* is repeated on the seats in the cartoons for the Alnwick window. The barley-sugar columns supporting Guinevere's arch are identical to those which support the windows in the glass design although the capitals differ. The inlaid mosaic pattern, based on a square divided into triangular segments, which decorates the lower step in the central panel of the Alnwick cartoon, is reiterated on the angles of the raised dais on which King Arthur stands in *Hospitality*. Experimental coloured drawings for polychromatic mosaics of this kind testify to William's serious study of detail for these large-scale undertakings.

(margin numbers: 139, 153, 147, 148, 162, 163)

[47] W. Dyce, Lecture on Ornament, reprinted in *Journal of Design and Manufacture*, i (1849).

[48] Winston, i, 241. The cartoons, in the Royal Collection, were kept at Hampton Court in William's day. They are now on loan to the Victoria and Albert Museum.

[49] *The Art Journal*, n.s. iii (1857), 64.

9

WILLIAM DYCE AND THE PRE-RAPHAELITE BROTHERHOOD
1857-1858

During the last seven years of his life William Dyce suffered increasingly from the strain and ordeal of his vast and unfulfilled commitment in the Queen's Robing Room. On board a steamboat making up the Thames for the Houses of Parliament in 1850, William had told Holman Hunt with sadness that he felt he was beginning the great task with his hair already grey.[1] By 1860, William was under attack in the House and was being censured in the press. Mr. Cavendish Bentinck in 1860 complained that public funds were being spent in paying artists who did not finish their work. Mr. Danby Seymour denounced William and his colleagues as unfit to decorate the Houses of Parliament and considered that the frescoes already completed were worthy only to be erased.[2] Moreover, the new technique of waterglass, advocated by Maclise in a report to the Commission in 1859,[3] rendered fresco already obsolete and, with the death of Prince Albert, chief promoter of the scheme, in December 1861, all remaining impetus ebbed away.

Decay was already apparent in the frescoes by 1860 and William begged Eastlake to excuse him from giving evidence before a new commission set up to inquire into the deterioration of the paintings to which he had devoted so much time and energy.[4] In his 'Observations on Fresco' of 1845, William had remarked that Zucchero's work in the Vatican Library was well preserved because the place was dry and the paintings had not been exposed

[1] W. Holman Hunt, *Pre-Raphaelitism and the Pre-Raphaelite Brotherhood* (1905), i. 229.
[2] *The Times*, 9 June 1863.
[3] Incorporated into the *Twelfth Report of the Royal Commission* ... (1861).
[4] D.P. XL, W. Dyce to Sir C. Eastlake, 2 Apr. 1860.

to smoke: 'dampness and smoke being . . . the great destructives of pictures in fresco'. He thought to add: 'if this be true our proposed works in London have a bad chance of durability.' It must have been a most painful experience to see this prognostication proved all too true. 'As no-one knows more of the practice of fresco than yourself, I wish you would from time to time make notes of what you consider the probable causes of the partial decay which has been noticed,'[5] Eastlake formally requested his friend. How reluctantly must poor William have made the necessary tour of Osborne, the Buckingham Palace Pavilion, and the Lords' Chamber to see, as his fellow fresco-painter and intimate friend C. W. Cope expressed it, the 'writing in the sand' which 'Time's effacing fingers' had begun to 'obliterate at one end' while they were still working at the other.[6]

Paradoxically, these were also the years in which William painted an unprecedented number of easel paintings of superb quality and great interest. It is on this series of paintings that his reputation as an artist has primarily rested. Posterity has benefited from the disillusionment and disappointment of the fresco painters for it is clear that, having completed the All Saints reredos in 1859, William determined that fresco should not henceforth dominate his life. As though propelled by a premonition of his own sudden and premature death, William set out to establish for himself in the space of seven short years (he died in February 1864) a reputation which few of his contemporaries hoped to gain from a lifetime spent before the easel. William's sudden surge of artistic activity certainly owes something to the deteriorating state of affairs at the Houses of Parliament. It also clearly owes much, firstly to the fact that he now had, in the person of his father-in-law, James Brand, a guaranteed purchaser for many religious canvases and landscapes, and secondly to the rising star of the Pre-Raphaelite Brotherhood.

At the Royal Academy exhibition in 1857, Ruskin—who had been so **108** quick to condemn *Christabel* two years earlier as representative of a false branch of Pre-Raphaelism—picked out William's *Titian Preparing to make his* **111** *first essay in colouring* as the only picture in the exhibition 'quite up to the high-water mark of Pre-Raphaelism'. He praised William for choosing 'a subject involving an amount of toil only endurable by the boundless love and patience which are the first among the Pre-Raphaelite characteristics'.[7]

[5] D.P. XL, Sir C. Eastlake to W. Dyce, 5 Aug. 1861.
[6] C. W. Cope, *Reminiscences*, 257–8.
[7] *The Works of John Ruskin*, ed. E. T. Cook and A. Wedderburn (1909), xiv, 98.

The painting is loosely based on Ridolfi's 'Life of Titian' in volume I of *Le Meraviglie dell'Arte*, the second edition of which was published in Padua in 1835–7, and shows the boy, Titian, perched on the edge of a chair, appropriated from his mother's parlour (or so it would seem), gazing at a statue of the Madonna which he has placed on a pleasantly gnarled tree stump. His cap and stick lie abandoned and near by are a flask of water, a drawing book, and a basket overflowing with flowers of every colour the aspiring artist could hope to include in his palette. This lyrical portrayal of a garden in spring is also, in its own way a polemical painting because if the startlingly white statue were painted in brilliant polychrome by the boy Titian, it would be a demonstration of the authenticity of coloured sculpture in churches, a subject with which William was to be much exercised in 1860.

Everything is shown in minute detail: the boy's clothing, the flowers, the bark of the trees, a nail knocked into the tree trunk at some earlier date. The colour is brilliantly applied on a white ground, and especially striking are the contrasts between the pallid flesh tints, the shabby, mauve leather of the chair, and the extraordinary display of all the natural colours of the garden. A remarkable precision is evident in the execution, every object being delicately circumscribed by a scarcely visible line, creating an effect of crystalline clarity and great tangibility.

'I have not the least idea whether you and I are friends or not', Ruskin told William, 'but I can't help writing to congratulate you on your wonderful picture . . . I don't think the colour of the face is right—but you have beat everybody this time for thoroughness.'[8] Later that year, the two men would co-operate in considering, yet again, the vexed topic of art education, this time in relation to the system of examinations which Acland was attempting to establish.[9] The picture which healed the breach between these two men of firm principle and somewhat intractable temperament is certainly charming and unforgettable. The vividness of the colour and the clarity of the forms imprint themselves indelibly on the retina. Yet one feels that William has, in the course of surpassing everyone, compromised himself. In comparison with the portraits of children which he painted with such sympathy and

[8] D.P. XXXVII, J. Ruskin to W. Dyce, 8 May 1857.

[9] D.P. XXXVIII, Correspondence between W. Dyce and G. Richmond, and W. Dyce and Sir T. D. Acland, July 1857 to June 1856. See also W. Dyce, *On the Connection of the Arts with General Education* (1858) and *On the Position of Art in the Proposed Oxford Examinations* (1858). Francina Irwin in 'William Dyce's Titian's First Essay in Colour', *Apollo*, Oct. 1978, 251–255 discusses the painting in relation to the artist's theories on education.

lack of sentimentality in the thirties, the boy Titian resembles a porcelain figurine. Titian's garden is peculiarly English with its great trees and prolific foliage and yet the town which we see in the distance through the trees is typically Italian. There is, in fact, a synthetic air about the whole.

William never again combined such a profusion of detail with such glorious colour. But the debt to the Pre-Raphaelites which Ruskin implied was not something which William, having attained the 'high-water mark', cast off and many of his subsequent paintings bear evidence of sustained interest in Pre-Raphaelite technique. At the same time, it is important to notice that, even in *Titian*, William exercised a discipline, a rigorous sense of organization in placing his figure, which distinguishes his painting from the overcrowded prolixity of the younger artists' work and, for all its brilliance, the colour of *Titian* appears relatively sober when compared to the paintings by Pre-Raphaelite followers that hung nearby when Dyce's picture was exhibited at the Manchester Jubilee exhibition in 1887. Arthur Hughes's *April Love* and W. S. Burton's *The Wounded Cavalier* (both 1855–6, Tate Gallery and Guildhall Art Gallery) make Dyce's most strident colours appear subdued.

William did not record his views of Pre-Raphaelite ideals and methods, and the debt which the Pre-Raphaelites owed to William must be traced in the scanty and disconnected comments of the various artists. William was, we must remember, a generation older than Holman Hunt, Millais, and Rossetti and, unlike them, he ensured that his art—indeed every detail of his life—was upheld by a devoutly practised religious faith. It should not surprise us that it was to Holman Hunt, easily the most religious as well as the most theologically learned member of the group that William should have been most drawn. The debt of the Pre-Raphaelites to High-Church symbolism has been examined and acknowledged an important ingredient in the movement.[10] William Dyce would have been, beyond any of his contemporaries, an ideal mentor for Millais, Holman Hunt, or Rossetti, struggling with the symbolism of *Christ in the House of His Parents*, *Christ in the Temple*, or *The Girlhood of Mary the Virgin*. He could have helped them to knowledge which, if not beyond the understanding of the Low-Church Ruskin, was certainly beyond his personal experience.

William was a member of the Hanging Committee at the Royal Academy in 1849 when Hunt's *Rienzi* and Millais's *Isabella* were selected and, no

[10] A. Grieve, *The Art of Dante Gabriel Rossetti: The Pre-Raphaelite Period, 1848–50* (Hingham, Norfolk, 1973).

doubt, his voice was heard in their favour. Ruskin, whose defence of the Brotherhood in 1851, brought their work to the serious attention of the public, confessed that he owed his 'real introduction to the whole school', to Dyce who 'dragged me literally up to the Millais picture of the Carpenter's Shop, which I passed disdainfully, and forced me to look for its merits'.[11] As we have seen, William conversed with Hunt in the life-class at the Royal Academy, procured for him the commission to restore the Rigaud frescoes at Trinity House, and offered him a job as his own assistant. Copying William's *Jacob and Rachel* would have provided Hunt with an excellent introduction to the older artist's methods.[12] The severe, outline style and unyielding poses in Millais's *Isabella* owe something to the unsentimental and determined approach of Dyce in *Joash* or *Jacob and Rachel*. Highly eclectic, the brethren picked up and reinterpreted items from the artistic vocabulary of many of their contemporaries. Haunting images and fragments of images appear and re-appear, passing back and forth, or so it would seem, between William and his young friends. Sometimes, as in William's etching *Grant of Tullocharron* of 1837[13] where a doorway scene seems to anticipate the setting of so many Pre-Raphaelite dramas (like Hunt's *Eve of St. Agnes* of 1848 and Millais's *The Black Brunswicker* of 1860) and a rigid figure behind the door evokes the terrified Claudio (in Hunt's *Claudio and Isabella* of 1850) the similarity is likely to be, at the most, the result of an unconscious allusion. In other cases, such as the way in which we are reminded of William's drawing of a boy prone on the floor when we look at Hunt's figure of the boy peering out for the persecutors in his *British Missionaries*, the resemblance may simply be the result of two artists on different occasions drawing the same model at the Academy life-class. There are similarities between some aspects of William's frescoes in the Queen's Robing Room and the work of the Pre-Raphaelites. The glimpse of open air and pasture, a view outside the confining relationship of two people, which William created in *Courtesy* comprises, on a basic level, a division of space and an allocation of different moods to different areas which becomes a highly developed and complex feature of Rossetti's art and later, to an even greater extent, of Burne-Jones's. But in general any similarity between William's interpretation of Malory and the Pre-Raphaelites' use of Arthurian material is due to a prevailing ethos rather

76

86

121

107

160

[11] *The Works of John Ruskin*, xxxvii, 427–8. J. Ruskin to E. Chesneau, 28 Dec. 1882.
[12] Hunt, i, 261.
[13] Sir T. D. Lauder, *The Highland Rambles* (1837).

than to actual influence and, in any case, the differences are more important than the similarities.

The Pre-Raphaelites were inspired primarily by Tennyson, but his interpretation of the Arthurian legend appeared in a different medium and, except for the fragment of the 'Morte d'Arthur' published in the 1842 *Poems*, at a later date than William's frescoes. Rossetti, Millais, and Hunt were developing their art between 1848 and 1850. During these years William was spreading forth in paint on a vast scale in the Houses of Parliament, the splendour and heroic magnificence of Malory, whilst Tennyson was touring Cornwall and pondering upon the origins of the Arthurian legend. The rebirth of Arthur's Britain is generally attributed with good reason to Tennyson. *The Idylls of the King* enjoyed an unprecedented popularity in the poet's own time and were the apogee of a movement which had begun haltingly with Southey, Scott, Peacock, and Bulwer Lytton. Yet William's frescoes in the Queen's Robing Room were undoubtedly known to a wider public in the fifties than any earlier Arthurian venture or any poem Tennyson had written or was presumed to be planning.

Holman Hunt, at least, must have been very familiar with William's work in the Queen's Robing Room, yet Pre-Raphaelite excursions into the court of King Arthur produced very different results. William was reluctant to use symbols and attributes in the consciously medievalizing manner employed by Rossetti, either to provide us with further information or to create an **161** emotional quality. In *Generosity*, Sir Tristram who, after knocking King Arthur from his horse, generously spares his life,[14] should be shown with the impregnable shield given him by Morgan le Fay. But William concentrates on a carefully planned construction of vigorous forms accentuated by the sharp contrast of dark armour against white horse and by the vertical thrust of sword and halberd. William's interpretation, for all his conscientious perusal of Malory, is essentially pictorial whilst that of Rossetti, whose reading into the background of the subject was less extensive, is essentially literary, demanding to be read.

152 Let us compare William's *Religion* with Rossetti's *The Damsel of Sanct Grael* (collection of Mrs. Robert Catto, a study for *Sir Launcelot's Vision of the Sanct Grael* in the Oxford Union, 1857–8). Rossetti gives us a formalistic rendering, rich with esoteric religiose emblems: the antique inscription, the white dove, the pure white cloth which covers the simple basket of bread, the benedictory gesture of the angel with her halo of hair, and the

[14] Malory, Book xx. ch. 13.

slender grail cup. It is significant that in the Oxford Union Rossetti represents an incomplete vision of the grail which occurs while the subject, **158** the unholy Launcelot, is asleep and which is, as described by Malory,[15] very much a dream and, therefore, in contrast to the waking experience of the deserving Galahad and his company.

Rossetti's whole design is packed with minute detail, the angelic and the human elements crushed into the closest proximity in a welter of the richest ornamental detail. This is Rossetti's strength just as William's own power lies in his breadth of approach and in the open spaces in which he places his vigorous figures. A sense of awe is created by the separation of those figures one from another. William was explicit on the question of the importance of open spaces in fresco painting and disliked the Carracci and Michelangelo because he found their style turgid and unarchitectonic.[16]

Rossetti also represented Sir Galahad, Sir Bors, and Sir Percival receiving **159** the Sanc Grael. Admittedly the intentions of the two artists differed and Rossetti's picture surpasses William's in mystical, quasi-religious other- **152** worldliness. But at worst, Rossetti's design is no more than a row of absurdly rigid and stooping individuals queuing for what looks like a beaker of water. William's dramatic rendering exploits the heroic, physical, virile aspects of the story and is more successful as an illustration and as an independent work of art. One is often left with the feeling that the essence of Rossetti's subject lies somewhere outside the picture space; a lack of focus which has its own peculiar charm but which is not well suited to the rendering of a subject so full of dramatic tension.

William painted Sir Lancelot kissing the hand of Queen Guinevere at **150** the moment of his departure in the design rejected by the commissioners, but he omitted any reference, oblique or direct, by symbol or by composi- tional means, to the adulterous love between Lancelot and the Queen. Rossetti, on the other hand, refers specifically to this aspect of the subject in *Sir Launcelot in the Queen's Chamber*. In Rossetti's work the total effect is built **151** up by the over-all application of detail within a rigorously enclosed space and this leads to a bubbling sense of anticipation. In William's work events take place in monumental and vastly defined areas. It certainly lacks the excitement and pent-up energy of Rossetti's but, after all, is not Rossetti's *Sir Launcelot in the Queen's Chamber* really more an *Awakening*

[15] Malory, Book xv. ch. 3.
[16] 'Notes on fresco'.

Conscience in the medieval mode than an illustration of an event in the Arthurian legend?

It would seem, then, that Rossetti was in no way indebted to William unless for the general inspiration of his subject. In view of the differences which clearly existed between the methods of the two artists it is reasonable to conclude that William, in his turn, learned little or nothing from Rossetti. The full extent of Pre-Raphaelite influence on William is concentrated in *Titian* of 1857. Here it is clear that it was not Rossetti, the designer and draftsman among the brethren, who impressed William but Holman Hunt, the painter, and probably also Ford Madox Brown.

In 1851 Ford Madox Brown had been confident of William's approval of paintings done on a pure white ground,[17] a device which William himself adopted in *Titian*. Madox Brown also shared his interest in the possibilities of *plein air* painting. William had expressed curiosity about this as early as 1846 when, observing the anomaly of Pinturicchio's unnatural colours which give a true idea from a distance, he remarked: 'I suspect that we modern painters do not study nature enough in the open air, or in broad daylight, or we should be better able to understand how the old painters obtained truth by such an apparently anomalous means.'[18] But despite his perceptive comments on 'that peculiar indefiniteness of the shadows and undercut parts', which he has observed in the open air and his advocacy of nature, not art as the master, William does not seem to have painted in oil out of doors as Ford Madox Brown and others were to do in the fifties. This failure to prove his own hypothesis is due neither to dilatoriness nor to lack of interest but simply to the fact that William was not primarily a landscape painter. He speculated about ways of recording the natural world and mastered the art of painting an actual scene as this was a medium through which he expressed himself, but the proper subjects of his paintings were almost invariably spiritual or intellectual as we shall shortly have occasion to discover.

In 1857, at the suggestion of his mother-in-law, William took up *St. John Leading the Blessed Virgin Mary from the Tomb*, a painting which he had commenced in 1842 but abandoned two years later.[19] The quality of controlled emotion, the use of uncrowded open spaces, and the still, quiet colour of the painting are some measure of the extent to which William

[17] Hueffer, 77.
[18] 'Notes on Fresco'.
[19] D.P. XL, statement by Dyce's son.

was able to subdue and, if it suited him, ignore the Pre-Raphaelite influence which is evident in the virtuoso *Titian* of the same year. According to **111** William's son, the painting remained virtually the same as it had been in 1842 so it is clear that William felt no urgent need to outdo the Pre-Raphaelites in detail or to flood the painting with colour.

St. John is one of William's most successful works. Although it contains **88** much detail and a strong sense of locality, it is rigorously restrained in composition and in colour. Nothing is permitted to detract from the all-pervasive silence and stillness. The sky is dark and the clouds are low on the horizon, suggesting the windless hush of dusk or the moment before a storm. The two chief figures are separate from the background activity at the tomb where the two Marys kneel and Joseph of Arimathea, carrying the linen sheet in which he had wrapped Jesus, leaves the enclosure of the tomb. Over St. John's right shoulder the dark walls of Jerusalem can be seen. St. John, his youthful features marked by sorrow, is the descendant of that St. John which William had depicted in 1835 in *The Dead Christ*, in a pen **62** and ink drawing and in his fresco at All Saints, Margaret St. It may well **64, 138** be that William identified strongly with St. John, as the witness, the scholar, and the disseminator of Christian truth.

In the preparatory sketch for *St. John*, William painted the main figures **89** in much closer proximity. He placed John slightly behind Mary holding her hand in both of his, inclining his head towards her, and generally made St. John a much more supportive figure than he appears in the finished painting. The result of the changes in the arrangement of these two figures is to attribute equal importance to each and to establish an element of separateness between them. Adaptations to clothing reinforce the sense of isolation and spiritual deprivation, especially the substitution of a dark head-dress for Mary's chaste white cowl and the enveloping of Mary in a closely hugging cloak. The figures in the sketch convey a sense of pathos but in the finished painting there is a far greater feeling of desolation and loss.

When one contrasts Dyce's religious easel-painting with *Religion: the* **152** *Vision of Sir Galahad* in the Queen's Robing Room or a drawing in the manner of Tintoretto, *The Assumption of the Virgin*, it becomes apparent that **73** in the easel-paintings William is concerned with the way in which spiritual experience affects our human condition. The revelatory quality of the fresco and the drawing is absent in the easel-painting. In place of it solid, if ascetic, human beings tread the real earth. We, as observers, are given the

86 feeling that the young St. John or the athletic Joash are special in their
88 spiritual awareness. This sense is conveyed to us not by the introduction
of extraneous devices, by violent expression or gesture, but by the artist's
meticulous and determined attention to these figures as human beings.
Through the clarity and unemotional quality of his statement William
endows these figures with a more than human dignity whilst retaining
their essential humanity.

　　William's concern with humanity is fundamental to his choice of theme:
maternity, bereavement, rebellion, patient and stoical acceptance of
misfortune, responsibility, love, and devotion to one's fellow human beings,
are all qualities and experiences inherent in the subjects which Dyce chose
from the Old and New Testaments. The strength of paintings like the
96, 86 Osborne *Madonna*, *Joash*, *St. John* and *Jacob and Rachel* lies in the fact that
88, 76 they are (with the possible exception of the last-mentioned picture)
restrained and unemotional. But this is not to say they lack feeling. An
72 undated drawing, *St. Christopher*, is a striking exposition not of the ethereal
joys of the Christian message but of the sheer weight of Christian
responsibility. Judging by the loose chalk and ink technique, it was
probably executed in the forties, a period when William—struggling at
the Schools of Design and deeply immersed in the ecclesiological movement
—felt most keenly the responsibilities which his faith imposed upon him.
The drawing is an expression of the Christian duty which William believed
in so implicitly and, like *Joash* and *Jacob and Rachel* was, for William, an
externalizing, through traditional subject matter and formal means, of an
intensely felt personal emotion. A number of subjects concerning the life of
Christ which are now lost might contribute to this picture of William Dyce
as a painter of religious subjects; *Christ Crowned with Thorns* (1830),[20] *The
Christian Yoke* (1841) and *Ecce Homo*.[21] Studies in pencil of the figure of Christ
and sleeping apostles now in the British Museum, suggest that William at
some time contemplated painting that subject also.

88 　　James Brand, William's father-in-law, bought *St. John Leading the Blessed
Virgin Mary from the Tomb*. Perhaps William and Jane and their young
family travelled for the summer of 1857 to Milnathort in Kinross, just north
of Edinburgh, where Jane's family lived, taking the painting with them.
William seems, at any rate, to have been in Edinburgh about that time.
In another painting which rejects Pre-Raphaelite idiom in favour of

[20] A. Agresti (*I Prerafaellisti* (Turin, 1908), 45) refers to this picture as 'd'un verita tragica'.
[21] John Guest sale, Christie's, 6 June 1863 (130).

William's own personal style, the result of accumulated and laboriously acquired experience, William portrayed the Librarian of Edinburgh University, John Small, and his young son, in half-length. Small was born **27** in 1828 and became Principal Librarian in 1854. The portrait shows a man of about thirty and, like the best of William's portraits, is characterized by a refreshing quality of unbroken directness of communication between subject and spectator, an untrammelled psychological impact, a freedom from sentimentality, and a strong sense of design. The portrait is smaller and more intimate—the figures seen frontally with the child slightly to the right and in front of his father, both gazing unhesitatingly before them—than is customary in official portraiture. This, and the unusual fact of the presence of a small child in a portrait belonging to an institution, suggests that William probably knew the Small family and that the picture was initially painted for them rather than for the university to whom it now belongs.

The view that William as an artist 'somehow wasted himself; . . . followed a wrong direction, or perhaps . . . followed too many'[22] has been commonly held. Yet, looking at a work like William's portrait of Small and his son, we find the artist yet again returning to a genre he had practised earlier, once more taking up a thread laid aside at an earlier date. All that he had learned in the thirties in Edinburgh of the psychology of portraiture, his resistance to the fashionable portrait domain of Landseer and Winterhalter, his knowledge of composition and chiaroscuro acquired in painting his nieces in *The Sisters* of c. 1841, all interact in this remarkable portrait of **41** a long-forgotten scholar and his fair-haired child.

Certainly William followed many directions but he also consolidated. His changes of direction were not senseless wanderings in uncharted territory but the well-equipped and highly productive explorations of an artist who believed a man should be given credit for doing more than one thing.[23] In 1858, William was to visit Pegwell Bay, the following year the Isle of Arran and, in 1860, North Wales. This was a period when he painted a series of subjects with landscape, remarkable in the history of English art. The treatment of landscape in as objective as possible a way and the portrayal of a human subject without embroidery or flattery have much in common. The intangible communication of the solemn sense of time and place which makes *Pegwell Bay: A Recollection of October 5th 1858* such a memorable **52** painting also illuminates the portrait of the Edinburgh University Librarian

[22] Bell, *The Schools of Design* (1963), 77–8.
[23] W. Dyce to J. Ruskin, preface to *Notes on Shepherds and Sheep* (1851).

and his son. Admirable as William's grand concept for the Queen's Robing Room was, miraculous as the colour and detail of *Titian Making his First Essay in Colouring* may seem, it is in paintings like *John Small and his Son* and *Pegwell Bay* that William really expressed his personal and individual sense of life.

10

UNOFFICIALLY TRIUMPHANT
1858–1860

In the summer of 1858, William returned to another familiar path, that of the designer, but this time he was less successful. Invited by the Royal Academy Council, along with Mulready and Maclise, to submit a design for the Turner medal, William made two drawings for the reverse side and painted a posthumous portrait of Turner for the obverse side of the proposed medal. The drawing he chose to submit, and which remains in the Academy, represents a scene from *The Divine Comedy* in which Dante and Virgil encounter Leah gathering flowers for her own enjoyment and adornment and, with her, Rachel who looks all day into a mirror like the Lady of Shalott. The quotation 'Lei lo veder e me L'oprar appaga' appears around the top section of the design.[1]

Translating the line as 'Sight pleases her and active working me', it becomes clear that William chose the scene as exemplary of the dualism of artistic life. Leah gathers flowers, an active process leading to joy in the visible beauties of creation. Rachel leaves the works of the creator and gazes at her mirror, which is God, in which she beholds her own nature glorified and transfigured. The eyes of Rachel are her thoughts, her ideas, and these she contemplates in the mirror as the ideas, in the Platonic sense, of God. Thus Leah and Rachel together present the sensuous and the spiritual, the active and the contemplative. A harmonious balance of these properties William regarded, evidently, as a necessity for the artist.

William represented Rachel—in the tradition of the celebrated *Sacred and Profane Love* of Titian—as a nude figure, in the more prominent position. She is naked because of her unworldliness and leans gracefully

[1] Dante, *Purgatorio*, xxvii.

against a tree, her abundant tresses waving about her shoulders. The bending figure of Leah is chiefly remarkable for the virtuoso treatment of the drapery which she holds up with her right hand and which is of inappropriate quantity and length for the active pursuit of its owner. Not surprisingly, the Council rejected this solemn and esoteric drawing in favour of the light-hearted and more effective design submitted by Maclise.

William was in the habit of taking his family off to some pleasant country place for the summer months. It was these holidays away from the tensions of London, and the constant reminder of still-unfinished frescoes, that enabled William to paint, either there and then, or later from sketches, some of his most distinguished pictures. 'These trips for a change of air always pay,' he remarked to his brother-in-law after the family's visit to Wales in 1860. 'I made £400 by my trip to Ramsgate two years ago and £260 by my last year's trip to Arran and I hope to make an equally good thing out of the Welsh excursion.'[2]

54 *The Highland Ferryman*, exhibited in Edinburgh in 1858 and in London the following year, probably resulted from sketches made on holiday in Scotland in 1856 or 1857. It is symptomatic of the pressure under which William was working in London that he should have exhibited this cool, still study of an old man seated before his stone cottage by the loch with the subtitle 'Contentment'. With the sizeable figure and the landscape painted from life, the picture unites the clear, objective perception of the human condition, which illuminates his best portraits and some of his subject paintings, with his strong sense of landscape and his feeling for the minute particularization of an individual location. Sadly William never **56** repeated the experiment; other landscapes like *A Scene in Arran* of 1859 have small-scale figures and the religious and literary landscapes of the **92, 115** fifties, like *Gethsemane* and *Henry VI at Towton* have slightly larger but less individualized figures.

William's *Highland Ferryman* is no rustic, picturesque figure in the Gainsborough tradition, nor is he in any sense either caricature or dispassionately studied physiognomy. Loving attention has been paid to all the details of dress and personal appearance: the grizzled whiskers, the knotted handkerchief around the neck, the carefully sewn patches at elbow and knee, the vest sleeves emerging at the man's wrists, the snuff horn in his right hand, the hobnails on his boots, and the mug and bottle discarded in the foreground. The looseness of limb and easy slump of the shoulders evoke

[2] D.P. XL, W. Dyce to R. Dundas Cay, 20 Oct. 1860.

the ferryman's relaxed way of life but it is remarkable the extent to which the exposed soles of the old man's boots convey the feel of the rough, stony ground he treads daily. There is nothing doctrinaire about Dyce's truth to nature; his artistic practice springs from a healthy respect for the identity and dignity of common objects and ordinary people. If we compare *The Highland Ferryman* with, for example, John Brett's *The Stonebreaker* (Walker Art Gallery, Liverpool) or Ford Madox Brown's *Work* (Manchester City Art Gallery), it seems all the more impressive as a painting.

William's response to the scene lacks the romantic, rosy overtones of Brett's painting with its eulogization of simple, outdoor pursuits; nor is it infused with political and social comment. William's response is more Wordsworthian. He shows the poverty (the patched clothes, the simple implements of living which are seen around the cottage door) but he also sees the ferryman and his way of life for what they are, peaceful, untroubled, and in close communion with nature. The figure of the ferryman in his natural environment is presented without any air of patronage as a dignified and, in his own right, as a complete person. William had been abroad in 1853 in connection with the discussions over the future of the National Gallery and it is interesting to speculate whether he was aware of Courbet's *The Stonebreakers*, exhibited at the Salon in 1850.

The colours of *The Highland Ferryman* are very restrained and subdued; **54** blues, greys, and buffs and an almost colourless sky. Only the ferryman's deep mauve waistcoat adds a splash of colour. The essential feeling for the natural scene, particularly for the variety of texture; smooth pebbles, rough lichens, spiky grasses, and so on, is a development from William's early water-colour studies in Glenlair and elsewhere. Likewise the tendency to **46** particularization is a logical progression from that other Scottish loch scene, *Shirrapburn Loch* of 1830–1. The faint but distinct outlining of all the main **45** objects which we identified as the main source of the extraordinary clarity of *Titian* in 1857 ensures in *The Highland Ferryman* the same structured **111** brilliance, in which colour is uncomplicated by reflected lights or melodramatic chiaroscuro.

The Dyce family holiday in 1857, and probably again in 1858, was spent at Ramsgate where, as he later told his brother-in-law, William acquired the artistic material for *Pegwell Bay* which he exhibited in 1860 **52** and sold to his father-in-law for £400. It seems probable that the small undated landscape known as *The Entrance to the Vicarage* was painted during **55** this summer. The stoniness, the loving attention to detail of vegetation

and objects, the bleached colour, and the presence of a single figure which is appropriate to the scene but in no way suggestive of narrative, all point

54 to a date between 1857 and 1860, that is, between *The Highland Ferryman*
71 and *The Man of Sorrows*. This charming painting, which possesses something
52 of the mood of stillness of *Pegwell Bay*, shows the entrance to a half-derelict Tudor house which is shrouded in trees and overgrown with bushes. At the centre of the house a gable containing a coat of arms can just be seen through the trees. The main gate is missing but a small side gate stands open and against the post a boy is leaning, hands in his coat-pockets, daydreaming. A dry-stone wall flanks the path to the right and a long wall stretches the length of the garden on the left, enclosing the house and separating it from a barn. An old wheelbarrow occupies the foreground. The walls appear to be of chalk or flint and this, as well as the very English architectural style of the buildings, suggest a location in Kent or the south-east. Perhaps, indeed, the little boy is William's son who also features in Pegwell Bay.

After the church of All Saints, Margaret St. had been consecrated in May 1859, and his obligations to Beresford Hope had at last been fulfilled, William must have thought longingly again of the countryside and days which could be spent, unrestricted by the fresco painter's scaffold, in open-air pleasures and landscape study. Accordingly the family left for the Isle of Arran where William painted a number of water-colours and, probably

56 later, *A Scene in Arran* in oil, from which he made, as he told R. D. Cay,
57, 58 £260. A water-colour of Glen Rosa and another of Goat Fell are extant and reveal William working in a novel technique involving thickly applied colour and heavy, stubby brush strokes. Gone are the cool colours and fluid washes of the water-colours of the forties. In their place we have a dry, almost a drawing technique through which detail is clarified, and harshly brilliant colour: bright blues and acid greens. The experiment in new technique and tone in water-colour was not, however, sustained in the painting of Arran which William executed in oil. Though the tonal range

56, 54 of *A Scene in Arran* is warmer than that of *The Highland Ferryman* it is very
58 restrained when compared with the water-colour *Goat Fell*.

Another difference between the oil and the two water-colours from William's Arran holiday is the introduction of a pronounced narrative element into *A Scene in Arran*. The water-colour *Glen Rosa* contains a small figure, a girl with a basket, in the bottom right-hand corner but *Goat Fell* has no figures. The oil, on the contrary, is full of human activity. The

painting shows a large, sandy bank covered in most places with lush grass **56**
and vegetation. In the distance a wood, and beyond, a mountain peak
can be seen. In the foreground a woman stands on a river bank and calls
to two of her children, who are standing in the water, to bring a wash-
tub to the shore. The cause of her gesticulation is apparent when we
notice that another tub containing a watering-can is floating away down-
stream. Two more children stand on the shore before a shelter made from
a boat turned upside down, around which are scattered buckets and cans,
while nearby a pot hangs from a pole over a small fire. In the background
a haymaker passes a stone-built house on his way to the fields.

A Scene in Arran is a new departure for Dyce. The landscape of the painting
relates to works like *The Highland Ferryman* but the narrative is un- **54**
precedented in William's work and was never repeated. It has been
suggested that *A Scene in Arran* has much in common with *Pegwell Bay* **52**
which William exhibited in 1860, that in both paintings the figures are
seen unawares and provide the minimum of narrative interest.[3] Certainly
there is no sense of communication between the figures in *Pegwell Bay*; they
share no common interest. This is one element that strengthens the
recollected quality of the painting which is emphasized in its full title,
Pegwell Bay: A Recollection of October 5 1858. The quality of William's Arran
scene is totally different. The landscape is softer and domesticated (ducks,
haymaking, washing, cooking), sandy and rounded (instead of chalky and
angular). Something really is happening by the riverside in Arran and all
the characters are involved, even the little girl on the bank who holds up
her skirt not, as has been suggested, in 'an unconscious act', but ready
to wade out into the stream too. Her little sister gazes immobile but even
she holds on to one side of a bucket, the counterpart to that which threatens
to disappear from view. The drama is rustic and domestic but none the
less real and, although it would be obtuse not to agree that the landscape
is of predominant importance, the fact remains that a convincing narrative
is created. The seemingly haphazard arrangement of figures, as in *Pegwell
Bay*, may suggest an objectively viewed scene caught accidentally on the
retina, but this belies the true nature of the painting which is a minutely
recorded drama in which the natural contours of the landscape—the lines
of the sandy path and the dry bed of the stream converging upon the
gesticulating mother—serve to emphasize the narrative.

It was perhaps on his way south, during the long journey from Arran

[3] A. Staley, *The Pre-Raphaelite Landscape* (Oxford, 1973), 167.

back to London, that William kept an appointment at Alnwick with the Duke of Northumberland. The Duke's interest in Northumbrian archaeology was considerable and he had amassed a large collection of English antiquities. One day at the beginning of October William was the Duke's guest, enjoying lunch and a tour of the estate followed by serious discussion about alterations and improvements to the castle, especially the substitution of architecture corresponding to the 'really ancient parts' for the 'rubbishing so-called Gothic windows, etc. of George III time in the Strawberry Hill style'.[4] If William and his host called in at St. Paul's Church to see **frontispiece** how the Munich glass William had designed was wearing, he did not see fit to mention it to his brother-in-law and, evidently, he was not reminded of the toil of working on a large scale and the awkwardness of his patron for before the day had passed William had accepted a commission to paint four long narrow pictures representing Chevy Chase for the sum of £400. The pictures, which were not to be in fresco, were never executed, perhaps owing to William's death early in 1864. Nor are there any sketches to suggest that he had begun planning Chevy Chase but the existence of a gigantic, solid-oak sideboard, carved by Gerrard Robinson of Newcastle-upon-Tyne with scenes from the ballad of Chevy Chase, undoubtedly intended for the dining-room at Alnwick Castle, suggests that William's painting was to be part of a total scheme of decoration.[5] Gerrard Robinson had been a pupil at the Newcastle School of Design where the director, William Bell Scott, was known to Dyce and the commission may, in fact, have come through the latter's good offices. Two years after the sideboard was completed in 1863 the fourth Duke died and he was succeeded by his cousin who was in his eighty-seventh year. The sideboard never reached its destination and William's paintings were never executed but together they might have helped to re-create in the Alnwick dining-room an atmosphere redolent of the ancient, northern heritage of the Percys, thus contributing to the general restoration of the castle about which William wrote to his brother-in-law.[6]

Considering the fecundity of Dyce's imagination, his breadth of know-

[4] D.P. XXXIX, W. Dyce to R. D. Cay, 6 Oct. 1859. For a discussion of the 'rubbishing so-called Gothic' at Alnwick see J. Macaulay, *The Gothic Revival 1745–1845* (Glasgow and London, 1975) ch. V.

[5] The sideboard is now in the residents' lounge of the Grosvenor Hotel, Shaftesbury. See G. Batho, *The Chevy Chase Sideboard* (Trust Houses Ltd. pamphlet, 1960).

[6] D.P. XXXIX, W. Dyce to R. D. Cay, 6 Oct. 1859.

ledge and experience, and the variety of media in which he worked, it is surprising how limited his choice of subject in easel painting was. With the possible exception of *The Highland Ferryman*, William painted no subjects **54** which could be described as genre or fancy pictures. For literary sources he rarely looked further afield than Shakespeare, Dante, and the Bible. His reputation as a painter in our own century has rested largely on his series of pictures of the Madonna, Christ and those near to him, a number of carefully chosen Old Testament subjects, and a collection of paintings of the late fifties which have hitherto been considered primarily as landscapes but in which there is unquestionably an important biblical content.[7]

The fact that William's choice of subject was limited does not mean that it was haphazard. On the contrary, he exercised great care in his choice of subject. In the area of biblical subject matter, as well as the predictable artistic questions, the necessity of reconciling traditional religion with the needs of contemporary life seems to have been at the forefront of his mind. When, in 1860, William exhibited *The Man of Sorrows*, **71** a painting of Christ in a desolate Scottish landscape, F. G. Stephens, writing in *The Athenaeum*, asked why the artist, with all this literalness, did not paint Christ in the land where he really lived.[8] In the previous year William had exhibited *The Good Shepherd*, in which Christ is represented full- **85** length, holding a lamb in one arm and a crook in his hand, guiding sheep through a narrow opening in a fence into an enclosed field. The landscape of rolling high country is reminiscent of Ayrshire or Galloway where William spent holidays in the thirties. It is, as *The Art Journal* recognized, overtly, even aggressively contemporary.[9] The landscape includes modern farm buildings and a feeding-trough fixed round the trunk of a dead tree. The figure of Christ is so much larger in relation to the rest of the scene than the comparable figures in *Gethsemane, David as a Youth, The Flight into* **92, 68** *Egypt* and *The Man of Sorrows*, about which Staley—who had not seen *The* **84, 71** *Good Shepherd*—has written so perceptively, as landscapes, that questions concerning the artist's intentions in this series of religious landscapes are inevitably raised.

Gethsemane, David as a Youth, and *The Flight into Egypt* are undated and were never exhibited in William's lifetime. They belong—like almost all

[7] They are regarded as landscapes by Staley in *The Pre-Raphaelite Landscape*.
[8] *The Athenaeum*, 11 May 1860, 653.
[9] *The Art Journal*, n.s. v (1859), 164.

his best easel pictures—to the group of paintings which he executed very much on his own account and which were given to or bought by friends and relatives. Some remain to this day with descendants of the artist. In

84 *The Flight into Egypt*, William introduced a large cactus into the foreground and painted a landscape which, whilst geographically convincing is much

85 less particularized than the landscape of *The Good Shepherd*. The holy family are engulfed in the generality of their surroundings as they wend their way through a twilight landscape, tender and mysterious. The scene evokes Elsheimer's *Flight into Egypt*. The somewhat elegiac mood of the painting, the eastern vegetation, and the rounded, less gritty, landscape has much in

88 common with *St. John Leading the Blessed Virgin Mary from the Tomb*, begun in the forties and completed in 1857 and, therefore, probably dates from

68, 92 the mid-fifties. *David* and *Gethsemane* compare with *The Flight into Egypt* and *The Man of Sorrows* in size and in medium (oil on panel). All three show relatively small-scale, single figures in highly particularized landscape

71 settings. We know *The Man of Sorrows* to have been exhibited in 1860, and it seems, therefore, reasonable to assume that *David* and *Gethsemane* were painted between 1857 and 1860.

Staley scarcely considers the figures in these paintings of the fifties and quotes the view expressed by the writer in *The Art Journal* of 1859 that Dyce, by placing the Good Shepherd in 'cultivated country, such as might be seen in any rural district around London' and locating Gethsemane in a Scottish glen, was merely following 'the simple conceptions of early Florentine painters'.[10] But William, as an extremely active and articulate High-Churchman, believed in a contemporary Christ. The passage of poetry written by his friend John Keble, which William selected to accompany *The Man of Sorrows* and which is inscribed on the picture's frame, stresses the human suffering of Christ in the wilderness, 'unsheltered and unfed'. William's deliberate presentation of biblical characters as very human and as existing in a physical environment described in concrete detail is essential to his theological interpretation of his subject and is not a means of evoking the ethos of an earlier style of art.

85 *The Good Shepherd*, though painted on canvas and much larger than the panels, is probably a replica of the small painting of the same subject which William exhibited at the Academy in 1857, and belongs to the same group as *Gethsemane* and *The Man of Sorrows*. With its detailed land-scape but large figure, *The Good Shepherd* draws attention to the error of

[10] Staley, p. 165.

discussing paintings like *David* and *Gethsemane* in terms of landscape exclusively or even primarily. The intention behind all these paintings is that of the subject painter. In *The Good Shepherd* Christ, in his most human form, **85** is engaged in the tender task of caring for the flock. The subject of Christ at the gate and the introduction of so much ivy must—despite the restrained colour—relate the painting to Pre-Raphaelite work.[11] Millais had employed complex and emotive pictorial symbolism in *Christ in the House of His Parents* of 1850 and it may be that William, who had not hitherto shown any tendency towards overt symbolism, was influenced here by Millais's painting. Possibly *The Good Shepherd* may have been planned as a pictorial exposition of the ideas William had put forward in *Notes on Shepherds and Sheep*, his reply to Ruskin in 1851, with the sheep being carefully conducted into the sheep-fold, that is, into the nave.

A small undated canvas, for which two drawings very similar to those for *David* have survived, must date from about this time. *Christ and the* **81** *Woman of Samaria* lends itself, like *The Good Shepherd*, to a doctrinal inter- **82, 83** pretation. The woman comes to Christ at the true fountainhead and, **69, 70** having drunk, will return through the narrow gap in the wall bearing her pitcher to the light beyond. The subject is the typological successor to that other biblical episode by the well, the meeting of Jacob and Rachel, that William had portrayed in the year of his marriage. In *Christ and the Woman of Samaria*, the figure of Christ is mysterious and deeply melancholy, passive and gloomy, as in *The Man of Sorrows*, but the strongly architectonic **71** structure of the painting, centring on the diagonal line of deep blue drapery, ensures that Christ is the compositional as well as the symbolic core of the picture.

Gethsemane can also be seen primarily as a religious subject painting in **92** which landscape is brilliantly used to reinforce the artist's presentation of Christ, the man, in his most human predicament.[12] No wonder William did not look to the Holy Land for geographically accurate landscape backgrounds. His native scenery had far more to offer an artist who valued the emotive and symbolic qualities of a landscape as a means of conveying a

[11] The relevant biblical passage is John 10:9: 'I am the door: by me if any man enter in, he shall be saved, and shall go in and out, and find pasture'.

[12] This painting continues to be misunderstood. Mr. Geoffrey Grigson refers to the possibility that it could have been a good landscape—without a badly drawn Christ in bright blue wandering awkwardly in front of trees ... and says that this would have 'the strongest human content and appeal' (*Listener*, 20 Nov. 1975).

92 specific religious conviction. In *Gethsemane* William depicts a figure even smaller in relation to his surroundings than is David in the picture of that name. Whereas David appears jubilant, feet astride, looking heavenward from his vantage point high above us, Christ appears intent, head bowed, cloak wrapped tightly around him as he ascends rough ground in a direction which leads him out of the picture. The fact that these figures are small in relation to the total surface of the canvas does not mean that they are incidental features in what is primarily a naturalistic landscape-painting. On the contrary, figure and landscape accord in a sensitively calculated total pictorial statement. The landscape element is so controlled as to convey most effectively the mood and the dramatic implications of an event in which the human figure is so overwhelmingly dominant as to render his actual size immaterial.

We view Christ in *Gethsemane* from a position high above the valley and the eye travels down the winding, stony, boulder-strewn path to a narrow gate set in a wall. Dark, lowering hills and thickly foliated trees oppress and bear down upon the small and vulnerable figure. All the confidence and airiness of *David* are lacking in this picture. Christ seems a small, lost figure as he turns from the difficult path towards no visible goal. If one considers the account of Christ's hours in the Garden of Gethsemane as described in the New Testament, it can be seen how Dyce calculatedly uses the landscape so familiar to him as a symbolic and as an emotional, associative means of expression. The narrow winding path and the half-open gate must be taken for what they are, symbols of the difficult path that Christ must tread. The gate is open ready for him and the path apparently leads to the gloomiest and densest of forests. But above the forest a bright sky holds promise for the future. Not only the details of the closely observed landscape are important but also the general forma-tion of the land. The geological structure of the plateau country in *David* offers a view calculated to inspire optimism whilst the claustrophobic valley of Gethsemane fills us with doubt and a sense of foreboding.

If we compare the religious paintings of William's contemporaries with *Gethsemane*, *David*, or *The Good Shepherd*, the strength and individuality of the latter are very evident. William's work is clearly outside the tradition of biblical histrionics of John Martin. J. R. Herbert, however, had much in common with William; he was a Roman Catholic convert from High Anglicanism, a member of the Etching Club and he worked with William at the School of Design where B. R. Haydon condemned them both as

'Vicious "and" German'.[13] His painting *Our Saviour Subject to His Parents at Nazareth* of 1856 shows, however, a conscious archaism and pedantry quite absent in William's work. In *Laborare est Orare* both subject and style are **91** Northern Gothic in origin and, historically accurate and pleasing as the painting is, it constitutes a form of pastiche which weakens the conviction of the artistic statement. William Henry Fiske in *The Last Night of Jesus* **90** *Christ in his Nazarene Home* of 1864 diffuses and dilutes the pictorial impact by the attention he pays to the narrative element in his subject. William devised his own means of conveying religious faith and, through the careful and restrained balance of figure against landscape, landscape against figure obviated all need for either archaistic detail or narrative emphasis.

What we might reasonably describe as a historical landscape, *Henry VI* **115** *at Towton*, probably also belongs to this period of the late fifties though it was never exhibited in Dyce's lifetime. It is painted on canvas, unsigned, and undated, but bears many of the hallmarks of the group of paintings we have just been considering: size about 35.5 × 50.8, a single figure in a particularized and barren landscape, cool restrained colours. Before a ruined cottage, the defeated king broods over the uncertainty of his future. The ex-king's gesture and facial expression are unhappily theatrical and the picture lacks the solemnity and vitality of *David*. It is significant, **68** however, that William should have chosen to present this figure as anti-hero, the king who is down on his luck, no better than a shepherd, an undramatic complement to the Lear he had painted in 1851. Carlyle was writing about heroes and G. F. Watts and Maclise were still painting heroic acts from historical and literary sources but William's *Henry VI* is typical not only of the artist's interest in individuals isolated or more or less solitary, in moments of intense mental or spiritual activity (Joash, Beatrice, George Herbert, Christ) but also of a new sort of historical subject painting which was developing at this period in which celebrated and royal personages were presented as ordinary people. Alfred Stevens painted *King Alfred as a Boy with His Mother* in 1848 and E. M. Ward painted the French royal family, down on their luck, in the prison of the Temple in 1850.

During these years William kept in touch with old friends. In March 1858 he had corresponded with W. E. Gladstone about the fine arts copyright bill,[14] finally passed in 1862, and the following year the

[13] B. R. Haydon, *Diary*, xxiv 4 Nov. 1842.
[14] D.P. XXXVII, W. Dyce to W. E. Gladstone, 8 and 12 Mar. 1858.

Chancellor (a great Dante enthusiast)[15] asked William to paint a picture of Beatrice. William used photographic studies of an unnamed subject chosen by Gladstone. The girl was, in fact, a magdalen, one of the prostitutes Gladstone had rescued from a life of sin.[16] The painting is known **66** as *Lady with the Coronet of Jasmine* and is an interesting reflection of the motives of Gladstone in his rescue work. The pensive stillness of Beatrice, seen in three-quarter view, head and shoulders (a pose William rarely used in painting portraits), the painstaking execution, and a surface gloss on the **108** drapery loosely pinned about the lady's shoulders remind us of *Christabel*. The mood of both subjects is akin to the devotional half-length paintings of the Madonna or of angels and saints by Dyce and by Eastlake. But there is a fullness and a sculptured quality about the face of Beatrice which distinguishes it from the flat features of Christabel which Ruskin had regarded as a pastiche of Botticelli. It is, therefore, surprising to learn that a Dante scholar, Mrs. Clara Detmold, writing from Florence in 1863, considered *Lady with the Coronet of Jasmine* as 'a perfect Florentine type' and likened the arrangement of Beatrice's hair to that used by Botticelli.[17] Gladstone, at any rate, was pleased with the ethereal lady and hung William's painting in an honourable position at eye level, flanked by a Gaudenzio Ferrari and a Lucas Cranach.[18] A further study from Dante: an unfinished *Dante and Virgil* in the manner of Ary Schaffer is in Aberdeen Art Gallery.

The following year William painted another head and shoulders, three-quarter view, this time returning to the Old Testament for a male character, **87** Eliazer of Damascus. The choice of this obscure biblical figure (even the spelling of his name varies) Abraham's chief steward, was certainly not made in order to give a plausible title to a picture of an elderly man in Eastern dress after William had painted it.[19] Although in his biblical painting William was interested in accurate costume and at some date had painted a water-colour of a young, bearded relative, Adam Wilson, in Arab head-dress and robe, it is not consistent with William's character nor with

[15] See Marcia Pointon, 'W. E. Gladstone as a Patron and Collector', *Victorian Studies*, ix no. 1 (Sept. 1975).

[16] D.P. XXXIX, W. Dyce to W. E. Gladstone, 6 and 9 Aug. 1859. My supposition about the identity of the sitter is confirmed by Colin Matthew, editor of Gladstone's diaries.

[17] Quoted in *William Dyce R.A. 1806–1864*, exhibition catalogue, Aberdeen Art Gallery 7 Aug. to 13 Sept. 1964, introduction.

[18] Gladstone–Glynne papers, Clwyd. County Record Office.

[19] A. Staley, *Eleazer of Damascus* by William Dyce, *Minneapolis Institute of Art Bulletin* (1967).

his practice as a painter that he should have painted a subject and identified it afterwards. Eliazer is a common Old Testament name and means 'Help of God'. In painting the head of this old and weary-looking man against a barren landscape William was again evoking the mood of gloom and despondency that emanates from *Henry VI at Towton* and *The Man of Sorrows*. **115, 71** Desperately struggling on in the Queen's Robing Room where, in more optimistic days, he had painted another Eliazer, King Pelles's son, in *Religion: the Vision of Sir Galahad*, William must have felt sorely in need of **152** God's help. It is interesting to note that Holman Hunt chose to depict Eliazer talking to Rebekah at the well in 1863 for Dalziel's *Bible Gallery*. Dyce remained an important influence on Hunt and *Eliezer and Rebekah at the Well* is a reinterpretation of Dyce's imagery in *Jacob and Rachel* and **79** *Eliazer of Damascus*.

II

'A CURIOUS FEELING OF WAITING': THE LAST YEARS
1860–1864

Throughout his life William had been troubled periodically by financial problems. As a young man in Edinburgh during the thirties he was not completely dependent upon his income from portrait painting and received some kind of monetary support from his father. This arrangement seems, however, to have had its drawbacks and a major quarrel between William and one of his sisters occurred in 1834 when she and a Mr. Ross, who was to be a signatory for a cash account, refused to have anything to do with William because of 'a series of affronts and insults' which she claimed William had heaped upon her, 'the climax of which was the affair of the dinner party'.[1] We know none of the details of this unfortunate incident nor the amount which Dyce received from his father. It is clear, however, from his correspondence in the forties that William was not well off financially. William's son tells us that his father's mother died in 1856 and he was then relieved of the responsibility of her allowance of £100 a year which had 'told heavily at times on his by no means large purse'.[2]

During the early years of his marriage, William had rented 'a delightful place' called 'The Oaks' in Norwood but in 1856, possibly because of his improved financial position, he commenced house hunting. Resisting the temptation of an 'old *Chateau* in Chelsea' overlooking the river with behind it 'a garden of an acre and a half with fine old trees in it',[3] where he would have had Rossetti and Carlyle as neighbours, William chose a recently built and well-proportioned house in Leigham Court Road, Streatham. At that

[1] D.P. II, W. Dyce to R. D. Cay, 22 Oct. 1834.
[2] D.P. XXXIII.
[3] See n.2.

time the area retained most of its rural charm though it was soon to be transformed by the 'alarming intrusion of small houses' that towards the end of the century threatened to 'drive the wealthier and professional class of residents further out'.[4]

Streatham offered the Dyce family a degree of quiet and seclusion, though William must have found the journey to Westminster, where he was still working on the Queen's Robing Room frescoes, tedious. The family also enjoyed summer holidays away from home. In October 1857 and again in 1858 they were in Kent, near Ramsgate, where William recorded the chalk cliffs and shell-strewn beach of Pegwell Bay in a water- **53** colour that he subsequently worked up into a full-scale oil for exhibition at the Royal Academy in 1860. The painting, exhibited with the title *Pegwell Bay: A Recollection of October 5th. 1858* shows the shore with the tide **52** out on a cool autumn day. A few people wander about the shore, fishing in the rock pools, leading donkeys, and in the case of the male figure at the far right of the canvas, carrying artist's materials. Perhaps this figure represents the artist himself since the foreground figures are (from right to left), the painter's wife and her two sisters, Grace and Isabella Brand. The boy is one of the artist's sons.[5] In the sky can be seen Donati's comet, first observed on 2 June 1858.

Pegwell Bay has often been described as William's finest painting[6] and it has, since it was first exhibited, evoked a consistently intense, though not always favourable, response. The 'shores of chalk' have been described as 'painted in a desperate pallid gleam of imagination' and the picture has been associated with 'the ugly end of the world'.[7] It has been criticized for the 'irritating spottiness'[8] with which the scene is depicted and admired for its 'peculiar quality of realism'. The smallest details, writes one critic, 'are exalted by that kind of immortal beauty which the artist bestows upon his family, on the pebbles of the beach, on the distant strollers walking on the seaweed, or on the crystal clear sky where the late afternoon light gives a curious feeling of waiting, of unease mingled with joy, of a calm solemnity which was for the artist the dominating emotion of this fifth of October which he has so magnificently perpetuated.'[9]

[4] *Building News*, xl, (1881) quoted by D. J. Olsen, *The Growth of Victorian London*, (1976), 243–4.
[5] D.P. XL, information from Dyce's son.
[6] e.g. K. Roberts, exhibition review, *Burlington Magazine*, cv (1964), 527.
[7] D. S. MacColl, *Nineteenth Century Art* (1902), 115.
[8] W. D. Mackay, *The Scottish School of Painting* (1906), 252.
[9] M. Brion, *Art of the Romantic Era* (1966), 95–8.

The years 1856–8 were precisely the time when photography ceased to be a somewhat specialized practice and became not only popular but highly regarded as an adjunct to other media. Photography in 1857 was 'Art's youngest and fairest child; no rival of the old family, no struggler for worn-out birthrights, but heir to a new heaven and a new earth, found by itself, to be left to its own children'.[10] *The Art Journal* during these years is full of advice to photographers and in 1856 a chair of photography was established at King's College, London. It is unlikely that an artist of William Dyce's breadth of knowledge would have been unaware of these developments. Moreover, there is concrete evidence that at a much earlier date William was already conversant with developments in the field of photography. His friendship with David Octavius Hill probably dates from the thirties when both men were working in Edinburgh and at the very time when Hill and Adamson were busy with their calotype equipment, William wrote to them from Rome advising that; 'a trip to Rome with your kulotype [*sic*] machinary would prove a profitable one to you'. William thought that 'with the miraculously intense light of a Roman sky and the beautiful subjects ... among the Calabrian peasants and others' Hill could 'work wonders'.[11]

52 It would be very surprising if *Pegwell Bay* were lacking the sort of detail associated with the relationship between photography and painting in the nineteenth century. But recent discussions of the influence of photography on pictorial art may be in danger of obscuring the complexity of the sensitive Victorian's response to external nature. As an essay in photographic realism *Pegwell Bay* will not stand close examination. James Dafforne, writing in the artist's lifetime, denied that the painting was based on a photograph[12] and the artist's cousin, the eminent Shakespearian scholar, Alexander Dyce, complained that William had embellished the features of Pegwell Bay and misrepresented the colour of its cliffs.[13]

53 If we compare the water-colour sketch of Pegwell Bay that William executed in 1857 with the completed painting, important differences are discernible. There are more figures in the painting and the fence at the right-hand side is less decayed and in a different position. The geological structure of the cliffs in the finished painting differs from that in the

[10] *Journal of the Royal Photographic Society* (Feb. 1857).
[11] D.P. XXIII, W. Dyce to D. O. Hill, 17 Mar. 1846.
[12] J. C. Dafforne, 'William Dyce, R. A.', *The Art Journal*, n.s. VI (1860), 293–6.
[13] A. Dyce, *The Reminiscences of A. Dyce*, ed. R. J. Schrader (Ohio, 1972), 212–13.

sketch; the caves have become shallower, a prominent gully has replaced the central cave, and the cliffs are higher. However, the most important difference is probably one of mood in a painting in which visual data are recorded in minute detail and subjected very deliberately to the imaginative faculty. The emotional effect of the sketch is concentrated in the power of the landscape without weakening the dominance of the natural surroundings, whereas in the painting the figures introduce an element of dream and nostalgia, the consciousness of time passing.

William stresses the quality of memory in his title, *Pegwell Bay: a Recollection of October 5th. 1858*, and as the sketch is dated 1857, the memory that is celebrated in the picture, exhibited in 1860 and painted presumably in 1859–60, is of a time more distant than is indicated in the title of the painting. In his insistence on recollection, William is at variance with the fashion of his time for photographic authenticity. The Pre-Raphaelites spent hours ensuring complete visual accuracy and W. P. Frith told students to 'go to nature for every detail . . . no dependence should be placed on memory whilst a possibility exists of referring directly to nature'.[14] William's vision and his way of looking at landscape was probably modified not by looking at photographs (as Frith did) but by his knowledge of how landscape appeared through a camera lens. The figures in *Pegwell Bay* are painted in the near foreground and treated in such detail as one might expect to see at close proximity and yet we view them and the scene across a vacant space. This contributes to the disconcerting effect of remoteness and isolation with which the painting has frequently been identified. Early cameras consisted of a positive (biconvex) lens of crown glass cemented to a negative (biconcave) lens of flint glass. They had a long focal length which meant that, when looking through the view-finder, everything was seen distanced from the viewer. The popular stereoscope picture, which was three-dimensional, had a very similar effect.

In so far as the rendering of the landscape in *Pegwell Bay* presents an air of exactitude, it is the result of artistic manipulation and the feeling of photographic realism in the painting is an illusion, albeit an assiduously cultivated illusion. The realism of *Pegwell Bay* is not an end in itself but a vehicle for the expression of an intellectual response to a scene which is also imbued with strong personal feeling. *Pegwell Bay* is a painting about time, explored through an image of a particular moment in time. William included a date in the title of his picture not because, like Constable,

14 W. D. Frith, *My Autobiography and Reminiscences* (1887), 6th edn. 1888, 206.

Mulready, and other nineteenth-century landscape painters, he desired to record weather conditions accurately and scientifically on a particular day. There is scarcely a perceptible movement of seas or cloud in *Pegwell Bay* and no breath of wind stirs the women's shawls. There can be only one reason for the date given by William, 5 October 1858, and that is Donati's comet. William chose to paint the day when the comet appeared at its most brilliant and when its progress was being recorded by astronomers throughout Europe. On 2 October, The *Illustrated London News* gave an account of the history of the comet and described its development, telling readers that the comet was then passing the star Arcturus and that its course on 5 October could be easily traced. 'At six p.m. of Oct. 5 it will be a *very little* to the right, and a *very little* to the south of Arcturus', writes the correspondent, 'and we hope our readers will have a clear sky to witness the conjunction of two such bright objects. . . .'[15]

Pegwell Bay is, therefore, an extremely topical painting. It could be that Donati's comet simply pinpoints more accurately the day and the hour but astronomy is not the only science which plays a part in the imagery of the painting. Tennyson described astronomy and geology as terrible muses[16] and it is, surely, no coincidence that astronomy, represented by the comet, is accompanied in Dyce's painting by her sister muse, geology, apparent in the fossil-embedded chalk cliff and the shell-strewn beach. Charles Lyell, in his revolutionary work on geology,[17] published between 1830 and 1838, established the modern view that the greatest geological changes were not the result necessarily of stupendous events but the result of processes in time that were still at work. Lyell regarded his subject, for all its vastness, as microscopic in comparison with that of the astronomer.[18] Donati's comet, which dominates the late afternoon at Pegwell Bay, represents a system immensely distant in space ('on Oct. 2nd . . . it is sixty-two million miles from us') and incalculable to any degree of accuracy in time ('It would seem that this comet will return in 2100 years time; but with comets of this period . . . calculators cannot be certain to a few centuries.').[19] Yet the artist portrays his relatives strung out like pebbles in

[15] *Illustrated London News*, 16 Oct. 1858. I am indebted to Mrs. Ruth Pitman for drawing my attention to this article and for much helpful discussion about *Pegwell Bay*.

[16] 'Parnassus', published 1889, *The Poems of Tennyson*, ed. C. Ricks (1969).

[17] C. Lyell, *Principles of Geology* (1830–3) and *The Elements of Geology* (1838).

[18] C. Lyell, *Elements of Geology* (1838), revised edn. 1865, 2.

[19] *Illustrated London News*, 2 Oct. 1858.

a stony land where all activity is desultory and humanity regards neither astronomy nor geology, nor even its fellow humanity. The terrible muses deny the validity of a single human life and, even more, of a single human day. Nevertheless, sea-shell gathering is the only reality for these people in this place on this day which the artist has transfixed in time.

Pegwell Bay is devoid of the frenetic holiday fun that we associate with other paintings celebrating the Victorian sea-side. In Frith's *Ramsgate Sands* (Collection of H.M. the Queen), man controls and dominates the beach but *Pegwell Bay* is almost devoid of habitation and the cliffs, threatened with erosion, menace a pebbly beach which is itself witness to the way in which geological time grinds rocks into stones. In this setting humanity is utterly vulnerable before the great forces of time. Dyce achieved in *Pegwell Bay* a coherent and sensitive appraisal of human perplexity before the beauty and the threat of time made discernible in nature. His concern with the new nineteenth-century sciences: time, geology, and nebular astronomy, was shared by many of his contemporaries. The effectiveness of William Dyce's portrayal of a concept of universal human time in opposition to human daily time is equalled in its period only, perhaps, by Matthew Arnold's 'Dover Beach' with its 'grating roar of pebbles' and its 'eternal note of sadness'.[20]

In 1860, William took his family to Wales for their holiday and there he was able to explore further aspects of nature that had fascinated him at Pegwell Bay. Shortly after this visit, William wrote to his friend and brother-in-law about his observations of the area:

The only place I have seen in Scotland which reminds me of the very wild parts of North Wales is Glen Rosa in Arran ... but there are a hundred such places in Wales ... and the mountains are generally more rugged, stony and precipitous, more awful and terrible looking than anything I know of in Scotland ... One great cause of the beauty of the Welsh mountains is, I think, to be found in their geological formation. In Scotland the granite mountains, by the process of disintegration become rounded and their asperities smoothed down ... but in Wales, the material being slate rock, it does not crumble like granite into dust or sand but splits and tumbles down in huge flakes which leaves the peaks from which they have fallen as sharp and angular as if they had never been acted upon by the atmosphere at all.[21]

[20] *Pegwell Bay is discussed in greater detail with relation to the history of ideas in M. Pointon, 'The representation of time in pictorial art: a study of William Dyce's Pegwell Bay: A Recollection of October 5th 1858', Art History,* i (Mar. 1978).

[21] D.P. XL, W. Dyce to R. D. Cay, 20 Oct. 1860.

William's comments on the comparative geological formation of Wales and Scotland indicate that he was by this time familiar with theories of erosion and suggest that he had read Lyell's *Principles of Geology* (1830–33) a book which was widely known and accepted by the late fifties. The imagery of time which is such an important part of *Pegwell Bay* is reiterated **61** in *Welsh Landscape with Two Women Knitting* which William painted shortly after his Welsh holiday. As in *Pegwell Bay*, there is little suggestion in the picture of human habitation (in this case only a small hut in the background) and an absence of purposeful, sustaining human activity. But *Welsh Landscape* makes no concession to nostalgia, memory, or affection, that is to those elements that man uses as a weapon against time and which William's contemporary exploited so effectively in his poem *In Memoriam*. *Welsh Landscape* is harsh in colour and lacks any sort of pastoral lyricism or subjective evocation of mood. It is as severe a statement as one might expect to find in a painting which draws on the traditions of naturalistic landscape and genre.

The two women in their Welsh costumes, surrounded by ancient rock formations are knitting. The painting cannot be explained simply as a realistic representation of natives in their natural habitat.[22] The activity of the two women, like Penelope's weaving or the ominous knitting of the old woman at the beginning of Conrad's *Heart of Darkness*, suggests the inexorable progress of time. The woman on the right is young and beautiful while the face of the woman on the left is wrinkled and sunken with extreme old age. Yet her age is as nothing compared to the age of the rocks on which she is seated. Above the two Welsh women a sickle moon suggests the cyclical routine of the universe beyond man's control.

From the end of the eighteenth century North Wales had been a great attraction for British landscape painters in search of the picturesque. Published volumes like Thomas Roscoe's *Wanderings and Excursions in North Wales* (1836), illustrated with engravings and drawings by Cox, Creswick, Cattermole, and others were commonplace. William painted at least two studies of the Trifan peak which he found 'very fearful to look at'. He described to R. D. Cay the terrors of the ascent as recounted to him and his family by another guest at their hotel who had attempted it but turned **60** back.[23] An oil painting in Hamburg shows the Snowdon range against a

[22] Such an explanation is offered by L. Nochlin who writes in *Realism* (1971), 124 of a 'harmless representation of colourfully costumed natives in their natural habitat'.

[23] D.P. XL, W. Dyce to R. D. Cay, 20 Oct. 1860.

stormy sky with a meadow and trees in the foreground. .A water-colour **59**
study similar to the Arran studies of 1859 but, if anything, rougher in
treatment and displaying a more liberal use of paint, is in the Ashmolean
Museum. The technique is comparable to that used by a contemporary
like Francis Danby who, in *Lyn Idwal* (Whitworth Art Gallery), uses a
range of colours dominated by greys, buffs, and sandy tones applied in a
determined and harsh manner.

After his experience of Welsh scenery, Devonshire, which William visited
in order to inspect a property that his wife, Jane, wished to purchase,
was a disappointment.[24] He seems, however, to have found some scenery
sufficiently attractive to wish to sketch as *Trebarwith Sand, Tintagel*, a water-
colour now lost, must have been done during this, William's only known
visit to the south-west.

George Herbert at Bemerton, which William exhibited at the Academy in **112**
1861, succeeds where *Titian* and *Henry VI* fail because it carries that sense **111, 115**
of personal conviction which strengthens *David* and *Gethsemane* and lifts **68, 92**
them above the level of spectacular but banal reproductions of reality. Like
Titian, it glows with remarkably jewel-like colour, and, as with *Henry VI*,
solitude as a real experience pervades the picture. Like *Pegwell Bay, George* **52**
Herbert fills us with a curious sense of waiting. The beautiful vista across
marshy land to Salisbury Cathedral, the calm stillness of the river, and
the breezeless sky help to create a mood which complements and enhances
the subject, a mood which is lacking in Titian's claustrophobic garden.

George Herbert was a particularly compelling subject for William. Not
only was he an artist in the service of God, but he was one of a group of
seventeenth-century divines whose writings were favoured by the Tract-
arians. As a result of this Bemerton became a shrine of true anglicanism
in the nineteenth century. The rector of Bemerton in 1860 was Cyril Page,
a friend of William's and the recipient of the fresco specimen which William
had sent to Westminster Hall in 1843. *George Herbert* was painted during
a visit that William made to Bemerton.

William painted George Herbert from a portrait of 1674 engraved by
R. White and frequently reproduced in nineteenth-century editions of
George Herbert's works. He stands, a small but dignified and very notice-
able figure, in the garden from which much of the natural imagery which
illuminates his poetry must have been drawn and which remains almost
totally unchanged to this day. He holds a book and is reciting verses aloud.

[24] D.P. XL, W. Dyce to Mrs. W. Dyce, 20 Nov. 1860.

The lute which is propped against the bench suggests the lyricism of Herbert's poetry and the fishing-tackle by the tree alludes to his vocation as a fisher of men. It might also refer to Izaak Walton, who wrote the first biography of Herbert in his *Lives* of 1670 and who, in his *Compleat Angler*, quoted from Herbert's poem 'Sweet Day so calm, so cool, so bright', because he believed Herbert to possess 'a spirit suitable to anglers'.

112 A nineteenth-century account of *George Herbert at Bemerton* describes how William at first depicted not only Herbert but also Walton and, on being reminded that the two men lived at different periods consented to remove Walton but said, 'I'm d—— if I take out his basket!'[25] There are no signs of painting-out and only an X-ray photograph could determine the veracity of this account.

Varied demands on William's time as well as his obvious preference for travel and painting small-scale subjects continued to distract him from his task in the Queen's Robing Room. In 1862 he was occupied for a month

111 as a juror in the stained-glass section of the International Exhibition. *Titian*

52 and *Pegwell Bay* hung in the fine art section and the condemnation of Dyce by his friend, F. T. Palgrave, who described him on the evidence of this exhibition as an artist capable of 'microscopic accuracy' but bereft of imagination, must have been very wounding.[26]

For some time since he had taken up residence in Streatham, William had been a churchwarden of St. Leonard's Church which had been re-built in 1831. The apse that had been added at the east end was removed in 1863 and a chancel was built by Benjamin Ferrey, a pupil of Pugin. Dyce is said to have been responsible for the design of the chancel and also to have supervised its construction.[27] In 1862, the parishioners of St. Leonard's raised a sum of money to erect a drinking fountain as a gesture of recognition to Dyce for his services to the parish.[28] William, himself, designed the fountain which still stands on Streatham Green. The parishioners were offered alternative designs. One is in the form of a font-

133 like basin from which rises a central colum surmounted by the figure of

[25] A. G. Temple, *The Art of Painting in the Queen's Reign* (1897), 62.

[26] F. T. Palgrave, *Descriptive Handbook to the Fine Art Collection of the International Exhibition of 1862* (1862), nos. 596 and 613.

[27] W. Godfrey Bell, M.A., *The Story of the Church of S. Leonard, Streatham* (1916), 35, 70, H. W. Bromhead, *The Heritage of St. Leonard's Parish Church, Streatham, being an account of the traditions and associations of the Church incorporating notes on the monuments by Mrs. Arundel Esdaile* (1932), 76.

[28] Col. Sir Geoffrey Hearn, 'An Itinerary of Streatham', TS. Lambeth Public Library, quoted by P. Cunningham, unpublished M.A. thesis, University of East Anglia, 1973.

Christ. It is decorated with mosaic patterns like those which William had used in his frescoes at Westminster and in the stained-glass window at St. Paul's Alnwick. The inscription round the bowl reads 'He that drinketh of this water shall never thirst'. William's fellow worshippers chose the **134** other design which is polychromatic with a trefoil arched recess and, around a blind arch, the inscription: 'For I will pour water on him that is thirsty'.

Meanwhile, William was still working on *Hospitality*[29] in the Queen's **163** Robing Room. Arthur appears bearded and venerable, stepping forth from the Round Table, brandishing his famous sword in welcome. By means of a violently receding pattern of floor tiles and the disposition of figures around the periphery of the picture space, William created a spacious and relatively dramatic central panel for his series. Perhaps it was inevitable that William, weary as he undoubtedly was with the whole scheme, should have been at his most eclectic in this fresco. The arched bays in deep shadow and the immensity of architecture and spatial dimensions remind us of John Martin in, for example, *Belshazzar's Feast*, whilst the wild figure of Merlin might be related to Martin's *The Bard* or the bearded sages so dear to Blake, James Barry, and John Hamilton Mortimer. Sir Tristram on his white horse introduces an air of Renaissance vigour, of imperial pomp and grandeur, into a design which might otherwise tend to be somewhat static with its numbers of gazing, motionless figures and its great, vacant, central floor-space. Marochetti's statue of Richard Coeur-de-Lion, first exhibited at the 1851 exhibition and later placed outside the House of Lords may have provided the inspiration for the figure of Sir Tristram, while the two small boys singing to the accompaniment of the harpist derive from Della Robbia.

The Romanesque arches of Arthur's Palace which are repeated in other compartments in the Robing Room must be a feature agreed upon by all the artists contributing to the scheme, as they appear, with slight variations, in Maclise's and Cope's work. But there is no real sense of continuity in the Robing Room frescoes themselves. *Courtesy* is architec- **160** turally enclosed and languid in feel, whilst *Generosity* is bursting out of the **161** picture-space. The subjects were conceived as a series of separate units and, although William was not ignorant of the visual problems of co-ordination, he undoubtedly had in mind the fact that his literary source was fragmentary and, in any case, he regarded the threat of coloured architec-

[29] Malory, Book x. ch. 6.

tural decoration being allowed to overwhelm his paintings as a far greater problem.[30]

Despite re-painting, cleaning, and the brash challenge of crimson plush carpet, and the more recent portraits on the east wall, the Queen's Robing Room still presents an impressive spectacle today. William, who believed that 'painted glass and fresco painted walls are sadly incongruous'[31] would, surely, have been delighted had he lived to see how the light floods from the garden outside through the grisaille glass of the south wall, lighting up the gentle greys, greens, and terracottas which, though faded, still suggest the cool and spacious colour scheme which William devised. The strength and clarity of form in William's frescoes and his feeling for space are not in the least suppressed by the ornate heraldic ceiling, the gold-tinted frieze with its coat of arms, or the 'Gothic' woodwork. In fact the intricate, light and coloured detail of the surroundings accentuates the vitality of William's designs, and the dark oak of Armitage's relief panels, immediately beneath the frescoes, supports them and relieves a perhaps otherwise slightly sombre effect. The decorated and inscribed frames provide a suitable transition from painting to woodwork. William would, surely, not have been dissatisfied had he lived to see the room complete.

This was not to be. In the winter of 1863, William was found by his plasterer, slumped in a chair, his brushes fallen from his hand. He never returned to Westminster and died a few months later, on 15 February 1864, at his home in Leigham Court Road.[32] The Queen had interposed graciously but tardily[33] and, by the time she expressed the hope that William would dismiss from his mind all anxiety about the unfinished frescoes and suggested that he should name any artist of his choice to complete the task he had begun almost twenty years before, it was too late. Mrs. Dyce named William's friend, C. W. Cope, and he finished *Hospitality* according to the design laid out in William's cartoon. The two remaining compartments were empty until the portraits which now occupy them were placed there.

William Dyce was buried in the north-east corner of St. Leonard's

[30] D.P. XX, W. Dyce to Sir C. Eastlake, 28 July 1845.

[31] D.P. XXX, W. Dyce to Sir C. Eastlake, 19 Mar. 1846.

[32] W. Godfrey Bell, M.A., in *The Story of the Church of S. Leonard, Streatham*, 70 says that Dyce lived in Streatham High Road but Stirling Dyce gives the family's address as Leigham Court Rd and this is confirmed by other sources.

[33] D.P. XLI, Mr. Cowper to W. Dyce, 6 Feb. 1864.

churchyard and, in 1865, a memorial brass was erected in the chancel of the church at the expense of his fellow-parishioners.[34] The brass, which is of a considerable size,[35] contains a portrait of the artist in a dressing gown, seated with his palette in his hand before a lectern on which is placed a copy of the Gospels. Behind him on an easel is *St. John Leading* **88** *the Blessed Virgin Mary from the Tomb* and at his feet is a prayer book. The portrait is a crude rendering of C. W. Cope's posthumous portrait of the **32** artist but the figure is set against a diapered background and surrounded by a design of vegetable scrolls incorporating medallions of 'saints and worthies that he loved' in the manner of the Winchester Bible and is, of its kind, not without distinction. The brass was executed by Hart, Son & Co. but someone with an intimate knowledge of the artist's life clearly contributed to the design. Isabelle Dyce, the artist's daughter, thought that her mother would have been consulted and suggested that C. W. Cope may also have been concerned with the design.[36] Whoever the designer was, the memorial is fitting. In the borders are portrayed St. Luke, the evangelist and patron saint of artists, St. Benedict Biscop, the Anglo-Saxon Churchman who brought books, music, pictures, and teachers from Rome to Northumberland, St. Cecilia, the patron saint of musicians, David with his harp, and St. Leonard, the patron Saint of the church. The inscription reads 'In memory of William Dyce, Royal Academician, painter, musician, scholar'.

[34] Bromhead, *The Heritage of St. Leonard's Parish Church, Streatham*, 49.

[35] It is not possible to give the exact measurements as at the present time it is lying in fragments in the crypt of St. Leonard's church after falling from the wall during the fire which destroyed much of the interior of the church in 1975. It is reproduced in Bromhead.

[36] Bromhead, p. 50.

CHECK-LIST OF WORKS
BY WILLIAM DYCE

ORDER OF ARRANGEMENT

Portraits

(i) *Female subjects* (ii) *Male subjects* (iii) *Children*

Landscapes, including drawings

(i) *Landscapes 1827–1837 (excluding the Continental tour of 1832)*
(ii) *Continental water-colours of 1832*
(iii) *Landscapes in England and Scotland 1840–1860*
(iv) *Figure subjects in landscape*

Subject paintings

(i) *Religious subjects, excluding the Madonna and Child*
(ii) *The Madonna and Child*
(iii) *Historical, mythological, and literary subjects*
(iv) *Genre subjects*

Cartoons, drawings, and studies for fresco, stained glass, and large-scale decorative work

Graphics and Design

(i) *Engravings* (ii) *Design* (iii) *Book illustrations*

Drawings

(i) *Figure studies* (ii) *Religious subjects*
(iii) *Literary and historical subjects*
(iv) *Miscellaneous*

Subjects are listed in chronological order as far as
possible within the classification given, except portraits
which are listed in alphabetical order according to the
surname of the sitter. Included are all those works about
which something is known other than simply the title.
No date is given where a work cannot be dated with any certainty.
Measurements are in centimetres, height before width.

Numbers in bold type refer to the Plates

ABBREVIATIONS USED IN THE CHECK-LIST

B.I.	British Institution.
Dyce Sale	Christie's, 5 May 1865.
I & D	List of paintings compiled by R. Ironside and Miss Isabelle Dyce (1932), Tate Gallery.
N.G.S.	National Gallery of Scotland
N.P.G.	National Portrait Gallery.
R.A.	Royal Academy.
R.I.E.A.S.	Royal Institution for the Encouragement of Art in Scotland.
R.S.A.	Royal Scottish Academy.
S.D.	Listed by Stirling Dyce in Dyce papers, ii.
S.N.P.G.	Scottish National Portrait Gallery.

Portraits

(i) *Female subjects*

Brown, Catherine Sarah (24)

b. 1821, m. Islay Burns 1845
first cousin once removed of artist
Oil on canvas
94.4 × 70.1
1837
Dr. W. Chalmers Burns
Coll. by descent to present owner.

Cay, Isabelle

(*née* Dyce) 1811–52 m. 1835
sister of artist
Oil on canvas
125.4 × 73.5
1835
Present whereabouts unknown.
Coll. formerly C. W. Dunn, Esq., Bishops
Stortford, grandson of sitter

Cockburn, Lady

m. Henry Lord Cockburn 1811
Oil on canvas
74.4 × 61.9
c. 1830
S.N.P.G.
Coll. Dowell's, 24 Jan. 1958 (93).

Crombie, Mrs. William

Oil on canvas
112.5 × 85.1
c. 1840
Aberdeen Art Gallery

Coll. Aberdeen City Council until 1885
Exh. Aberdeen 1888 (240)
I & D.

Davidson, Frances Mary (19)

(*née* Pirie) 1786–1859, m. Duncan Davidson
Oil on canvas
91.4 × 71.0
1829
Private collection, Staffs.
Coll. Mrs. L. E. O. Davidson, Minarloch,
Aboyne, descendant of sitter, to 1972
S.D.

Dundas, Jemima Christian

(*née* Macdowall), 1806–63, and her
daughter, Mary
Oil on canvas
91.4 × 130.0
R.S.A. 1836 (247)
James Findlay, Esq.,
Newliston, Kirkliston,
E. Lothian
Coll. Major R. T. A. Hog, by
descent to present owner
S.D.; I & D.

Dyce, Isabelle (21)

1811–52
sister of artist
Chalk
58.4 × 47.2, oval
c. 1830
Private collection, Perthshire
Coll. by descent to present owner.

Dyce, Isabelle

1811–52
sister of artist
Oil on canvas
51.1 × 43.5, oval
c. 1831–2
Aberdeen Art Gallery (as *Portrait of a Lady*)
Coll. Alexander Walker, Aberdeen
Exh. Aberdeen 1964 (4)
I & D.

Dyce, Margaret (4)

(*née* Chalmers)
mother of artist
Pencil
31.7 × 20.3
c. 1836
P. A. Campbell Fraser, Esq.
Coll. by descent to present owner.

Dyce, Margaret

(*née* Chalmers)
Mother of artist
Oil on canvas
74.5 × 61.0
c. 1823
Private collection, Perthshire
Coll. by descent to present owner
Exh. N.G.S. 1901 (33); Glasgow Scottish
National, 1911
S.D.; I & D.

Fergusson, Lady (15)

(*née* Helen Boyle), 1808–69, m. Sir Charles
Dalrymple Fergusson, 1829
Oil on canvas
127.0 × 101.6
1829
Sir Charles Fergusson, Kilkerran
Coll. by descent to present owner.

Hare, Mary Anne

(*née* Maconochie Welwood), m. 1834,
d. 1854
Oil on canvas, probably a copy of lost

original
76.4 × 63.5, oval
1834
James Findlay Esq., Newliston, Kirkliston,
E. Lothian
Coll. Major R. T. A. Hog, by descent to
present owner
Exh. Possibly R.A. 1834 (348); Grafton
Galleries 1895 (182)
S.D.

Logan, Janet

(*née* Edmond) m. 1794, d. 1833
Oil on canvas
76.4 × 63.5
c. 1832
Destroyed by fire 1962
Coll. M. Wardell Esq., Hengwrt, Dolgelly
S.D.

Maxwell, Frances Clerk (22)

(*née* Cay m. John Clerk Maxwell, relative
by marriage of artist, and her son, James,
aged five years
Oil on canvas
91.7 × 71.6
1835
Birmingham Museums and Art Gallery
Coll. from the sitter's family in 1941
Exh. R.S.A. 1836 (145)
Engraved by G. F. Stodart
S.D.; I & D.

Noel, the Hon. Charlotte

d. 1848
Oil on canvas
76.4 × 70.0
c. 1832
Southampton City Art Gallery
Coll. purchased 1933 through Smith
bequest
Exh. Southampton 1958–9.

Webster, Anne

1809–97, m. Robert Catto

Oil on canvas
77.3 × 63.2
c. 1831
Aberdeen Art Gallery
Coll. from Alexander Webster in 1921
Exh. Edinburgh, Scottish National 1908;
Glasgow, Scottish National 1911;
Edinburgh Arts Club 1951; Aberdeen 1964
(ii) S.D.; I & D.

Wilson, Elizabeth

m. Frederick Doubleday
relative by marriage of artist
Oil on canvas
74.1 × 61.0
c. 1823
Private collection, Perthshire
Coll. by descent to present owner.

Wilson, May Agnes

(*née* Dyce), and her infant son, Adam
sister of artist
Oil on canvas
90.0 × 70.4
c. 1823
Private collection, Perthshire
Coll. by descent to present owner.

(ii) *Male subjects*

Bain, Nicolson (**25**)

c. 1787–1840
Librarian of Edinburgh University
Oil on canvas
76.4 × 63.5
c. 1832
The University of Edinburgh
Coll. from the subject's daughter
S.D.

Chalmers, Alexander

1759–1834
great-uncle of the artist
Oil on canvas, in a ruined condition

81.4 × 66.0
1834, unfinished
P. A. Campbell Fraser Esq.
Coll. by descent to present owner
Exh. Edinburgh Portraits 1884; Aberdeen,
1896
S.D.; I & D.

Clerk, Sir George,
6th Bt. 1787–1867
Oil on canvas
127.0 × 101.6
1837
Sir John Dutton Clerk, Bt., Penicuik
Coll. by descent to present owner
Exh. R.S.A. 1837 (160)
S.D.

Cole, Gen. the Hon. Sir Galbraith
Lowry (**28**)

1772–1842
Oil on canvas
140.34 × 110.4
1835
N.P.G.
Coll. purchased 1893 from J. S. Dyce,
the artist's son
Exh. R.S.A. 1835 (146); R.A. 1837
(497); Aberdeen 1964 (7)
Engraved by A. J. Ward

Cole, Gen. the Hon. Sir Galbraith
Lowry (**29**)

1772–1842
Oil on canvas
76.4 × 63.5
c. 1840
The General Assembly of the Church of
Scotland
Coll. gift of G. W. Wilson
Exh. Aberdeen, 1873
I & D.

Davidson, Duncan (**20**)

Oil on canvas
91.4 × 71.0

c. 1829
Private collection, Staffs.
Coll. Mrs. L. E. O. Davidson,
Minarloch, Aboyne, descendant of
sitter to 1972
S.D.

Dyce, William M.D. (3)

1770–1836
father of artist
Oil on canvas
127 × 101.6
c. 1835
Aberdeen Medico Chirurgical Society
Exh. Grafton Galleries 1895 (156)
S.D.; I & D.

Dyce, William R.A. (2)

1806–64
self-portrait
Oil on board
54.5 × 44.4
c. 1820
Private collection, Perthshire
Coll. by descent to present owner.

Etty, William R.A.

1787–1849
Charcoal on grey paper
20.3 × 34.2
c. 1842
Whereabouts unknown, photograph in
Witt Library
Coll. Christie's, 12 Mar. 1928 (141)
Exh. Victoria and Albert Museum,
National portraits
1868 (564).

Hamilton, James, M.D.

1749–1835
Oil on canvas
238.7 × 147.3
c. 1832
S.N.P.G.
Coll. gift of Heriot's Hospital 1870
S.D.

Irving, the Revd. Edward

1792–1834
Oil on canvas
1831
Whereabouts unknown
Exh. R.A. 1831 (1006); R.S.A. 1836 (99);
Edinburgh Portraits 1884
S.D.; I & D.

Ivory, James (26)

1792–1866
Oil on canvas
124.5 × 96.9
c. 1835
Private collection, Scotland
Coll, by descent to present owner
S.D.

M'Grigor, Sir James M.D. (16)

1771–1858
Oil on canvas
139.7 × 109.2
1823
University Court of the University of
Aberdeen
Coll. commissioned by students of
Marischal College.

Small, John and his son (27)

1828–86
Librarian of Edinburgh University
Oil on canvas
76.4 × 63.5
c. 1858
The University of Edinburgh
Exh. R.S.A. 1880 (271)
S.D.

Stoll, Frederick Lewis

Wherabouts unknown
Coll. J. Stirling Dyce, son of the artist
Exh. Grafton Galleries 1895 (102), lent
by J. Stirling Dyce
S.D.

Turner, J. M. W., R.A.

1775–1851
Oil on canvas
1857
Whereabouts unknown
Coll. Dyce sale (59), also medallion
drawing.

Webster, Alexander

Oil on canvas
90.1 × 69.7
c. 1831
Aberdeen Art Gallery, on loan from
Incorporated Trades of Aberdeen
Exh. Edinburgh International 1886;
Grafton Galleries 1895 (179);
Edinburgh N.G.S. 1901 (138)
S.D.; I & D.

Welwood, Alexander Maconochie,
Lord Meadowbank **(23)**

1777–1861
Oil on canvas
122 × 82.6
1832
S.N.P.G.
Coll. Dowell's, 24 Jan. 1958 (196) anon.
artist and subject
Exh. R.A. 1832 (358)
S.D.

Wilson, Adam

relative of the artist's wife
Water-colour
Circular, 10.33 diam.
Private collection, Perthshire
Coll. by descent to present owner.

Wilson, George

brother-in-law of artist
Oil on canvas
74.7 × 63.5
c. 1823
Private collection, Perthshire
Coll. by descent to present owner
S.D.

(iii) *Children*

A child of the Chalmers family, aged
about 2 years

first cousin once removed of artist
Black chalk on white paper
28 × 24.0
1830s
Dr. W. Chalmers Burns
Coll. by descent to present owner.

A child with a muff **(31)**

Oil on canvas
74 × 62
c. 1835
Dr. W. Chalmers Burns
Coll. by descent to present owner.

Dyce, Lowry William Frederick **(34)**

son of artist's elder brother, Robert
Oil
65.4 × 52.0
c. 1835
Aberdeen Art Gallery
Coll. from Mrs. Arthur Rathbone
Exh. R.S.A. 1835 (53); Grafton Galleries
1895 (37); Glasgow International 1901
(96); Liverpool, Walker Art Gallery 1886
(732); Wembley, Palace of Arts 1925;
R.A. British Art 1934 (544); Venice
19th International 1934; Edinburgh Arts
Club 1951; Aberdeen 1964 (8)
S.D.
Often mistakenly called *The Artist's Son*
or *Goody Two Shoes.*

Dyce, Lowry William Frederick;
'Who Goes There?' **(35)**

son of artist's elder brother, Robert
Oil on canvas
91.4 × 71.0
c. 1837
A. L. P. F. Wallace, Strathdon
Coll. from the artist's family
Exh. R.A. 1837 (329)?; Aberdeen 1964 (9)
S.D.

Grant, Dora Louisa of Congalton (36)

1827–37
Oil on canvas
92 × 72
1833
Private collection, Brighton
Coll. by descent to present owner
Exh. R.A. 1833 (316); R.S.A. 1839 (207)
S.D.

Jardine, Alexander (39)

(*later* Sir Alexander, 8th Bt.) 1829–92
Oil on canvas
122 × 91.4
1834
Colonel Sir William E. Jardine of
Applegirth, Bt., O.B.E., T.D., D.L.
Exh. R.A. 1834 (6); R.S.A. 1835 (99).

Jardine, Catherine Dorcas Maule
(2nd daughter of 7th Bt.)

Oil on millboard
43.8 × 36.1
c. 1836
Colonel Sir William E. Jardine of
Applegirth, Bt., O.B.E., T.D., D.L.

Jardine, Jane Home

eldest daughter of 7th Bt. m. 1820
Oil on canvas
127.0 × 101.6
c. 1825
Colonel Sir William E. Jardine of
Applegirth, Bt., O.B.E., T.D., D.L.

Lindsay, John, '*No, Guess Again*' (40)

10th Earl, 1827–94
Oil on canvas
91.4 × 71.0
1833
The Earl of Lindsay
Exh. R.S.A. 1833 (52); Aberdeen 1964
(10)
I & D as *Lindsay Bethune*.

The Sisters (41)

daughters of the Revd. D. Brown,
brother-in-law of the artist
Oil on canvas
77.0 × 63.8
post 1840
Private collection
Coll. by descent to present owner
Exh. Glasgow Scottish National 1911;
Aberdeen 1951 (30); R.A 1956–7 (448);
Aberdeen 1964 (6)
I & D.

Wales, Prince of

1841–1910
Crayon
47.2 × 38.2, oval
c. 1847
National Gallery of Victoria, Melbourne
Coll. Dyce sale (55); Duncan Elphinstone
Cooper, who presented it to present
collection.

Welwood, Harriet Maconochie (38)

youngest daughter of Lord Meadowbank
Oil on canvas
77.6 × 62.9
1832
L. R. Maconochie Welwood, Esq.
Exh. R.A. 1832 (220); R.S.A. 1833 (9);
Grafton Galleries 1859 (56); Edinburgh
Loan Exh. 1901 (27); Edinburgh Scottish
National 1908 (39); Kirkcaldy 1926; R.A.
Scottish Art 1939 (218); Aberdeen 1964 (5)
S.D.

Wilson, Adam (42)

1827–92
nephew of artist
chalk
15.8 × 12.71, oval
1830s
Private collection, Perthshire
Coll. by descent to present owner.

Landscapes, including drawings

(i) *Landscapes 1827–1837 (excluding the Continental tour of 1832)*

Westburn (**43**)
Oil on board
74.1 × 148.93
1827
Aberdeen Art Gallery
Coll. D. M. A. Chalmers to
1929
Exh. Aberdeen 1964 (3).

The Church of La Trinità di Monte, Rome
Whereabouts unknown
R.I.E.A.S. 1829
S.D.

Landscape in the Style of the Early Italian School
Water-colour
c. 1829
Whereabouts unknown
Coll. Dyce Sale (115).

View on the Île de France (Scene from *Paul et Virginie*)
Whereabouts unknown
R.S.A. 1830 (210)
S.D.; I & D.

Landscape with Cattle and Buildings
Oil
15.2 × 23.4
Whereabouts unknown
Coll. Dyce Sale (142), Heugh Sale,
Christie's, 10 May 1878 (75).

A Rustic Scene
Whereabouts unknown
Coll. John Pender Sale, Christie's, 27–30
Jan. 1873 (452).

Fisher Folk (**44**)
Oil
91.4 × 116.8
1830, inscribed on back 'W. Dyce, 1830'
A. F. Nicholls, Esq.
Coll. Sir William Jardine of Applegirth, Bt.

Shirrapburn Loch (**45**)
Oil
30.5 × 40.6
pre-1837
N.G.S.
Coll. James Brand; Lord Guthrie; Mr.
Charles Guthrie
Exh. Edinburgh N.G.S., 1901 (12);
Aberdeen, 1964 (33).

The Castle of Threave
Oil on board; unfinished
27.9 × 33.6
c. 1832
Colonel Sir William E. Jardine of
Applegirth, Bt., O.B.E., T.D., D.L.

Landscape
1830s?
Whereabouts unknown
Exh. Aberdeen 1873, lent by Alexander
Walker.

Dundrennan Abbey
Water-colour
1833
Whereabouts unknown
Coll. Dyce Sale (99).

Glenlair (**46**)

Water-colour
19.4 × 32.4
1832, signed with monogram
Victoria and Albert Museum
Exh. Aberdeen 1964 (65).

Roslin Chapel, Interior (**47**)

Oil on canvas
29.4 × 36.7
1830s
Christopher Gibbs, Esq.
Coll. R. D. Hay, Lord Justice General
Inglis some time before 1880; Sir Maxwell
Inglis; Sotheby's Belgravia, 1 July 1975
(42)
Exh. Edinburgh, N.G.S. 1901 (133)
I & D.

The Confessional, Beauchamp Chapel,
St. Mary's, Warwick

Water-colour
Whereabouts unknown
Coll. Isabelle Cay; Elizabeth Mary
Giles (*née* Dunn); Alan Stewart Giles
of Port Hope, Ontario, Canada to
1964.

Greenwich Park

Water-colour
Whereabouts unknown
Coll. Dyce Sale (100).

(ii) *Continental water-colours*
of 1832

The Rhône at Avignon (**50**)

1832 dated
27.9 × 45.7
British Museum
Coll. Dyce Sale (117).

A Study in Switzerland

Whereabouts unknown
Coll. Dyce Sale (90).

Trent in the Tyrol

Whereabouts unknown
Coll. Dyce Sale (106).

River Scene

Whereabouts unknown
Coll. Dyce Sale (125).

Views in Villeneuve

Whereabouts unknown
Coll. Dyce Sale (97, 116, 126).

The Dogana, Venice

dated 1832
Whereabouts unknown
Coll. Dyce Sale (124), bt. Heugh; Heugh
sale Christie's, 10 May 1878 (77).

Part of the Arsenal, Venice

Whereabouts unknown
Exh. R.S.A. 1833 (91).

The Square of the Pope's Palace, Avignon

dated 1832
Whereabouts unknown
Coll. Dyce Sale (108).

Street and Harbour Scenes in Venice

Whereabouts unknown
Coll. Dyce Sale (122, 123, 124).

Calais

dated 1832
Whereabouts unknown
Coll. Dyce Sale (105).

A Coast Scene

20.3 × 17.1
Aberdeen Art Gallery
Coll. Miss Louisa Dyce to 1889, Alexander
Webster
Exh. Aberdeen 1964 (55).

(iii) *Landscapes in England and Scotland 1840–1860*

Osborne House, Isle of Wight (**51**)

Water-colour
27.9 × 45.7
1847
British Museum
Coll. Dyce Sale (118).

Study of Rocks and Ferns, Isle of Wight

Water-colour
1847–8
Whereabouts unknown
Coll. Dyce Sale (119).

Puckaster Cove, Isle of Wight

Water-colour
24.7 × 34.2
1847–8
Whereabouts unknown
Coll. John Pender Sale, Christie's, 27–30
Jan. 1873.

Culver Cliff, Isle of Wight (**48**)

Water-colour
16.4 × 27.3
1847–8
G. Goyder Esq.
Coll. T. E. Lowinsky
Exh. Aberdeen 1964 (170).

Culver Cliff, Isle of Wight (**49**)

pen and ink and water-colour over pencil,
heightened with white
37.1 × 49.2
1847–8

Yale Center for British Art, the Paul Mellon
Collection
Coll. Fine Art Society, 1965, bt. anon.

Study of Waterlilies and Other Plants

Water-colour
20.9 × 33.6
c. 1847
Victoria and Albert Museum
Coll. Agnew's from Dyce Sale (111) to
1888
Exh. Aberdeen 1964 (67).

Landscape with Trees

Oil, unfinished
40.6 × 61.00
mid-1840s
Private collection.

Landscape, A Country Lane

Water-colour
20.9 × 13.97
mid-1940s
Victoria and Albert Museum
Coll. Agnew's from Dyce Sale (101)
Exh. Aberdeen 1964 (66).

Glen Sannachs, Isle of Arran

Water-colour
1859
Whereabouts unknown
Coll. Dyce Sale (107).

A Study of Rocks and Foliage, Arran

Water-colour
1859
Whereabouts unknown
Coll. Dyce Sale (112).

Near Glen Rosa, Isle of Arran

Water-colour
1859
Whereabouts unknown
Coll. Dyce Sale (109).

Goat Fell, Isle of Arran (**58**)

Water-colour
20.3 × 33.6
1859
Victoria and Albert Museum
Coll. Dyce Sale (112), bt. Agnew's
Exh. Aberdeen 1964 (72).

Trebarwith Sand, Tintagel

Water-colour
24.7 × 34.9
1860
Whereabouts unknown
Coll. John Pender Sale, Christie's 27–30
Jan. 1873, bt. Agnew's
I & D.

Trifan, Snowdonia (**59**)

Water-colour
22.8 × 34.9
1860
Ashmolean Museum, Oxford, cat. *Study
for a Distant Range of Mountains*
Coll. Sir D. Y. Cameron, R.A.
Exh. Aberdeen, 1964 (71).

Landscape in Snowdonia (**60**)

Oil on board
25.4 × 45.7
1860
Kunsthalle, Hamburg (cat. as 1842)
Exh. R.A. 1878 (94), lent by G. C.
Schwabe.

A Welsh Landscape with Cattle

Water-colour
16.4 × 13.7
1860
Whereabouts unknown
Coll. Dyce Sale (127); A. Lavey Sale 1876
I & D.

Snowdon from Capel Curig

Water-colour
1860

Whereabouts unknown
Coll. Dyce Sale (121).

A Welsh Scene

17.8 × 32.4
1860
Whereabouts unknown
Coll. Heugh Sale, Christie's, 10 May 1878
(76).

(iv) *Figure subjects in landscape*

The Dead Christ (**62**)

Oil
210.8 × 165.1
1835
Whereabouts unknown
Coll. Ilchester Sale, Christie's, 31 July
1947, *Pietà, Landscape with the Dead Saviour,
the Virgin, St. Joseph and St. John*
Photograph in Witt Library.

The Flight into Egypt (**84**)

Oil on board
30.5 × 40.6
c. 1851
Private collection
Coll. by descent to present owner
Exh. Manchester 'Jubilee', 1887 (861);
Glasgow 'International', 1901 (122);
Newcastle 'Scottish Artists', 1908;
Edinburgh 'Scottish National', 1908 (71);
Glasgow 'Scottish', 1911; Aberdeen 1951
(27); Aberdeen 1964 (31).

Gethsemane (**92**)

Oil on board
42.8 × 32.1
c. 1855
Walker Art Gallery, Liverpool
Coll. John Farnworth; Albert Grant;
George Holt; Miss Emma Holt to Walker
Art Gallery
Exh. Manchester 'Jubilee', 1887 (760);

Glasgow 'International', 1909 (4);
Whitechapel 'British Art', 1905 (305);
Edinburgh 'Scottish National', 1911
(127); R.A. 'Primitives to Picasso', 1962
(196); Aberdeen 1964 (32).

The Good Shepherd

Cartoon
13.34 × 12.7
1856
Whereabouts unknown
Coll. Christie's 11 Mar. 1935, bt. Hooper;
Christie's, 6 Mar. 1942, bt. Morgan
Exh. R.A. 1856 (881).

*Titian Preparing to Make his First Essay
in Colouring* (**111**)

Oil on canvas
91.4 × 67.2
1857
Aberdeen Art Gallery
Coll. James Brand; Christie's, 10 Mar.
1894 (84), bt. Mrs. Ashton Jonson to 1923
Exh. R.A. 1857 (107); R.S.A. 1858 (260);
London 'International', 1862 (596);
Manchester 'Jubilee', 1887 (859);
Edinburgh 'National', 1908 (69);
Whitechapel 'Pageant', 1912 (30);
Wembley Palace of Arts 1925; R.S.A.
'Centenary', 1926 (129); Brussels 'Peinture
Anglaise', 1929 (60); Harrogate A. G.
1929; R.A. 1934 (571); Paisley Art
Institute 1935; R.A. 'Scottish Art', 1939
(214); London I.C.A. 'A Century of British
Taste', 1951 (8); Glasgow A.G. 'Scottish
Painting', 1961 (51); Aberdeen 1964 (35);
Sheffield 'Victorian Art', 1968; Royal
Academy Jubilee exhibition 1977.

Henry VI at Towton (**115**)

Oil on canvas
35.4 × 50.8
late 1850s
Guildhall Art Gallery, City of London
Coll. Sir John Pender; Charles Gassiot to
1902

Exh. Manchester 'Jubilee', 1887 (856);
Whitechapel 1909 (60); Agnew's 'Victorian
Painting', 1961 (56); Aberdeen 1964 (40)
Unsigned, undated engraving B.M.

The Highland Ferryman (**54**)

Oil on board
48.4 × 59.6
1858
Aberdeen Art Gallery
Coll. John Houldsworth 1858; Leicester
Galleries; Sir George Reid, P.R.S.A. to
1912
Exh. R.S.A. 1858 (406); R.A. 1859 (437);
R.A. Scottish Art 1939 (222); Edinburgh
Arts Club 1951; R.A. 1951–2 (301);
Aberdeen 1964 (36).

*Pegwell Bay: A Recollection of October
5th, 1858* (**52**)

Oil on canvas
63.5 × 88.9
1859
Tate Gallery
Coll. James Brand to 1894, bt. Agnew's
for National Gallery
Exh. R.A. 1860 (141); London, S.
Kensington 'International', 1862
(613); R.S.A. 1865 (511); Paris 1867;
Leeds 1868 (1449); Manchester 'Jubilee',
1887 (1862); Birmingham 'The Pre-
Raphaelite Brotherhood', 1947 (23);
Whitechapel 'The Pre-Raphaelites', 1948
(26); Aberdeen 1964 (37); Paris 'La
Peinture Romantique Anglaise', 1972.

Pegwell Bay (**53**)

Water-colour
24.7 × 34.9
1857
Private collection
Exh. Manchester 'Jubilee', 1887; Aberdeen
1964 (69).

The Entrance to the Vicarage (**55**)

Oil on board

30.5 × 40.6
late 1850s
Coll. James Dugdale to 1927; Christie's,
24 June 1927, bt. Agnew;
c. 1930 bt. Mr. G. F. Rose; Sotheby's
Belgravia, 10 July 1973 (39) *The Manse*
Exh. Aberdeen 1964 (34)
I & D.

A Scene in Arran (**56**)

Oil
34.9 × 49.1
1859
Aberdeen Art Gallery
Coll. James Brand; John Edward Taylor,
Esq., London; Christie's 5–8 July 1912
(224)
Exh. Edinburgh Arts Club 1951; Aberdeen
1964 (38).

Glen Rosa, Isle of Arran (**57**)

Water-colour heightened with white
24.0 × 34.9
1859
Private collection
Coll. Dyce Sale (93); J. Broughton
Dugdale; R. F. Goldschmidt; Christie's,
26 June 1941 (25); Christie's 2–3 Apr.
1969 (47)
Exh. R.S.A. 1865, *Mouth of R. Rosa, Arran*;
Manchester 'Jubilee', 1887 (1510)
I & D.

David as a Youth (**68**)

Oil on board
34.2 × 48.4
c. 1859
Private collection
Coll. Stock. Christie's, 17 Feb. 1933, bt.
Col. D. B. D. Stewart
Exh. Liverpool Inst. of Fine Arts 1867
(59); Burslem 'Wedgwood Exhibition'
1869; Aberdeen 1951 (29); Aberdeen 1964
(41).

The Good Shepherd (**85**)

Oil on canvas
78.9 × 63.5
R.A. 1859 (174)
St. Peter's Church, Little Budworth,
Cheshire
Coll. gift of Mrs. Stocks of Whitehall,
Little Budworth, formerly of Glenhope
Castle.

*Welsh Landscape with Two Women
Knitting* (**61**)

Oil on board
35.2 × 49.4
1860
Private collection
Coll. Mrs. Robert Frank, London
Exh. London, 'English Romantic
Paintings', Maas Gallery 1965 (8); Detroit
and Philadelphia, 'Romantic Art in
Britain', 1968 (191).

The Man of Sorrows (**71**)

Oil on board
34.9 × 48.4
R.A. 1860 (122)
Private collection
Coll. Christie's, 17 Feb. 1933, bt. Col.
D. B. D. Stewart
Exh. Liverpool Academy 1861 (122);
Burslem 'Wedgwood Exhibition', 1869;
Aberdeen 1951 (28); R.A. 'The First
Hundred Years of the R.A.', 1951–2 (349);
Aberdeen 1964 (42).

George Herbert at Bemerton (**112**)

Oil on canvas
86.4 × 111.6
1861
Guildhall Art Gallery, City of London
Coll. Agnew's from R.A. 1861; Christie's
1861, bt. Samuel Mendel; *c.* 1875 bt. back
Christie's; bt. Baron Grant; 1877 sold
Christie's, bt. Agnew's; sold same year to
Charles Gassiot to 1902

Exh. R.A. 1861 (98); Franco–British 1908
(107); Glasgow 1914; Birmingham, 1947
(24); Port Sunlight 1948; R.A. 1934 (542);
R.A. 1951 (276); A.E.B. Tour 1954–5;
Aberdeen 1964 (43); Sheffield 1968.

Christ and the Woman of Samaria (**81**)

Oil on canvas

34.2 × 48.4
1860
Birmingham Museums and Art Gallery
Coll. Sir John Pender till 1897
Exh. R.S.A. 1865 (272); Manchester
'Jubilee', 1887 (857); Manchester 1911
(287); Tate Gallery 1911 (44); R.A.
'British Art', 1934 (550); Agnew's 1957
(48); Aberdeen 1964 (39).

Subject Paintings

(i) *Religious subjects, excluding the Madonna and Child*

Christ's Entry into Jerusalem

Oil on panel (unfinished)
31.1 × 46.9
pre-1840
Aberdeen Art Gallery
Coll. from the Misses Cran (1931)
Exh. Edinburgh Arts Club 1951; Aberdeen
1964 (16).

St. Catherine (**63**)

Oil on panel
90.1 × 67.2
pre-1845
N.G.S.
Coll. from Sir Alec Martin (1964)
Exh. Aberdeen 1964 (19).

The Daughters of Jethro Defended by Moses

1829
Whereabouts unknown
Coll. Dyce Sale (143) 'an early work'
Exh. R.I.E.A.S. 1829 (51).

The Christian Yoke

1841
Whereabouts unknown
Exh. B.I. 1841 (1862) '*Take my yoke
upon you*'; R.S.A. 1844 (423).

Joash Shooting the Arrow of Deliverance (**86**)

Oil on canvas
77.6 × 110.4
1844
Kunsthalle, Hamburg
Coll. G. C. Schwabe from the artist
Exh. R.A. 1844 (284) (elected A.R.A.);
R.A. 1871 (99) (see also drawings).

St. John Leading the Blessed Virgin from the Tomb

Oil on panel
35.5 × 30.5
c. 1844
Coll. Anon. sale Christie's, 8 May
1962 (132); C. and L. Handley Read
Exh. Aberdeen 1964 (21); R.A. 1972
(A40); Fine Art Society, Edinburgh
and London, 1974 (27)
Study for Tate Gallery painting of
same subject
Engr. J. Thompson (V. & A. proof 16141).

St. John Leading the Blessed Virgin from the Tomb (**89**)

Oil on panel
20.0 × 20.9
c. 1844
Aberdeen Art Gallery
Coll. Mrs. G. Richmond

Exh. Edinburgh Arts Club 1951; Aberdeen 1964 (20)
Study for Tate Gallery painting.

St. John Leading the Blessed Virgin Mary from the Tomb (**88**)

Oil on canvas
76.4 × 109.8
1844–60
Tate Gallery
Coll. Brand Sale, Christie's, 10 Mar. 1894 (85), bt. Agnew; presented anon. to N.G. London 1894; transferred Tate Gallery 1897 Exh. R.A. 1860; Manchester 'Jubilee' 1867 (863); Aberdeen 1964 (22).

St. Joseph (**97**)

Oil on canvas
80.1 × 63.5
1846–7
H.M. Queen Elizabeth II
Coll. Commissioned by Prince Consort as companion to *The Madonna and Child* of 1845
Exh. R.S.A. 1855 (475); Aberdeen 1964 (24).

Omnia Vanitas (*A Magdalen*) (**67**)

Oil on canvas
62.3 × 74.7
1848
Royal Academy
Exh. R.A. 1848 (889) (elected A.R.A.); R.A. 1951 (308); Aberdeen 1964 (26)
I & D mention drawing for this, coll. I. Dyce.

Jacob and Rachel

Oil on canvas?
R.A. 1850 (92)
Present whereabouts unknown
Reproduced *The Art Journal*, 1 Oct. 1860, p.293
Coll. Mr. W. Bower
Exh. Manchester Art Treasures 1857.

Jacob and Rachel (**76**)

Oil on canvas
70.4 × 91.1
c. 1850–3
Leicestershire Museums and Art Gallery
Coll. Felix Pryor; Christie's, 16 May 1885, bt. Agnew; H. S. Leon; Lady Leon, Bletchley Park; Agnew 1937, bt. Leicester Museum and Art Gallery
Exh. International 1862 (591); Paris 1867; Agnew's, Coronation 1937 (7); Arts Council, British Subject and Narrative Pictures 1955 (14); Nottingham University Art Gallery 1959 (16); Aldeborough 1962; Aberdeen 1964 (28)
Engr. on wood by Dalziel Bros. for Dalziel *Bible Gallery* but not included in 1881 ed.; first pub. in *Art Pictures from the Old Testament*, ed. A. Fox (1894).

Jacob and Rachel (**79**)

Oil on canvas
58.4 × 57.0 arched top
R.A. 1853 (140)
Kunsthalle, Hamburg
Coll. G. C. Schwabe
Exh. R.A. 1871 (59)
(See also drawings).

Jacob and Rachel

Oil on canvas
48.4 × 66.0
1857
Knodishall parish church, Suffolk
Coll. W. J. Burningham.

Eliazer of Damascus (**87**)

Oil on canvas
61.27 × 50.80
1860
Minneapolis Institute of Arts
Coll. James Brand; Mrs. Robert Frank; Christie's, 17 Mar. 1967 (127).

Cain?

Oil on canvas, unfinished
47.2 × 40.1
Brighton Art Gallery
Coll. gift of A. A. Loose, Esq., 1893.

Charity

Oil on board, unfinished
17.8 × 48.4
Aberdeen Art Gallery
Coll. Miss Ella Dyce to 1940
Exh. Edinburgh Arts Club 1951; Aberdeen
1964 (30) 'Motherhood'.

(ii) *The Madonna and Child* (see also drawings)

The Madonna and Child (**93**)

Oil on canvas
102.8 × 80.8
c. 1838
Tate Gallery, London
Coll. J. H. Green; Col. E. Carrick
Freeman to 1932
Exh. Manchester Art Treasures 1857
(341); Aberdeen 1964 (17).

The Madonna and Child (**101**)

Oil on canvas
25.4 × 20.0
c. 1838
Private collection, Perthshire
Coll. by descent to present owner.

The Madonna and Child (**98**)

Oil on board
75.4 × 52.0
c. 1845
The Castle Museum, Nottingham
Probably a study for the painting in the
Royal Collection.

The Madonna and Child (**96**)

Oil on canvas
80.1 × 63.5
1845
H.M. Queen Elizabeth II
Coll. bt. from artist by Prince Consort
Exh. R.A. 1846 (451); International 1871
(362); R.A. 1951 (352); Aberdeen 1964
(23)
Engr. Thomas Vernon in *The Royal
Gallery of Art.*

The Madonna and Child

Oil?
88.9 × 68.5, arched top
Whereabouts unknown
Coll. Heugh Sale, Christie's, 11 May 1878
(205) bt.? £210.

The Virgin Seated in a Portico caressing the Child

Oil?
Whereabouts unknown
Coll. John Brett Sale, Christie's, 5 Apr.
1864 (717), illustrated in catalogue.

(iii) *Historical, mythological, and Literary subjects*

The Infant Hercules Strangling the Serpents Sent by Juno to Destroy him (**6**)

Oil on canvas
90.1 × 69.4
1824
N.G.S.
Coll. Sir John Hay, Bt., presented by him
to Royal Institution in 1845
Exh. R.S.A. 1830 (60); Glasgow A.G.
1961 (55); Aberdeen 1964 (1).

Bacchus Nursed by the Nymphs of Nysa (**9**)

Oil on panel, unfinished
29.8 × 40.1

1826
Aberdeen Art Gallery
Coll. Miss Ella Dyce to 1940
Probably study for large painting exh.
R.A. 1827 (313); B.I. 1828 (48)
Exh. Edinburgh Arts Club 1951; Aberdeen
1964 (2)
(see also drawings).

Puck

Oil?
122 × 96.9
1829
Whereabouts unknown
Coll. possibly Heugh Sale, Christie's,
10 May 1878 (78), but this measured
58.4 × 45.7
Exh. R.I.E.A.S. 1829; B.I. 1831 (146)
(see also drawings).

Francesca da Rimini (**113**)

Oil on canvas
137.65 × 172.71
1837
N.G.S.
Coll. R.S.A. 1867, transferred N.G.S. 1910
Ex. R.S.A. 1837 (49); Aberdeen 1964 (15).

*John Knox Dispensing the Sacrament at
Calder House* (**114**)

Oil on canvas
38.8 × 59.6
1835–7
Church of Scotland, John Knox House,
Edinburgh
Coll. Dyce Sale (133) bt. Agnew;
J. E. Taylor coll; Christie's, 5 July 1912
(223) bt. Wallis, who sold it to Lord
Guthrie
Exh. Manchester 'Jubilee' 1887 (855).

*John Knox Dispensing the Sacrament at
Calder House*

Oil on canvas
36.7 × 55.8

1835–7?
Aberdeen Art Gallery
Coll. Alexander Webster to 1921
Exh. Glasgow 1911; Edinburgh Arts
Club 1951; Aberdeen 1964 (12)
Sketch for painting at John Knox
House.

The Descent of Venus (2 versions)

Oil on canvas
both 36.7 × 55.8
1835–6?
Aberdeen Art Gallery
Coll. Miss Ella Dyce to 1940
Exh. R.A. 1836; Edinburgh Arts Club
1951; Aberdeen 1964 (13, 14).

St. Dunstan Separating Edwy and Elgiva

Oil?
1839
Present whereabouts unknown
Exh. R.A. 1839 (471) with description.

Titian and Irene de Spilembergo

Oil?
1840
Present whereabouts unknown
Exh. R.A. 1840 (197) with description.

Jessica

Oil? -
1843
Present whereabouts unknown
Coll. W. E. Gladstone, purchased from
the artist (not in Gladstone Sale, Christie's,
26 June 1875)
Exh. R.A. 1843 (300)
Engr. H. Robinson and published
G. Vertue as '*The Signal*' (**106**)

Christabel (**108**)

Oil on canvas
50.8 × 43.2, oval
1855

Glasgow Art Gallery
Coll. from Agnew's 1971, as part of
Hamilton bequest
Exh. R.A. 1855 (181) with quotation from
Coleridge.

King Lear and the Fool

Oil?
137.1 × 182.8
1851
Present whereabouts unknown
Coll. John Knowles, sold 1865; James
Brand; Christie's, 10 Mar. 1894 (86) bt.
Bonsor (£210); Sir Bryan Bonsor recalls
seeing it in his aunt's house before the
last war
Exh. R.A. 1851 (77) with quotation.

*Beatrice (Lady with the Coronet of
Jasmine)* **(66)**

Oil on panel
64.7 × 49.1, arched top
1859
Aberdeen Art Gallery
Coll. bt. from the artist by W. E.
Gladstone; Gladstone Sale, Christie's,
26 June 1875 (628) bt. Agnew (£350);
presented to Whitworth Institution,
Manchester; sold to J. Kent
Richardson; to Aberdeen in 1937
Exh. Bradford 1882 (74); Manchester
'Jubilee', 1887 (858); Melbourne 1888;
Edinburgh Arts Club 1951; Arts
Council, 'British Subject and Narrative
Paintings', 1955 (16); Aberdeen 1964
(29).

Dante and Beatrice

Oil on panel (unfinished)
155.36 × 80.1

1850s?
Aberdeen Art Gallery
Coll. Miss Ella Dyce to 1940
Exh. Edinburgh Arts Club 1951;
Aberdeen 1964 (18).

Mary Queen of Scots Refusing to Sign

Oil?
223.5 × 223.5
Present whereabouts unknown
Exh. N.G.S. 1901 (144).

(iv) *Genre subjects*

The Italian Beggar Boy **(13)**

Water-colour
22.8 × 30.5
1836
A. W. Donaldson, Esq.
Coll. Morison, McChlery & Co. Glasgow,
3 Dec. 1971 (lot 81) as 'The Good
Samaritan', bt. A. W. Donaldson, Esq.
Exh. R.S.A. 1836 (35).

The Choristers

Oil on canvas
59 × 49
c. 1830
Coll. P. A. Campbell Fraser, Esq.; by
descent from artist's family; Sotheby's,
30 Aug. 1974 (298) *The Ballad Singers*.

Head of a Dog, 'Envy'

Oil on millboard
27.9 × 22.8
Sir William Jardine of Applegirth, Bt.

Cartoons, drawings and studies for fresco, stained glass, and large-scale decorative work

The Judgement of Solomon (**11**)

Cartoon, tempera on paper
150.35 × 244.35
1836
N.G.S.
Design for tapestry, awarded premium
£30 in competition organized by the
Board of Manufactures
Coll. presented by Prof. Godsir to R.S.A.
1864; to N.G.S. 1910.

The Judgement of Solomon (**12**)

Pencil
5.0 × 5.0
1836
Victoria and Albert Museum (4371).

The Consecration of Archbishop Parker

Fresco in Lambeth Palace (now
destroyed or covered?)
Engr. F. K. Hunt, *The Book of Art*
(1846), f. 127 (**140**)

The Consecration of Archbishop Parker (**141**)

Brown chalk on paper
15.8 × 21.5
1843
Victoria and Albert Museum
(E 1797–1910).

The Consecration of Archbishop Parker (**142**)

Ink and charcoal on paper
15.8 × 21.5
1843
Victoria and Albert Museum, 4381.

Comus

Fresco in Buckingham Palace Pavilion,
now destroyed 1844
Engraving in Mrs A. Jameson and
L. Gruner, *The Decorations of the Garden
Pavilion of Buckingham Palace* (1846). (**144**)

The Attendant Spirit from Milton's 'Comus'

Black chalk on cream paper mounted
on canvas
47.6 × 31.7
1844
Frederick Cummings, Esq.
Exh. Detroit Institute of Art and
Philadelphia Museum of Fine Art,
1968 (189)
Study for fresco in Buckingham Palace
Pavilion.

The Baptism of King Ethelbert (**147**)

Fresco
1846
House of Lords Chamber.

The Baptism of King Ethelbert

Cartoon
Dept. of the Environment
Exh. Westminster Hall 1845.

The Baptism of King Ethelbert (**148**)

Charcoal
18.4 × 16.7
1845
Victoria and Albert Museum (E. 1795–
1910)
Group of people, study for fresco.

The Baptism of King Ethelbert
Chalk
25.4 × 18.4
Victoria and Albert Museum (E. 1796–
1910
A monk, study for fresco.

The Baptism of King Ethelbert (**149**)
Brown chalk
25.4 × 22.2
1846
Victoria and Albert Museum (4333)
Inscribed 'central figure in fresco House
of Lords'.

*Neptune Resigning to Britannia the Empire
of the Sea* (**146**)
Fresco
1847
Osborne House, Isle of Wight.

*Neptune Resigning to Britannia the Empire
of the Sea*
Charcoal and pink chalk
47.6 × 31.1
1847
Victoria and Albert Museum (E. 2971–
1910)
Fragment of cartoon showing female head.

Neptune and Britannia
Oil on paper laid down on board
31.7 × 47.8
1847
Forbes Magazine Collection, New York
Coll. H.M. Queen Victoria; Prince Arthur,
Duke of Connaught; Lady Ramsay;
Christie's, 26 July 1974 (252)
Exh. R.A. 1847 (42); Aberdeen 1964 (25).

*Religion: The Vision of Sir Galahad and
His Company* (**152**)
Fresco
Completed Apr. 1851

Queen's Robing Room, Palace of
Westminster.

*Religion: The Vision of Sir Galahad and
His Company* (**155**)
Cartoon, brown chalk on paper laid down
on canvas
1850
R.S.A.

Lion's Head
Pencil on grey paper, heightened with
white
15.8 × 19.4
British Museum
Study for fresco of Religion.

*Religion: The Vision of Sir Galahad and
His Company* (**156**)
Pen and ink
22.8 × 30.5
1847
Aberdeen Art Gallery
Coll. Miss Ella Dyce to 1940
Exh. Aberdeen 1964 (6).

*Courtesy: Sir Tristram Harping to La
Belle Isoude*
Fresco
Completed October 1852
Queen's Robing Room, Palace of
Westminster.

*Courtesy: Sir Tristram Harping to La
Belle Isoude*
Cartoon, brown chalk on paper laid down
on canvas
Whitworth Art Gallery, University of
Manchester
(in a very poor state of repair).

*Courtesy: Sir Tristram Harping to La
Belle Isoude* (**160**)
Pen, ink, and coloured wash
27.9 × 15.2

c. 1851
Fine Art Society, London
Coll. C. and L. Handley-Read; Forbes
Magazine Collection, New York
Exh. Aberdeen 1964 (59); R.A. 1972 (A41)
Study for fresco.

*Generosity: King Arthur, Unhorsed, is
Spared by His Adversary* (**161**)

Fresco
completed July 1852
Queen's Robing Room, Palace of
Westminster.

*Generosity: King Arthur, Unhorsed, is
Spared by His Adversary*

Cartoon, brown chalk on paper laid down
on canvas
Whitworth Art Gallery, University of
Manchester.

*Generosity: King Arthur Unhorsed is Spared
by His Adversary*

Water-colour
28.2 × 15.2
N.G.S.
Exh. Aberdeen 1964 (61)
Study for fresco.

Mercy: Sir Gawaine Swearing to be Merciful
(**162**)

Fresco
Completed 1854
Queen's Robing Room, Palace of
Westminster

Mercy: Sir Gawaine Swearing to be Merciful

Cartoon, brown chalk on paper laid down
on canvas
R.S.A.

Mercy: Sir Gawaine Swearing to be Merciful

Water-colour
28.2 × 15.2

N.G.S.
Study for fresco.

*Hospitality: The Admission of Sir Tristram
to the Fellowship of the Round Table* (**163**)

Fresco
Incomplete 1864
Queen's Robing Room, Palace of
Westminster

*Hospitality: The Admission of Sir Tristram
to the Fellowship of the Round Table*

Cartoon, brown chalk on paper laid down
on canvas
Whitworth Art Gallery, University of
Manchester
In three sections
(in a very bad state of repair, photography
virtually impossible).

*Piety: The Departure of the Knights of the
Round Table on the Quest for the Holy Grail*
(**150**)

Water-colour
23.1 × 44.1
1849
N.G.S.
Study for projected fresco in Queen's
Robing Room, never executed
Exh. R.A. 1849 (889); Aberdeen 1964 (58).

The Holy Trinity and Saints

Fresco
Completed 1859
All Saints' Church, Margaret St., London
(now covered by Comper's copies).

The Holy Trinity and Saints (**138**)

Oil on cavas
38.8 × 87.0
c. 1849
Victoria and Albert Museum
Study for fresco
Exh. Aberdeen 1964 (27).

Head of Christ

Oil on canvas
30.5 × 40.6
c. 1849
Victoria and Albert Museum
Study for Christ in Majesty in fresco at
All Saints'.

St. Peter

Cartoon for fresco at All Saints'
R.A. 1853 (931)
Whereabouts unknown.

The Choristers

Stained glass window
pre-1856
Ely Cathedral
Oliphant and Dyce.

The Choristers

Cartoon for window, Ely Cathedral
Charcoal and wash
121.3 × 40.1
pre-1856
Oliphant with the collaboration of Dyce
Aberdeen Art Gallery
Exh. Aberdeen 1964 (78).

*St. Paul and St. Barnabas Preaching at
Antioch* (**frontispiece**)

Stained glass designed by W. Dyce and
executed by Ainmüller of Munich
1856
St. Paul's Church, Alnwick,
Northumberland

*St. Paul and St. Barnabas Preaching at
Antioch* (**139**)

Coloured cartoon in five sections
1853
Laing Art Gallery, Newcastle upon Tyne.

Graphics and Design

(i) *Engravings*

The Border Tower

Etching
10.33 × 14.20
1830s
Exh. Aberdeen 1964 (73).

A Visit to the Alchemist

Etching
12.7 × 17.8
Signed with monogram and dated 1833
Exh. Aberdeen 1964 (74).

An Old Woman

Etching
23.4 × 18.4
Signed with monogram and dated 1834
Exh. Aberdeen 1964 (75).

Cottage Interior (**124**)

Etching
7.70 × 12.39
1830s
Signed with monogram
Exh. Aberdeen 1964 (76).

The Young Angler (**125**)

Dry point
8.0 × 12.39
Signed with monogram and dated 1834
Exh. Aberdeen 1964 (77).

Girl Looking out of a Window

Dry point
11.91 × 7.39
1830s
V. & A. printed from artist's plate after his death
(c.f. states in British Museum and Glasgow Museum and Art Gallery).

(ii) *Design*

Design for candlestick (after Nicolo dell' Arca)

Pen and ink
17.8 × 12.7
British Museum.

Two designs for decorative mosaic work (**127**)

Ink and water-colour
5.0 × 15.2
Jupp Catalogue, R.A. Library.

Design for the facade of a chapel (**131**)

Pen, ink, and water-colour (unfinished)
35.5 × 28.5
Victoria and Albert Museum
probably R.A. 1839 (1187).

Design for the Cover of the *Government Drawing Books* (**126**)

Brown ink
22.5 × 16.1
1843
Victoria and Albert Museum.

The Gothic Crown (**130**)

Minted 1847
Designed by W. Wyon with Dyce's help.

Design for Certificate of Merit, International Exhibition 1851 (**135**)

Pencil
38.6 × 39.2
Victoria and Albert Museum, which also owns an example of the certificate Engr. G. T. Doo.

Winged figure (**136**)

Pen and ink
10.1 × 15.2
Victoria and Albert Museum
Sketch for Certificate of Merit 1851.

Design for Certificate of Exhibition, International Exhibition 1851 (**137**)

Pencil
39.3 × 39.1
Victoria and Albert Museum, which also owns an example of the certificate Engr. G. T. Doo.

Design for the reverse of the Turner medal (**129**)

Charcoal and white chalk on grey paper
61.0 diam., circular
1858
R.A.
Coll. presented by Sir Alec Martin, 1939.

Design for Drinking Fountain (**133**)

Water-colour
33.0 × 24.3
1862
Victoria and Albert Museum.

Design for Drinking Fountain

Water-colour
32.85 × 24.1

1862
Victoria and Albert Museum
Erected near St. Leonard's Church,
Streatham. (**134**)

(iii) *Book illustrations*

*An Account of the Great Floods of August
1829 in the Province of Moray and Adjoining
Districts* by Sir Thomas Dick Lauder
(Edinburgh 1830)
(**120**)
8.33 × 6.27
Engravings by W. H. Lizars and W. Dyce,
unsigned.

The Highland Rambles by Sir Thomas
Dick Lauder (Edinburgh 1837)
Seven etchings, 14.31 × 8.33 by William
Dyce:

Old Stachan
Frontispiece, vol. I
Etched by Dyce after a sketch by the
author.
Margery's Vision, vol. I
Designed and etched by Dyce.

Mary Rose and Robin Stuart, vol. I
Designed and etched by Dyce.

Willox the Wizard and his cottage
Frontispiece, vol. II
Etched by Dyce from a sketch by the
author.

Grant of Tullocharron, vol. I (**121**)
Designed and etched by Dyce.

Chirsty Ross, vol. II
Designed and etched by Dyce.

Priest Innes, vol. II
Designed and etched by Dyce.

Nursery Rhymes, Tales and Jingles
(1842) (**122**)
Five engraved illustrations by Dyce,
unsigned.

Poems and Pictures (1846):

'Ladye Marie' by the Revd. Alford
Engraving f.4 by C. Gray after W. Dyce.

'Ladye Marie'
Engraving f.5 by H. L. Clark after W.
Dyce.

'A Christ Cross Rhyme' by the Revd.
R. S. Hawker
Engraving f.65 by C. Gray after W. Dyce.

'The Spinning Maiden's Cross' by
the Revd. W. Whewell (**123**)
Engraving f.125 by C. Gray after W.
Dyce.

'The Spinning Maiden's Cross'
Engraving f.126 by C. Gray after W.
Dyce.

'The Spinning Maiden's Cross'
Engraving f.127 by C. Gray after W.
Dyce.

Six designs for historiated capital letters
Pen and ink
5.0 × 5.0
Victoria and Albert Museum.

Design for a book illustration
Pencil
16.4 × 10.1
Victoria and Albert Museum.

Drawings

(i) *Figure studies*

Nude woman reaching upwards (two studies) **(8)**

Brown ink
22.27 × 15.98
1826
Victoria and Albert Museum
Signed with monogram
Study for *Bacchus and the Nymphs of Nysa*.

Study of a woman in heavy drapery **(117)**

Black chalk heightened with white
38.5 × 24.7
Dated 1840
Birmingham Museums and Art Gallery.

A Demoniac Boy **(110)**

Pencil and coloured wash
36.7 × 24.7
c. 1843
Victoria and Albert Museum
Detail copied from a fresco by
Domenichino, Chapel of Nilus, Grotta
Ferrata, near Rome.

Life study, male **(116)**

Charcoal and white chalk
56.1 × 38.8
Signed and dated 1844
Victoria and Albert Museum
Probably used for the left arm of King Joash
in *Joash Shooting the Arrow of Deliverance*
(R.A. 1844).

Female figure study

Silverpoint on grey prepared paper
11.91 × 16.4
Signed with a monogram and dated 1845
British Museum.

A Sybil **(128)**

Black and white chalk and grey wash
91.4 × 87.6, circular
1852
Cecil Higgins Art Gallery, Bedford
Exh. R.A. 1852 (94) 'Study for fresco';
Aberdeen 1964 (53).

A Sybil

Silverpoint on washed paper heightened
with white
11.61 × 11.61
Signed with a monogram
Victoria and Albert Museum.

A hand wearing a wedding ring

Pencil
8.33 × 10.1
Victoria and Albert Museum.

Rear view of draped female figure

Silverpoint on red washed paper
15.2 × 5.0
Victoria and Albert Museum.

Draped female and child seen from side

Pen and ink
13.32 × 7.6
Victoria and Albert Museum.

Monk washing his hands

Pen and ink
7.6 × 5.0
Victoria and Albert Museum.

Head of a bearded man

Pencil
5.0 × 5.0
Victoria and Albert Museum.

Head of an old man

Charcoal
25.4 × 20.9
Aberdeen Art Gallery.

Female figure study

Silverpoint on lilac prepared paper
14.31 × 11.91
British Museum.

Female figure studies

Pen and ink
13.97 × 10.97
British Museum
Exh. Aberdeen 1964 (50).

Head of a young woman

Black and white chalk on grey prepared
paper
16.4 × 13.32
N.G.S.
Exh. N.G.S. 1960, 'Scottish Drawing';
Aberdeen 1964 (64).

Young boy lying on ground (**107**)

Charcoal and pencil
12.7 × 24.4
Victoria and Albert Museum.

Profile of a young boy, singing

pencil
3.32 × 3.32
Victoria and Albert Museum.

Study of hands

Chalk
22.8 × 15.2
Jupp Catalogue, R.A. Library.

Head of a classical figure crowned with
berries

Brown ink
22.8 × 15.2
Jupp Catalogue, R.A. Library.

Draped woman walking with small boy

Charcoal on grey paper, heightened with
white paint
15.2 × 10.1
Victoria and Albert Museum
(catalogued as *Hagar and Ishmael*).

Figure reading

Pen and ink
10.1 × 5.0
Victoria and Albert Museum

Woman attending a bedridden man

Ink and charcoal
5.0 × 5.0, enclosed in a round-headed arch
Victoria and Albert Museum.

Thumb-nail narrative sketches

Ink and pencil
5.0 × 5.0
Victoria and Albert Museum.

(ii) *Religious subjects*

The Entombment (**64**)

Brown ink
17.8 × 21.5
1829?
British Museum
(Possibly design exh. R.I.E.A.S. 1829
(179))
Exh. Aberdeen 1964 (52) as 'Deposition'.

The Entombment

Water-colour
18.4 × 16.7
1843?
Birmingham Museums and Art Gallery
Coll. Murray Marks, presented by him to
gallery 1916
Exh. Aberdeen 1964 (63)
Copy of Taddeo Gaddi's fresco in Bardi
Chapel
S. Croce, Florence.

Madonna and Child (**94**)

Silverpoint touched with white
21.63 × 19.4
Signed with a monogram and dated 1848
N.G.S.
Coll. Sir James and Lady Caw
Exh. N.G.S. 1960 'Scottish Drawings';
Aberdeen 1964 (62).

The Entombment (**63**)

Pen, ink, and wash
21.9 × 32.7
dated 1850
Whitworth Art Gallery, University of
Manchester
Presented by Friends of the Whitworth
1960.

Jacob and Rachel

Pen and ink
20.9 × 20.3
1850
Aberdeen Art Gallery
Coll. Miss Ella Dyce to 1940
Exh. Aberdeen 1964 (56).

David with his Harp (profile) (**69**)

Pencil and silverpoint on grey paper
11.28 × 5.0
c. 1859
Aberdeen Art Gallery
Study for David as a Youth.

David with his Harp (**70**)

Pencil and silverpoint on grey paper
12.7 × 8.32
c. 1859
Aberdeen Art Gallery
Study for David as a Youth.

Christ Seated (**83**)

Pencil and silverpoint on grey paper
12.7 × 20.3
c. 1860

Aberdeen Art Gallery
Study for *The Man of Sorrows* and *Christ and
the Woman of Samaria*.

The Woman of Samaria (**82**)

Pencil and silverpoint on grey paper
10.1 × 20.3
c. 1860–3
Aberdeen Art Gallery
Study for *Christ and the Woman of Samaria*.

Madonna and Child

Silverpoint
43.2 × 35.5
Whereabouts unknown
Exh. Whitechapel Art Gallery, Summer
exhibition 1912, 'Scottish Art and
History', property of Mrs. Robert
Cholmeley, 133 Sackville Rd., Hove,
Sussex.

Virgin and Child (**95**)

Pen and ink
20.3 × 13.32
Jupp Catalogue, R.A. Library.

Virgin and Child (**102**)

Pencil
12.7 × 8.33
Victoria and Albert Museum
Copy of Lucca della Robbia *Virgin of the
Apple*

Virgin and Child with Saints (**99**)

Ink and wash
Hon. C. A. Lennox Boyd, London
Coll. Truro Museum to 1966.

The Holy Family with the Infant St. John
(**104**)

Pencil heightened with white
22.8 × 36.7

N.G.S.
Coll. David Laing, R.S.A. transferred
1910 to N.G.S.
Exh. N.G.S. 1960 'Scottish drawings';
Glasgow 1961 'Scottish Painting',
(111); Aberdeen 1964 (54).

Woman in Old Testament Dress (**77**)

Pencil and water-colour
40.6 × 26.6
Aberdeen Art Gallery.

Ruth and Boas (**78**)

Water-colour
17.8 × 30.5
Mrs. Patrick Gibson
Coll. J. E. Taylor, Mrs. V. G. Bird
Exh. Aberdeen 1964 (68).

St. Christopher (**72**)

Pen, wash, and pencil
1840s
20.6 × 20.6
Aberdeen Art Gallery
Coll. Miss Ella Dyce
Exh. Edinburgh Arts Club 1951;
Aberdeen 1964 (46).

The Assumption of the Virgin (**73**)

Pen and wash
23.4 × 18.4, sketch book page
1840s
Earl of Wemyss
Coll. Lady Ruthven
Exh. Aberdeen 1964 (47).

The Trinity (**157**)

Black chalk heightened with white
17.8 × 24.0
c. 1850
Aberdeen Art Gallery
Possibly related to *Religion, the Vision of Sir
Galahad and his Company.*

Studies related to the subject of Christ's
Agony in the Garden

Pencil on blue prepared paper heightened
with white
27.9 × 21.9
British Museum
Purch. July 1889
Exh. Aberdeen 1964 (49).

The Rest on the Flight into Egypt

Pencil and water-colour
28.4 × 33.6
N.G.S.
(No. 3803, catalogued as *Poet and his Wife in
an Italian Landscape*).

(iii) *Literary and historical subjects*

Puck (**14**)

Charcoal heightened with white
21.5 × 17.1
Signed and dated 1825
Coll. Sotheby's, 1 Aug. 1951 (50); L. G.
Duke, Esq.
Exh. Aberdeen 1964 (44).

Bacchus Nursed by the Nymphs of Nysa (**7**)

Water-colour
11.28 × 8.96
c. 1827
Beinecke Rare Book and MS. Library,
Yale University
Mounted on f.59 verso of Denham Album
Coll. Catherine Case Copeman Denham;
Frances Copeman; Louisa Jane Copeman;
James Miles Bookshop, Leeds, 1924; Sir
Harold Mackintosh; Edward J. Beinecke;
given to Yale 1935
Exh. Detroit Institute of Arts and
Philadelphia Museum of Art 1968 (188)
Study for painting exh. R.A. 1827.

Bacchus Nursed by the Nymphs of Nysa (**10**)

Pen and ink heightened with white
22.2 × 33.0
Signed with monogram and dated 1827
Aberdeen Art Gallery
Coll. Miss Ella Dyce to 1940
Exh. Edinburgh Arts Club 1951; Aberdeen
1964 (45)
Possibly R.A. 1851 (107) '*Bacchanal*, an
early study'
Study for painting exh. R.A. 1827.

James Clerk-Maxwell as Puck

Pencil
c. 1833
Whereabouts unknown
Photographs of this work in the possession
of P. A. Campbell Fraser, Esq., and
Aberdeen Art Gallery.

Luca Signorelli Painting the Portrait of his Dead Son

Pencil heightened with white on grey paper
(sketch book page)
13.32 × 22.8
Signed 'W. D.1836'
Earl of Wemyss
Coll. Lady Ruthven
Exh. Aberdeen 1964 (48).

Christabel (**109**)

Pencil and brown chalk on grey paper
13.32 × 10.1
Inscribed 'Wm. Dyce, Crossgate Manse,
July 21st, 1849'
Aberdeen Art Gallery

(iv) *Miscellaneous*

Study of foliage

Pencil and chalk
15.2 × 11.28
Jupp Catalogue, R.A. Library.

A Cat

Black chalk (sketch book page)
26.0 × 36.1
Unsigned but with contemporary
attribution to Dyce
Earl of Wemyss.

Flat pattern with stars and rosettes

Ink and water-colour
15.2 × 11.28
Jupp Catalogue, R.A. Library.

CLASSIFIED BIBLIOGRAPHY

All works are published in London unless otherwise stated.

CLASSIFICATION:
1. Unpublished and Manuscript Sources
2. Prospectuses and catalogues of particular importance
3. Journals and Books published before 1870
4. Works of special relevance to a study of William Dyce
5. Monographs and Autobiographical Works
6. General critical and historical works
7. Works of reference
8. Literary works

1. UNPUBLISHED AND MANUSCRIPT SOURCES

Aberdeen Art Gallery, The Dyce Papers.

Aberdeen, Forrester Hill, J. G. Henderson, 'Notes on the Aberdeen Medico-Chirurgical Society' (n.d.).

Aberdeen University Library, W. Dyce, 'On the Relations between the Phenomena of Electricity and Magnetism, and the Consequences deducible from those Relations' (1830).

Birmingham City Art Gallery, papers relating to Dyce's portrait of Mrs. Clerk Maxwell and her son, James.

Campbell-Fraser, Mr. P. A., Dyce correspondence.

Cardiff, National Museum of Wales, Geology department, de la Beche correspondence.

Clwyd County Record Office, Gladstone-Glynne papers.

Edinburgh, The National Library of Scotland, Dyce correspondence.

Edinburgh University Library, Dyce correspondence.

Hampstead, John Keats Museum and Library, Joseph Severn correspondence.

Leeds University Library, G. J. Haigh, 'The Frescoes in the Houses of Parliament', M.A. thesis, 1962.

London, The British Library, W. E. Gladstone correspondence.

London, The Courtauld Institute of Art, W. Vaughan, 'The German Manner in English Art 1815–61', Ph.D. thesis, 1977.

London, The Royal Academy Library, the Jupp catalogue.

London, The Tate Gallery, R. Ironside and Miss I. Dyce, check list of paintings by W. Dyce (1932).

London, Victoria and Albert Museum, W. Mulready's account book; R. J. B. Walker, 'A Catalogue of Paintings and Drawings in the Palace of Westminster' (1962); Sir C. Eastlake correspondence.

Manchester Public Libraries, Dyce correspondence; six lectures by E. F. Rimbault on the secular music of England.

Norwich, The University of East Anglia, P. Cunningham, 'William Dyce and the High Church Movement', M.A. thesis, 1973 (Dept. of History of Art).

Symondson, Mr. A., Comper, J. N., 'Recollections of All Saints', Margaret St. and St. Alban's, Holborn' (n.d.).

Vienna, The National Library, Steinle correspondence.

Yale University, Beinecke Rare Book Library, the Denham album.

2. PROSPECTUSES AND CATALOGUES OF PARTICULAR IMPORTANCE

The Handel Society (1843–4).

The London Professional Choral Society (1841)

The Motett Society (1841).

The Musical Antiquarian Society (1840–1).

The Percy Society (1840–1).

The British Library, *Catalogue of Additions to the Manuscripts. The Gladstone Papers* (1953).

The British Library, *Catalogue of Engraved British Portraits* (1922).

Christie's, 5 May, 1865, W. Dyce's Studio Sale.

William Dyce R.A. 1806–64, Centenary exhibition, Aberdeen. Art Gallery and Thos. Agnew and Sons Ltd. (1964).

Manchester Art Treasures Exhibition, official catalogue (1857).

The Royal Academy, London; The Royal Scottish Academy, Edinburgh, annual exhibition catalogues

The Science Museum Photography Collection (1969)

3. JOURNALS AND BOOKS PUBLISHED BEFORE 1870

Archaeologia Scotica. Transactions of the Society of Antiquaries of Scotland.

The Art-Union (after 1848 *The Art Journal*)

The Athenaeum

The Builder

The Christian Remembrancer

The Ecclesiologist

Fraser's Magazine
Gentleman's Magazine
The Illustrated London News
Journal of Design and Manufacture
Journal of the Royal Photographic Society
The Morning Chronicle
The Parish Choir
The Times

ACLAND, SIR THOMAS DYKE, 11th Bt., *Some Account of the New Oxford Examinations for the Title of 'Associate in Arts' etc.* (1858).

BUNSEN, FRANCES, BARONESS, *A Memoir of Baron Bunsen* (1868).

COCKBURN, HENRY, LORD, *Memorials of his Time* (Edinburgh, 1856).

COOPER, ANTHONY ASHLEY, 3rd Earl of Shaftesbury, *Charakteristiks* (1707).

DUNLOP, JOHN COLIN, *The History of Fiction* (1814, 2nd edn. Edinburgh, 1816).

DYCE, WILLIAM, *On the Connection of the Arts with General Education* (1858).

——*The Drawing Book of the Schools of Design* (1843).

——and Wilson, C. H., *Letter to Lord Meadowbank and the Committee of the Honourable Board of Trustees for the Encouragement of Arts and Manufactures on the best means of ameliorating the arts and manufactures in point of Taste.* (Edinburgh, 1837).

——*The National Gallery, its formation and Management, addressed by permission to H.R.H. Prince Albert* (1853).

——*Notes on the Altar* (1844).

——*Notes on Shepherds and Sheep* (1851).

——'Observations on Fresco-Painting', Appendix IV to *Sixth Report of the Commissioners on the Fine Arts* (1846).

——*The Order of Daily Service*, etc. (1843).

——*On the Position of Art in the Proposed Oxford Examinations* (1858).

——*Report on Reports Made by Mr. Dyce, Consequent to his journey on an Inquiry into the State of Schools of Design in Prussia, Bavaria and France*, written in 1838, printed in *Parliamentary Papers*, 1840 (98) xxix.

——*Theory of the Fine Arts, An Introductory Lecture delivered in the classical Theatre of King's College, London, May 24, 1844* (1844).

GILCHRIST, ALEXANDER, *The Life of William Etty R.A.* (1855).

HUNT, F. K., *The Book of Art* (1846).

JAMESON, MRS. ANNA, *Legends of the Madonna* (1852), vol. iii of *Sacred and Legendary Art*.

——and GRÜNER, L., *The Decorations of the Garden Pavilion at Buckingham Palace* (1846).

LANDON, C. P., *A Collection of Etchings of the Most Celebrated Ancient and Modern Productions in Painting, sculpture and architecture of the Italian and French Schools: from originals preserved in the Louvre, Paris. With descriptions from the French of C. P. Landon, etc.* (1821).

LENOIR, ALEXANDRE, *Monuments des Arts Libéraux, Mécaniques et Industriels de la France* (Paris, 1840).

LYELL, CHARLES, *Elements of Geology* (1838; revised 1865).

——*Principles of Geology* (1830–3).

MARTIN, LAWRENCE, *Not so Good as we Seem or the Guilt of Art* (1853).

MERRIFIELD, MRS. M. P., *The Art of Fresco* (Brighton, 1846).

OLIPHANT, F. W., *A Plea for Painted Glass, An Inquiry into Its Nature, Character and Objects* (Oxford, 1855).

PALGRAVE, F. T., *Descriptive Handbook to the Fine Art Collection in the International Exhibition of 1862* (1862).

——*Essays on Art*, (1866).

PUSEY, E. B., ed., *A Library of the Fathers* (Oxford, 1836–44).

RIDOLFI, C., *Le Meraviglie dell'Arte* (2nd edn. Padua, 1835–7).

ROSCOE, THOMAS, *Wanderings and Excursions in North Wales* (1836).

SANDBY, P., *History of the Royal Academy* (1862).

SCOTT, DAVID, *British, French and German Painting being a reference to the grounds which render the proposed painting of the New Houses of Parliament important as a Public Measure* (Edinburgh, 1841).

SCOTT, W. BELL, *Memoir of David Scott, containing his Journal in Italy, Notes on Art and other Papers* (Edinburgh, 1850).

VULLIAMY, LEWIS, *Examples of Ornamental Sculpture in Architecture* (1823).

WAAGEN, DR. G. F., *Treasures of Art in Great Britain* (1854).

WINSTON, CHARLES, *An Inquiry into the Differences of Style Observable in Ancient Glass Painting* (Oxford, 1857).

——*Memoirs Illustrative of the Art of Glass Painting* (1865).

ZANOTTI, F. *Pinacoteca delle Imp. Reg. Academia Veneta delle Belle Arte* (Venice, 1834).

4. WORKS OF SPECIAL RELEVANCE TO A STUDY OF WILLIAM DYCE

ANDREWS, KEITH, *The Nazarenes* (Oxford, 1964).

BELL, QUENTIN, *The Schools of Design* (1963).

BOASE, T. S. R., 'The Decoration of the New Palace of Westminster, 1841–63', *Journal of the Warburg and Courtauld Institutes* (1954).

ANON., *The Chalmers and Trail Ancestry of Dr. and Mrs. Guthrie's Descendants* (Edinburgh, 1902).

CHESTER, AUSTIN., 'The Art of William Dyce, R.A.', *The Windsor Magazine* (1909).

DAFFORNE, J. C., 'William Dyce, R.A.', *The Art Journal*, vi (1860).

ERRINGTON, LINDSAY and HOLLOWAY, JAMES, *Rediscovering Scotland*, Edinburgh; National Gallery of Scotland, 1978.

GAUNT, WILLIAM, Review in *The Times*, 11 Aug. 1964.

IRWIN, D. and F., *Scottish Painters at Home and Abroad* (1975).

IRWIN, F. 'William Dyce's Titian's First Essay in Colour', *Apollo*, Oct. 1978.

POINTON, M., 'William Dyce as a Painter of Biblical Subjects', *Art Bulletin*, June 1976.

——'W. E. Gladstone as an Art Patron and Collector', *Victorian Studies*, xix, 1 (Sept. 1975).

——'The representation of time in pictorial art: a Study of William Dyce's *Pegwell Bay: A Recollection of October 5th 1858*', *Art History*, i (Mar. 1978).

REYNOLDS, GRAHAM, 'An Aberdonian at Agnews', review in *Apollo* (Oct. 1964).

STALEY, ALLEN, 'William Dyce and Outdoor Naturalism' *Burlington Magazine* (1963).

——'Eleazer of Damascus by William Dyce', *Minneapolis Institute of Art Bulletin* (1967).

——*The Pre-Raphaelite Landscape* (Oxford, 1973).

THOMPSON, PAUL, *William Butterfield* (1971).

5. MONOGRAPHS AND AUTOBIOGRAPHICAL WORKS

BASSETT, A. TILNEY, *Gladstone to his Wife* (1936).

BLACKIE, JOHN STUART, *Notes of a Life*, ed. A. Stodart-Walker (Edinburgh, 1910).

CAMPBELL, L., and GARNETT, W., *The Life of James Clerk-Maxwell* (1882).

CHALMERS, ALEXANDER, *In Memoriam, Alexander Chalmers 1759–1834* (privately printed, n.d.).

COLE, SIR HENRY, *Fifty Years of Public Work* (1884).

COPE, C. W., *Reminiscences* (1891).

DODGSON, CAMPBELL, C.B.E., *The Etchings of Sir David Wilkie and Andrew Geddes* (1936).

DYCE, ALEXANDER, *The Reminiscences of Alexander Dyce*, ed. R. J. Schrader (Ohio, 1972).

EASTLAKE, LADY E., *Journals and Correspondence of Lady Eastlake*, ed. Charles Eastlake Smith (1895).

——'Memoir of Sir Charles Eastlake', prefixed to Sir Charles Eastlake, *Contributions to the Literature of the Fine Arts* (1870).

FARR, DENNIS, *William Etty* (1958).

FOTHERGILL, BRIAN, *Nicholas Wiseman* (1963).

FRITH, W. P., *My Autobiography: Reminiscences* (1887).

GLADSTONE, W. E., *The Gladstone Diaries*, ed. M. R. D. Foot and H. C. G. Mathew (Oxford, 1968–74).

HAYDON, B. R., *The Diary of Benjamin in Robert Haydon*, ed. W. B. Pope (Cambridge, Mass., 1963).

HELMORE, FREDERICK, *Memoir of the Rev. Thomas Helmore, M.A.* (1891).

HOGG, T. J., *The Life of Percy Bysshe Shelley*, ed. E. Dowden (1906).

HUEFFER, FORD MADOX, *Ford Madox Brown, A Record of His Life and Work* (1896).

LYTTELTON, LADY, *Correspondence of Sarah Spencer, Lady Lyttelton*, ed. Hon. Mrs. Hugh Wyndham (1912).

MARTIN, SIR THEODORE, *The Life of H.R.H. The Prince Consort* (1875).

ROSSETTI, W. M., *Pre-Raphaelite Diaries and Letters* (1900).

SCOTT, W. BELL, *Autobiographical Notes of the Life of William Bell Scott*, ed. W. Minto (1892).

SHARP, WILLIAM, *The Life and Letters of Joseph Severn* (1892).

TENNYSON, SIR CHARLES, *Alfred Tennyson* (1949).

TRAPPES-LOMAX, MICHAEL, *Pugin: A Medieval Victorian* (1932).

WALKER, ARCHIBALD STODART, *The Letters of John Stuart Blackie to his Wife* (Edinburgh, 1909).

WATKIN, D. *The Life and Work of C. R. Cockerell* (1974).

6. GENERAL CRITICAL AND HISTORICAL WORKS

AGRESTI, A, *I Prerafaellisti* (Turin, 1908).

AMES, WINSLOW, *Prince Albert and Victorian Taste* (1968).

ARMSTRONG, WALTER, *Scottish Painters* (1888).

ASHE, GEOFFREY, *The Quest for Arthur's Britain* (1968).

BATHO, GORDON, *The Chevy Chase Sideboard* (Trust Houses Ltd. pamphlet, 1960).

BELL, QUENTIN, *Victorian Artists* (1967).

BELL, W. GODFREY, *The Story of the Church of St. Leonard, Streatham* (1916).

BOASE, T. S. R., *English Art, 1800–1870* (Oxford, 1959).

BØE, ALF, *From Gothic Revival to Functional Form. A Study of Victorian Theories of Design* (Oslo, 1957).

BOND, F. A., *The Chancel of English Churches* (1916).

BORSOOK, E., *The Mural Painters of Tuscany* (1960).

BRION, MARCEL, *Art of the Romantic Era* (1966).

BROMHEAD, H. W., *The Heritage of St. Leonard's Parish Church, Streatham, being an account of the traditions and associations of the Church incorporating notes on the monuments by Mrs. Arundel Esdaile* (1932).

BRYDALL, R., *A History of Art in Scotland* (1889).

BUCKLEY, J. H., *The Triumph of Time; A Study of the Victorian Concepts of Time, History, Progress and Decadence* (Cambridge, Mass., 1967).

BURROW, J. W., 'The Uses of Philology in Victorian England' in R. Robson, ed., *Ideas and Institutions of the Victorians. Essays in Honour of G. Kitson Clark* (1967).

CARLINE, RICHARD, *Draw They Must* (1968).

CAW, JAMES L., *Scottish Painting Past and Present* (1908).

CHADWICK, OWEN, *The Victorian Church*, vols. vi–vii of *An Ecclesiastical History of England* (1966).

CLARK, BASIL F. L., *Parish Churches of London* (1966).

DARTON, F. J. HARVEY, *Children's Books in England. Five Centuries of Social Life* (Cambridge, 1932; new edn. 1958).

DAVIS, FRANK, *Victorian Patrons of the Arts* (1963).

Detroit Institute of Arts and the Philadelphia Museum of Art, *Romantic Art in Britain, Paintings and Drawings, 1760–1860* (1968).

DIDRON, ADOLPHE NAPOLEON, *Christian Iconography* (1851), trans. E. J. Millington (New York, 1965).

EDDY, J. P., *The Law of Copyright* (1957).

Fasti Academiae Marischallanae Aberdoniensis 1593–1860, ed. P. J. Anderson (1889–98).

FRANKFURT, STAEDEL, *Die Nazarener*, (1977).

GERNSHEIM, HELMUT, *The History of Photography* (1955).

GRAFTON GALLERIES, LONDON, *Works of Old Scottish Portrait Painters* (1895).

GRAY, J. M., *Man and Myth in Victorian England: Tennyson's the Coming of Arthur* (The Tennyson Society, Tennyson Research Centre, Lincoln, 1969).

GRIEVE, ALASTAIR, 'The Pre-Raphaelite Brotherhood and the Anglican High Church', *Burlington Magazine* (May 1969).

Grieve, Alastair, *The Art of Dante Gabriel Rossetti: The Pre-Raphaelite Period 1848–50* (Hingham, Norfolk, 1973).

Hardie, William, *Scottish Painting 1837–1939* (1976).

Hilton, Timothy, *The Pre-Raphaelites* (1970).

Hitchcock, Henry Russell, *Early Victorian Architecture in Britain* (1954).

——'High Victorian Gothic', *Victorian Studies*, (1957–8).

Howitt, Margaret, *Frederick Overbeck* (1886).

Hubbard, Hesketh, *A Hundred Years of British painting 1851–1951* (1951).

Hunt, W. Holman, *Pre-Raphaelitism and the Pre-Raphaelite Brotherhood* (1905).

Hutchison, Sidney C., *The History of the Royal Academy* (1968).

Ironside, R., and Gere, J., *Pre-Raphaelite Painters* (1948).

Jack, I., *Keats and the Mirror of Art* (Oxford, 1976).

Jannattoni, Livio, *Roma e gli Inglesi* (Rome, 1945).

Johnson, E. D. H., *The Alien Vision of Victorian Poetry* (Princeton, 1952).

Knapp, F., *Andrea Mantegna: der Meisters Gemälde und Kupferstiche* (Stuttgart, 1910).

Law, H. W., and I., *The Book of the Beresford Hopes* (1925).

Leslie, G. D., *The Inner Life of the Royal Academy* (1914).

Levey, Michael, *Painting at Court* (1971).

Lonsdale, Revd. J. G. *Recollections of the Work done in and upon Lichfeld Cathedral from 1856–1894* (Lichfeld, 1895).

Maas, Jeremy, *Victorian Painters* (1969).

Macaulay, J., *The Gothic Revival 1745–1845* (Glasgow and London, 1975).

MacColl, D. S., *Nineteenth-Century Art* (1902).

MacDonald, D. K. C., *Faraday, Maxwell and Kelvin* (1964).

MacDonald, Stuart, *The History and Philosophy of Art Education* (1970).

MacKay, W. D., *The Scottish School of Painting* (Edinburgh, 1906).

——and Rinder, Frank, *The Royal Scottish Academy 1826–1916, A Complete List of the Exhibited Works by Raeburn and by Academicians, Associates and Hon. Members ...* (Glasgow, 1917).

MacKerlie, P. H., *Lands and Their Owners in Galloway* (Edinburgh, 1870–9; new edn. 1906).

Mâle, Émile, *Religious Art from the Twelfth to the Eighteenth Century* (1949).

——*Les Saints Compagnons du Christ* (Paris, 1958).

Marle, Raimond Van, *The Italian Schools of Painting* (The Hague, 1924).

Morison, S., *English Prayer Books. An Introduction to the Literature of Christian Public Worship* (1943).

Murdoch, John, *Forty-two British Water-colours from the Victoria and Albert Museum* (1977).

Muther, R., *The History of Modern Painting* (1896).

Nochlin, Linda, *Realism* (1971).

Olsen, D. J., *The Growth of Victorian London* (1976).

Oppé, A. P., 'Victorian Art' in G. M. Young, ed., *Early Victorian England* (1951).

Ornsby, R., *Memoirs of James Robert Hope-Scott* (1884).

Petrie, Sir Charles, *The Victorians* (1960).

Pevsner, Sir Nikolaus, *High Victorian Design* (1951).

Port, M. H., *The House of Parliament* (1976).

RAINBOW, BERNARR, *The Choral Revival in the Anglican Church, 1839–72* (1970).

RÉAU, LOUIS, *Iconographie de l'Art Chrétien* (Paris, 1956).

REDGRAVE, R. and S., *A Century of Painters of the English School* (1866; new edn. 1947).

REYNOLDS, GRAHAM, *Victorian Painting* (1966, new edn.).

RICE, D, TALBOT, *The Edinburgh University Portraits* (1957).

The Works of John Ruskin, ed. E. T. Cook and A. Wedderburn (1903–12).

ST. QUIN, G., *A History of Glenalmond* (1956).

SAXL, F., and WITTKOWER, R., *British Art and the Mediterranean Tradition* (1948).

SCHOLES, PERCY, *The Mirror of Music* (1947).

SEABY, H. A., and RAYNER, P. A., *The English Silver Coinage from 1649* (3rd edn. revised, 1968).

STANTON, PHOEBE, *Pugin* (1971).

STEEGMAN, J., *A Survey of Portraits in Welsh Houses* (1957).

——*Victorian Taste* (1970), first published as *Consort of Taste* (1950).

STUCKEY, C. F., *Temporal Imagery in the Early Romantic Landscape* (Ann Arbor, Michigan, 1972).

SUTTON G., *Artisan or Artist* (1967).

TATE, GEORGE, *The History of the Borough, Castle and Barony of Alnwick* (1868–9).

TEMPLE, A. G., *The Art of Painting in the Queen's Reign* (1897).

——*Sacred Art* (1898, new edn.).

TERRY, RICHARD RUNCIMAN, *A Forgotten Psalter and Other Essays* (Oxford, 1929).

THOMAS, CAVE W., *Mural or Monumental Decoration* (n.d. [1870?]).

TILLOTSON, G. and K., *Mid Victorian Studies* (1965).

WATKINSON, RAYMOND, *Pre-Raphaelite Art and Design* (1970).

WESTON, JESSE L., *From Ritual to Romance* (1920).

WHITE, GLEESON, ed., *The Master Painters of Britain* (1909).

WHITING, G. W. W., 'The Artist and Tennyson', *Rice University Studies*, 1, no. 3 (Summer 1964).

WHITWORTH, W. A., *Quam Dilecta* (1890).

WOLFF, MICHAEL, 'Victorian Study: An Interdisciplinary Essay', *Victorian Studies*, viii (1964–5).

7. WORKS OF REFERENCE

BENÉZIT, E., *Dictionnaire des Peintres, Sculpteurs, Dessinateurs et Graveurs* (1966 edn.).

Dictionary of National Biography.

Encyclopaedia Britannica (Cambridge, 1910).

FOSKETT, DAPHNE, *A Dictionary of British Miniature Painters* (1972).

FREDEMAN, WILLIAM F., *Pre-Raphaelism. A Bibliographical Study* (Cambridge, Mass., 1965).

GRAVES, ALGERNON, *The Royal Academy of Art. A Complete Dictionary of Contributors ... etc.* (1905).

GROVE, SIR GEORGE, *Dictionary of Music and Musicians* (1890; new edn. 1954).

PEVSNER, SIR NIKOLAUS., *The Buildings of England* (1951–75).

REDGRAVE, S., *A Dictionary of Artists of the English School* (2nd edn. 1878).

8. LITERARY WORKS

BLACKIE, J. S., *Songs and Verses, Social and Scientific* (Edinburgh, 1910).

DANTE ALIGHIERI, 'Purgatorio', *Divina Commedia*.

DICKENS, CHARLES, *Bleak House* (1853).

LAUDER, SIR THOMAS DICK, *An Account of the great Floods of August 1829 in the Province of Moray and Adjoining Districts* (Edinburgh, 1830).

LAUDER, SIR THOMAS DICK, *The Highland Rambles* (Edinburgh, 1837).

MALORY, SIR THOMAS, *The Morte d'Arthur*, ed. E. Vinaver (1954; 1st edn. 1947).

Nursery Rhymes, Tales and Jingles (1842).

Poems and Pictures (1846).

TENNYSON, ALFRED, 1st Baron, *The Poems*, ed. C. Ricks (1969).

INDEX

Italic type indicates main references; **bold** type is used for Check-list page numbers.

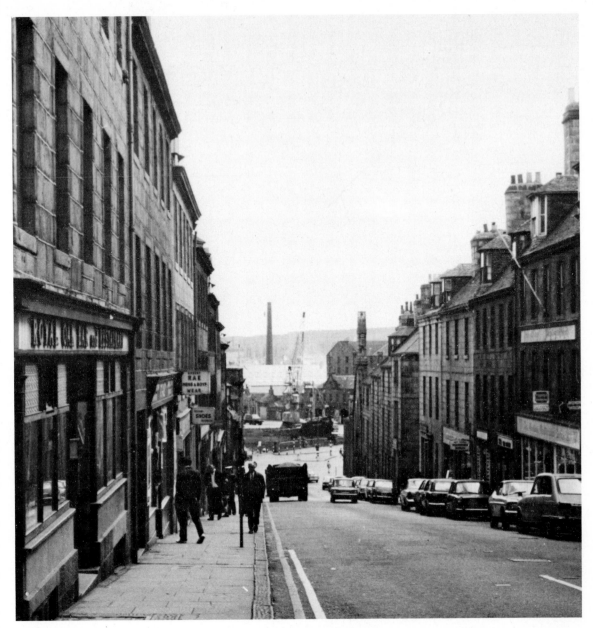

1. Marischal Street, Aberdeen

3. *William Dyce, M.D.*, oil on canvas, 127 × 101.6, *c.* 1835

2. *Self-portrait*, oil on board, 54.5 × 44.4, *c.* 1820

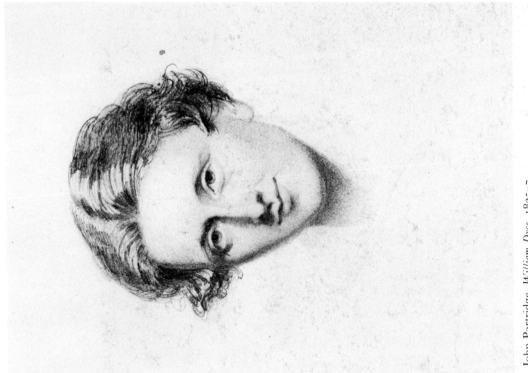

5. John Partridge, *William Dyce*, 1825–7

4. *Margaret Dyce*, pencil, 31.7 × 20.3, *c*. 1836

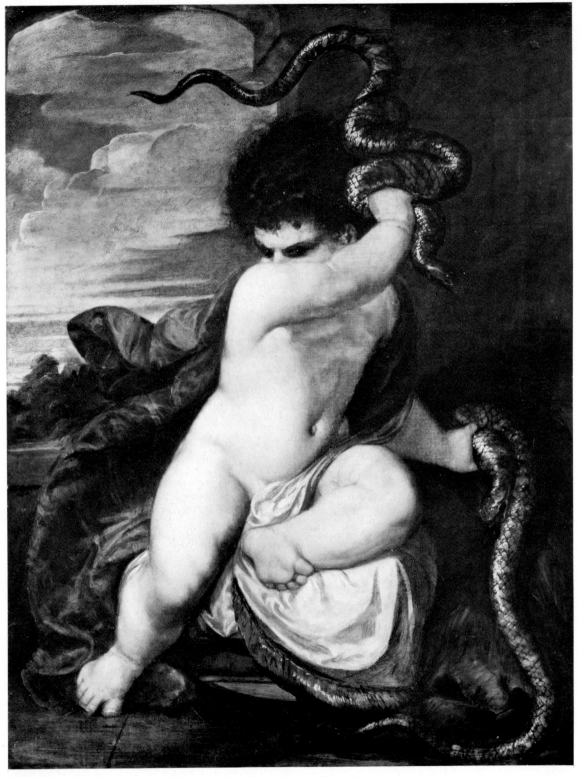

6. *The Infant Hercules Strangling the Serpents sent by Juno to Destroy Him*, oil on canvas, 90.1 × 69.4, 1824

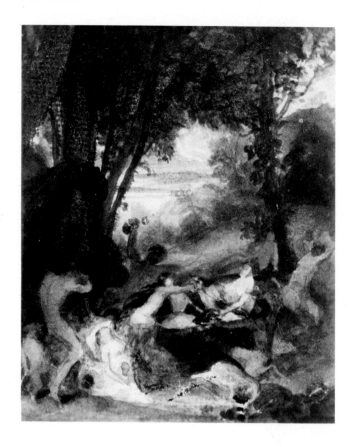

7. *Bacchus Nursed by the Nymphs of Nysa*, water-colour, 11.28 × 8.96, c. 1827

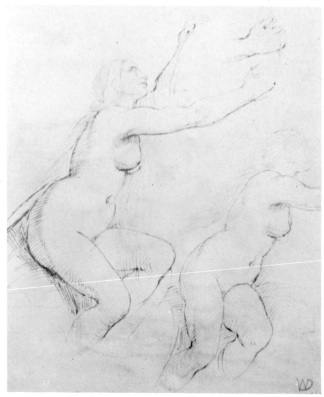

8. *Nude Woman Reaching Upwards*, brown ink, 22.27 × 15.98, 1826

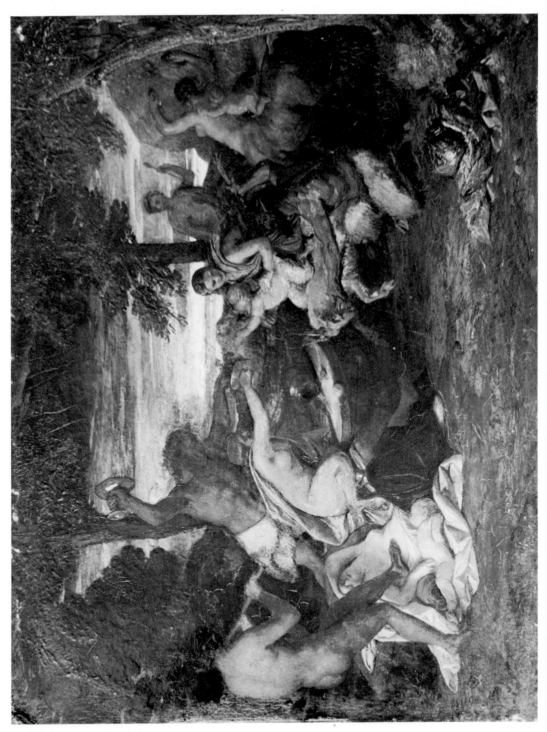

9. *Bacchus Nursed by the Nymphs of Nysa*, oil on panel (unfinished), 29.8 × 40.1, 1826

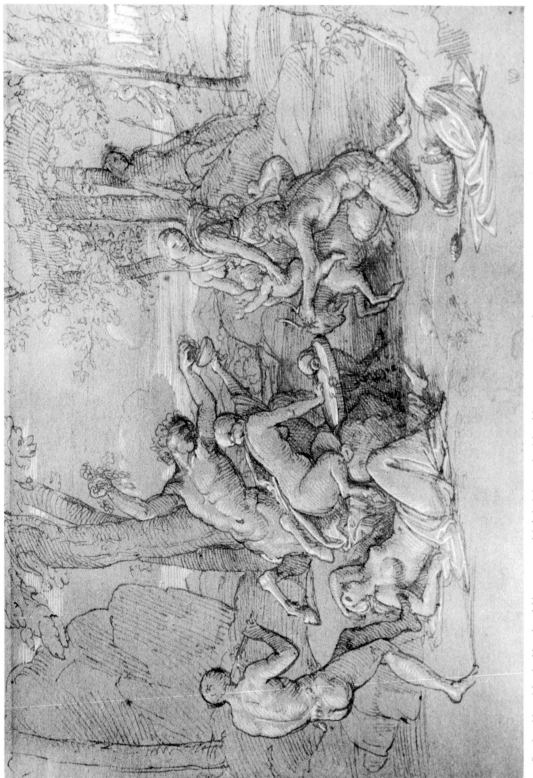

10. *Bacchus Nursed by the Nymphs of Nysa*, pen and ink heightened with white, 22.2 × 33.0, 1827

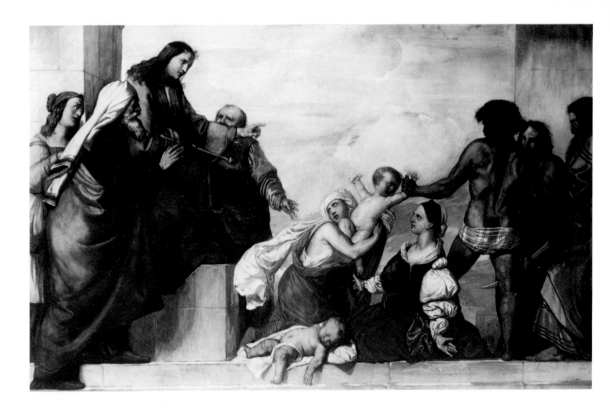

11. *The Judgement of Solomon*,
tempera on paper, 150.35 × 244.35,
1836

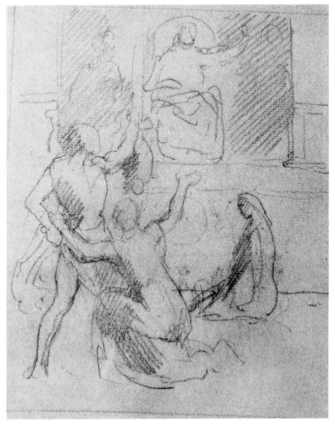

12. *The Judgement of Solomon*,
pencil, 5.0 × 5.0, 1836

13. *The Italian Beggar Boy*, water-colour,
22.8 × 30.5, 1836

14. *Puck*, charcoal heightened with white,
21.5 × 17.1, 1825

16. *Sir James M'Grigor*, oil on canvas, 139.7 × 109.2, 1823

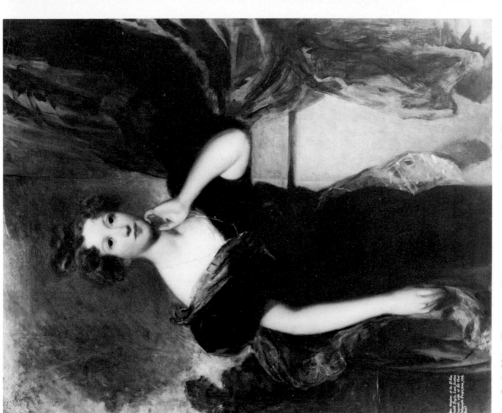

15. *Lady Helen Fergusson*, oil on canvas, 127.0 × 101.6, 1829

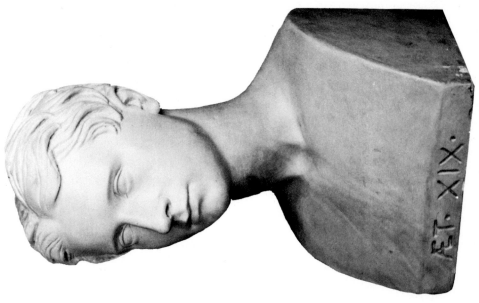

18. Lawrence Macdonald, *Bust of William Dyce*, 1825

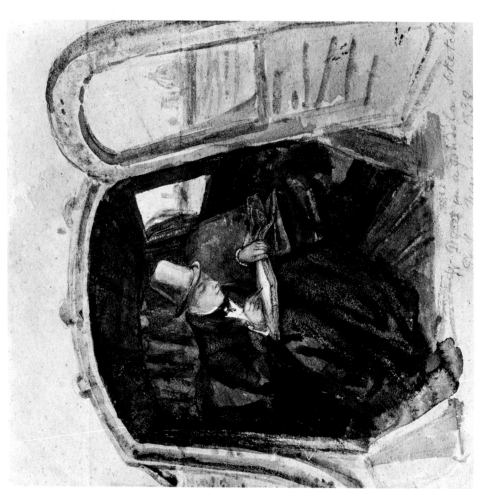

17. David Scott, *William Dyce in a Gondola*, 1832

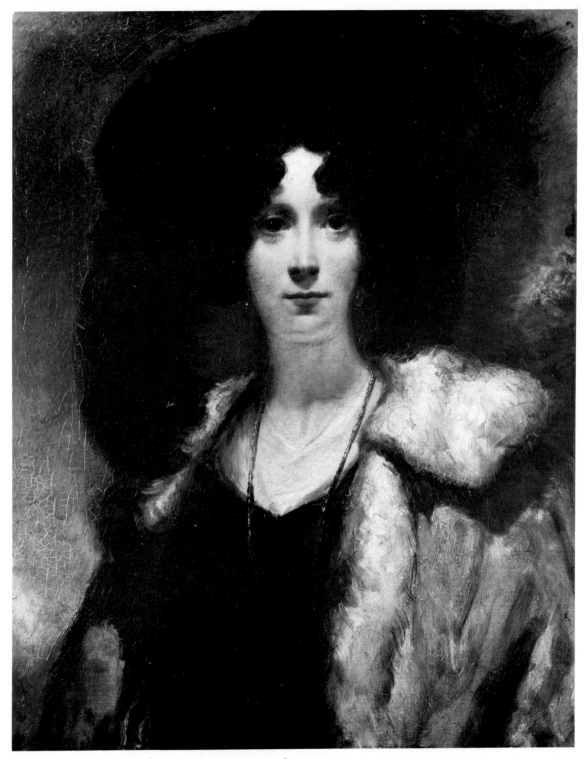

19. *Frances Mary Davidson*, oil on canvas, 91.4 × 71.0, 1829

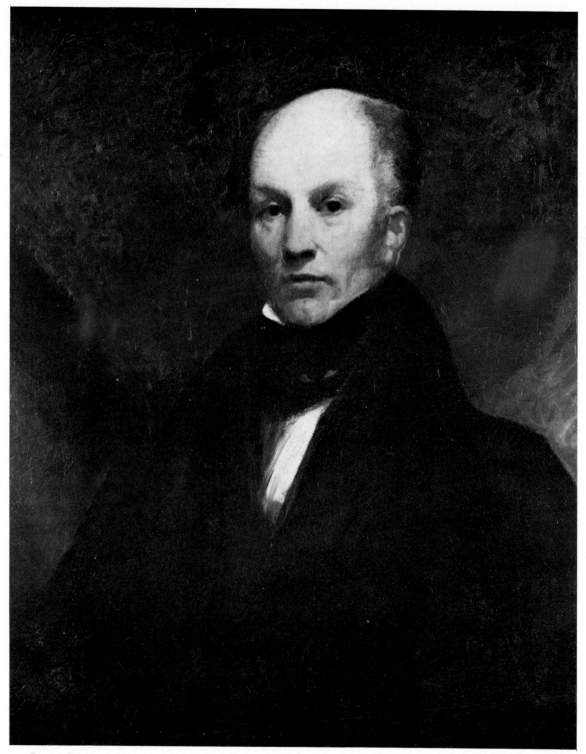

20. *Duncan Davidson*, oil on canvas, 91.4 × 71.0, *c.* 1829

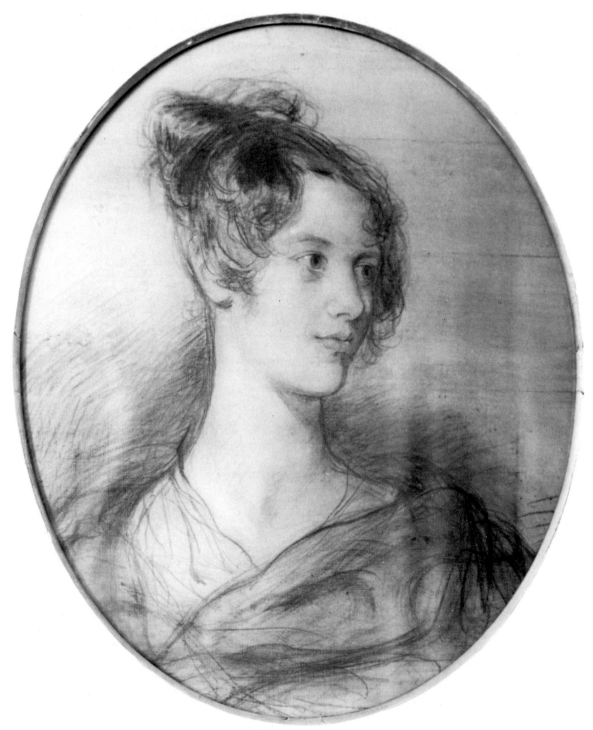

21. *Isabelle Dyce*, chalk, 58.4 × 47.2, oval, *c.* 1830

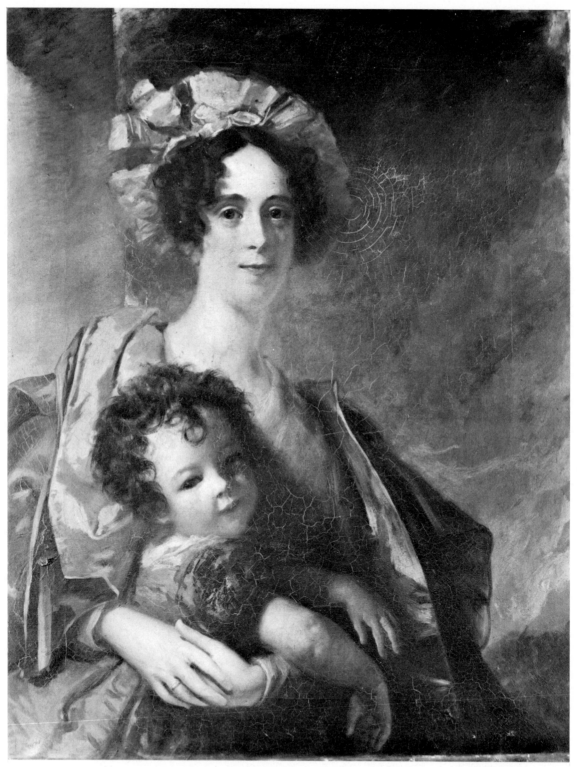

22. *Frances Clerk Maxwell and her Son, James*, oil on canvas, 91.7 × 71.6, 1835

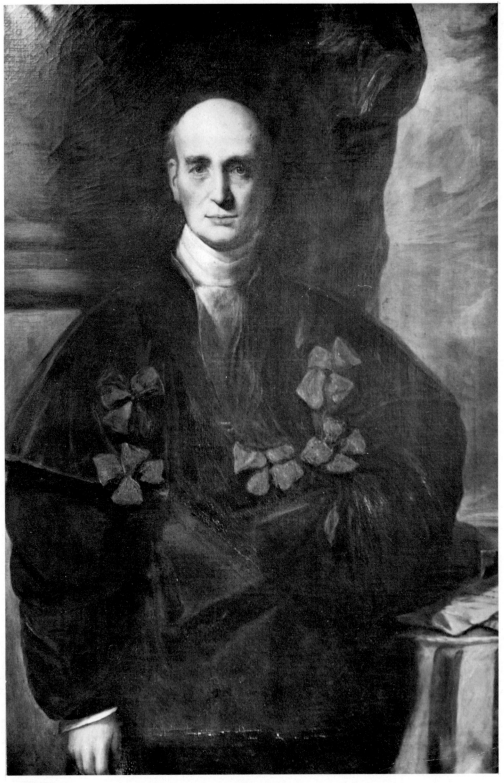

23. *Alexander Maconochie Welwood, Lord Meadowbank,* oil on canvas, 122 × 82.6, 1832

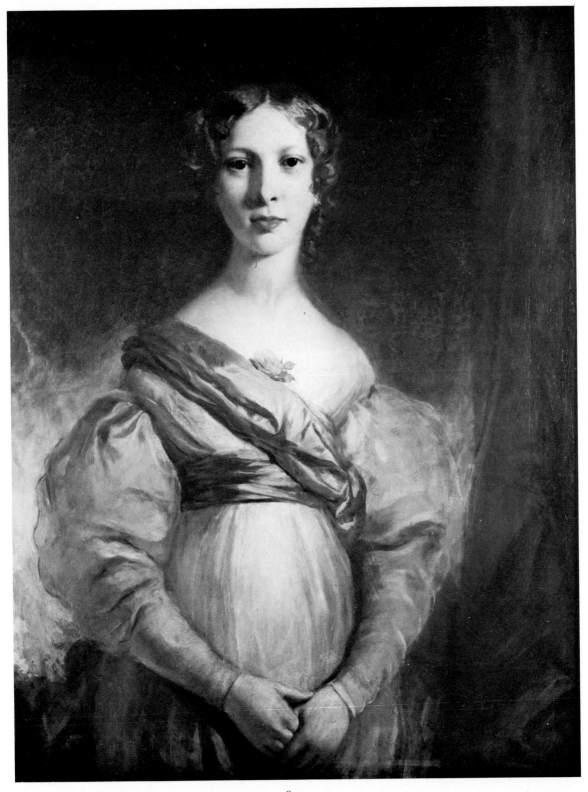

24. *Catherine Sarah Brown*, oil on canvas, 94.4 × 70.1, 1837

26. *James Ivory*, oil on canvas, 124·5 × 96·9, *c.* 1835

25. *Nicolson Bain*, oil on canvas, 76·4 × 63·5, *c.* 1832

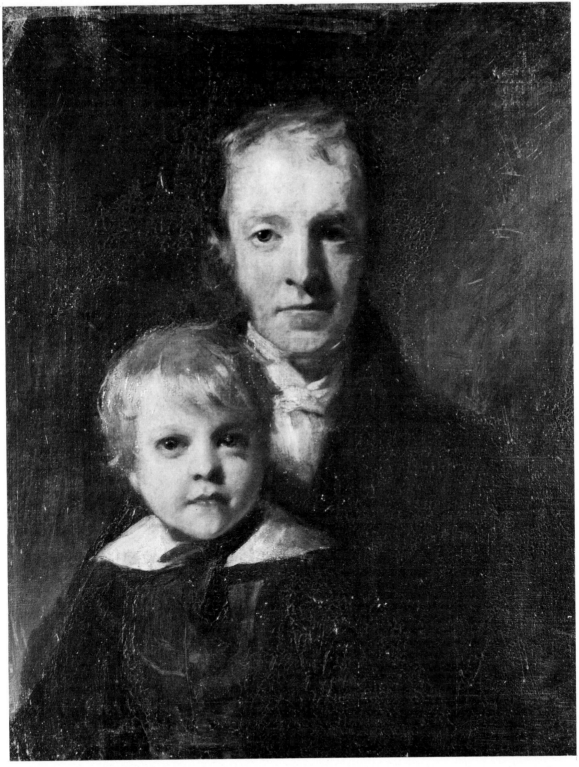

27. *John Small and his Son*, oil on canvas, 76.4 × 63.5, *c.* 1858

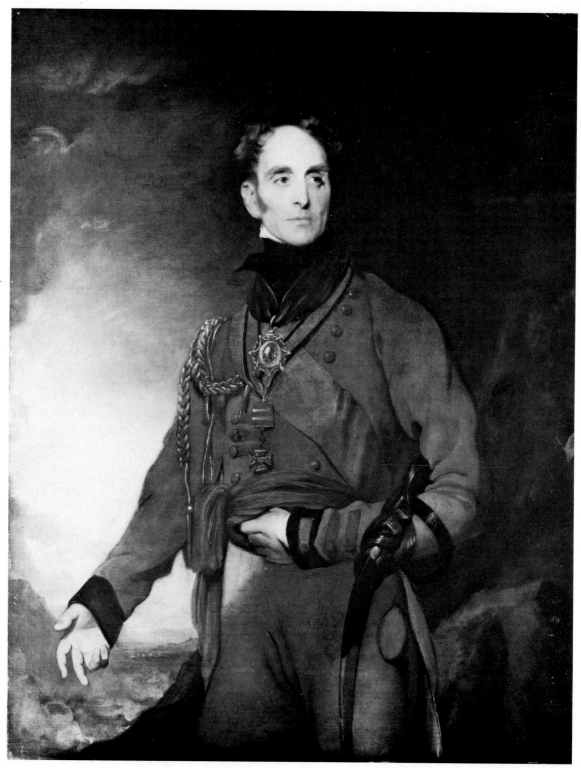

28. *General the Honourable Sir Galbraith Lowry Cole*, oil on canvas, 140.34 × 110.4, 1835

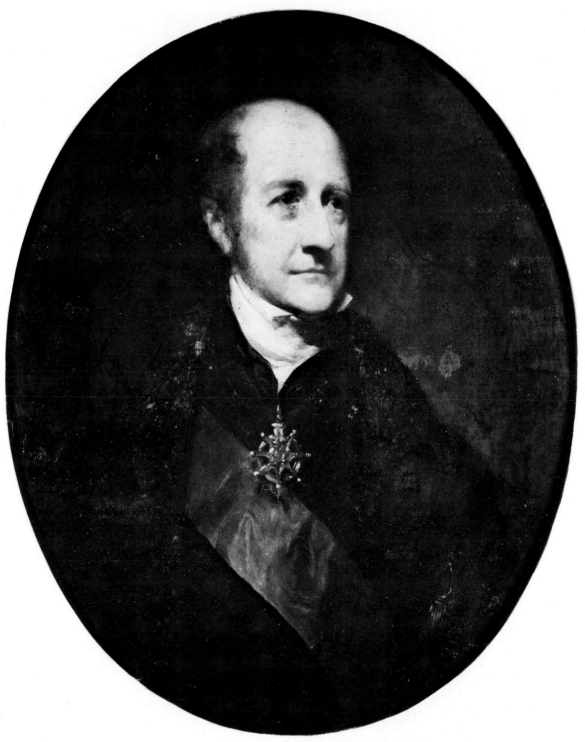

29. *General the Honourable Sir Galbraith Lowry Cole*, oil on canvas, 76.4 × 63.5, *c.* 1840

31. *A Child with a Muff*, oil on canvas, 74 × 62, *c.* 1835

30. Lady Bell, *Charlotte Chalmers*, before 1825

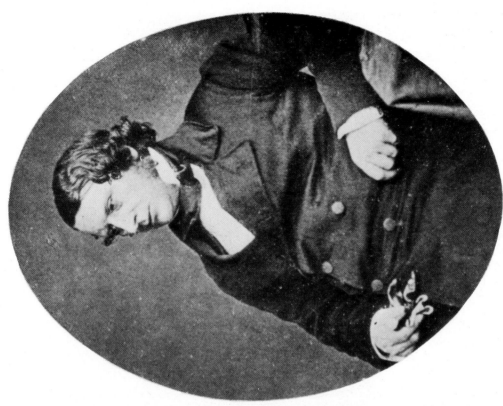

33. *Photograph of William Dyce, R.A., from The Chalmers and Trail Ancestry of Dr. and Mrs. Guthrie's Descendants*

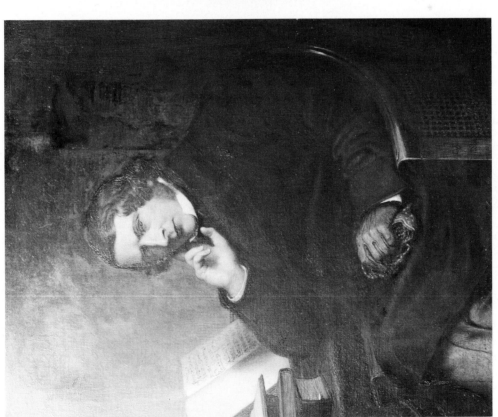

32. C. W. Cope, *William Dyce, R.A.*, posthumous portrait

34. *Lowry William Frederick Dyce*, oil on canvas, 65.4 × 52.0, *c.* 1835

35. *Lowry William Frederick Dyce: 'Who goes there?'*, oil on canvas, 91.4 × 71.0, *c.* 1837

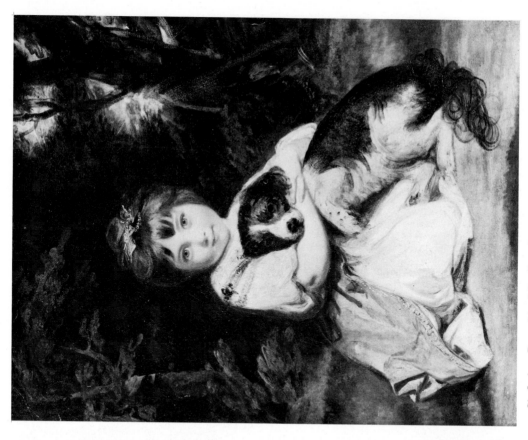

37. Sir Joshua Reynolds, *Miss Jane Bowles*

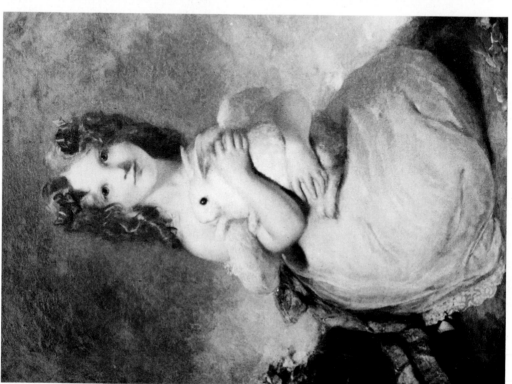

36. *Dora Louisa Grant*, oil on canvas, 92 × 72, 1833

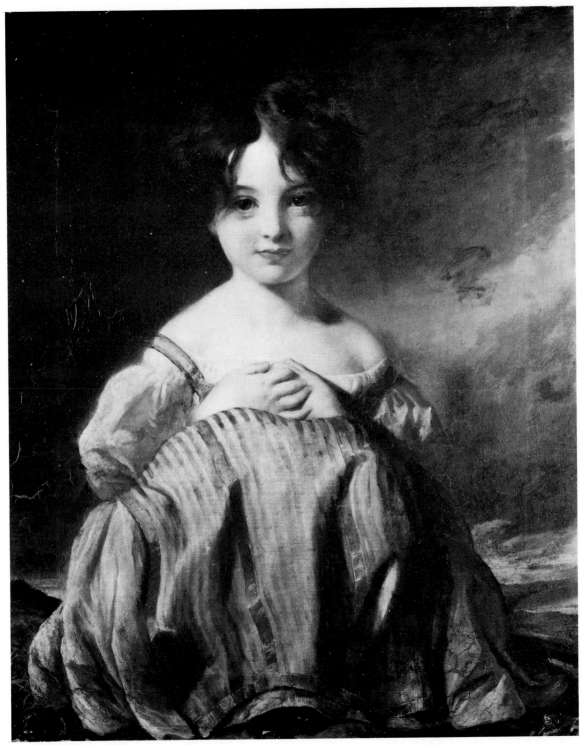

38. *Harriet Maconochie Welwood*, oil on canvas, 77.6 × 62.9, 1832

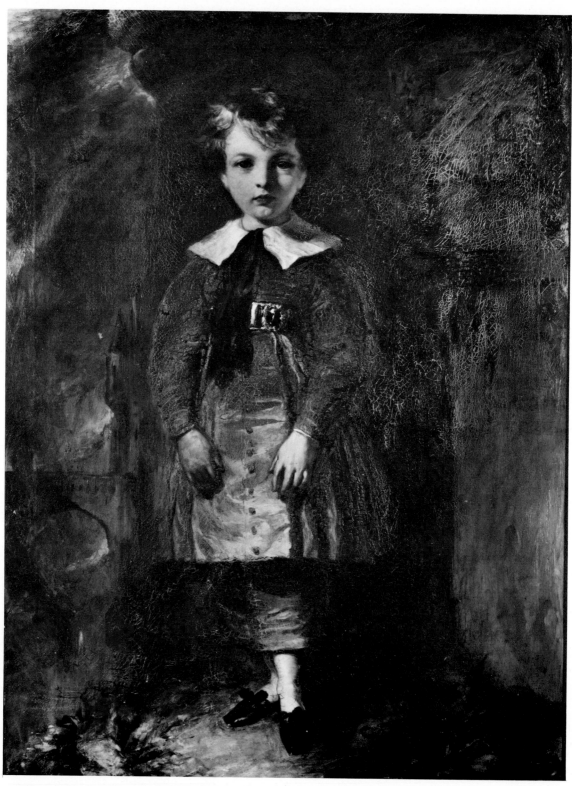

39. *Alexander Jardine*, oil on canvas, 122 × 91.4, 1834

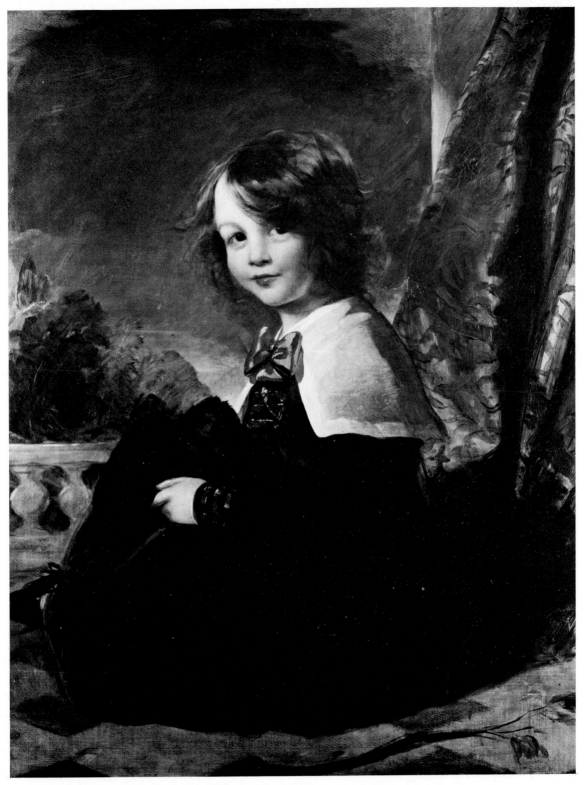

40. *John Tenth Earl Lindsay: 'No, guess again'*, oil on canvas, 91.4 × 71.0, 1833

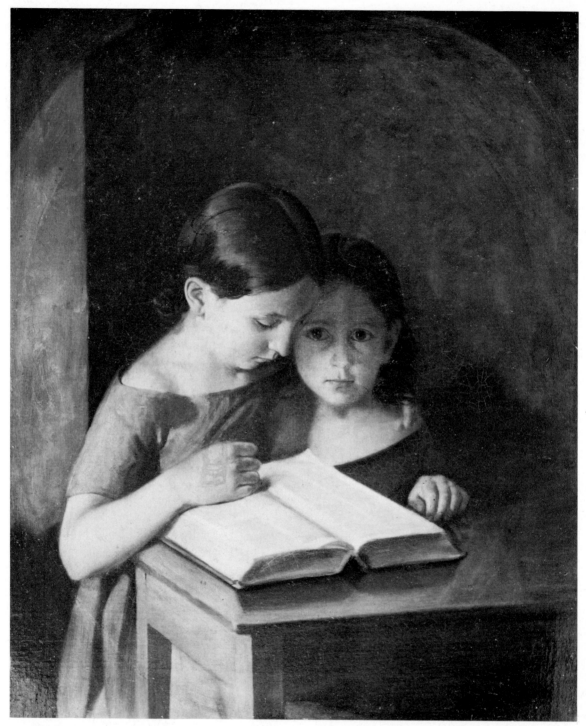

41. *The Sisters*, oil on canvas, 77.0 × 63.8, post 1840

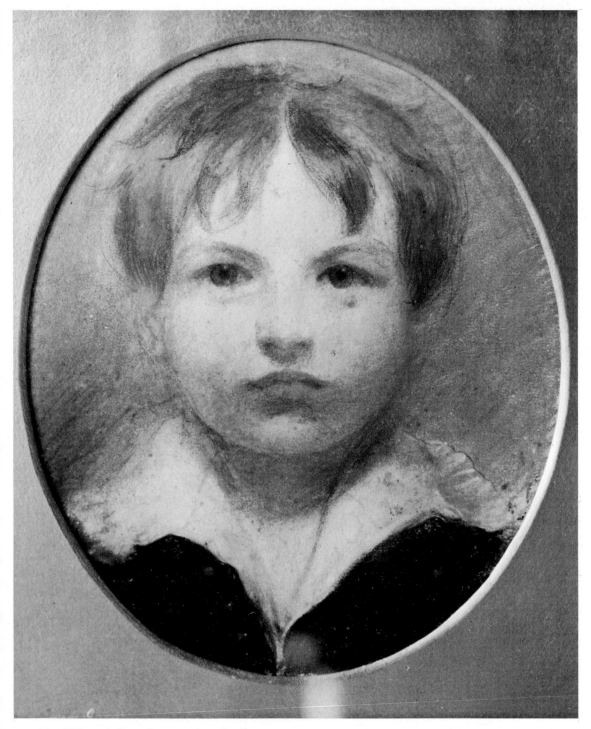

42. *Adam Wilson*, chalk, 15.8 × 12.71, oval, 1830s

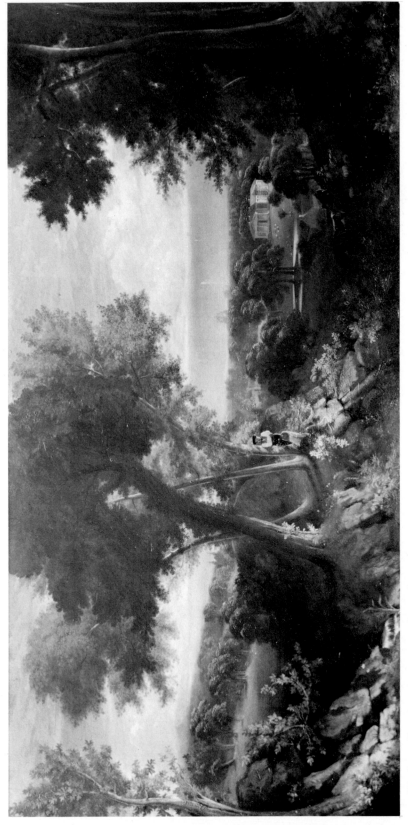

43. *Westburn*, oil on board, 74.1 × 148.93, 1827

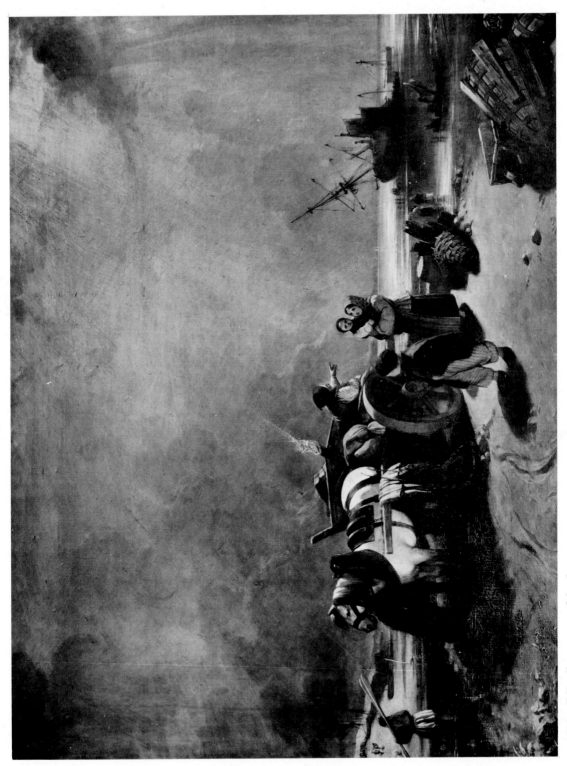

44. *Fisher Folk*, oil, 91.4 × 116.8, 1830

45. *Shirrapburn Loch*, oil, 30.5 × 40.6, pre-1837

46. *Glenlair*, water-colour, 19.4 × 32.4, 1832

47. *Roslin Chapel, interior*, oil on canvas, 29.4 × 36.7, 1830s

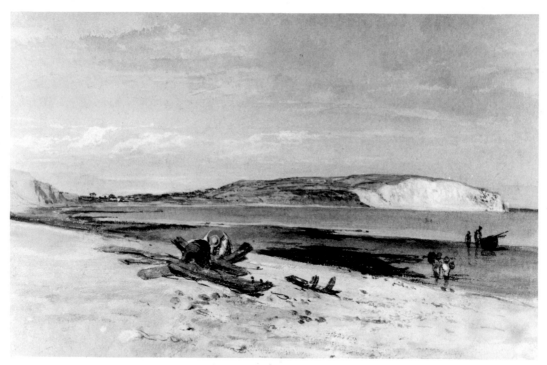

48. *Culver Cliff, Isle of Wight*, water-colour, 16.4 × 27.3, 1847–8

49. *Culver Cliff, Isle of Wight*, pen and ink and water-colour over pencil heightened with white, 37.1 × 49.2, 1847–8

50. *The Rhône at Avignon* (detail), water-colour, 27.9 × 45.7, 1832

51. *Osborne House, Isle of Wight*, water-colour, 27.9 × 45.7, 1847

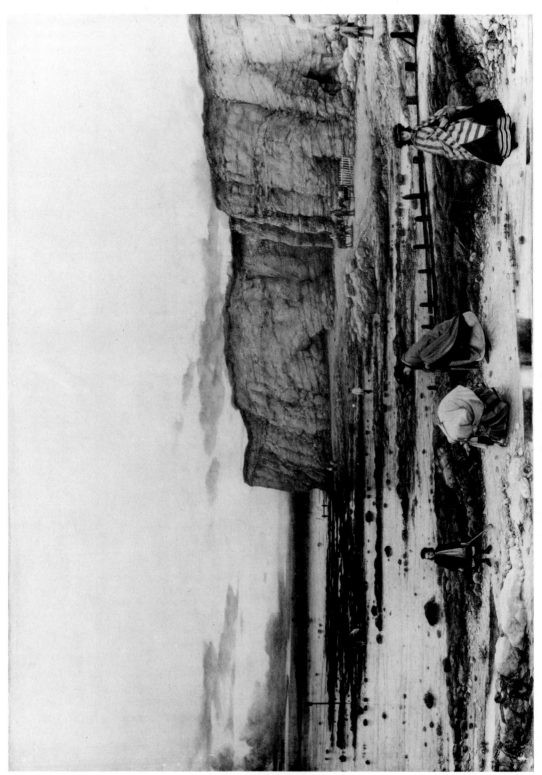

52. *Pegwell Bay: A Recollection of October 5th 1858*, oil on canvas, 63.5 × 88.9, 1859

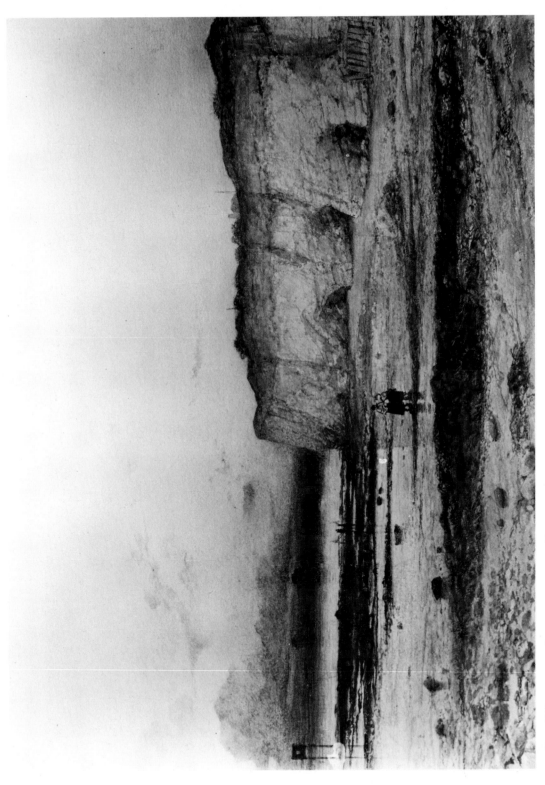

53. *Pegwell Bay*, water-colour, 24.7 × 34.9, 1857

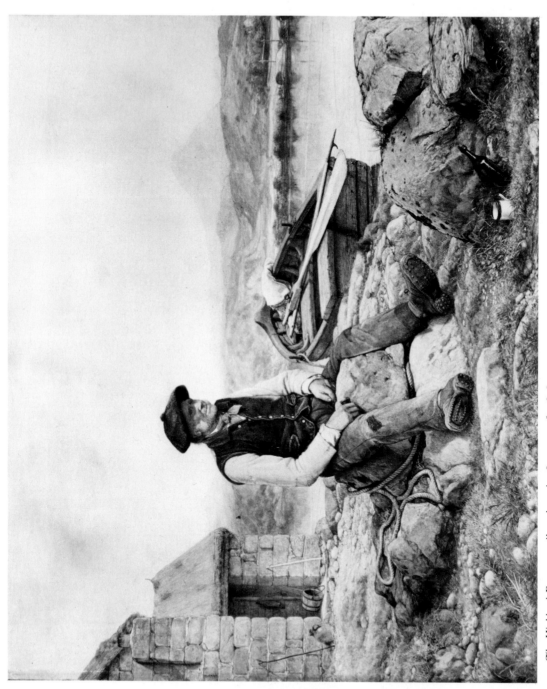

54. *The Highland Ferryman*, oil on board, 48.4 × 59.6, 1858

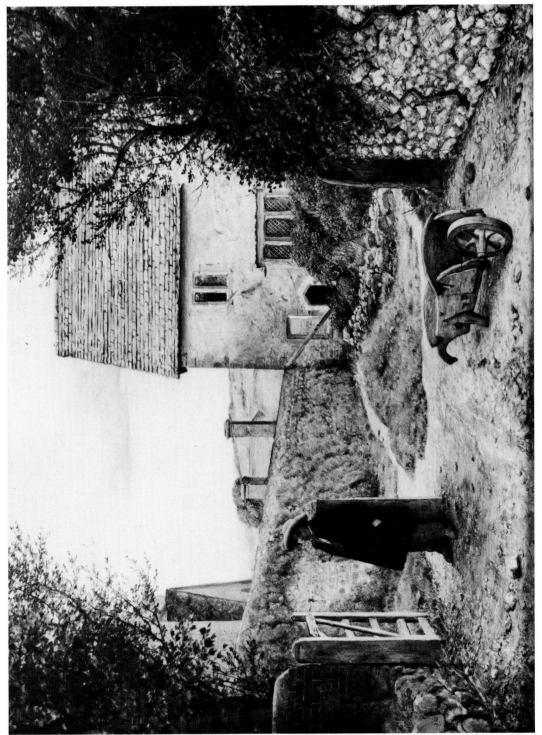

55. *The Entrance to the Vicarage*, oil on board, 30.5 × 40.6, late 1850s

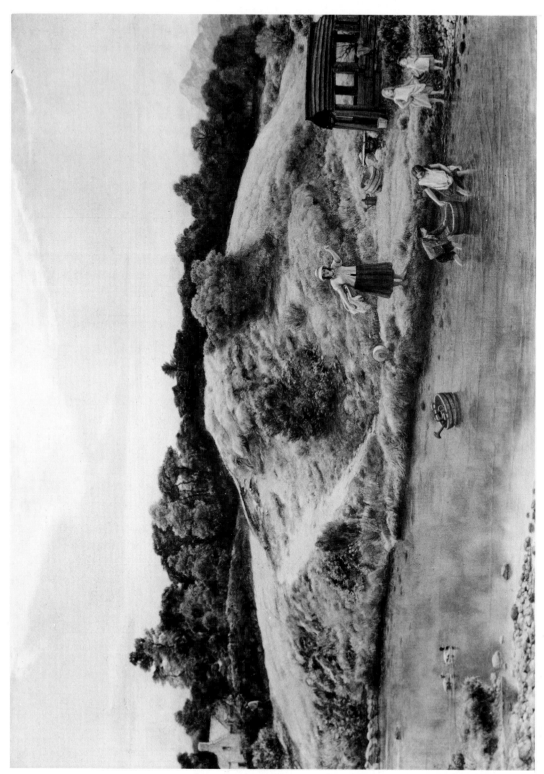

56. *A Scene in Arran*, oil, 34.9 × 49.1, 1859

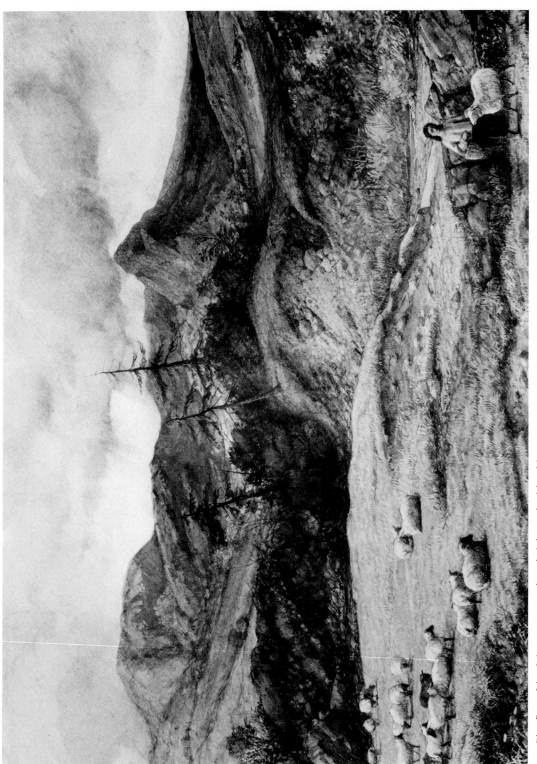

57. *Glen Rosa, Isle of Arran*, water-colour heightened with white, 24.0 × 34.9, 1859

58. *Goat Fell, Isle of Arran*, water-colour, 20.3 × 33.6, 1859

59. *Tryfan, Snowdonia*, water-colour, 22.8 × 34.9, 1860

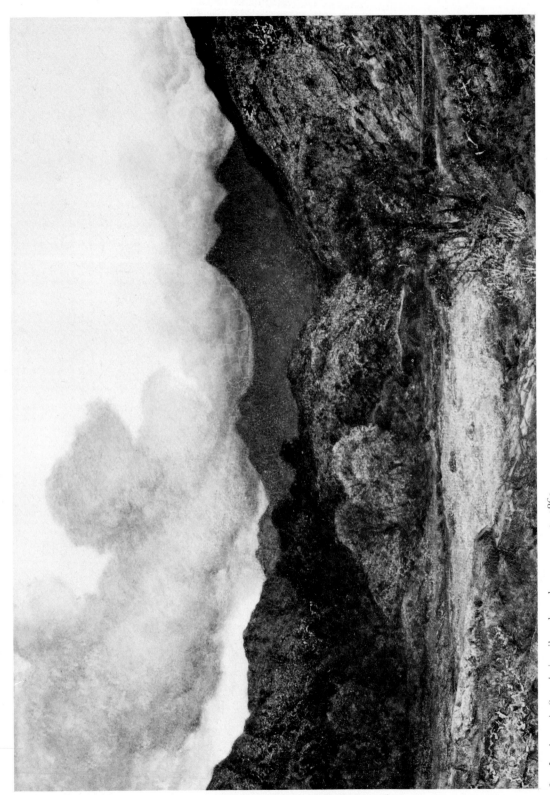

60. *Landscape in Snowdonia*, oil on board, 25.4 × 45.7, 1860

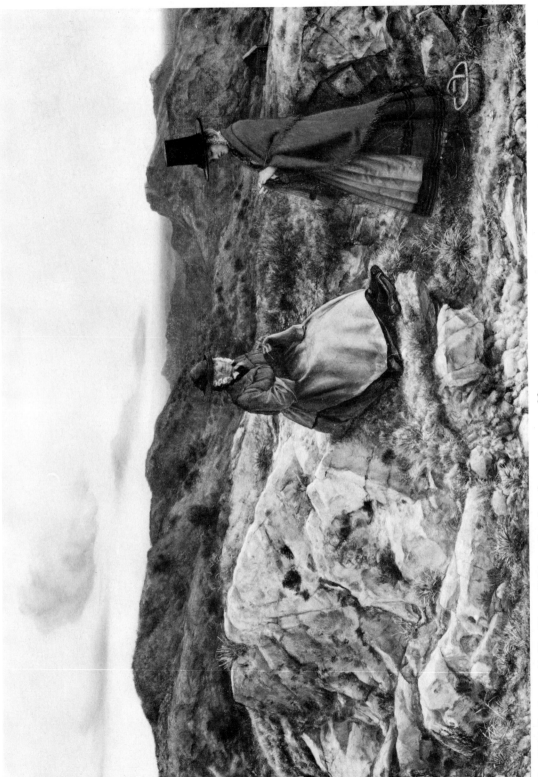

61. *Welsh Landscape with Two Women Knitting*, oil on board, 35.2 × 49.4, 1860

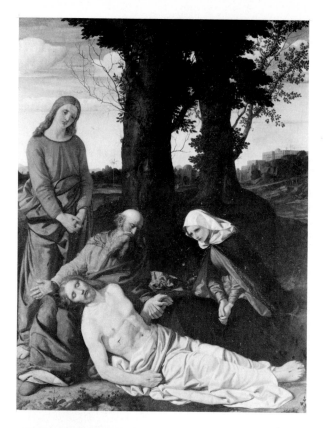

62. *The Dead Christ*, oil, 210.8 × 165.1, 1835

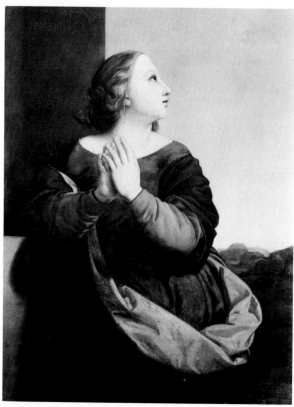

63. *St. Catherine*, oil on panel, 90.1 × 67.2,
pre-1845

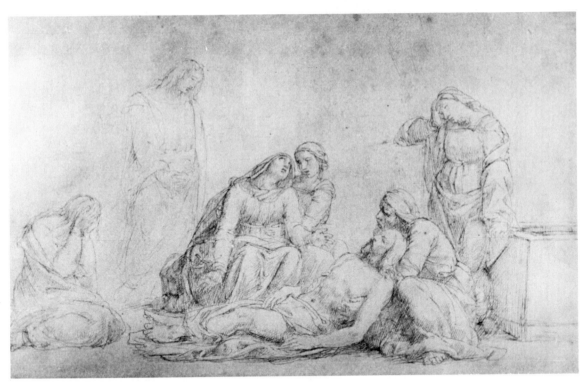

64. *The Entombment*, brown ink, 17.8 × 21.5, 1829?

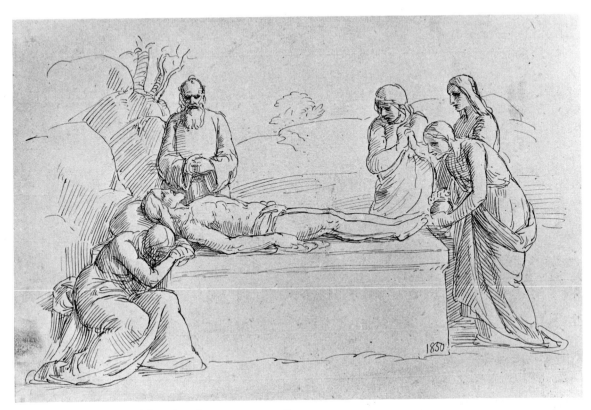

65. *The Entombment*, pen, ink and wash, 21.9 × 32.7, 1850

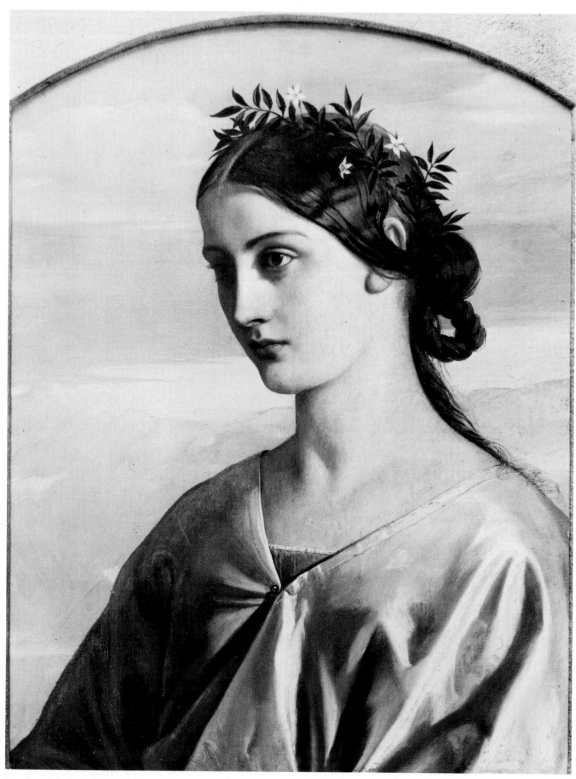

66. *Beatrice*, oil on panel, 64.7 × 49.1, 1859

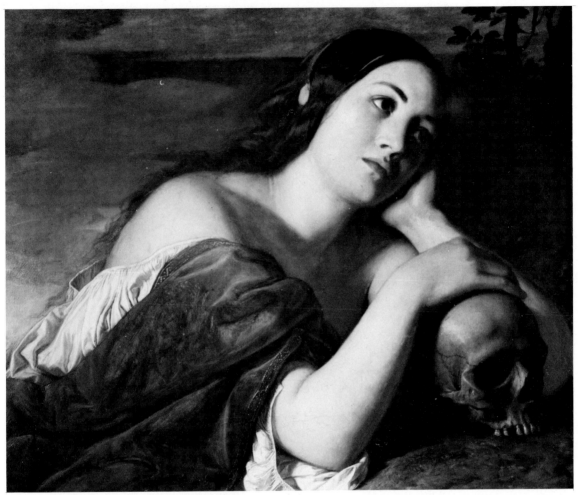

67. *Omnia Vanitas* (*A Magdalen*), oil on canvas, 62.3 × 74.7, 1848

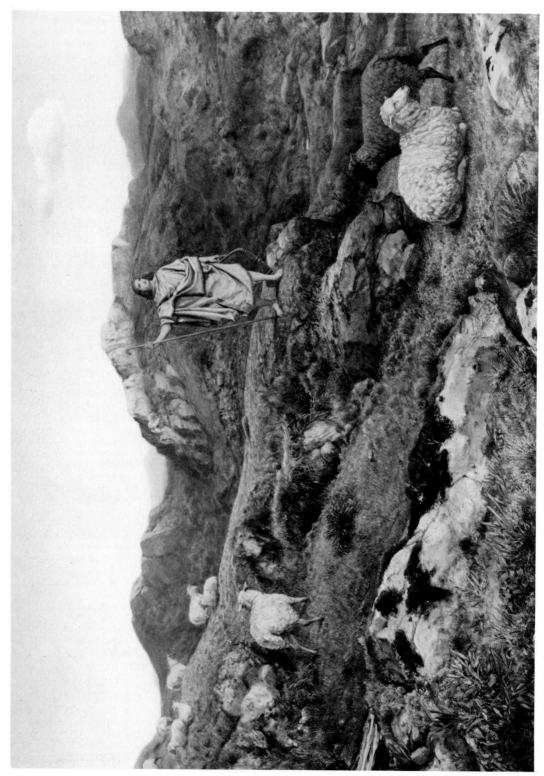

68. *David as a Youth*, oil on board, 34.2 × 48.4, c. 1859

70. *David with his Harp*, pencil and silverpoint on grey paper,
12.7 × 8.32, c. 1859

69. *David with his Harp*, pencil and silverpoint on
grey paper, 11.28 × 5.0, c. 1859

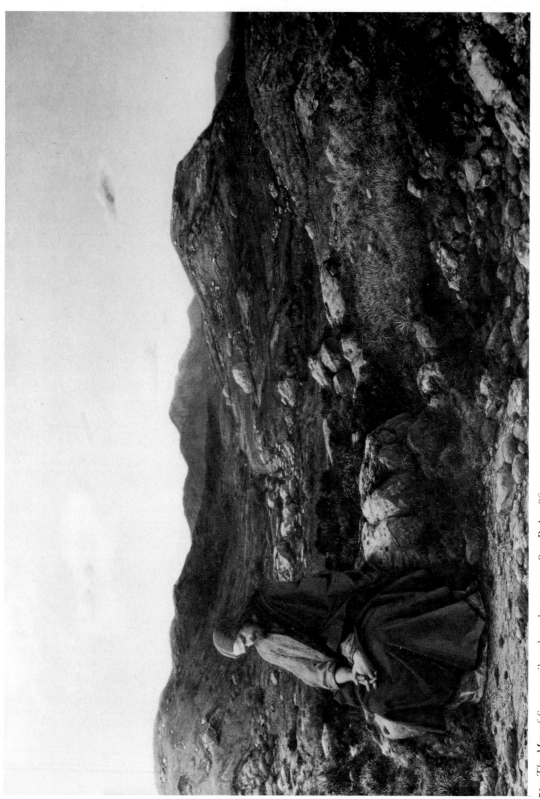

71. *The Man of Sorrows*, oil on board, 34.9 × 48.4. R.A. 1860

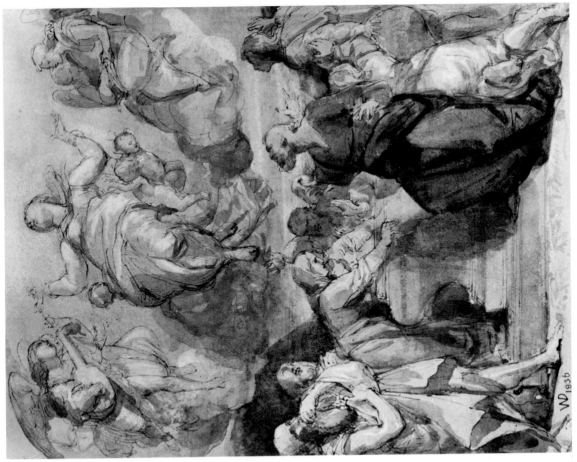

72. *St. Christopher*, pen, wash and pencil, 20.6 × 20.6, 1840s

73. *The Assumption of the Virgin*, pen and wash, 23.4 × 18.4, 1836

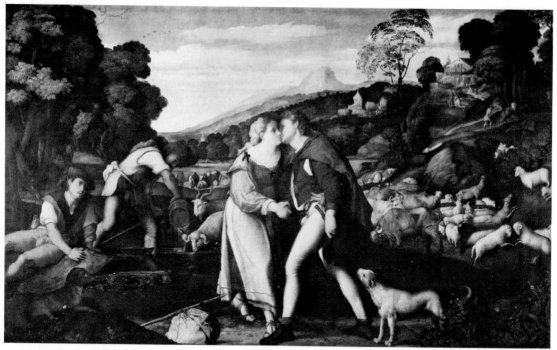

74. Palma Vecchio, *Jacob and Rachel*

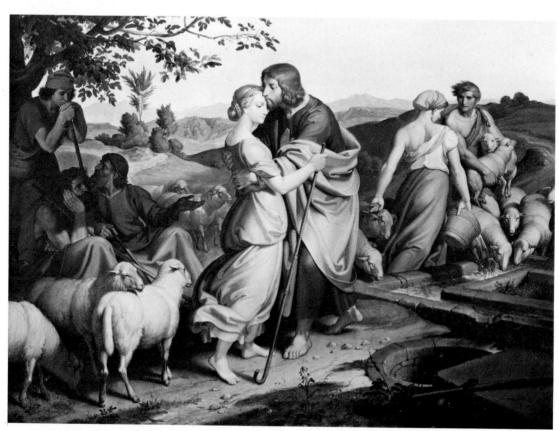

75. J. Führich, *Jacob and Rachel*

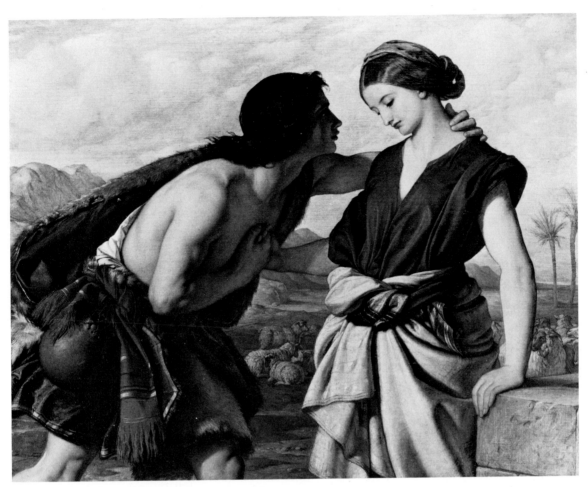

76. *Jacob and Rachel*, oil on canvas, 70.4 × 91.1, 1850–3

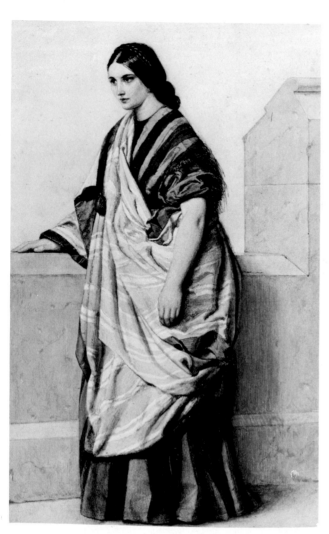

77. *Woman in Old Testament Dress*,
pencil and water-colour, 40.6 × 26.6

78. *Ruth and Boas*, water-colour, 17.8 × 30.5

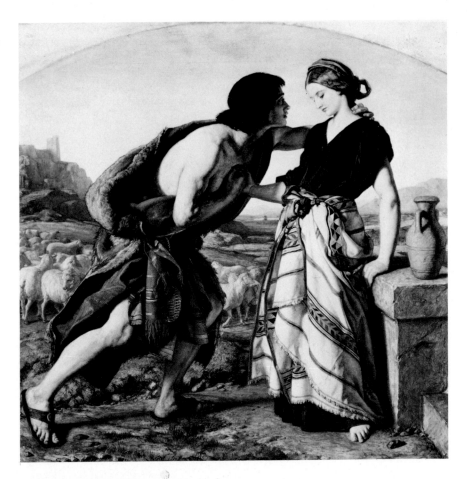

79. *Jacob and Rachel*, oil on canvas, 58.4 × 57.0, R.A. 1853

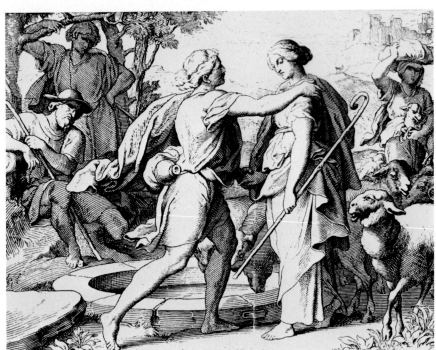

80. After A. Strähuber, *The Meeting of Jacob and Rachel*

81. *Christ and the Woman of Samaria*, oil on canvas, 34.2 × 48.4, 1860

83. *Christ Seated*, pencil and silverpoint on grey paper, 12.7 × 20.3, c. 1860

82. *The Woman of Samaria*, pencil and silverpoint on grey paper, 10.1 × 20.3, c. 1862–3

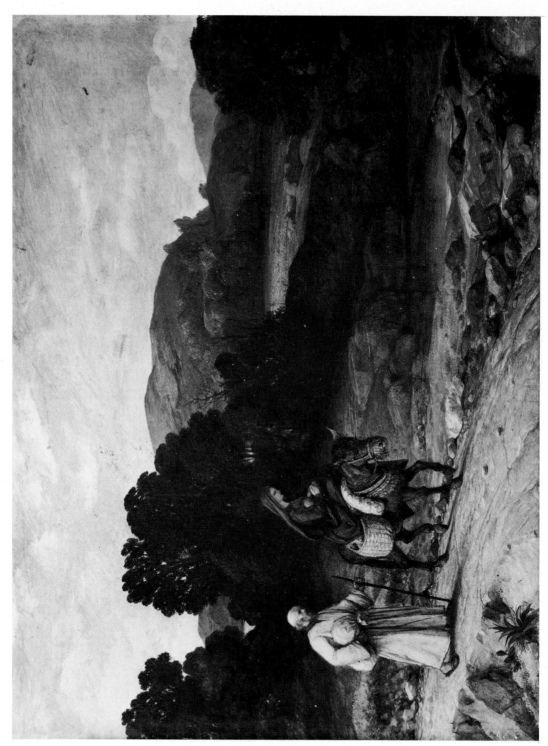

84. *The Flight into Egypt*, oil on board, 30.5 × 40.6, *c.* 1851

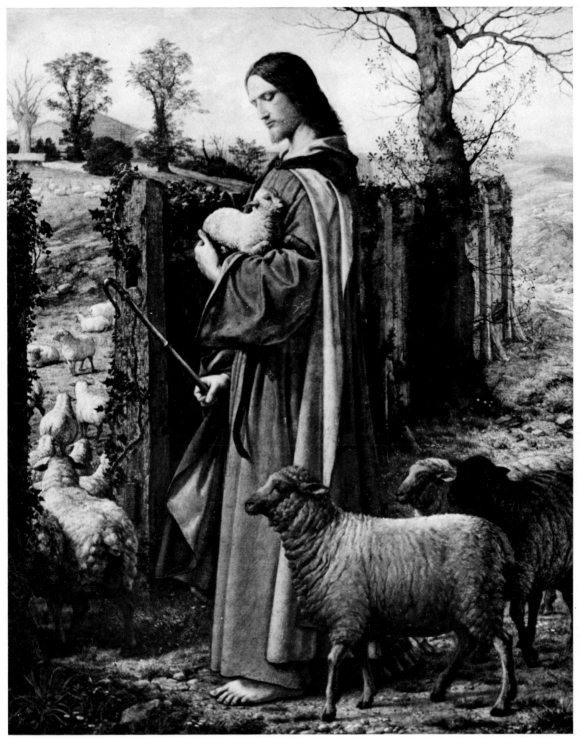

85. *The Good Shepherd*, oil on canvas, 78.9 × 63.5, R.A. 1859

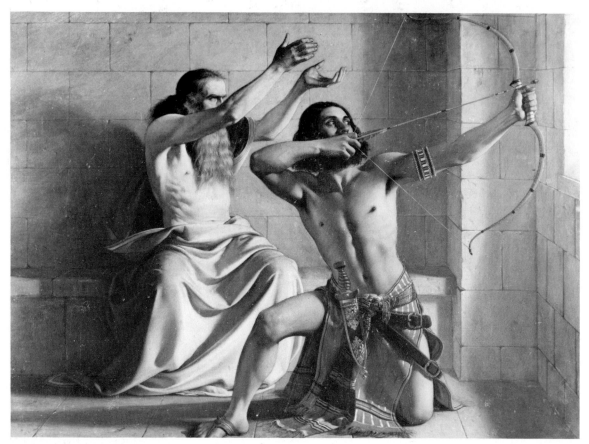

86. *Joash Shooting the Arrow of Deliverance*, oil on canvas, 77.6 × 110.4, 1844

87. *Eliazer of Damascus*, oil on canvas, 61.27 × 50.80, 1860

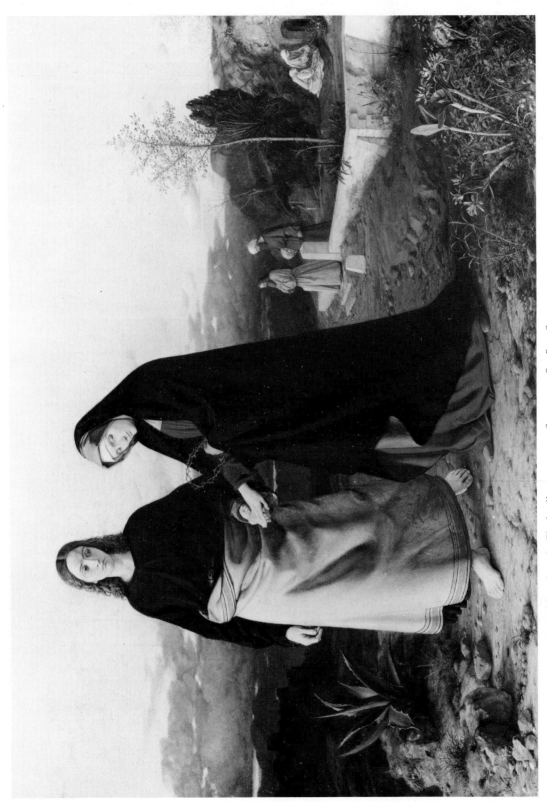

88. *St. John Leading the Blessed Virgin Mary from the Tomb*, oil on canvas, 76.4 × 109.8, 1844–60

89. *St. John Leading the Blessed Virgin Mary from the Tomb*, oil on panel, 20.0 × 20.9, *c.* 1844

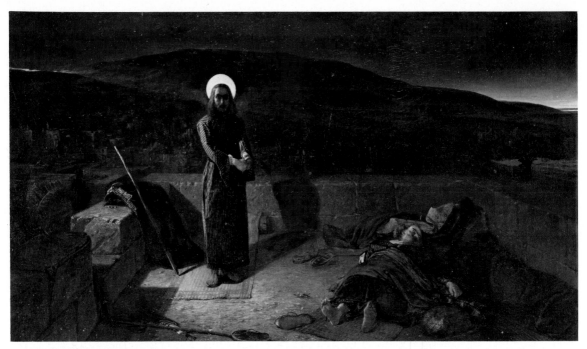

90. William Henry Fiske, *The Last Night of Jesus Christ in his Nazarene Home*, R.A. 1864

91. J. R. Herbert, *Laborare est Orare*, R.A. 1862

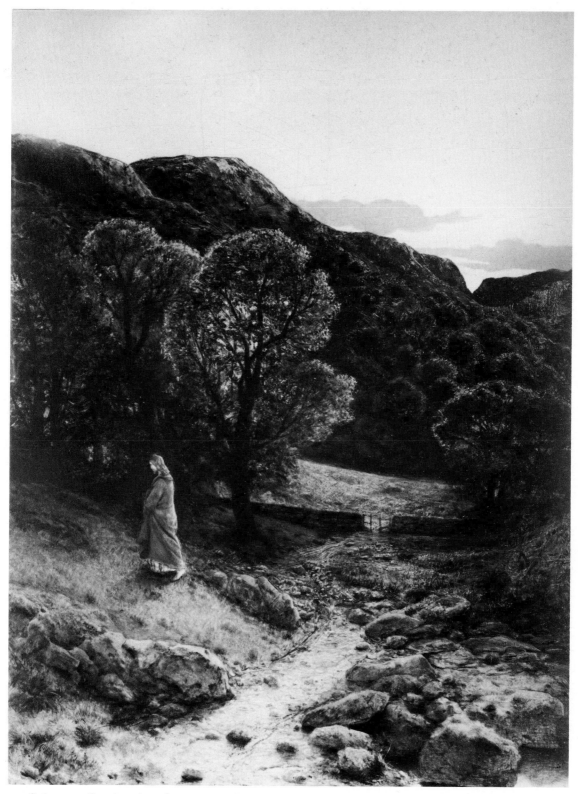

92. *Gethsemane*, oil on board, 42.8 × 32.1, *c*. 1855

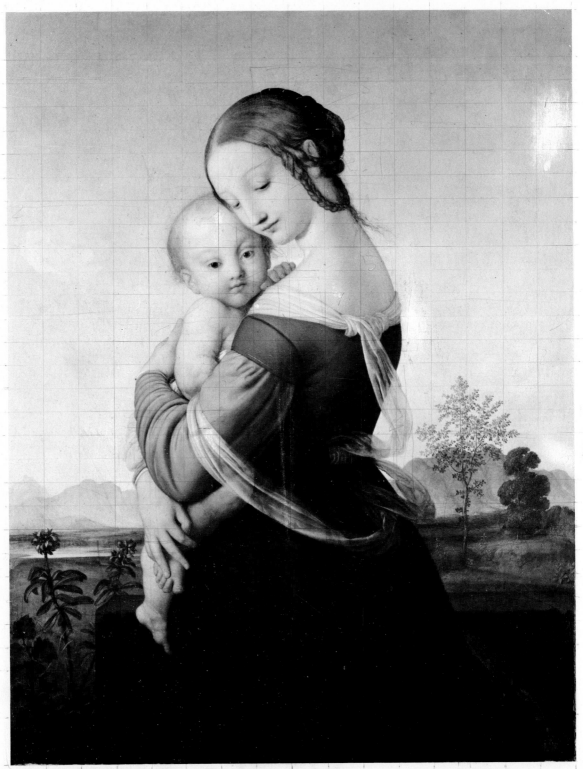

93. *Madonna and Child*, oil on canvas, 102.8 × 80.8, *c.* 1828

94. *Madonna and Child*, silverpoint
touched with white, 21.63 × 19.4, 1848

95. *Virgin and Child*, pen and ink,
20.3 × 13.32

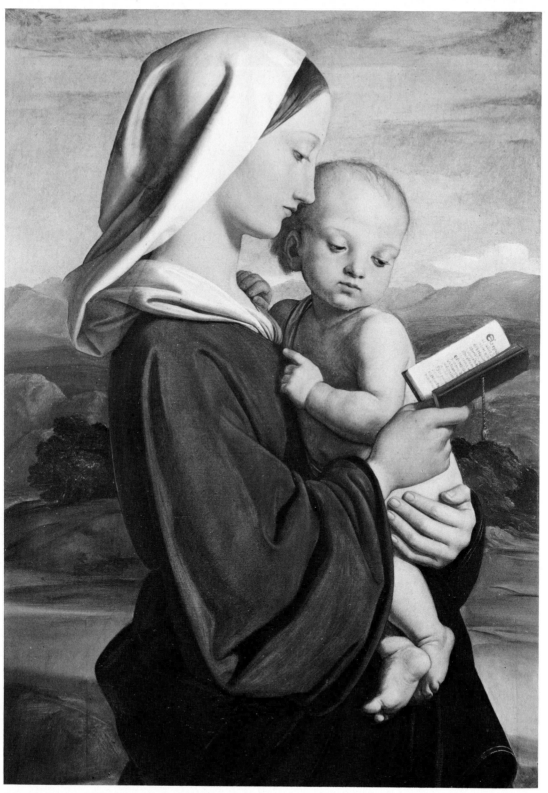

96. *Madonna and Child*, oil on canvas, 80.1 × 63.5, 1845

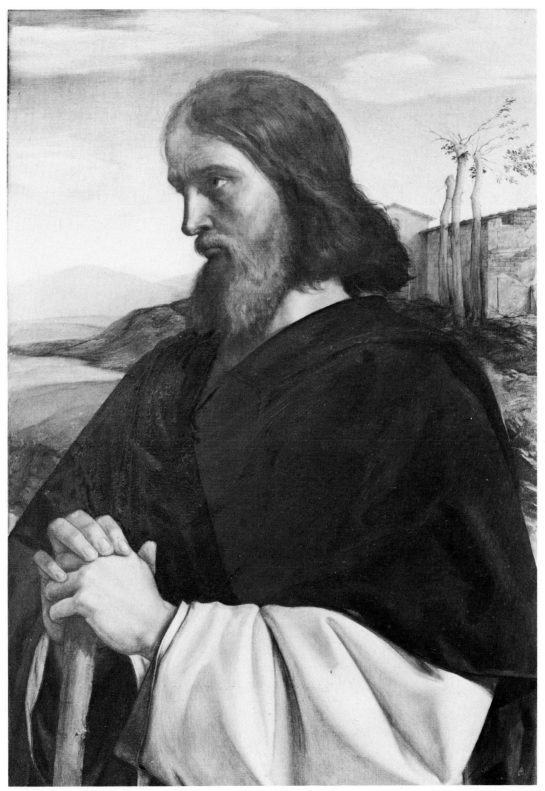

97. *St. Joseph*, oil on canvas, 80.1 × 63.5, 1846–7

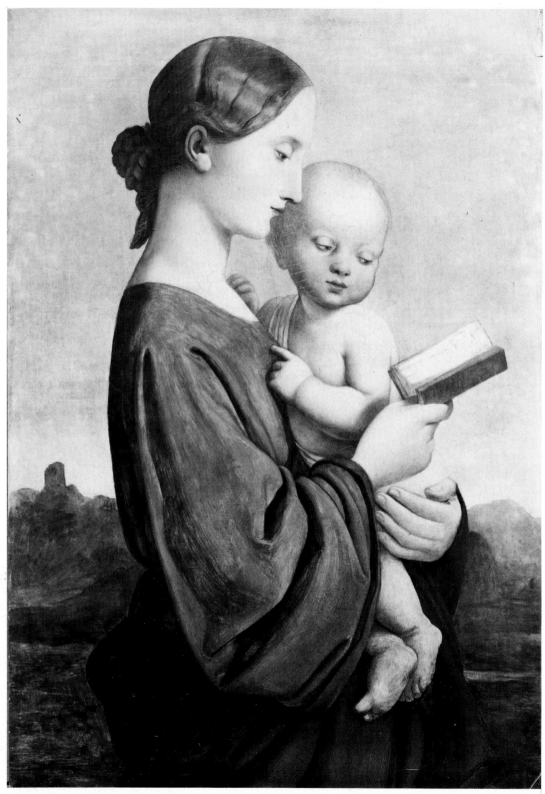

98. *Madonna and Child*, oil on board, 75.4 × 52.0, *c.* 1845

99. *Virgin and Child with Saints*, ink and wash

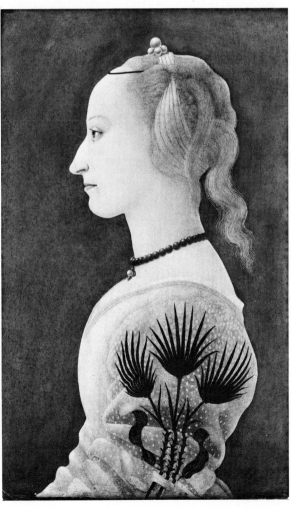

100. Baldovinetti, *Portrait of a Lady*

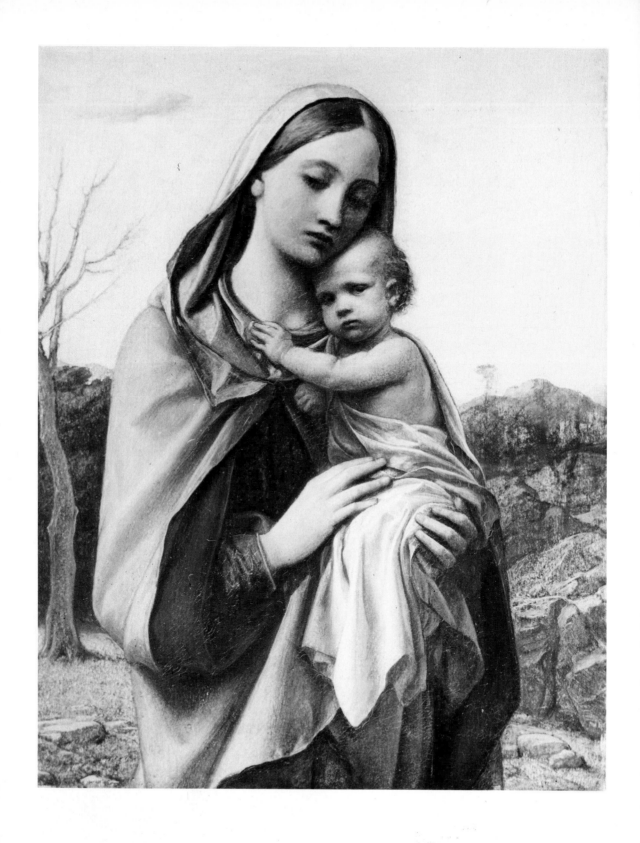

101. *Madonna and Child*, oil on canvas, 25.4 × 20.0, *c.* 1828

102. *Virgin and Child*, after Lucca della Robbia, pencil, 12.7 × 8.33

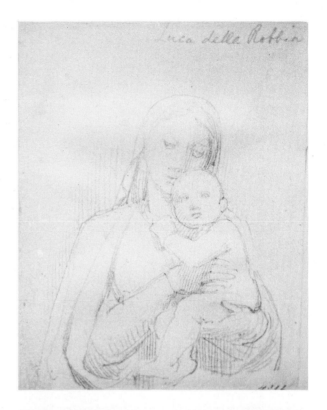

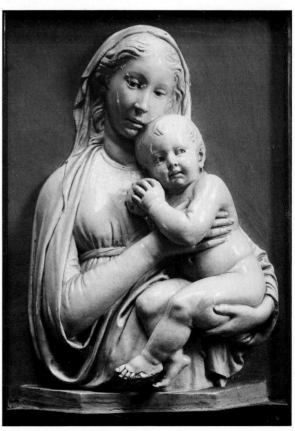

103. Lucca della Robbia, *Madonna of the Apple*

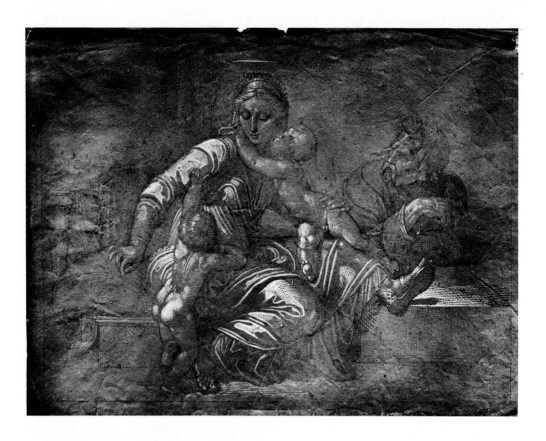

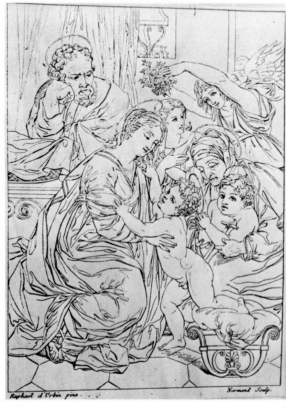

104. *The Holy Family with the Infant St. John*, pencil heightened with white, 22.8 × 36.7

105. C. Normand after Raphael, *The Holy Family*, from C. P. Landon, *A Collection of Etchings . . .* , 1821

106. After W. Dyce, *The Signal*

107. *Young Boy Lying on the Ground*,
charcoal and pencil, 12.7 × 24.4

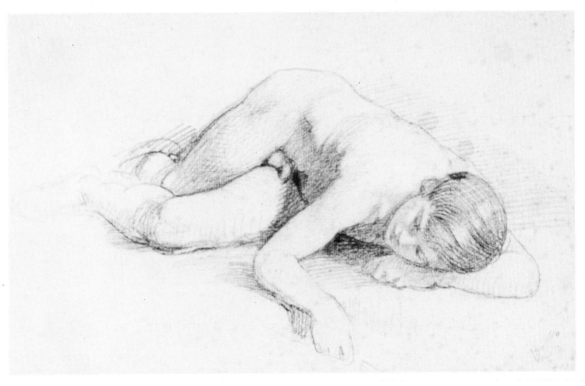

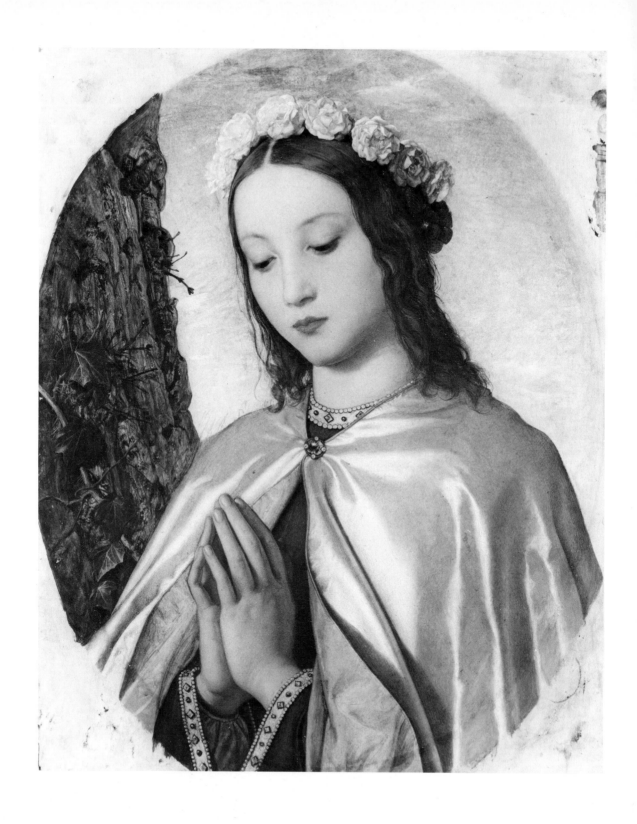

108. *Christabel*, oil on canvas, 50.8 × 43.2, oval, 1855

109. *Christabel*, pencil and brown chalk
on grey paper, 13.32 × 10.1, 1849

110. *A Demoniac Boy*, after Domenichino,
pencil and coloured wash, 36.7 × 24.7,
c. 1843

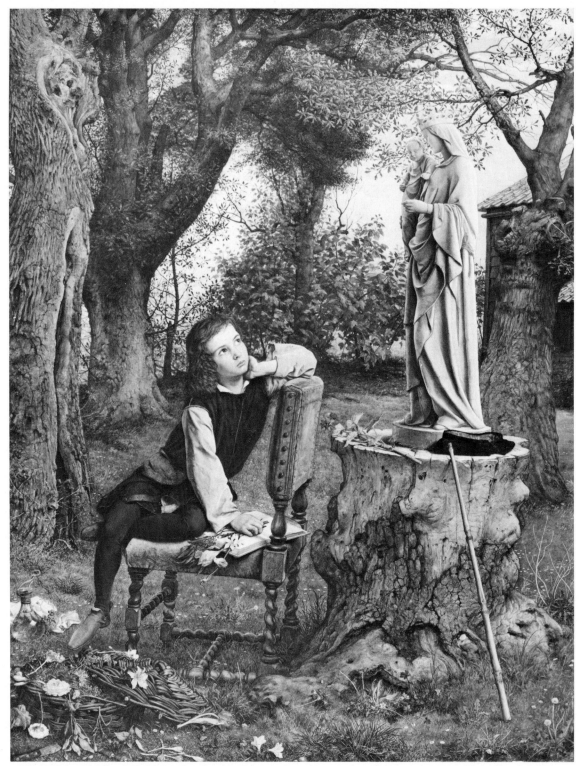

111. *Titian Preparing to Make his First Essay in Colouring*, oil on canvas, 91.4 × 67.2, 1857

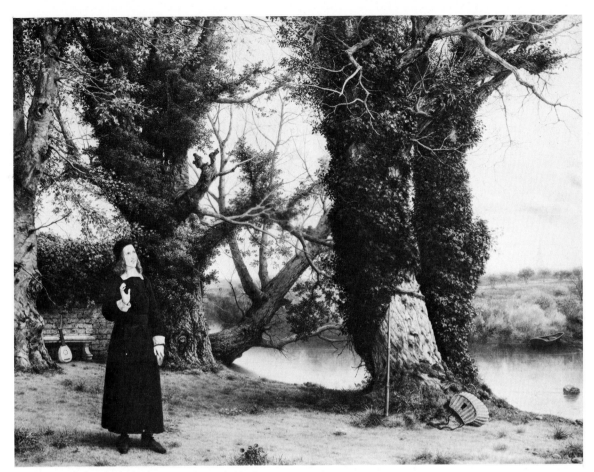

112. *George Herbert at Bemerton*, oil on canvas, 86.4 × 111.6, 1861

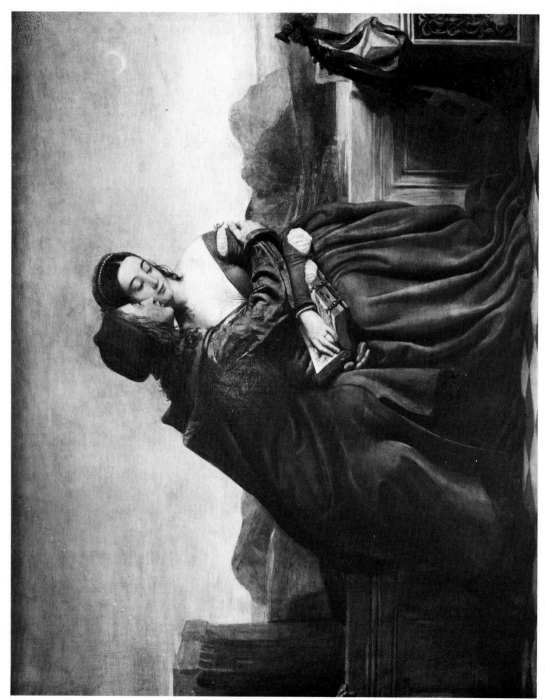

113. *Francesca da Rimini*, oil on canvas, 137.65 × 172.71, 1837

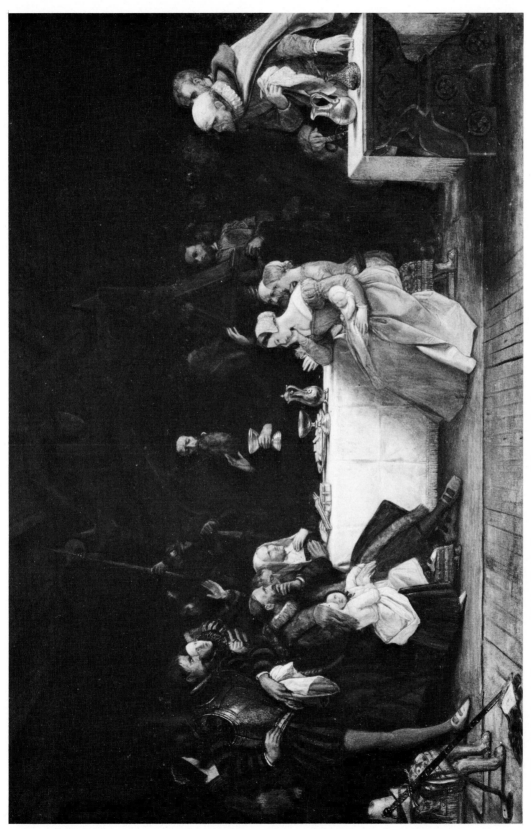

114. *John Knox Dispensing the Sacrament at Calder House*, oil on canvas, 38.8 × 59.6, 1835–7

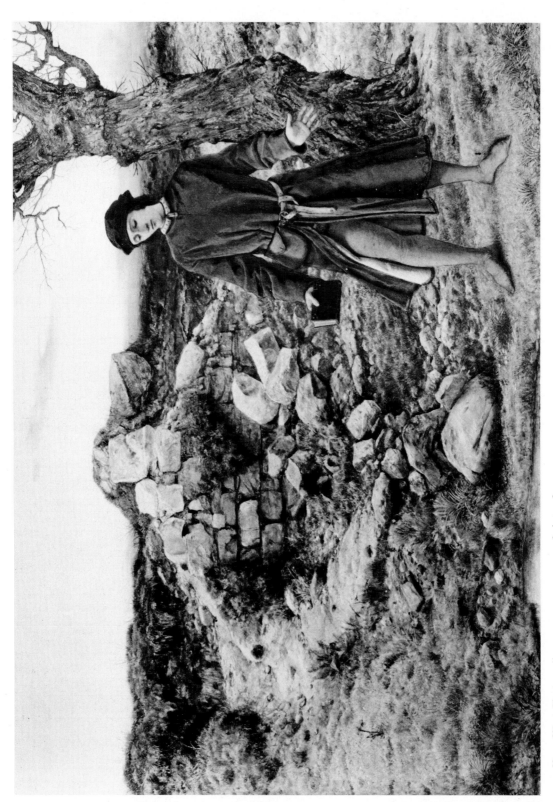

115. *Henry VI at Towton*, oil on canvas, 35.4 × 50.8, late 1850s

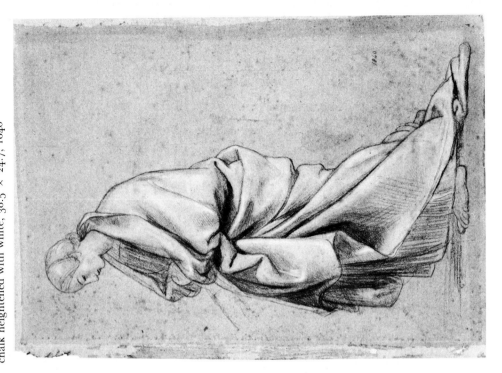

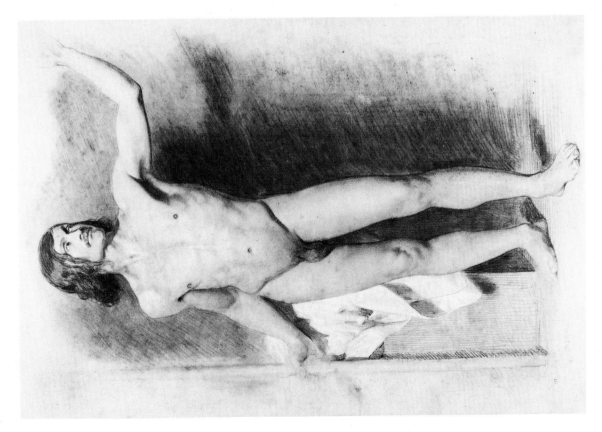

116. *Life Study*, charcoal and white chalk,
56.1 × 38.8, 1844

117. *Study of a Woman in Heavy Drapery*, black
chalk heightened with white, 38.5 × 24.7, 1840

A

LIBRARY OF FATHERS

OF THE

HOLY CATHOLIC CHURCH,

ANTERIOR TO THE DIVISION OF THE EAST AND WEST.

TRANSLATED BY MEMBERS OF THE ENGLISH CHURCH.

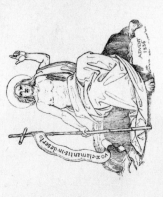

vox clamantis in deserto

ADVENT 1836

YET SHALL NOT THY TEACHERS BE REMOVED INTO A CORNER ANY MORE, BUT THINE EYES SHALL SEE THY TEACHERS. *Isaiah* xxx. 20.

OXFORD,

JOHN HENRY PARKER;

J. G. F. AND J. RIVINGTON, LONDON.

MDCCCXLII

The Order of Daily Service,
the Litany,
and Order of the
Administration of the
Holy Communion,
with PLAIN-TUNE,
according to the use of the
United Church of England and Ireland.

London:
James Burns, Portman Street.
MDCCCXLIII

118. Title-page from *The Order of Daily Service, the Litany and Order for the Administration of the Holy Communion, with Plain-tune according to the use of the United Church of England and Ireland,* 1843

119. Title-page from *The Library of the Fathers,* x, ed. E. B. Pusey, 1842, title-page dated 1836

120. Illustration to *An Account of the Great Floods of August 1829 in the Province of Moray and Adjoining Districts* by Sir Thomas Dick Lauder, 1830

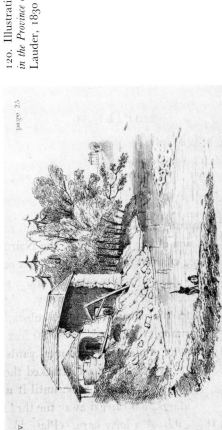

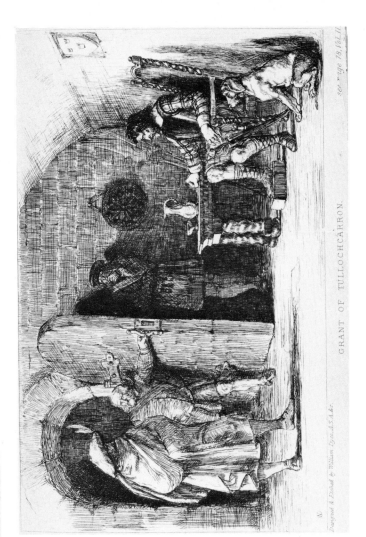

121. *Grant of Tullacharron*, illustration to *Highland Rambles* by Sir Thomas Dick Lauder, 1837

She felt within her inmost heart
A strange bewilder'd swell,
Too soft to break with sudden start,
Too gentle to rebel.

And what she hoped or thought to earn
Poor Margaret never knew,
But on her distaff oft she'd turn
A thoughtful, hopeful view.

And by the stone where last they met
Each day she took her stand;
And twirl'd the thread till daylight set,
With unremitting hand.

Her little store upon the stone
She spread to passerby;
And oft they paused and gazed upon
Her meek and mournful eye.

And e'en from those who had but few,
Full oft a coin she won,
And faster for her treasure grew
Than e'er her hopes had done.

But all in vain it grew, alas!
Her destined ransom store;
For from the Holy Land there pass
The travellers once more.

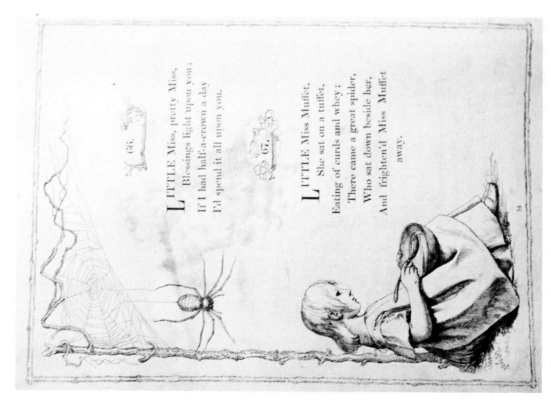

123. C. Gray after W. Dyce, *The Spinning Maiden's cross,*
illustration to *Poems and Pictures,* 1846

66.

LITTLE Miss, pretty Miss,
Blessings light upon you;
If I had half-a-crown a day
I'd spend it all upon you.

67.

LITTLE Miss Muffet,
She sat on a tuffet,
Eating of curds and whey;
There came a great spider,
Who sat down beside her,
And frighten'd Miss Muffet
away.

122. Illustration to *Nursery Rhymes Tales and Jingles,* 1842

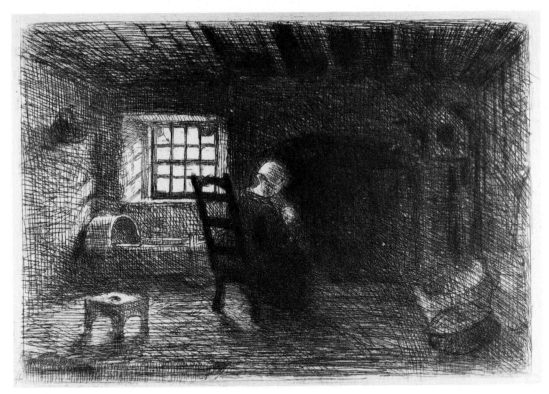

124. *A Cottage Interior*, etching, 7.70 × 12.39, 1830s

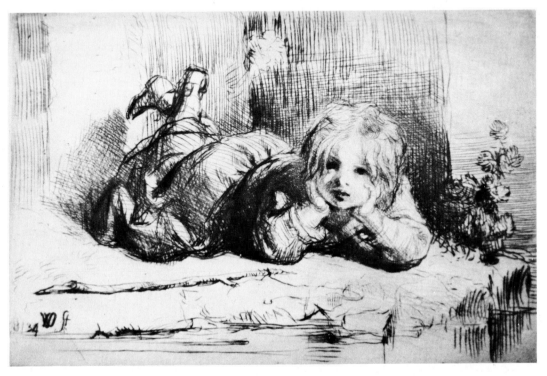

125. *The Young Angler*, dry point, 8.0 × 12.39, 1834

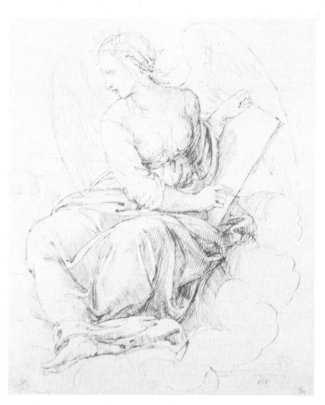

126. Design for the cover of the
Government Drawing Book, brown
ink, 22.5 × 16.1, 1843

127. *Design for Decorative Mosaic
Work*, ink and water-colour,
5.0 × 15.2

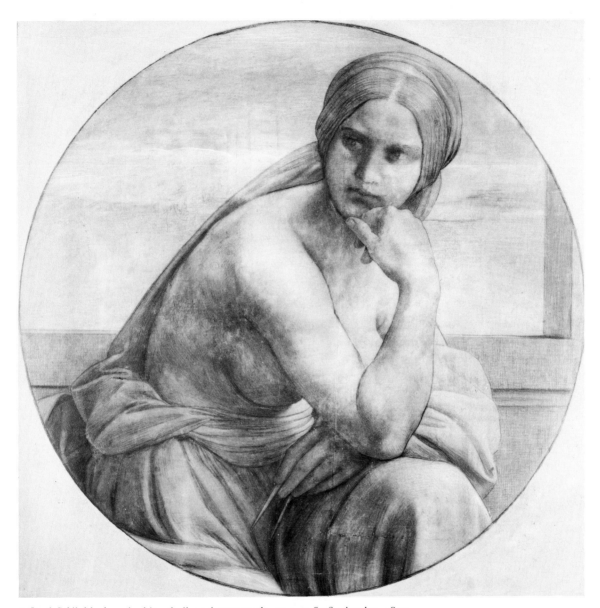

128. *A Sybil*, black and white chalk and grey wash, 91.4 × 87.6, circular, 1852

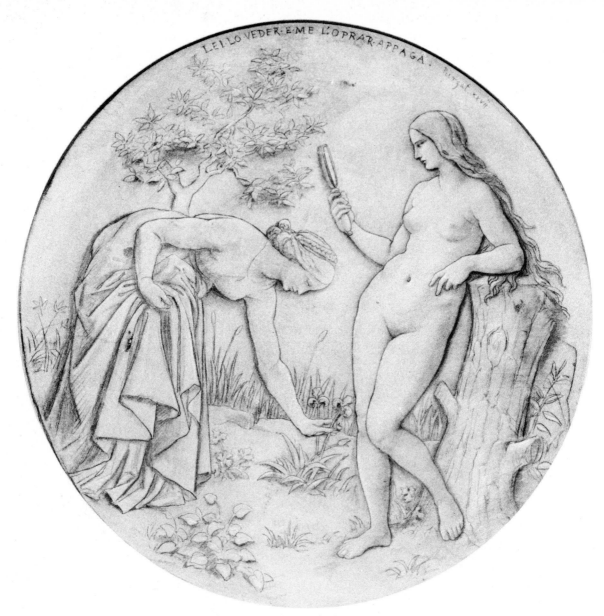

129. *Design for the Reverse of the Turner Medal*, charcoal
and white chalk on grey paper, circular, 61.0 dia. 1858

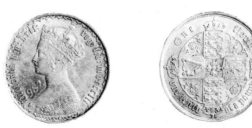

130. 'Gothic' coin, designed by William Dyce and William Wyon, 1847

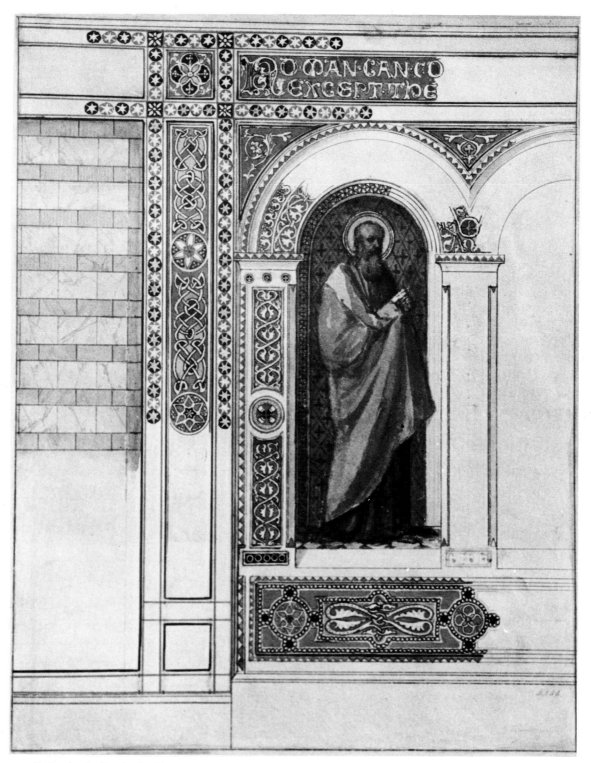

131. *Design for the Façade of a Chapel*, pen, ink and water-colour (unfinished) 35.5 × 28.5, 1839?

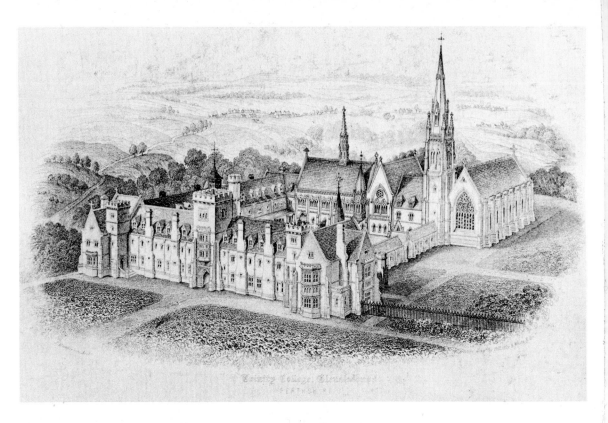

132. *Trinity College, Glenalmond, Perthshire,*
engraved by Gellatly and White
after J. Henderson, the architect

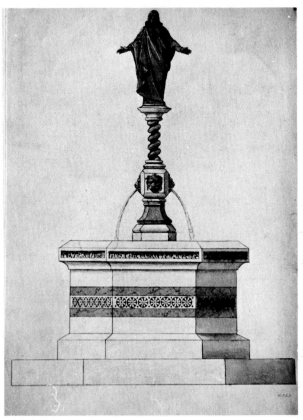

133. *Design for a Drinking Fountain,*
water-colour, 33.0 × 24.3, 1862

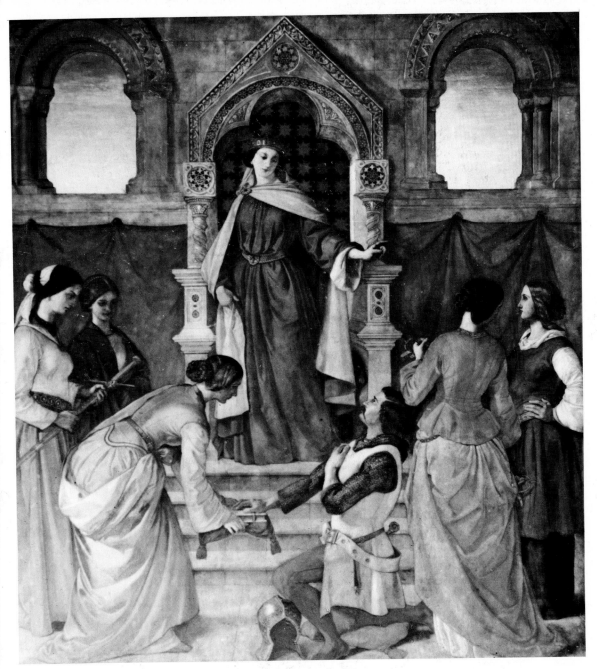

162. *Mercy: Sir Gawaine Swearing to be Merciful*, fresco, completed 1854

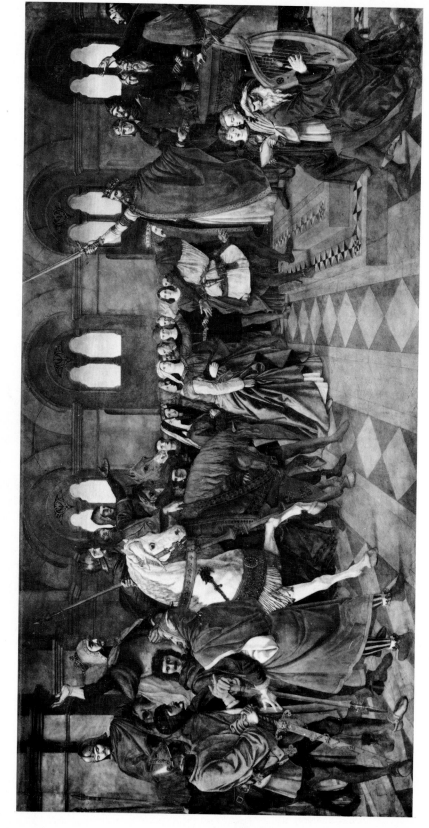

163. *Hospitality: The Admission of Sir Tristram to the Fellowship of the Round Table*, fresco, incomplete in 1864